FRENCH PAINTING

PLATE I

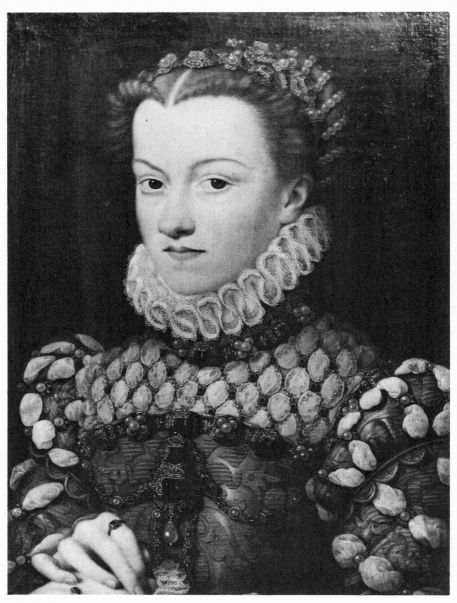

Paris, Louvre

Ascribed to FRANÇOIS CLOUET (1510-1572)
Elizabeth of Austria, Queen of France

FRENCH PAINTING

BY

R. H. WILENSKI

THIRD REVISED EDITION

DOVER PUBLICATIONS, INC.
NEW YORK

Published in Canada by General Publishing Company, Ltd., 30 Lesmill Road, Don Mills, Toronto, Ontario.
Published in the United Kingdom by Constable and Company, Ltd., 10 Orange Street, London WC 2.

This Dover edition, first published in 1973, is an unabridged republication with corrections of the revised edition published in 1949 by the Medici Society in London. Additional notes have been prepared especially for this edition. Plates I-XII which appeared in color in the original edition are reproduced here in black and white.

International Standard Book Number: 0-486-22931-9
Library of Congress Catalog Card Number: 72-92760

Manufactured in the United States of America
Dover Publications, Inc.
180 Varick Street
New York, N. Y. 10014

PUBLISHER'S NOTE
TO THE DOVER EDITION

This is an unabridged reprint of the second revised (1949) edition. Recent information on changes in ownership, attributions, etc., is reflected in a new section of Notes to the 1973 Edition, beginning on page 295; the symbol N (for notes) is used to call the reader's attention to the new commentary. We are grateful to Mrs. Elizabeth Gardner, Associate Curator of European Paintings at the Metropolitan Museum of Art in New York, for undertaking much of the research involved in this project.

The picture selection is the same as that in the 1949 edition, but whereas the illustrations previously were grouped, they are now dispersed throughout the work and generally occur close to the text references.

PREFACE
TO THE REVISED EDITION

The text of this new edition has been revised and improved throughout, and some sections have been completely rewritten.

In particular I have rewritten the earlier chapters and the epilogue—the first because, since the book was written, there have been some important exhibitions adding to knowledge of the French Primitives, and the second in order to enlarge the account of the main movements now generally known as modern painting and to discuss more works by living men.

The main body of the illustrations in the copiously illustrated first edition has been retained ; but I have made some substitutions and additions. MM. Matisse, Dufy and Ozenfant, among the living artists, are represented by new plates ; among the nineteenth century artists Degas, Delacroix, Daumier and Courbet are now better shown.

R. H. W.

London, 1949.

CONTENTS

PART ONE

THE FRENCH PRIMITIVES

PART TWO

RENAISSANCE PAINTING IN FRANCE

PART THREE

THE SEVENTEENTH CENTURY

PART FOUR

THE EIGHTEENTH CENTURY

CONTENTS xi

PART FIVE

FROM THE REVOLUTION TO THE SECOND EMPIRE

PART SIX

THE IMPRESSIONISTS

PART SEVEN

THE POST-IMPRESSIONISTS

PART EIGHT

THE CUBIST-CLASSICAL RENAISSANCE

EPILOGUE

LIST OF ILLUSTRATIONS

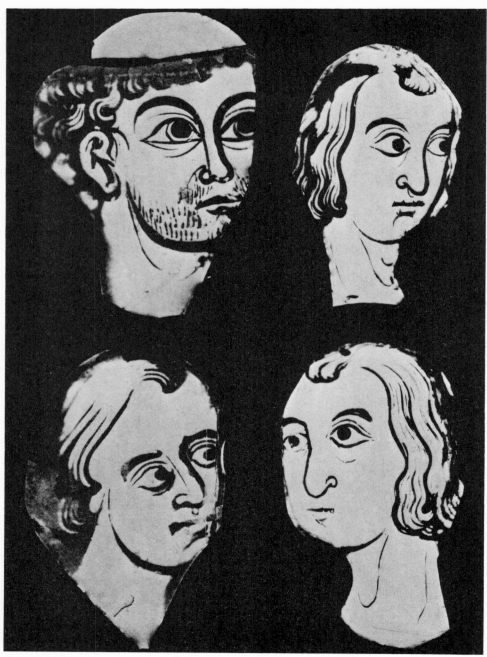

1. GLASS PAINTING (XIIIth CENTURY): Heads from Windows

PART ONE

THE FRENCH PRIMITIVES

THE FRENCH PRIMITIVES

A. FROM SAINT LOUIS TO AGINCOURT

I PAINTING IN FEUDAL FRANCE

The artist in the modern world refuses to be ranked among artisans or tradesmen; he claims the right to be regarded as a member of a liberal profession and sometimes to be following a vocation. He is nobody's servant and nobody is responsible for his existence.

No French artists attained or aspired to this position till the reign of Louis XIII. In Feudal France there were at first artist-valets, artist-monks and artist-artisans; and when the first independent artists appeared they were artisan-tradesmen without pretension to any other rank.

The artist-valets were originally in the regular service of the King. They were attached to the Lord Chamberlain's department of the King's household. They bore the title of *peintre et valet de chambre du roi*; they were concerned with the King's comforts and pleasures, and they were expected to be architects, sculptors, decorators, painters of easel pictures, designers of tapestry, cabinet makers, book makers, pageant masters and so forth. When King Jean le Bon (1350-1364) was brought as a prisoner to England he was accompanied by an artist-valet, one Girard of Orleans, who had made him at various times a litter, a number of chairs, a tailor's dummy and a set of chessmen. When the royal establishments became larger and the number of artist-valets increased, their functions were divided, and the man considered suitable was selected for the post of *premier peintre du roi* with jurisdiction over all the decorative works in the Lord Chamberlain's department. This system, which remained in force with modifications till the Revolution, was imitated by members of the royal family and at the noblemen's courts; from the thirteenth century to the Revolution Queens, Princes and nobles as well as Kings had artists attached to their establishments.

The artist-monks were in the regular service of the Church. They worked in monasteries where they wrote and illustrated ecclesiastical manuscripts. These manuscripts were used in the monasteries and they were also sold for ecclesiastical purposes; sufficient survive to indicate that the style of the monks'

illustrations was based on traditions which went back to the earliest Christian art at Byzantium. Illustrated manuscripts had been a powerful instrument in the propagation of the faith among illiterate populations in the early middle ages. It was thanks to the manuscripts that the Byzantine iconography, standardising the appearance and attributes of the sacred characters, permeated to all Christian countries, and was adopted everywhere by the Church for early mediæval sculpture and mosaics and for the painted windows of the great cathedrals. The formal character of this style is well known ; it persisted in Russia right up to the recent Revolution ; its essence was the deliberate dehumanisation of sacred figures in order that they might appear impressive and aloof. The French artist-monks drew such figures in their manuscripts in the thirteenth century.

The artist-artisans were in the regular service of the builders of the Gothic cathedrals ; they had incessant occupation all through the thirteenth and fourteenth centuries ; they covered the porches with sculpture and filled the windows with painted glass. From the many examples of this glass painting which have fortunately survived we know that the painters were influenced by the manuscripts—though it must be noted that these glass paintings in turn influenced later generations of illustrators who found that the patterns of the leading in the windows gave them new ideas.

These superb cathedral windows are outside my subject. But I must note, in passing, that, though the glass painters in a cathedral such as Chartres were ordered by the Church to retain the former Byzantine style when representing sacred characters, they were given a relatively free hand in narrative scenes in which they recorded their fresh and direct observation of the life around them. I reproduce some thirteenth-century heads from the Chartres windows (Pl. 1). In our photograph-sodden age it is hard for the layman to appreciate this naïf calligraphic art, where every line is a record of a new realisation of life as expressed in form, and not a record of some momentary appearance of form in light. But its qualities have been fully realised by certain intelligent and widely cultivated artists of the modern French school, and when we come to the latest aspects of French painting we shall find them, in appearance, most singularly like the first.

Independent artist-artisans were very exceptional figures in thirteenth-century France, and it would seem from the records that they were shopkeepers and tavern-keepers who illustrated manuscripts in their spare time and offered them for sale. But in

the fourteenth century the independent painter becomes less exceptional, especially in Paris, which was now the seat of the monarchy, with a Court, a University and a considerable number of well-to-do citizens willing to buy not only ecclesiastical, but also secular manuscripts. A new class of independent bookmaking-artisans accordingly arose in response to this demand, and these men with secular customers to please soon found themselves abandoning the fixed traditions of the Byzantine style, though there was still a tendency to retain them when delineating the sacred figures. A pioneer among these new illustrators was one Jean Pucelle, who won so high a reputation that he was commissioned by Charles IV (1322-1328) to paint a Book of Hours for the Queen.

At the same time we note the appearance in Paris of the first independent painters of easel pictures. But before considering their work, we must recall the Papal Court at Avignon, an art centre from which the Parisian painting was derived.

2 THE FIRST SCHOOL OF AVIGNON

The Papal Court at Avignon played a most important part in the development of French Gothic painting. The Papacy was established in Avignon in 1309 and remained till 1370; two Antipopes reigned there between 1378 and 1408. The Palace of the Popes was primarily a fortress, since the Papacy had migrated to France for security; but within the fortress there was a Palace, and this dual character is apparent to this day. The Avignon Popes, though not Italian, were in touch with Italian art. The structure of the Palace is Italian, not French, in style; and Italian artists were summoned to decorate the walls. The Sienese painter Simone Martini went to Avignon in 1339 and died there five years later. In the Audience Chamber and the Chapels of St. John the Baptist and St. Martial in the Palace we can still see frescoes, representing saints and sacred subjects, in the Sienese-Florentine fourteenth-century style. In the Garderobe Tower, moreover, we also see frescoes (now much repainted) representing outdoor scenes, hunting, bathing, fruit-gathering, and so forth in a style resembling the " verdure " type of Gothic tapestry which inspired William Morris.

In addition to the frescoes in the Palace, numerous easel pictures were produced at and round Avignon in this Papal period. These works of this first School of Avignon were fundamentally Italian in style, but they also show cosmopolitan elements. For the Papal

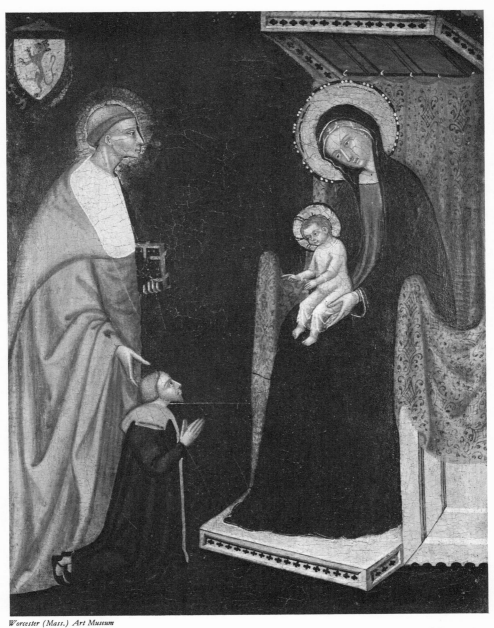

2. FIRST SCHOOL OF AVIGNON: Virgin and Child with Saint and Donor

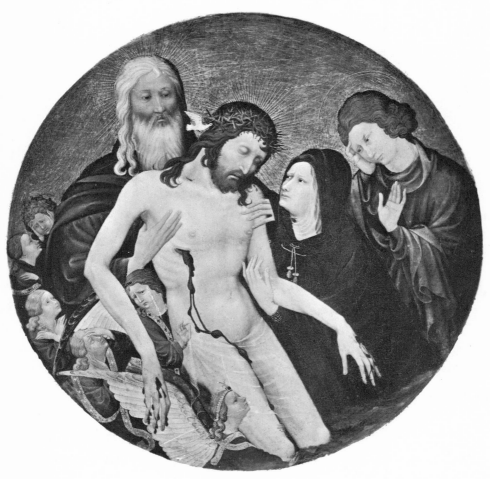

3. *Ascribed to* JEAN MALOUEL: Pietà

Court itself was cosmopolitan ; Avignon lay on the main route to Italy ; there was continual passage through the city of French and Flemish artists to Italy and of Italian artists to the North ; travellers, artists and dealers came and went, bringing Italian pictures for royal and noble patrons in Flanders and France. In particular there was continuous contact with Milan where the Cathedral, begun in 1386, gave work to artists of many different nationalities ; and there was also, of course, continuous contact, across the frontier, with Spain.

As an example of the cosmopolitan style of this first School of Avignon, which was the foundation of the first School of Paris, I reproduce the charming *Virgin and Child with Saint and Donor*[N1] (Pl. 2). Here we have the gentle spirit and the formalism of Sienese art together with characters resembling some aspects of early Catalonian painting. The saint represented is the Blessed Pierre de Luxembourg, a young cardinal who died in 1387 and was treated as a local patron saint in Provence for some time after his death.

3 THE FIRST SCHOOL OF PARIS

King Charles V (1364-1380) built the fortress castle of the Bastille and the fortress-palace known as the Old Louvre. His predecessor, Jean le Bon, already referred to, had ordered his artists to decorate the walls of his Château de Vaudreuil with religious subjects and hunting scenes ; Charles V ordered his artists to paint similar frescoes in the Louvre and in the Queen's palace of St. Pol. The frescoes in the Queen's palace are said to have represented " a forest of trees covered with fruit, mingled with shrubs and flowers, among which birds and other animals disported and children ran eating fruit and picking flowers." From this description it is clear that this Parisian decorative style resembled the paintings in the Garderobe Tower at Avignon.

The first easel pictures produced by the independent artists in Paris date from the reign of Charles VI (1386-1422), who lives in history as Charles le Fou. In the early part of his reign there was a temporary cessation of the war with England, a brief period of peace before Henry V led his army to Agincourt in 1415. In this period Paris was prosperous. The royal and feudal courts were extravagant and willing to buy objects of luxury of all kinds, more indeed than could be supplied by the artists attached to their establishments. In these conditions the independent painters of easel pictures arose and also prospered. By the end of the century they had become so notable they were recognised as a distinct class

of trading artisans, and in 1391 they were granted a Charter on the basis of which they were subsequently organised as the Guild of St. Luke, known as the *Maîtrise*.

From this time forward the Parisian artists all belong either to the class of royal or ducal domestics or to the class of independent artisans organised in this *Maîtrise*, their own trade association, which soon adopted the Guild system of apprenticeship terminating in the rank of Master. The *Maîtrise* was a corporation and the members had the dual status of artisan and merchant, the second being considered the more reputable as it carried with it certain civic rights—the exact opposite of the relative status of the artist and the dealer in later times.

In Feudal France neither class of artist was sufficiently numerous for any conflict to arise ; the demand for art still greatly exceeded the supply. But later, under Louis XIII and Louis XIV, the mutual jealousy of the two classes created a third class consisting of members of the Royal Academy, which was founded in 1648.

The few easel pictures which survive from this first School of Paris are works of much interest and charm. The Louvre has a grisaille (monochrome) altar-front on silk, and two paintings with gold backgrounds, by unnamed artists of this School. The grisaille —which is known as the *Parement de Narbonne* (because it was discovered and bought by the painter Boilly in Narbonne, before it reached the Louvre in 1852)—consists of a central panel of the Crucifixion, with Charles V and Queen Jeanne de Bourbon as donors, and six other panels with scenes from the Passion. The paintings on gold backgrounds are an *Entombment* and a circular *Pietà*. The celebrated *Wilton Diptych* (London : National Gallery) showing Richard II in adoration before the Virgin with angels, which many assume to be English, is possibly a product of this first Paris School.

4 THE FIRST SCHOOL OF BURGUNDY

In addition to Avignon and Paris there was a third important art centre in France between the accession of Charles VI and the English occupation of Paris after Agincourt. This was the city of Dijon, where Philippe le Hardi, Duc de Bourgogne, held his court. This Duke of Burgundy was Charles le Fou's uncle, and with his brother, Jean Duc de Berry, he was the King's guardian during his minority—for Charles was eleven years old when he succeeded. The two Dukes lived in great magnificence, giving entertainments where their courtiers wore the most fantastic

costumes, embroidered with pearls, hung with gold chains and trimmed with furs. To support their extravagances they were rapacious in the vast areas which they administered—Philippe in Burgundy and Flanders (he inherited Flanders in 1384) and Jean in the regions round Bourges and Poitiers, in the Auvergne and Languedoc. From the standpoint of the student of French painting both men were figures of outstanding importance, because both were enthusiastic patrons of the arts. Duke Philippe le Hardi's artists included Jean de Beaumetz, Melchior Broederlam and Jean Malouel, who all worked for the Chartreuse de Champmol at Dijon, which Philippe constructed as a memorial of himself and his family.

No works known to be by Beaumetz survive—though records tell us that he produced twenty-four paintings in the monks' cells in the Chartreuse and that he designed two thousand banners for the King's troops.

Melchior Broederlam, who came from Ypres, was appointed court painter and *valet de chambre* by Duke Philippe in 1385. He, too, designed banners for the Duke's troops, also ceremonial costumes for his court, and for the aldermen of Ypres. Of his paintings we have one of two pairs of shutters which he painted to cover two carved reredos in the Chartreuse; these panels, preserved in the Dijon Museum, show *The Annunciation, The Visitation, The Presentation,* and *The Flight into Egypt*; they are valuable as rare examples of the period, but intrinsically they are dull. On the other hand, there is great charm in two panels (in the Mayer Van den Berg museum in Antwerp) representing *The Nativity* and *St. Christopher,* which are said to have been painted for this Chartreuse and have been presumed by some to be the work of Broederlam.

Jean Malouel entered Duke Philippe's service in 1397. At the Chartreuse de Champmol he coloured the statues round the base of a calvary known as the *Puit de Moise* by the Flemish sculptor, Claus Sluyter, which can still be seen in the grounds of what remains of the Chartreuse. He is also known to have painted five altarpieces for the Chartreuse, and one before which the Duke habitually said his private prayers. When Duke Philippe died, he was succeeded in 1404 by Jean sans Peur, who sat to Malouel for his portrait and sent it to the King of Portugal in 1412. Jean Malouel died in 1415, and it is recorded that in 1416 Duke Jean employed Henri de Bellechose to complete one of the Chartreuse altarpieces begun by Malouel and left unfinished. This altarpiece is believed to be *The Last Communion and Martyrdom of St.*

Denis (Pl. 4). In this we see the Crucifixion in the centre ; on the left St. Denis receives the Communion from Christ through the bars of his prison ; on the right is the execution scene, where the saint is kneeling at the block, while behind him his companion, St. Eleutherius, awaits his martyrdom, and in front, his other companion, St. Rusticus, has already been beheaded. This is a lovely picture in pure glowing colours on a gold ground—the finest extant Burgundian painting of the period. With it is associated the tender *Pietà* (Pl. 3) also in the Louvre, which is ascribed to Jean Malouel. No other pictures are documented to Henri de Bellechose, who worked also for Duke Philippe le Bon when he succeeded Duke Jean in 1419. But it is recorded that he painted the figures on the ' Jaquemart ' clock still extant on Nôtre Dame at Dijon ; also that in his later years he fell out of favour and had to be supported by his wife, who had a concession to sell salt in a retail shop.

5 THE DUC DE BERRY'S MANUSCRIPTS

I have referred to the misgovernment of his domain by Jean Duc de Berry, Philippe le Hardi's brother. This was so serious that Charles VI, when he took the reins into his own hands, made a ceremonial progress through Languedoc and burned the Duke's chief tax-collector to appease the public discontent. When the King succumbed to the madness which has earned him his title, the Duke became Governor of Paris, and there again his exactions were so unmerciful that popular risings destroyed his châteaux of Nesle and Bicêtre. But the man lives in history as the most enthusiastic French art patron of his age. He built himself magnificent castles ; he borrowed Beaumetz and other artists from the Duke of Burgundy ; he covered his castles with sculpture ; he collected tapestries and jewels. It was above all for manuscripts that he seems to have had a passion. No fewer than forty books adorned with miniatures are known to have been produced to his order ; and his name is immortalised in *Les Très Riches Heures du Duc de Berry* now preserved in the Musée Condé at Chantilly.

In the superb Chantilly manuscript, the work of Paul, Jean and Armand of Limbourg, the artists painted a calendar which marks an early stage in the history of the genre picture as an *objet-de-luxe*. Here, for January, we see the Duke himself at dinner in a tapestried hall ; he is burly and red-faced and is waited upon by servants in his livery. For February we see a snow-covered landscape and within doors a lady who dries her petticoat by the fire at which

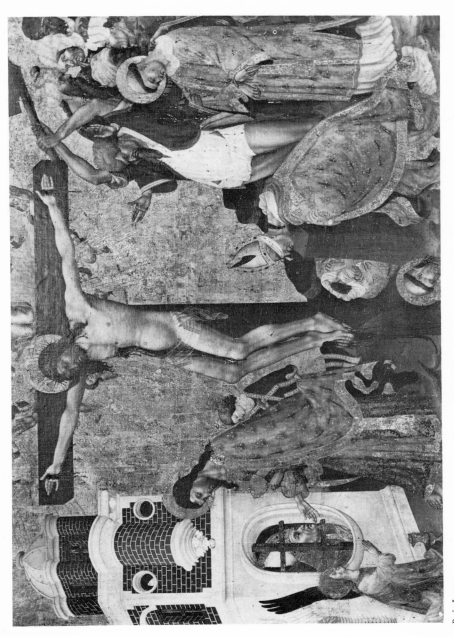

4. J. MALOUEL and H. DE BELLECHOSE: Last Communion and Martyrdom of St. Denis

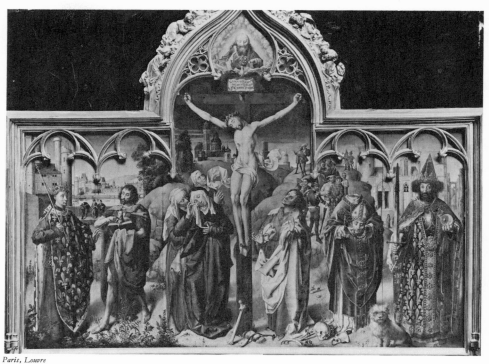

5a. FRENCH SCHOOL c. 1470 : The Altarpiece of the Parliament of Paris

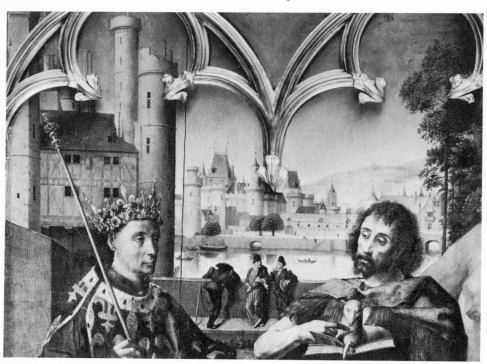

5b. FRENCH SCHOOL c. 1470 : St. Louis and St. John the Baptist
(Detail of 5a above)

her male and female servants, destitute of underclothes, also warm themselves with their gowns pulled up above their knees; for March we see peasants ploughing and pruning their vines; for July harvesting; for September the vendange; and so forth. In the background of each picture one of the Duke's castles is exquisitely portrayed. The October picture, which is particularly famous, shows peasants sowing and, in the background, the old Louvre.

Other manuscript illustrators employed by Jean Duc de Berry were Jacquemart de Hesdin, who is presumed the painter of a famous page, *Jean Duc de Berry presented by SS. Andrew and John to the Virgin and Child enthroned* in a Book of Hours in the Brussels library, and André Beauneveu, who illustrated his Psalter (Paris : Bibliothèque Nationale).

Beauneveu, born (like Watteau) at Valenciennes, was sculptor and architect as well as painter and illustrator; he made tombal statues for Charles V and his Queen, and became one of the Duc de Berry's artists on the King's death in 1380; for the Duke he worked at Mehun-sur-Yèvre Château, and in 1390 Froissart wrote of his service there : " The Duke could not have done better, for there was nobody anywhere who surpassed or equalled Master André, and nobody of whom so much excellent work existed in France, Hainut where he was born, or England "—a passage which lends some support to a supposition that Beauneveu may have painted the *Wilton Diptych*, already referred to as possibly a work of the First School of Paris. It has also been suggested that Beauneveu may have painted the celebrated portrait *Richard II enthroned* in Westminster Abbey.

B. FROM AGINCOURT TO FRANÇOIS I

I THE SECOND SCHOOL OF BURGUNDY

Between Agincourt and the English evacuation in 1453 conditions in France were not favourable to painting. Many nobles were killed in the war and more were ruined. The English occupied Paris from 1420 to 1436, and when the Court moved to Bourges the first School of Paris came to an end. The Court held at Bourges by Charles VII (who succeeded in 1422) was an impecunious makeshift affair in distressing times, when half France was occupied by the invaders and their ally, Philippe le Bon, the new Duke of Burgundy. The Duke's fortune, however, was in striking contrast to that of the King. The Duke had inherited from his father and his grandfather, the patrons of Malouel and Bellechose, their vast domains in Burgundy and Flanders. He increased them by the purchase of Luxembourg, and by various territorial concessions when he made terms with the King in 1435. At the height of his power he ruled over Burgundy, Luxembourg, Belgium and Holland. He was immensely rich ; his Court at Bruges was luxurious ; and he had admirable artists—most of whom must, however, be credited to the Flemish School. Thus, while Jeanne d'Arc was being bullied in a trial that lasted five months, Jan van Eyck, the Duke's chief painter, was working on the *Altarpiece of the Lamb* ; and when the Duke died in 1467 the world had already been enriched by the work of Roger van der Weyden.

The reputations of the van Eycks and of Roger van der Weyden spread to many parts of France where notabilities began to desire their pictures. Jan van Eyck's *The Virgin with Chancellor Rolin*, in the Louvre, was commissioned by Nicholas Rolin, Chancellor of Burgundy, and given by him to Notre Dame at Autun ; this became a widely famous picture and was imitated both by Flemish and by French artists. The *Last Judgement* altarpiece at Beaune, probably by Roger van der Weyden, was commissioned by the same chancellor, and this also must have attracted much attention. The van Eyck tradition is the foundation of the *Annunciation Altarpiece*, the central panel of which is in the Eglise Ste. Marie-Madeleine at Aix-en-Provence and other portions are in the museums of Brussels and Amsterdam, and in the Cook Collection[N1] at Richmond. Documents tell us that this, technically most accomplished, picture was ordered for the Saint Sauveur Church at Aix in 1442 ; but no one knows who painted it ; and the artist goes accordingly by the title " The Master of the Aix Annunciation."

We see influences from the types of work we associate with Dirck Bouts and Memlinc in other French paintings of the century. Thus Bouts would seem to have inspired the *Chartreuse de Thuison-lès-Abbeville Retable* (Chicago Art Institute), with its dramatic presentations of *The Last Supper*, *The Pentecost* and *The Ascension*; and Memlinc, perhaps, the charming young woman's portrait, *Dame coiffée d'un hennin*, both in the Louvre. And on this point of Flemish influence we must remember that Flemish artists were employed to fresco Nôtre Dame at Dijon.

2 RENÉ OF ANJOU AND NICOLAS FROMENT

Another art patron of the period was King René of Anjou, the vicissitudes of whose career are typical of the times. He was the nephew of Charles V, the brother of Charles VII's Queen, the father of Margaret of Anjou (Queen of Henry VI of England), and the son of Louis of Anjou, who had been crowned King of Naples by the Antipope Clement VII at Avignon. On paper he was King of Naples, Sicily and Jerusalem, Duke of Anjou, Lorraine and Bar, and Count of Provence. But his father had never been able to make good his claim to Naples, and René was not able to do so either, or even to retain the Dukedom of Lorraine until he had suffered imprisonment at the hands of another claimant and paid him a large ransom. From 1442-1471 he held his Court at Angers; then he was dispossessed by Louis XI and during the remaining eleven years of his life he held his Court at Aix-en-Provence, where he ruled as Comte de Provence.

Le bon roi René, as he was known in his day, was himself an author, and he is said to have painted pictures—(the Portuguese painter Francis of Holland wrote in 1571, " I saw in France, at Avignon, a very good painting by King René done from la belle Anne after death he having disinterred her for the purpose "). Among the surviving writings by or ascribed to King René is the *Coeur d'Amour épris* in the Vienna Library; this is illustrated with charming and very original paintings, but whether by the King himself or by one of many manuscript illustrators employed by him is not known.

Though he was thus both a patron and a practitioner of the arts, King René was as unæsthetic to look upon as his uncle, Jean Duc de Berry. We know this from his portrait as donor of the *Altarpiece of the Burning Bush*, which he commissioned Nicolas Froment to paint for the Cathedral of Aix, and which can still be seen there.

Of Nicolas Froment we know that he was born at Uzès, near Nimes, and it is presumed that he visited Italy. The *Altarpiece of the Burning Bush* was ordered in 1475. This altarpiece and an earlier signed work, painted in 1461, the *Resurrection of Lazarus* (Florence : Uffizi), are his only authenticated pictures. Apart from its subject, the *Altarpiece of the Burning Bush* is rather a dull picture. In the central panel we see the Virgin and Child in the Burning Bush appearing to Moses ; a flock of sheep and goats and a large dog are in the foreground between Moses and an angel. René and his second wife Jeanne de Laval (Pls. 9a and 9b) appear in the side panels as kneeling donors in the traditional attitude ; René is accompanied by a small dog. The colours in this picture, which struck me when I last saw it as in need of cleaning, are lifeless ; and the hybrid nature of the style—which gives us a Flemish angel opposite an Italian Moses—is curiously disconcerting. The convincing passages are the admirably incisive portraits.

3 THE SECOND SCHOOL OF AVIGNON

The composite nature of Froment's altarpiece is characteristic of all Provençal work of this period where a second and most interesting School of Avignon was now flourishing. The Papal Legates who now occupied the Palace of the Popes continued the traditions which had made Avignon a centre of art production. The Legates Cardinal de Foix and Cardinal della Rovere were notable art patrons ; and there are records of many commissions given by convents, monasteries, churches and rich citizens of the Avignon region. The second School of Avignon was in fact as influential as the first, and it was quite as cosmopolitan.

Of the surviving works, I must mention first a *Pietà* and a *Christ standing in the Tomb*, both by unknown masters and both in the Louvre, and a *Coronation of the Virgin*, by Enguerrand Charonton in the Hospice of Villeneuve-lès-Avignon.

The *Pietà* (Pls. 6b and 10b) is one of the world's most affecting pictures. It was in the Chartreuse of Villeneuve-lès-Avignon till the Revolution. It has been disgracefully neglected and it is now in need of conditioning. But the artist's majestic design and his deep restrained passion are still tremendously moving. All the noblest elements in the cosmopolitan world of the Avignon School seem to have combined to produce this masterpiece. We have Italian rhythm, Flemish pathos, Spanish drama, and French tenderness. And the disparity in style between the sacred group and the donor is not disconcerting, because, whereas in Froment's

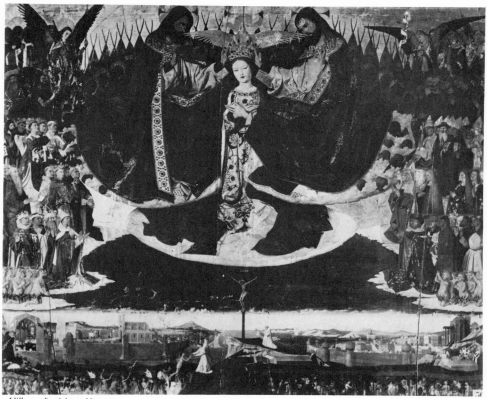

Villeneuve-lès-Avignon, Museum

6a. ENGUERRAND CHARENTON: Coronation of the Virgin

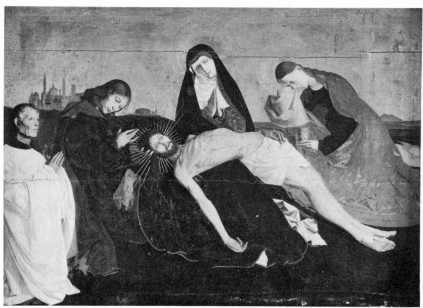

Paris, Louvre

6b. SECOND SCHOOL OF AVIGNON: Pietà

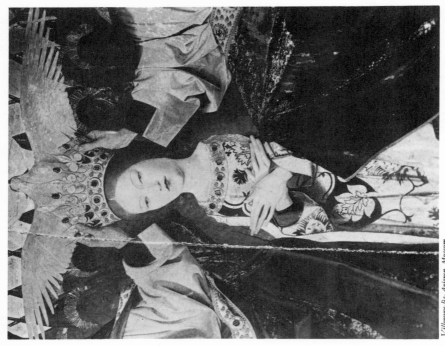

7b. ENGUERRAND CHARENTON:
Coronation of the Virgin (Detail of 6a)

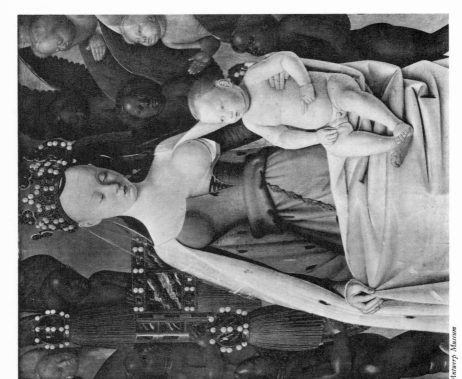

7a. JEAN FOUQUET: Virgin and Child

Burning Bush, against the early traditions of Christian art, the angel is naturalistic-Gothic and Moses is formal-Italian in design, here the early relations are maintained—the sacred figures are hieratic and the donor is realistically portrayed. No one knows who painted this picture ; some students suggest a Spanish artist working in Avignon, and the Moorish city in the background is pointed to in support of this view. Some believe it the work of Bermejo, the great Spanish painter who signed " Bartolomeus Rubeus " on *S. Michael and the Dragon* in the Wernher Collection.

The *Christ standing in the Tomb* (Pl. 10a) emanates from the Church of Boulbon (Bouches-du-Rhône). It has been even more neglected in the past than the *Pietà*, but it has now been restored. In this impressive and most curious work, Christ stands in the tomb ; behind we see the instruments of the Passion, and, withered to the bone, the hand which received the thirty pieces of silver ; in the foreground is the pillar of the flagellation ; behind the kneeling donor is the figure of St. Agricola ; behind the saint there is a coat of arms showing a stork—a reference to the legend of St. Agricola who obtained by prayer a flight of storks which destroyed a plague of snakes in the countryside.

In the case of the *Coronation of the Virgin* (Pls. 6a and 7b) we know the name of the artist—Enguerrand Charonton (sometimes referred to as Quarton) ; and we also know that the work was commissioned in 1453 by the Chartreuse of Avignon. The contract with the artist, which still exists, provides for all the details as they actually appear in the picture. It prescribes, for example, that the figures of the Father and the Son are to be the same, that the Virgin's robe shall be damask, that right and left in the heavenly zone there shall be such and such assemblies of saints and ecclesiasts, that on earth there shall be shown the cities of Rome and Jerusalem with sundry happenings specified, in each, and that below shall be shown the fate of the good and wicked on the Judgement Day—the good being welcomed by the angels, the bad remaining in the tortures and fires of hell. The result, as can be seen in the reproduction, is related to the early tradition of Church performances of plays on three stages—the top stage representing heaven, the middle earth, and the third the regions after death (a tradition which persisted into Baroque art, as I note in my chapter headed " Louis XIV, Court Spectacles and Versailles ").

There is only one other authenticated picture by Charonton— a *Virgin of Pity* commissioned in 1452 for the Celestin Convent at Avignon and now in the Musée Condé at Chantilly. This type of

picture, which shows the Virgin's outspread mantle protecting groups of kneeling adorants (usually portraits of notabilities of the community which ordered the work) was frequent in Spain at this period; but it also occurs in Italian painting, as in a famous example by Piero della Francesca. On this *Virgin of Pity*, documents tells us, Charonton worked with one Pierre Villate, an artist of status in his day, but by whom no personal productions are known to survive.

It is perhaps with this Second School of Avignon that we must also group some pictures which appear to have characters recalling contemporary art in Spain—*St. Michael* in the Musée Calvet at Avignon, the highly interesting *Death and Coronation of the Virgin* in the Lyons Museum, the *Claude de Toulongeon and his patron St. Claude of Besançon* (Worcester, Mass.), a *Pietà* in the Wadsworth Athenæum, Hartford (Conn.), and the *Pietà with SS. Martin and Catherine* painted by Louis Bréa in 1475 for the Eglise de Cimiez at Nice and still to be seen there. A late example of the cosmopolitan Avignon tradition is a beautiful picture, showing Italian influence, *The Infant Jesus adored by the Virgin, a Knight and an Ecclesiastic* in the Musée Calvet at Avignon.

4 THE SECOND SCHOOL OF PARIS (AND THE NORTH)
(CHARLES VII AND LOUIS XI)

The paintings surviving from the Second School of Paris (and the North) are, in the first place, illustrated manuscripts, including some commissioned by the English. Duke Philip the Good was a keen collector of such manuscripts, and this taste was shared by John, Duke of Bedford (Regent of France 1422-1435), who was married to the Duke's sister and commissioned some French artist or artists to paint the famous *Bedford Book of Hours* (British Museum) about 1423, and who was also probably responsible for the *Salisbury Breviary* (Paris : Bibliothèque Nationale), which is French work of approximately 1433. We know little of panel pictures produced in Paris and the regions north of the Loire occupied by the English (or in the regions round Bordeaux also held by them). The surviving works from the North date from after the English evacuation in 1436, when Charles VII began to revisit Paris (after the period of his pathetic Court at Bourges from 1422 till he was crowned at Rheims in 1429, while Jeanne d'Arc held aloft her standard designed by one Henri Poulvoir, who had been summoned from Poitiers to Bourges for the purpose). The Louvre has *The Virgin as Priest*—a rare subject which

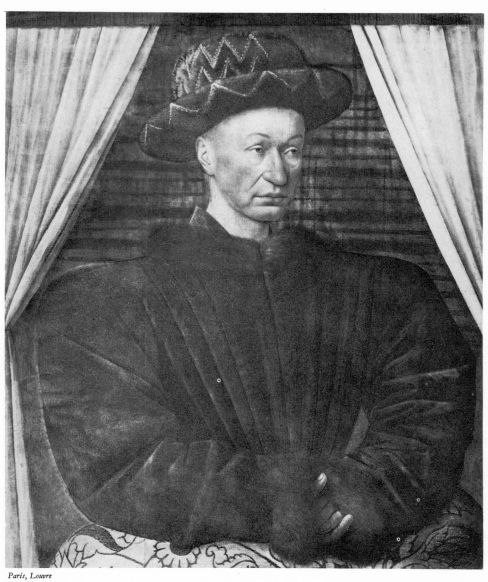

8. JEAN FOUQUET: Charles VII

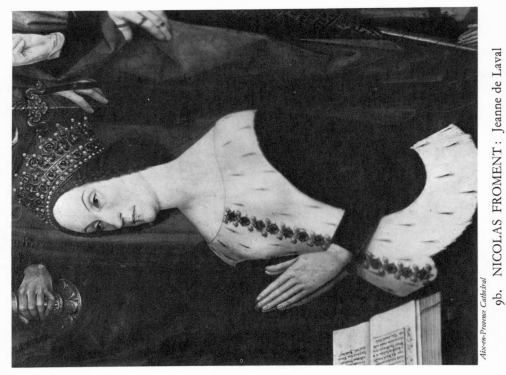

9b. NICOLAS FROMENT: Jeanne de Laval

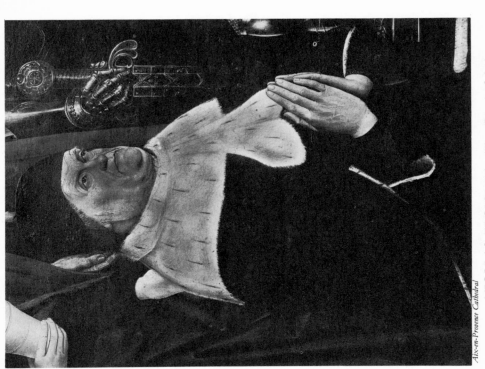

9a. NICOLAS FROMENT: King René of Anjou

can be securely dated as 1437, a charmingly coloured *Mass of S. Gregory* of about 1440-1450, and a curious frieze-like archaic portrait group, *Jean Jouvenal des Ursins with his wife and eleven children (including two Bishops)*, painted before 1450, and preserved for centuries in a chapel of Notre Dame Cathedral.

We also know little of the artists who worked for the sly and sinister Louis XI (1461-1483), though it is recorded of Colin d'Amiens, who was one of them, that he was commissioned to design a sepulchral effigy of the King in which the face was to be "*jeune et plein*," and the head, it was expressly stated, was not to be shown as bald.

The Louvre has two highly interesting pictures dating from this reign—the *Finding of the True Cross* and the *Altarpiece of the Parliament of Paris*.

The *Finding of the True Cross* is an unusual variant of the legend [N1] already painted by Agnolo Gaddi in the church of S. Croce in Florence, and by Piero della Francesca at Arezzo. No one knows who painted this engaging picture, though some have guessed Simon Marmion, who worked at Amiens 1449-1450, at Valenciennes from 1458, and at Tournai in 1468, and who may have painted two little panels in the National Gallery, *A Choir of Angels* and *The Soul of S. Bertin carried up to God*.

The *Altarpiece of the Parliament of Paris* (Pls. 5a and 5b) was painted for the Parlement de Paris and remained there in the Chambre Dorée till the Revolution. The work of an unknown, very able artist much influenced by the Flemish painters of the Second School of Burgundy, it shows right and left of a central crucifixion, S. Louis with S. John the Baptist and S. Denis with Charlemagne; S. Denis carries his decapitated head in his hands in illustration of the legend that after his martyrdom he rose from the ground where his body had been cast to wild beasts, and walked thus for two miles to the Hill of Martyrs (Montmartre), while angels surrounded him and chanted hymns; in the background across the river we have old Paris with the Tour de Nesle, the Louvre, and the Royal Palace.

We see another glimpse of fifteenth-century Paris in the manuscript illustration (now in the Louvre), *S. Martin dividing his Cloak with a Beggar*, ascribed to Jean Fouquet (*c.* 1417?—*c.* 1480), who was the most famous painter in the Royal domain under Charles VII and Louis XI, and whose work must now be separately considered.

5 JEAN FOUQUET

BORN TOURS C. 1417 DIED TOURS BEFORE 1481

Characteristic Works
MS. Illustrations

Paris	Bibliothèque Nationale	Pages from *Antiquités Judaïques*
Paris	Bibliothèque Nationale	One page of *Statuts de l'Ordre des Chevaliers de St. Michel* (ascribed)
Paris	Louvre	Pages from *Livre d Heures d'Étienne Chevalier* (ascribed)
Chantilly	Musée Condé	Forty pages from *Livre d'Heures d Étienne Chevalier* (ascribed)
Munich	Staats-bibliothek	*Le Lit de Vendôme* (Frontispiece to Boccaccio : *Les cas des nobles hommes et femmes malheureux*) (ascribed)

Paintings

Paris	Louvre	Charles VII (ascribed)
Paris	Louvre	Guillaume Jouvenel des Ursins (ascribed)
Antwerp	Museum	Virgin and Child (ascribed)
Berlin	Kaiser-Friedrich Museum	Étienne Chevalier and St. Stephen (ascribed)

Jean Fouquet was a painter and an illustrator of manuscripts. Little is known of his life. He seems to have been born at Tours about 1417, and to have been employed before he was thirty by Charles VII. He went to Rome and painted Pope Eugenius IV. Back in France he painted some murals for Notre-Dame-la-Riche in Tours—paintings celebrated in his day as far away as Italy but now no longer extant. In 1469 he is known to have done some work for the newly founded *Ordre des Chevaliers de St. Michel.* In 1472 he visited Blois in connection with a Book of Hours for Marie de Cleves, Duchesse d'Orléans. At Tours in 1476 he designed a dais for the State reception of Alfonso V, King of Portugal, by Louis XI whose tomb he had some hand in designing. The date of his death is uncertain, but his wife is referred to as his widow in a document of 1481.

His only quite authenticated illustrations are a number of pages in a two-volume version of Joseph's *Antiquités Judaïques.* There are no authenticated easel pictures. But all the works listed above seem reasonably ascribed to him ; and from them he appears a most engaging and highly gifted artist.

The two volumes of *Antiquités Judaïques* were made for Jacques d'Armagnac, Duc de Nemours, who was beheaded as a traitor in

1477, and there is a fifteenth-century inscription in the first volume stating that all but the first three illustrations are Fouquet's work. At one time most of the illustrations in the second volume were at Windsor Castle; but King Edward VII presented them to France to join the others. These illustrations, brilliant compositions with a great many figures, include a *Building of the Temple* (shown as a Gothic cathedral in course of construction, with contemporary masons, sculptors, and so on at work), and battle pieces set in marvellous landscapes with rivers winding in valleys between mountains.

In the forty celebrated pages from Etienne Chevalier's *Book of Hours* at Chantilly, the scenes are gently depicted in bright colours with white notes a feature in the patterning; in the *Adoration of the Kings* in this series, Charles VII, the Dauphin (later Louis XI) and Charles Duc de Berry are represented as the Magi; beneath the *Calvary* there is a little scene with a man and woman forging the nails to be used at the Crucifixion; in the *Birth of John the Baptist* an attendant warms a towel by the fire, while another pours water into a basin for the child. One of the pages from the same book, in the Louvre, shows *Ste. Marguerite* in a meadow with sheep, and the Château de Loches in the background.

In some of his compositions Fouquet seems fond of a diamond-shape or triangular motif with the apex of the shape at the bottom. This motif occurs in the frontispiece to a Boccaccio MS. which shows Charles VII presiding at the trial for treason of Jean Duc d'Alence at Vendôme in 1458; here we have scores of Court officials hieratically seated within the formal structure, while behind them ushers try to control a crowd of spectators who protest and gesticulate.

The portrait which Fouquet painted of Pope Eugenius IV is now lost. But we can date it by the adventures of this Pope, a Venetian who succeeded Pope Martin V (a Roman Colonna), and claimed from the Colonna family their vast inheritance from Martin V as Papal property; when the Colonnas refused to surrender the property, he joined their rivals, the Orsini, seized their castles and imprisoned various members of the family; the Roman populace, stirred up by the Colonnas, then rose in revolt, and Eugenius fled down the Tiber in a ship, at which the rioters flung stones; he did not return to Rome till ten years later, 1443, and, as he died in 1447, Fouquet's picture was evidently painted in 1445-6.

The intensely characterised portrait, *Charles VII* (Pl. 8), is

believed to represent the King in his *loge* at the Sainte Chapelle de Bourges (where a picture corresponding to this composition was preserved till 1757). The physiognomy fits in with the character of this neurasthenic prince, who was shaken from his lethargy by Jeanne d'Arc, and later dominated by Agnès Sorel ; and it contrasts strangely with the inscription round the frame : " Le très victorieux roi de France."

The Antwerp *Virgin and Child* (Pl. 7a) (traditionally supposed to be a portrait of Agnès Sorel, who died in 1450) has scarlet cherubim against a deep blue ground. The picture, which is at once serene in hieratic concept and humanly tender, may be Fouquet's work, but it may alternately be the work, as Count Durrieu has suggested, of another Tours artist, one Piètre André, documented as painter of " The Virgin in light raiment with behind her some angels entirely blue and others entirely red." The Berlin *Étienne Chevalier and St. Stephen*, which is believed to have been originally a pendant to this *Virgin and Child*, is much less interesting and attractive ; it shows Étienne Chevalier, Treasurer of the Realm, on his knees, with his patron saint behind him in a handsome Italian apartment.

The Louvre *Guillaume Jouvenel des Ursins* is presumed to have been painted about 1465, judging by the age of the sitter, who was Chancellor of France and a notability under both Charles VII and Louis XI; he is depicted with elaborate Renaissance architecture in the background, and the broad silhouetting of the composition is Italian in character.

Italian elements occur in fact in many of the works now ascribed to Fouquet. But at bottom his art was eminently French, and much nearer to the Gothic tradition than to contemporary Renaissance concepts. Elie Faure, the excellent French critic, has said of him : "*Il parlait en familier des troupeaux domestiques et les travailleurs du sol. . . . Il possédait de la nature un sentiment qui ne peut guère appartenir qu'à un peuple de cultivateurs et qui est proprement français.*"

He was really the last great Gothic artist of France.[1]

6 CHARLES VIII, LOUIS XII AND THE MAÎTRE DE MOULINS

Darkness descends again in respect of the painters of the period of Charles VIII (1483-1498) and Louis XII (1498-1515). We

[1] The student should consult Durrieu, *Les Antiquités Judaïques*, Paris, 1908, which reproduces all Fouquet's illustrations ; Gruyer's *Catalogue of the Musée Condé* at Chantilly ; Trenchard Cox's *Fouquet* (Faber), 1931 ; and Sterling : *Les peintres du Moyen Age*, 1942.

have seen that Jean Fouquet came from Tours, and that city would appear to have had a group of independent artists, probably working as a local Guild. In the last quarter of the century these Tours artists had a reputation as makers of illustrated manuscripts ; their works represent the last important production in this art which, destroyed by the invention of the printing press, developed to the art of the wood-cut and the copper-plate engraving.

One Jean Bourdichon (1457-1521) passed from this School at Tours to the Royal service in the reign of Charles VIII, and he painted pictures for this sovereign and also for Louis XII. There are no extant paintings certainly by him. But a triptych in the Naples Museum is ascribed, for various reasons, to him, and a triptych with *Scenes from the life of St. Anne* in Philadelphia (J. G. Johnson Collection), and a *Virgin and Child with angels* in the Minneapolis Institute of Arts, are ascribed to his School. We have from his hand a very celebrated series of miniatures, the *Livre d'Heures* (Bibliothèque Nationale), which he painted for Anne de Bretagne, Charles VIII's Queen. Bourdichon is believed to have worked also for François I.

The most mysterious figure of the period is, however, one Jean Perréal, known also as Jean de Paris, who was a Court painter in both reigns. Perréal, it is recorded, painted portraits, and designed effigies and pageants. He was sent to London in 1514 to help in the preparation of the trousseau which Mary Tudor, Henry VIII's sister, was to take for her marriage to Louis XII. No paintings by Perréal survive, unless, as has been suggested, he was the artist now known as the Maître de Moulins, whose work must now be discussed.

7 THE MAÎTRE DE MOULINS

BORN BEFORE 1480 DIED AFTER 1520

Characteristic Picture

Moulins	Cathedral	Triptych. The Virgin and Child in Glory with Pierre Duc de Bourbon, the Duchesse Anne de France and their daughter as donors

Ascribed Pictures

London	National Gallery	Meeting of Joachim and Anna
Glasgow	Art Gallery	Saint with Donor
Chicago	Art Institute	Annunciation
New York	Lehman Collection	Portrait of a Girl (Suzanne de Bourbon ?)

Philadelphia	J. G. Johnson Collection	Portrait of a Young Man
Paris	Louvre	Woman as donor with St. Mary Magdalen
Autun	Museum	Nativity
Munich	Alte Pinakothek	Cardinal Charles VI of Bourbon in prayer
Brussels	Museum	Virgin and Child with angels

The Maître de Moulins is one of those intriguing figures in art history who is not a person but merely a name. He is the artist who painted the triptych, *Virgin and Child in Glory with Donors* (Pl. 11), in the Cathedral at Moulins. That is really all we know about him.

The donors represented in this picture are Pierre Duc de Bourbon and his wife, Anne de France. It is therefore clear that the artist was commissioned to paint the altarpiece by the Bourbons, then immensely powerful, since the Duchess was Louis XI's remarkable daughter, who was Regent during the minority of her brother, Charles VIII, and earned for herself the title of " Madame la Grande."

The altarpiece is obviously the work of an able artist, who must have been famous in his day both on the strength of his talents and by reason of his connection with the Bourbon Court. But there is no record of the commissioning of this Moulins picture.

On the other hand, there are numerous records of the artist Jean Perréal, already mentioned, by whom no works are known. We have thus at one and the same period an outstanding picture but no artist, and a celebrated artist with no pictures. Some scholars accordingly suggest, as noted, that Jean Perréal is the missing name. It has also been suggested that the painter was Jean Clouet the Elder, who came to France from Flanders in 1475, and this is supported by what is read as a rebus signature on a lectern which appears in the grisaille *Annunciation* on the outside of the Moulins wings. But all this is conjecture, and until proof is forthcoming, the painter of the Moulins picture must remain the Maître de Moulins, whose actual identity is unknown.

Various pictures are ascribed to the Maître de Moulins on the ground of their real or imagined resemblance to the Moulins picture. I have set down some of them above. But these ascriptions, it must be remembered, are also purely conjectural. Two pictures in the Louvre, wings of an altarpiece, showing the same Duc de Bourbon and the Duchess Anne, now catalogued as by the " Maître de 1488," have been approximated by some to the list above. I reproduce the figure of the Virgin from the *Nativity*

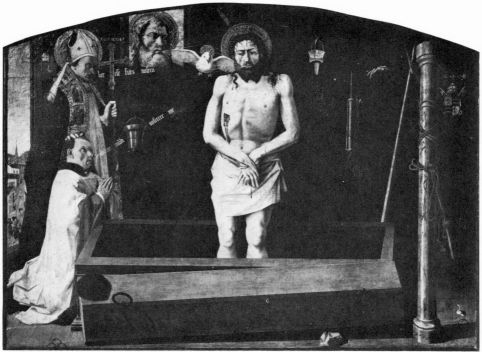

10a. SECOND SCHOOL OF AVIGNON: Christ standing in the Tomb

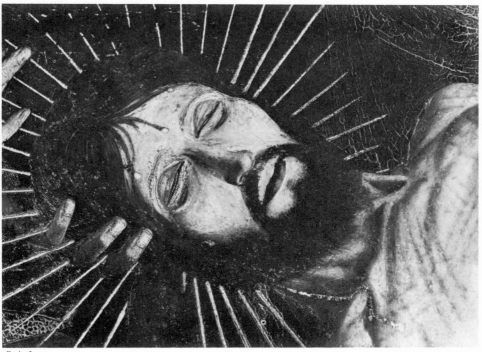

10b. SECOND SCHOOL OF AVIGNON: Head of Christ (Detail of 6b)

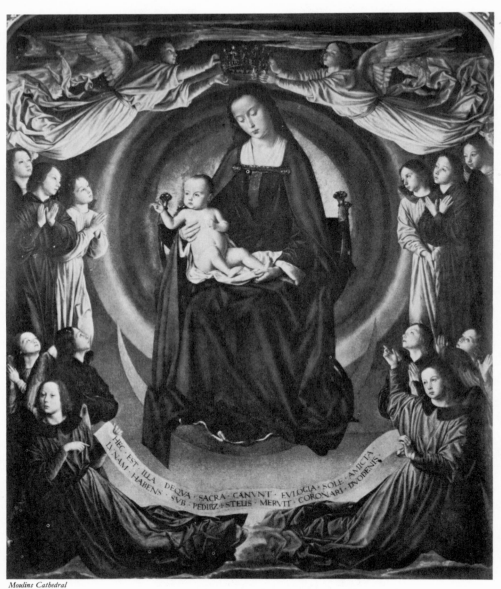

11. MAÎTRE DE MOULINS: Virgin and Child with Donors
(Central panel of Triptych)

(Pl. 12) at Autun, which is equally charming, whether the ascription to the Maître de Moulins is justified or not.

8 THE MAÎTRE DE S. GILLES

Another mysterious artist who worked about 1500 is the painter of *S. Giles and the Hind* in the National Gallery, who is therefore known as the Maître de S. Gilles (and in English catalogues as the Master of S. Giles). The scene represented in this interesting picture is described as follows in the latest National Gallery catalogue : " S. Giles (Aegidius) retired into the desert at La Baume, where a hind was his only companion ; the Royal Hunt tried several times to capture the hind, until at last one of the huntsmen shot an arrow blindly among the brambles where it had taken refuge ; the arrow struck S. Giles ; the King of France, or according to some, Flavius Wamba, King of the Goths, and an unnamed bishop came later to ask pardon." In the background there is a little town which, it has been suggested, shows S. Gilles-du-Gard, near Arles.

It is presumed that the same artist painted *The Mass of S. Giles*, also in the National Gallery, where the scene is set before the High Altar of the Abbey of Saint-Denis, just north of Paris, and shows some of the Abbey's sacred treasures then in use.

9 THE NEW ITALIAN TASTE

Under Charles VIII and Louis XII, aristocratic taste was influenced by Italian painting. This was the period of the fantastic quarrels about the Kingdom of Naples and the beginning of the Italian wars. In these wars the Kings and notables of France came into contact with Italy in the full flush of the Renaissance ; and this contact caused a revolution in taste. When Charles VIII returned from Italy in 1495 he brought back Italian pictures from Naples. Louis XII in Milan endeavoured to induce Leonardo da Vinci to work for him, and in his reign various Italian artists were imported from Italy. Benedetto Ghirlandaio came to France and painted an *Adoration of the Magi* in the Church of Aigueperse in Auvergne ; and other Italian artists painted frescoes in the Cathedral of Albi.

The most enthusiastic of the many French patrons of Italian art at this period was the Cardinal d'Amboise, who owned a *Descent from the Cross*, by Perugino, and summoned Solario from Milan to paint frescoes in the chapel of his Château de Gaillon, which he built in the new Italian style and made a centre for the new Italian taste.

François I, who is usually credited with the introduction of Renaissance art to France, did indeed consolidate and disseminate new standards. But at the time of his accession the new movement was in fact already launched.[1]

[1] For the period covered by Part One of this book the student might well begin with all the writings of Count Durrieu (including his contributions to Michel's *Histoire de l'Art*) and continue with H. Martin's *La Miniature Française*. C. Sterling's *Les peintres du Moyen Age*, 1942, already referred to (which has an excellent bibliography) should also be consulted.

PART TWO
RENAISSANCE PAINTING IN FRANCE

A. THE SCHOOL OF FONTAINEBLEAU

1 FRANÇOIS I AND THE PALACE OF FONTAINEBLEAU
2 LATER WORK AT FONTAINEBLEAU
3 THE FONTAINEBLEAU STYLE

B. FRENCH RENAISSANCE PORTRAITS
1 THE PORTRAIT ALBUMS
2 THE CLOUETS AND CORNEILLE DE LYON

RENAISSANCE PAINTING IN FRANCE

A. THE SCHOOL OF FONTAINEBLEAU

I FRANÇOIS I AND THE PALACE OF FONTAINEBLEAU

François I was twenty when he ascended the throne. He was a fine figure of a man, physically courageous, attractive to women, and a lover of the arts. His taste from the outset was for the new Italian movement; and he already had several Italian artists in his service—including one Bartolomeo Guetti, who was later to paint nymphs and satyrs round the Tennis Court of the new Louvre. His reign opened with the victory of Marignano in which he personally played a valiant part. He returned to Paris in 1516 to a Court of men who lauded him as a hero, and of women who were ready to fall into his arms. The monarchy, moreover, had been much strengthened towards the end of the preceding century. By one more turn of the wheel, François became in fact as well as in name an absolute King with a plentiful supply of money. He set out to make the most of all aspects of the position and, *inter alia*, to indulge in his taste for art.

After Marignano François had visited Milan, Pavia and Bologna. At Bologna he had a four-day conference with Leo X—when their talk was doubtless more of Michelangelo and Raphael than history records. In Milan he continued the intercourse with Leonardo da Vinci begun by Louis XII. As all the world knows, Leonardo accepted his invitation to go to France and the King gave him an estate near Amboise, where he lived till his death in 1519. Andrea del Sarto accepted a similar invitation from the King; he arrived in 1518, painted the *Charity* in the Louvre, and some other pictures, and returned to Italy. Then began the long struggle between François and the Emperor Charles. The defeat of Pavia was in 1525; François was for six months a captive in Madrid; when he returned to France he began to build the Palace of Fontainebleau which is so closely associated with his name.

In the first period François had lived partly at St. Germain-en-laye and partly at Blois, which he enlarged, and other places. In 1519 he had begun the building of the vast Château de Chambord, which in fact he rarely occupied. Later he embarked on rebuilding the Louvre, and began the structure which we know. On Fontainebleau, begun in 1528, he spent immense sums of

money. He filled it with treasures, and he made it a monument of his personal taste.

To decorate the interior François summoned further artists from Italy—Giambattista di Guasparre, known as Rosso, a young Florentine who had made his reputation with an individual style ; and Francesco Primaticcio (a pupil of Giulio Romano), who had just decorated the Tè palace at Mantua with paintings and stucco figures. Rosso arrived in 1530, Primaticcio three years later. Both artists were accompanied by Italian assistants ; they were joined possibly by the Italian artists who had come to France with Leonardo and Andrea del Sarto ; and they also employed French artists as assistants.

Hardly anything now remains of the actual paintings done at Fontainebleau by these artists. But we can still see the general schemes of the painted panels and the stucco ornaments surrounding them. Rosso was responsible for the Gallery of François I. This had panels of mythological subjects which were repainted by Couder under Louis Philippe and again later by one Brisset. Primaticcio finished Rosso's Gallery, collaborated with him in various other work in the Palace and was himself responsible for the Chamber of the Duchesse d'Etampes, the King's mistress, of whom Benvenuto Cellini has said some hard words in his account of his sojourn at the French King's Court. The Chamber of the Duchess, which can still be seen to-day, was decorated with painted panels supported by stucco female nudes of great elegance. The panels, depicting the story of Campaspe and Alexander, with allegorical allusions to the relations of the King and the Duchess in the taste of the time, were all repainted by Abel de Pujol under Louis Philippe.

Primaticcio also designed the King's Bathing Hall which was decorated with paintings of the story of Calisto ; and he was in charge of the ante-chamber to this bathroom where, curiously enough, the King kept favourite pictures from his collection, which included the *Virgin of the Rocks*[1] and other pictures by Leonardo, the *Charity*[1], by Andrea del Sarto, Raphael's *La Belle Jardinière*[1] and *Jeanne d'Aragon*,[1] Michelangelo's *Leda*,[2] a *Magdalen*[3] by Titian, and Bronzino's *Venus, Cupid, Folly and Time*[4] (Pl. 14b). Primaticcio also fitted up and decorated a fantastic grotto in the gardens, where, it has been said, the ladies of the Court were

[1] Now in the Louvre.
[2] Copy ascribed to Rosso now in the London National Gallery.　[3] Now in he Bordeaux Museum.　[4] Now in the London National Gallery.

wont to bathe and where by an ingenious arrangement of mirrors the King could observe them.

2 LATER WORK AT FONTAINEBLEAU

Rosso committed suicide in 1540. François I died in 1547. But the work continued. Under Henri II (1547-1559) Primaticcio painted the Ball Room (known as the Gallery of Henri II), and the Ulysses Gallery, which had been commenced in the previous reign. About 1551 he was joined by Niccolo del Abbate, who had paid one visit to Fontainebleau from Italy and had worked with him in 1533 and who now settled in France. With Niccolo's aid, Primaticcio painted, in the Ball Room, a series of compositions symbolising the Seasons (which were repainted by Toussaint Dubreuil in the time of Henri IV and again in the nineteenth century by Alaux), and under Primaticcio's direction Niccolo painted in the Ulysses Gallery (now demolished) fifty-eight pictures of the story of Ulysses on the walls, and ninety-eight panels of mythological subjects on the ceiling.

Under François II (1559-1560) and Charles IX (1560-1574) various other decorations were carried out at Fontainebleau by Italian and French followers of Primaticcio, who died in 1570, and of Niccolo dell' Abbate, who died in 1571. The troubled period that followed the Massacre of St. Bartholomew (1572) naturally caused a decline in artistic patronage and production. Henri III (1574-1589), however, patronised one Antoine Caron, who designed decorative compositions, fêtes and pageants (including the triumphal arches for the entry of Henri III when he returned from Poland in 1573) and painted portraits (Pl. 18b).

Henri IV (1589-1610), who added to the Louvre, also put in hand extensions and new decorations at Fontainebleau where he observed the traditions by ordering elaborate decorations of the apartments allotted to his mistress Gabrielle d'Estrées. These new decorations depicting scenes from the story of Hercules were the work of Toussaint Dubreuil (1562?-1602). In the same apartment Ambroise Dubois (1543-1614) painted Gabrielle d'Estrées as Diana with hounds and cupids. None of these paintings now exist. Later the King ordered for Marie de Medicis a set of decorations for the famous Gallery of Diana; these paintings, which were destroyed under the Empire, were the work of Ambroise Dubois, who also painted the Salon of Louis XIII (who was born there in 1601), and a series of pictures in the apartment known as the Clorinda Chamber. The pictures in the Salon of

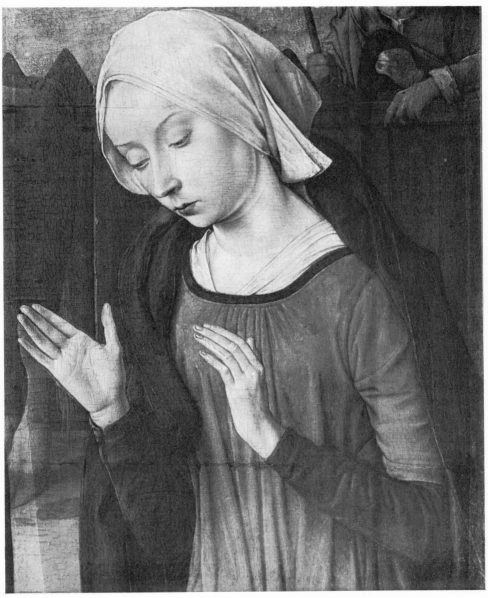

12. *Ascribed to* MAÎTRE DE MOULINS: The Virgin
(Detail of the Nativity)

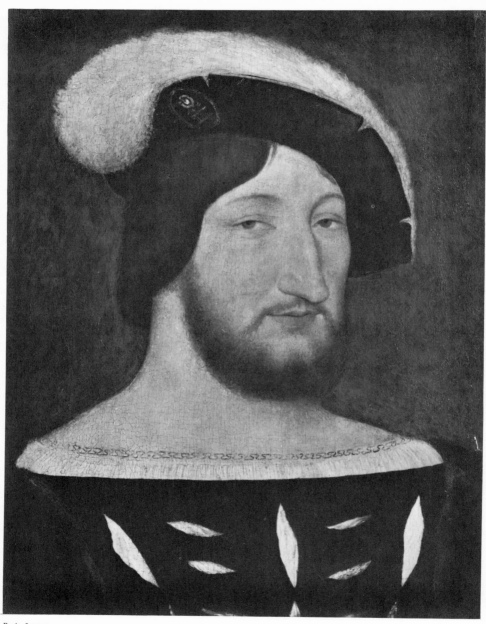

13. JEAN CLOUET: François I

Louis XIII represented the story of Theagenes and Chariclea, some of which, repainted, can still be seen there. One of the Clorinda series, *The Baptism of Clorinda by Tancred*, is preserved in the Louvre.

3 THE FONTAINEBLEAU STYLE

The School of Fontainebleau thus lasted for some ninety years. It represents French decorative and pictorial art between the beginning of the age of François I and the beginning of the age of Richelieu and Mazarin. It begins with Rosso, who came from Italy, and ends with Ambroise Dubois, who was born at Antwerp. Fontainebleau was regarded as one of the marvels of the age, till its reputation was eclipsed by the Louvre and Versailles.

This School cannot be understood or judged by the repainted remains now on the walls at Fontainebleau. We have to try to understand it by considering (*a*) the paintings produced by Rosso before he left Italy and by his *Pietà* in the Louvre ; (*b*) the drawings by Primaticcio in the Louvre, at Chantilly and elsewhere, one or two paintings ascribed to him, and the pictures by the Italian artists on whom he based his style—Parmigiano, Pontormo and Bronzino; (*c*) the few easel pictures by Niccolo dell' Abbate and unnamed Italian and French artists of the School which survive in various museums.

Rosso was an eclectic artist and temperamentally a realist. He was influenced by Michelangelo, Pontormo and Bronzino. In his *Pietà* in the Louvre, we have obvious echoes of Michelangelo's style in the massive limbs, but the open mouth of Christ reveals detailed rendering of tongue and teeth, and the teeth too are delineated in the mouth of the Virgin, which is set in a face founded on some Greek marble head. In his *Pietà* at Borgo San Sepolcro we meet again the stylistic distortions of Michelangelo, and in the background a hideous, noseless, bat-faced figure, which is among the most nightmarish creations in art.

I suspect, indeed, that Rosso had a streak of madness. Various episodes in his life encourage this suspicion. He was always quarrelsome, as we learn from Benvenuto Cellini, who knew him in his Italian days ; his departure for France was largely motived by a quarrel with a priest in Borgo ; and his suicide followed a quarrel with one of his friends in France. Perhaps physical causes contributed to this condition. When Rome was sacked in 1527 he was captured and ill-treated by the Germans, and later a roof fell in upon his head and he suffered fever and concussion. He was

an immensely interesting artist ; but he never arrived at a symbolic
unity in pictorial expression, and he thus lacked the first essential
of pictorial style.

The essence of the Fontainebleau style can, however, be found
in Primaticcio, who absorbed the stylistic conceptions of Parmi-
giano, Pontormo and Pontormo's pupil, Bronzino. From these
sources Primaticcio evolved the type of female figure which we
regard as characteristic of this School. The figures in his drawings
have small heads and narrow shoulders ; and the long torsos widen
into majesty at the hips, from which elegant lines flow down over
full thighs and neat knees to shapely calves and slim ankles.

François himself was a great admirer of the Italian masters on
whose works Primaticcio's art was based ; we know from Vasari
that he was anxious to possess some pictures by Pontormo ; and
he owned Bronzino's *Venus, Cupid, Folly and Time* (Pl. 14b). We
may assume that the conception of beauty in the female figure
which we associate with this School made a special appeal to his
taste.

The artists of the School of Fontainebleau soon lost the funda-
mental stylistic qualities presented to French art by Primaticcio.
There is still a measure of the School's real style in Niccolo dell'
Abbate's *Continence of Scipio* in the Louvre, and in the delightful
picture, *Aristaeus and Eurydice* ascribed to him in the London
National Gallery. We see it also in the *Eva Prima Pandora*
(Pl. 15) by Jean Cousin père (*c.* 1490- *c.* 1561). There is charm too
in the Rouen *Venus*, which has been ascribed to Primaticcio him-
self, but which is more probably a School picture representing
Henri III's Queen, Louise de Lorraine. Some French artist who
had not forgotten the lesson of Bronzino's *Venus, Cupid, Folly
and Time*, painted the attractive *Flora with Attendants* (Pl. 14a),
now in a private collection in Montpellier. But if we compare
the Montpellier picture with Bronzino's we see that the lesson is
but dimly remembered after all.

The middle style of the School can be seen in allegorical figures
called *Justice and Peace* in the Musée Dobrée at Nantes, in a pretty
Artemisia in a Parisian collection, ascribed to Jean Cousin fils
(*c.* 1522-*c.* 1592), in the celebrated *Diana* (Pl. 17) in the Louvre,
and the still more celebrated *Gabrielle d'Estrées in her bath* (Pl. 16)
at Chantilly.

The *Gabrielle d'Estrées in her bath* dates from the fifteen-nineties.
Gabrielle, whom Marguerite, Henri IV's first Queen, always
referred to as *cette bagasse*, is here seen in a baignoire which is half

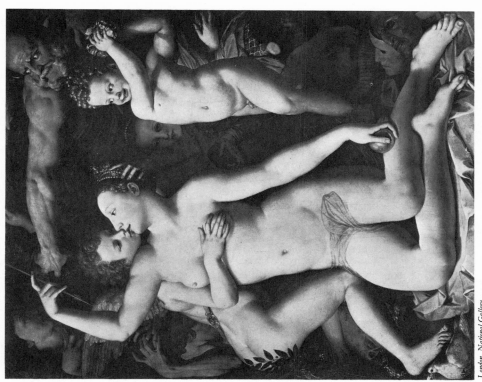

14b. BRONZINO: Venus, Cupid, Folly and Time

14a. SCHOOL OF FONTAINEBLEAU: Flora and Attendants

15. JEAN COUSIN *père*: Eva Prima Pandora

Paris, Louvre

covered with a tablet bearing fruit and flowers ; her little son from the King—César, Duc de Vendôme, aged about three—is stretching out his hand to reach a fruit ; her second son, Alexandre de Vendôme, is at his nurse's breast ; behind we see the interior of a kitchen with a serving-woman and a half-opened window. Commentators on this picture have not, I think, observed that this kitchen scene is reflected in a mirror on the wall behind the nurse, and another mirror—in days when mirrors were still luxuries imported from Venice—appears on the wall beside the fire.[1] Another version of this picture, signed by François Clouet, and probably the original painted about 1550, is in the collection of [N1] Sir Francis Cook in Richmond ; there is a third in the Musée des Arts Décoratifs in Paris, and I know part of a fourth (containing only the left-hand portion) in the collection of Mr. Oliver Brown in London. It has been suggested that the Richmond picture represents Diane de Poitiers, and that the Chantilly picture is a copy where the head of Gabrielle d'Estrées has been substituted.

The French Musées Nationaux owns another charming bath [N2] picture of this School. It represents *Gabrielle d'Estrées and her sister the Duchesse de Villars* seated facing one another in a baignoire with rose-red curtains behind.

The last development of the School is seen in a Louvre picture, the *Baptism of Clorinda*, by Ambroise Dubois, one of the numerous Flemish artists who were attracted to Fontainebleau. In this picture we meet the Italianising Flemish style of the late sixteenth century. The materials that go to the making of this *Baptism of Clorinda* strike us as so ridiculous in themselves that we cannot imagine a tolerable picture resulting from their exploitation. But the same materials were being used in Spain at almost the same moment by El Greco, in his *Martyrdom of St. Maurice* in the Escorial.

[1] For the use of mirrors by the Dutch seventeenth-century painters, *cf.* my *Dutch Painting* (Faber) ; chapter titled " Vermeer's Mirrors."

I THE PORTRAIT ALBUMS

While French decorative art was thus acquiring and forgetting, an Italian style, the members of the Kings' Courts were patronising local talent in the field of portraiture. At the beginning of the reign of François I it became the fashion to summon an artist to the house and to sit to him for a crayon drawing from which, if required, an oil painting was subsequently painted in the artist's studio. Replicas were sometimes made both of the drawings and the paintings ; and the drawings were put into albums, as people put photographs into albums in the nineteenth century.

Hundreds of these sixteenth-century French drawings have survived. There are many in the Musée Condé at Chantilly and others at Versailles, in the Louvre, in the Bibliothèque Nationale, the British Museum, and elsewhere. Thanks to these drawings we know the features of all the outstanding members of the Courts of François I and his immediate successors. One celebrated album in the Museum of Aix-en-Provence belonged to Mme de Boisy, wife of Gouffier de Boisy, Grand Master of France, who had fought by the King's side at Marignano. In this album the portraits of the notabilities bear comments believed to have been written at the dictation of the King himself. The commentator is especially outspoken about the ladies. On the drawing of Diane de Poitiers who was later to be Henry II's mistress, we read : " Fair to see and virtuous to know," on that of Madame de Chateaubriand, " Better figured than painted " ; another lady is described as " honest, fat and pleasant at times " ; yet another is praised for her peerless figure.

The character of all these drawings and paintings, apart from variations in skill, is much the same. The style remained unchanged throughout the reigns of François I, Henri II, François II and Charles IX. The artists were quite uninfluenced by the prevailing styles in decorative art. They were concerned with recording the features of their sitters. Their work is usually less drastically categoric than the similar portraits by Holbein, and the best of the French drawings are warmer and more sympathetically observed.

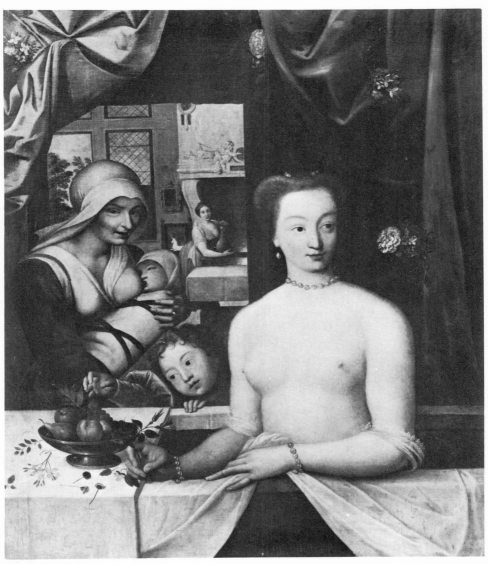

16. SCHOOL OF FONTAINEBLEAU: Gabrielle d'Estrées in her Bath

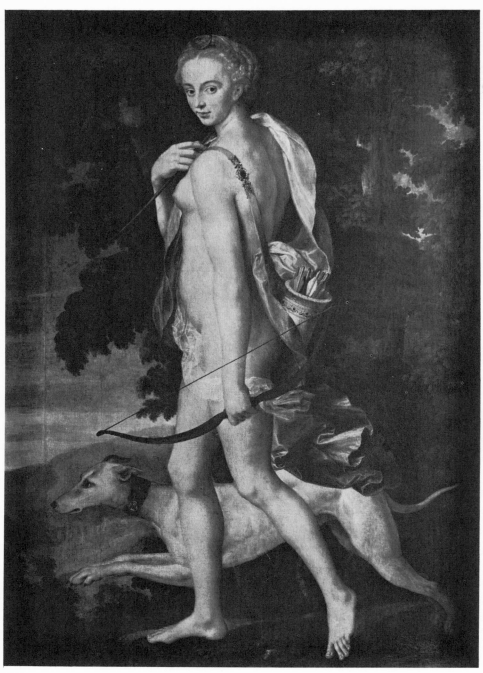

17. SCHOOL OF FONTAINEBLEAU: Diana

2 THE CLOUETS AND CORNEILLE DE LYON

In the case of most of these drawings and the pictures painted from them there is no factual evidence informing us of the artists' names; but ascriptions have been made on the basis of style characteristics which, as all such ascriptions, may be right and may be wrong, and must remain no more than conjectures until factual evidence appears. These conjectures assign a first group to one Jean Clouet the Younger, who was of Flemish birth and was attached to the establishment of François I from approximately 1516 till 1540. A second group is assigned to his son, François Clouet, who succeeded to his father's position and held it under Henri II and Charles IX. Other groups go to artists known as Jean Decourt, Etienne and Pierre Dumonstier, François Quesnel, and to artists given reference names such as L'Anonyme Lecurieux and Le peintre de Luxembourg-Martiques. There is also the able painter known as Corneille de Lyon.

The following paintings are presumed to be characteristic of Jean Clouet (1486 ?-1540):

Hampton Court		Portrait of a Man with a volume of Petrarch
Paris	Louvre	Portrait of François I (No. 126)
Paris	Louvre	Portrait of François I (No. 127)
Antwerp	Museum	The Dauphin François, son of François I
Florence	Uffizi	Claude, Duc de Guise

The portrait of François I (Pl. 13) is of all the portraits of the King the one which convinces me most as likely to have been a faithful likeness. It was painted presumably from a drawing at Chantilly where the curious character of the face is still more incisively portrayed. The Hampton Court picture is extremely expressive and the portrait of the Dauphin (Pl. 18a), showing the sitter at an early age, is a most engaging picture.

In the case of François Clouet (1510-1572), who was known as " Janet," there are the following signed pictures :

Richmond	Sir Francis Cook Collection	Diane de Poitiers in her bath (signed Fr.[N1] Janethii *opus*)
Paris	Louvre	The apothecary Pierre Quthe (signed Fr. Janetii *opus* PE. Quittio Amico, Singulari Aetatis Sue XLIII 1561)
Vienna	Kunsthistorisches Museum	Charles IX in black doublet and white hose (signed Charles VIIII Tres Chrestien Roy de France, en l'Aage de XX Ans Peinct au Vif par Jannet 1563)

Paintings presumed to be his work include :

Paris	Louvre	Elizabeth of Austria
Rouen	Museum	Diana with nymphs and satyrs (and Henri II hunting in the background)
Toledo (Ohio)	Museum	Elizabeth of Valois
Philadelphia	Johnson Collection	Portrait of a Gentleman
Florence	Uffizi	Francis I on horseback (Replica in the Louvre)
Liverpool	Walker Art Gallery (Roscoe Collection)	Marguerite of Valois with a parrot [N1]

I have already referred to his *Diane de Poitiers in her bath* when discussing the Chantilly picture, *Gabrielle d'Estrées in her bath* (Pl. 16).

The portrait of Elizabeth of Austria (Pl. I) is one of the most charming of the whole school. It represents Charles IX's Queen in the year of her coronation, 1571, when she was seventeen years old. Brantôme wrote of her : " She was a very beautiful Princess with a fine and delicate complexion . . . she had a very beautiful figure though she was not tall. She was very good and virtuous and kind-hearted, she did harm to no one and never spoke a word that might have offended ; she was very quiet, spoke little and always in her native Spanish." She was the daughter of the Emperor Maximilian II, and when Charles IX died she returned to Vienna ; there she founded a convent, where she died at the age of thirty-eight.

Corneille de Lyon was born (date unknown) at The Hague and came to Lyons before 1534. He was " painter to the Dauphin " by 1540, and later painter to Henri II and Charles IX. In 1544 he was described by the poet Eustorge de Beaulieu as an " incomparable " portrait painter. He was naturalised French in 1547 and painted portraits of many Court notabilities. Like many other Lyonnais Huguenots he abjured his religion in 1569. He died probably at Lyons after 1574.

He was thus clearly a very successful and celebrated artist. But unfortunately there are no signed or factually authenticated pictures by his hand. The nearest are some recorded as his work in a seventeenth-century catalogue. The pictures catalogued under his name in the Louvre, at Chantilly, in the London National Gallery, in American museums, and so forth, are small portraits with plain, usually blue or green, backgrounds, and the most attractive of them are very delicately drawn and painted.[1]

[1] The student will find the facts and conjectures about the French Renaissance portrait drawings and paintings set forth in H. Bouchot, *Les Clouet et Corneille de Lyon*, 1897 ; Moreau-Nelaton, *Les Clouet et leurs Emules*, 3 vols., 1924, and L. Dimier's *Histoire de la Peinture de Portrait en France au XVIᵉ Siècle*, 3 vols., 1924-6.

PART THREE

THE SEVENTEENTH CENTURY

A. THE AGE OF THE CARDINALS

B. THE AGE OF LOUIS XIV

THE SEVENTEENTH CENTURY

A. THE AGE OF THE CARDINALS

I THE TRANSFORMATION OF PARIS

The seventeenth century falls naturally into two periods. The first, the Age of the Cardinals, extending from 1610 to 1661, covers the reign of Louis XIII and the minority of Louis XIV. It is the period of the successive dominations of Richelieu while Marie de Medicis was Regent during the minority of Louis XIII, and of Mazarin while Anne of Austria was Regent during the minority of Louis XIV—(Richelieu died in 1642, Marie de Medicis in the same year, Louis XIII the year after, Mazarin in 1661, Anne of Austria in 1666). The second period, the Age of Louis XIV, extends from the King's assumption of personal government in 1661 to his death in 1715.

Paris in the first half of the century completely changed its appearance. New buildings appeared on every hand and new quarters were laid out. Marie de Medicis built the new Luxembourg Palace ; Richelieu built the Palais Cardinal (which has been known as Palais Royal since he bequeathed it to Louis XIII) ; and the King himself conceived the project of quadrupling the original proportions of the Louvre and built the Clock Pavilion in 1624—(Catherine de Medicis had built the Little Gallery of the Louvre and the Long Gallery connecting the Louvre and the Tuileries ; Henri IV added second storeys to both structures ; the apartments in the Louvre known to-day as the Long Gallery and the Gallery of Apollo occupy the position of these second storeys. The old structure was destroyed by fire in 1661, and the present Gallery of Apollo is work carried out later for Louis XIV. The ground floor, entresol and Long Gallery were fitted up as lodgings for artists in the Royal service by Henri IV, who installed there not only a number of painters and sculptors, but also an engraver of precious stones, an upholsterer, and one Bourgois, described as *ouvrier en globes mouvants et en constructions mécaniques*. Artists and some craftsmen continued to have lodgings in the Louvre till 1806).

La Place Dauphine and La Place des Vosges also date from this period ; and the rich nobles and bourgeoisie began to build magnificent mansions, known as *hôtels*, in the region of the

34

Luxembourg Palace, round St. Germain-des-Prés and in the St. Antoine, the Marais and Ile-St.-Louis quarters.

There was also much ecclesiastical building. Under Richelieu and Mazarin there was a spectacular religious revival, accompanied by a measure of real piety ; the old religious Orders flourished and new Orders were founded ; and ample money was forthcoming for building monasteries, convents, and churches in the new style of architecture which the Jesuits had introduced from Rome.

The religious attitudes of the time were very various. It was the age of François de Sales and Vincent de Paul, and the beginning of Jansenism. It was also an age when there were still armed conflicts between official Catholics and the Huguenots, and considerable persecution of free thought. The century which opened with the burning of Giordano Bruno in Rome (1600) continued with the burning of Vanini at Toulouse (1619), and of Fontanier in Paris (1621). There was much superstition and brutality. Vanini's tongue was torn out in presence of the populace, and his atheism was said to have been demonstrated because at the pain he emitted a cry like an ox being killed. When Louis XIII and de Luynes wanted to follow the assassination of Concini by the removal of his wife, the confidante of the Queen Mother, they had her burned as a sorceress (1617) ; she was tried before Parliament, which was satisfied of her dealings in Black Magic and her frequentation of " Anabaptists, Jews, magicians and poisoners," when it was proved that in an attempt to cure herself of chronic neuralgia she had followed the advice of a Jewish doctor and applied chickens and pigeons to her head—though she had taken the precaution to have the birds first blessed by a priest. There were no executions for free thought under Richelieu. The freethinkers (*libertins* as they were called in French) realised that all the Cardinal really asked of them was discretion and decent conduct and the recognition of the temporal authority of the Catholic Church. The Curé of St. Pierre de Loudun, who was burned alive by Richelieu (1634), was indeed described as one who had sold himself to the devil, but he was really executed for offences against nuns. Others executed under Richelieu as *libertins* were also guilty of sexual crimes. Richelieu, whose personal religious attitude has puzzled all his biographers, was superstitious. He had the relics of St. Fiacre brought to him from Meaux as he believed they would cure his hemorrhoids. Under Mazarin one Claude Petit was hanged and burned for the publication of " chansons

impies " ; and M. d'Ambreville was burned alive for unorthodox opinions.

The churches which rose in Paris in this atmosphere included Saint Sulpice, Saint Gervais, Saint Eustache, Saint Etienne-du-Mont, Saint Paul, the Val-de-Grâce, and the churches of the Sorbonne and the Invalides. And all this ecclesiastical and secular building created a great demand for artists to adorn the interiors with decorations and pictures. A new school of French painting arose in response. For though Marie de Medicis summoned Rubens to the Luxembourg in 1625 to paint the superb set of pictures now in the Louvre, and tried in vain to tempt Guido Reni to come to Paris for other work, it was to French painters and sculptors that the majority of the countless commissions were now given.

Parisian taste in this period demanded a certain pomposity and pretension from the decorators. Though the artists patronised were French they were expected to produce pictures that recalled Italian painting of some kind. Preference was given to those who had spent some years in Italy and knew how to invest their compositions with some characteristic of contemporary Italian painting or some echo of the Italian Renaissance masters. The taste of the time was willing to accept the flamboyance of the Italian Baroque style, familiarised by the work of Rubens, and the more sober compositions of the so-called Eclectic Italian School which was based on the teachings of the Carracci ; and it also favoured echoes of the Raphaelesque tradition. All the artists who worked in the new *hôtels* and churches complied with these conditions in varying degrees. The most famous and the most sought after were Simon Vouet and Eustache Le Sueur.

2 SIMON VOUET

BORN PARIS 1590 DIED PARIS 1649

Characteristic Pictures

London	Hampton Court	Diana
Paris	Louvre	Louis XIII, with allegorical figures of France and Navarre
Paris	Louvre	The Presentation of Jesus in the Temple
Paris	Louvre	Wealth, Faith, Victory, Eloquence (four pictures)
Paris	Saint Merry	St. Merry delivering the prisoners
Paris	Saint Nicolas des Champs	The Assumption of the Virgin

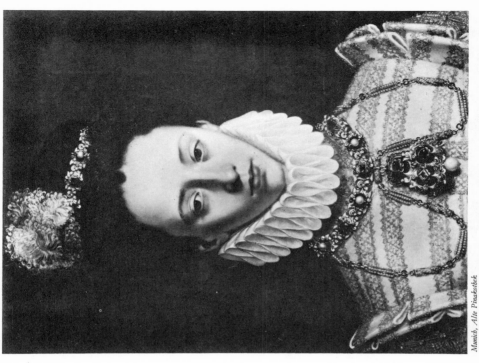

Munich, Alte Pinakothek

18b. ANTOINE CARON : Princess Sibylle of Julich Cleve

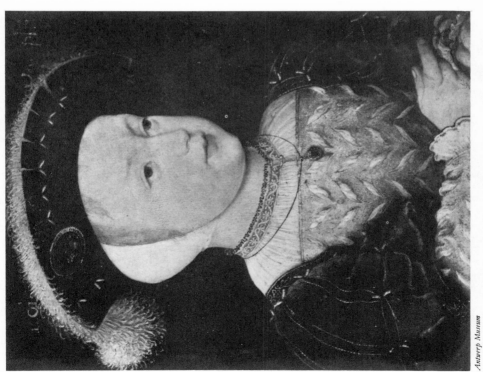

Antwerp Museum

18a. JEAN CLOUET : François II as Dauphin

Grenoble Museum

19a. SIMON VOUET : The Rest on the Flight

Paris, Louvre

19b. SIMON VOUET : Wealth

Paris	S. Eustache	Martyrdom of S. Eustache
Dijon	Museum	Presentation of the Virgin
Grenoble	Museum	The Rest on the Flight
Grenoble	Museum	Temptation of St. Anthony
Besançon	Museum	Death of the Magdalen
Lyons	Museum	Christ on the Cross
Nantes	Museum	Apotheosis of St. Eustache
Naples	Certosa di San Martino	S. Bruno
Rome	S. Lorenzo in Lucina	Scenes from the Life of S. Francis

Simon Vouet, son of a decorative painter attached to the service of Henri IV, showed precocious talent for drawing and painting. If we are to credit Walpole, he was already known as a portrait painter by the time he was fourteen ; and before he was twenty he had visited England and painted a portrait at the Court of James I. At the age of twenty-one he accompanied the French ambassador to Constantinople, where he is said to have had an audience with the Sultan and to have painted a successful portrait of him from memory. In 1612 we find him in Venice, in 1613 in Rome. He remained in Italy for thirteen years. Cardinal Barberini (later Urban VIII) was his patron, and the poet Marini was his friend. He decorated the splendid Doria Palace, in Genoa, and a chapel in the Vatican. His reputation in Italy eventually became so great that he was made a director, or Prince, as the office was called, of the Roman artists' Academy of St. Luke. In 1627 he received a royal command to return to France, and Louis XIII made him *Premier peintre du roi* with a handsome salary and apartments in the Louvre.

Vouet painted the King's portrait, gave him lessons in pastel drawing, and executed to his order some ·decorations in the Louvre. From Marie de Medicis he received decorative commissions for the Luxembourg, and he was also called on for numerous decorations for *hôtels*, and for altarpieces in the new churches. He had an army of assistants and of apprentice pupils. At one moment Le Sueur, Mignard and Le Brun were all working in his atelier. His output was tremendous, and his position was unchallenged for many years.

Vouet's ecclesiastical style can be well seen in the *Rest on the Flight* (Pl. 19a), in the Museum of Grenoble, and in the Louvre *Presentation of Jesus in the Temple*, which he painted for the Church of the Jesuits in Paris to the order of Richelieu ; it was a compound of all the contemporary Italian formulæ rendered tiresome in a

special way by the heaviness of the figures, accompanied by attempts at affected grace—note the angel's little finger in Pl. 19a. His decorative style can be seen in the allegorical figures of *Wealth* (Pl. 19b), *Faith*, *Victory* and *Eloquence*, now in the Louvre, and in the *Diana* at Hampton Court.

His reputation suffered a setback when Poussin visited Paris in 1640. The King, after receiving Poussin in audience, exclaimed to his Courtiers, *"Voilà Vouet bien attrapé,"* and the word went round. Vouet suffered further when Le Brun returned from Italy and intrigued against him at the time of the foundation of the Academy in 1648 ; and retaining his dignity he refused to join in.

Though now almost forgotten, he was a most important figure in the history of French art. His work stands at the root of nearly all the Parisian ecclesiastical and decorative painting of the first half of the century ; and his influence is seen not only in pictures by his pupils, Le Sueur and Le Brun, but also in certain works by Poussin himself.

3 EUSTACHE LE SUEUR
BORN PARIS 1616 DIED PARIS 1655
Characteristic Pictures

Paris	Louvre	Noli me tangere
Paris	Louvre	The Angel appearing to Hagar in the desert
Paris	Louvre	The Descent from the Cross
Paris	Louvre	St. Paul preaching at Ephesus
Paris	Louvre	The Virgin appearing to St. Martin of Tours
Paris	Louvre	The Mass of St. Martin of Tours
Paris	Louvre	View of the Chartreuse de Paris, with figures and plan
Paris	Louvre	SS. Gervais and Protais before Astasius
Paris	Louvre	The life of St. Bruno (twenty-two pictures)
Paris	Louvre	Hôtel Lambert, " Cabinet d'Amour " (seven pictures)
Paris	Louvre	Hôtel Lambert, " Chambre des Muses " (six pictures)
Paris	Louvre	Portrait group of M. de Chambray and friends
Paris	Louvre	Tobias receiving instructions for his journey from his parents
Grenoble	Museum	The Angel leaving Tobias
Montpellier	Musée Fabre	The Wedding Night of Tobias
Budapest	Museum	Tobias returning to his parents
Le Mans	Museum	Diana and her attendants hunting
Tours	Museum	St. Louis tending the sick
Rouen	Museum	The dream of Polyphilus
Leningrad	Hermitage	Moses in the Bulrushes

20b. EUSTACHE LE SUEUR: Melpomene, Erato and Polymnia

20a. EUSTACHE LE SUEUR: Clio, Euterpe and Thalia

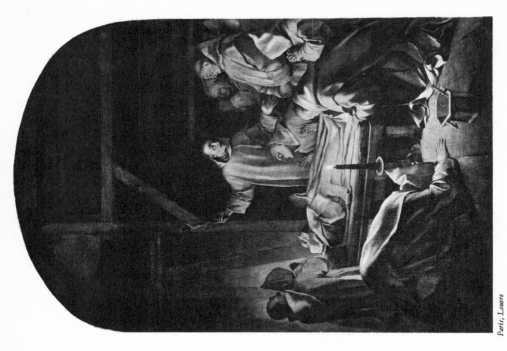

21b. EUSTACHE LE SUEUR: The Death of St. Bruno

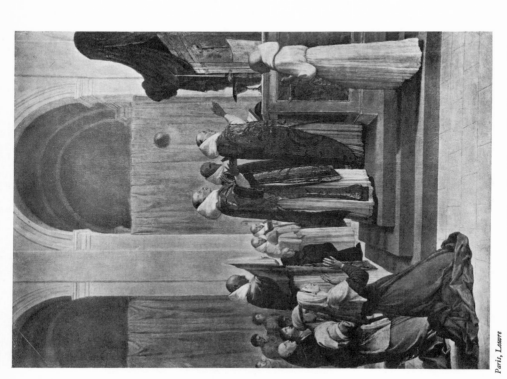

21a. EUSTACHE LE SUEUR: The Mass of St. Martin of Tours

Eustache Le Sueur is another artist who is largely forgotten to-day, though he painted some of the most charming religious and decorative pictures of the seventeenth century. I use the word religious, rather than ecclesiastical, in speaking of this artist's work, because his best pictures of religious subjects seem imbued with an intense and simple religious spirit that is rarely met with in any painting after the early years of the Italian Renaissance.

Le Sueur was born in Paris. His father was a turner. He thus belonged to the artisan class, and in that class he remained all through his life. He never went to Italy, though Poussin wrote from Rome urging him to go there ; and he never aspired to the fashionable position of Vouet, though he worked for some people in the fashionable world. He married the daughter of a painter, one of his sons was a grocer, and one of his daughters also had a grocer for her husband. He graduated as Master in the *Maîtrise* ; when invited to do so he joined the Academy, without fuss ; and he paid his subscriptions regularly to that institution, which the more fashionable members in the main omitted to do. He was a kindly, simple man without pretensions ; and his character is reflected in his pictures.

He was fifteen when he was apprenticed to Vouet, and he was doubtless regarded as a dunce by his fellow-pupils, Mignard and Le Brun. He profited, however, by Vouet's instruction and absorbed his manner so completely that one of his earliest pictures, the portrait group, *M. de Chambray and his friends*, in the Louvre, was long ascribed to Vouet himself ; at twenty-one he made the cartoons for a Gobelins tapestry *The Dream of Polyphilus*, which Richelieu commissioned from Vouet ; and the influence of Vouet is seen in his curiously hybrid *Diana and her attendants hunting* (which I presume is an early work) in the Le Mans Museum, for the figures are painted in the manner of Vouet, with artificial flying draperies and bare breasts and legs, and they are accompanied by realistically painted sporting dogs complete with collars and chain-rings.

After leaving Vouet's atelier he began to get commissions to design frontispieces and vignettes for books, and for pictures in churches, monasteries and private *hôtels*. His most important decorative commission was a series of panels for two rooms, known as the *Cabinet d'Amour* and the *Chambre des Muses*, in the[N1] Hôtel Lambert, belonging to Nicolas Lambert de Thorigny, President of the *Chambre des Comptes*.

The panels in the *Chambre des Muses*—now in the Louvre—consist of two large and three small compositions. The large pictures represent groups of the Muses—the first Clio, Euterpe and Thalia (Pl. 20a), the second Melpomene, Erato and Polymnia (Pl. 20b); the small pictures represent single figures of Urania, Terpsichore and Calliope. Here we see Le Sueur in the field where Raphael's *Parnassus* in the Vatican reigns supreme. But Raphael's fresco is a superb pageant designed by a pageant master of genius and executed as it were by skilled professional actors wearing costumes from the best theatrical costumier of the day. Le Sueur's pictures are *tableaux vivants* performed by amateurs who make up in friendliness for their shortcomings in professional *panache*. In the first group the performers, I feel, are the more mature and experienced of the members of the family who have organised these *tableaux*; they are elder sisters or possibly young aunts. Clio, the Muse of History, has a book and the Trumpet of Fame, Euterpe, the Muse of Lyric Poetry, plays the flute, and at their feet Thalia, the Muse of Comedy, contemplates a mask. They all wear blue or bluish-grey draperies, and Clio has a red drapery across her knees. In the second group, on the other hand, we have younger members of the family. Here Melpomene, the Muse of Hymns, is chanting from a book of music, Polymnia, the Muse of Tragedy, plays on the bass violin, and casts her eyes to heaven in anguish, and Erato, the Muse of Erotic Poetry, who is discreetly given no attribute, peeps over Polymnia's shoulder. What could be more engaging than Melpomene sitting as good as gold upon the ground with a drapery thrown over her frock and flowers in her hair, singing so demurely from the book of choral music—borrowed maybe for the occasion?

Most of these pictures from the Hôtel Lambert—for Louvre pictures—are in very fair condition. But in some cases there has evidently been clumsy repainting, especially in the red draperies, which have become a heavy and crude scarlet. Where Le Sueur's work has been preserved the reds are of a delicate rose-vermilion, and the blues are warmed with a gold glaze; in the original passages the surface has a tapestry-like quality that is very characteristic.

The Hôtel Lambert pictures date from the sixteen-forties. About the same time Le Sueur was commissioned to paint twenty-two pictures of the life of St. Bruno, the founder of the Carthusian Order, for a cloister in the Chartreuse Monastery in Paris.

The Chartreuse Monastery in Paris was situated on a site now occupied by the Avenue de l'Observatoire and the houses between

this avenue and the rue d'Assas. It is seen in Le Sueur's Louvre *View of the Chartreuse of Paris with plan,* which makes an interesting contrast with El Greco's *View of Toledo with plan* (in the Casa Greco, at Toledo) painted about fifty years before. The episodes assigned to Le Sueur were those which are related in the official Lives of St. Bruno, together with the episode of Raymond Diocres, which is described by Butler in his *Lives of the Fathers, Martyrs and other Principal Saints* as " mere hearsay fiction injudiciously credited by those who committed it to writing." St. Bruno was born in 1030. " In his infancy," says Butler, " he seemed above the usual weakness of that age, and nothing childish ever appeared in his manners." After various scholastic and theological studies he eventually rose to distinction in the Church and was about to be made Archbishop of Rheims when he felt a call to renounce the benefits and pleasures of the world. The episode of Raymond Diocres occurs as the motif for this decision, which is otherwise attributed to less dramatic causes. Raymond Diocres was a famous theological doctor of Paris whose sermons were attended by the youthful St. Bruno and fired him with enthusiasm. When Diocres died he was granted the funeral honours of a holy man ; but in fact he was an impostor and when his body was lying in state the horror-stricken mourners observed it rise in agony and utter three terrible cries : " By the just judgement of God I am accused," " I am judged," " I am condemned." Le Sueur's first picture is *St. Bruno listening to the Sermon of Raymond Diocres* ; the second, *The Death of Raymond Diocres* ; the third, *The corpse of Raymond Diocres announcing his damnation,* represents the writhing, shrieking corpse striking the spectators with consternation. These pictures are now in the Louvre, but it is almost impossible to judge them in their present condition as they were originally placed in the open air, where they suffered from damp, exposure, neglect and wilful damage, and since then they have been completely repainted on three occasions. One picture alone of the series, *The Death of St. Bruno* (Pl. 21b), still conveys to us the spirit of the artist's work.

We can see Le Sueur's individuality as a religious painter most clearly in *The Mass of St. Martin of Tours* (Pl. 21a), painted for the Abbaye de Marmoutiers. The episode represented is not that of St. Martin dividing his cloak with the beggar at the gate of Amiens, but a similar episode at Tours when the saint gave his own tunic to a beggar and celebrated the Mass in a cheap tunic which the archdeacon had intended him to give to a beggar for whom he had been instructed to provide clothes. In Le Sueur's picture

St. Martin (wearing his own vestments, not the cheap tunic of the legend) is celebrating the Mass and above his head is a globe of fire—the sign that the beggar had in fact been Christ. Le Sueur has here achieved a very lovely work. There is a gentle serenity in this picture which is not destroyed by the genre painting of the congregation, because the genre passages are treated with formal simplicity. The colour, too, is quite enchanting ; the woman in the foreground wears a rose-vermilion skirt, an olive-green bodice and a blue wimple ; the globe of fire is the same red as the skirt ; the rest of the picture is composed of delicate blues, whites and greys.

In another picture by Le Sueur, *The Apparition of the Virgin to St. Martin*, formerly catalogued as *St. Scholastica appearing to St. Benedict*, the figure of St. Martin is extremely moving in its intense humility.

In addition to these commissions for churches and religious institutions, Le Sueur painted a number of religious pictures for private patrons. The Louvre has a charming *Hagar and the Angel in the Desert*, and a scene from the story of Tobias—one of a series of which others are preserved in the museums of Grenoble, Montpellier and Buda Pesth.

The Montpellier picture represents *The Wedding Night of Tobias*, an incident which is rare in the many pictured versions of the story in Italian and Dutch art of the sixteenth and seventeenth centuries. Tobias, it will be remembered, was sent by his blind father Tobit to Rhages in Ecbatana to recover a debt. As Tobit had won favour in God's sight, Tobias was accompanied on his journey by the angel Raphael. On the journey Tobias washed his feet in the Tigris and was attacked by a fish ; aided by the angel, he killed the fish and became possessed of its liver and heart and of its gall. At Rhages he recovered his father's money and was able to win his cousin Sara of Ecbatana as his bride. Sara had been the victim of an evil spirit Asmodeus ; she had been married seven times and by the action of the evil spirit her husbands had always died on the wedding night ; instructed by the angel, Tobias burned the liver and heart of the fish, and the fumes drove away the demon so that he could marry Sara in peace ; and when he returned home he was able to cure his father's blindness by application of the fish's gall. In Le Sueur's picture we see the liver and heart of the fish being burned in a brasier while the demon departs in the smoke, and Sara, seated on the nuptial bed, looks on with approbation.

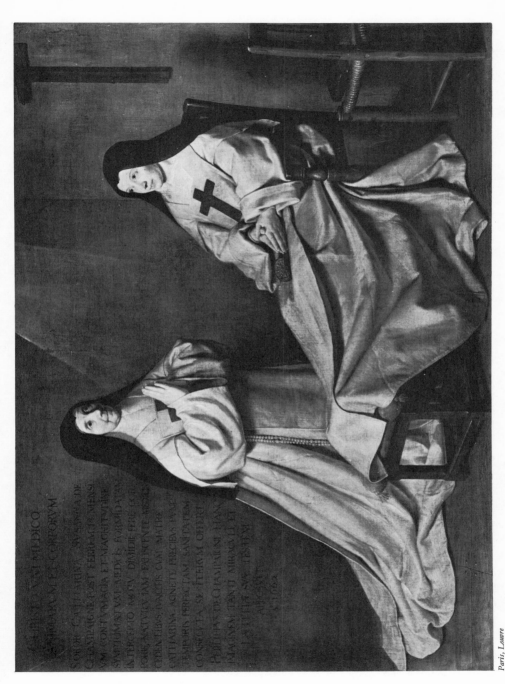

22. PHILIPPE DE CHAMPAIGNE: La Mère Catherine-Agnès Arnauld et la Soeur Catherine de Sainte-Suzanne

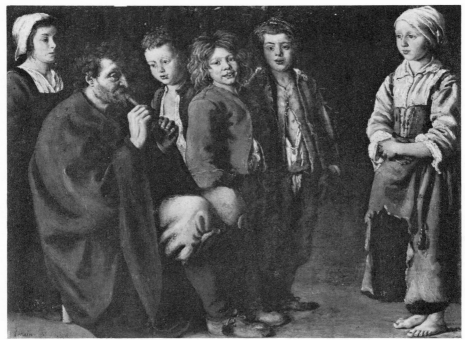

23a. ANTOINE and LOUIS LE NAIN: The Village Piper

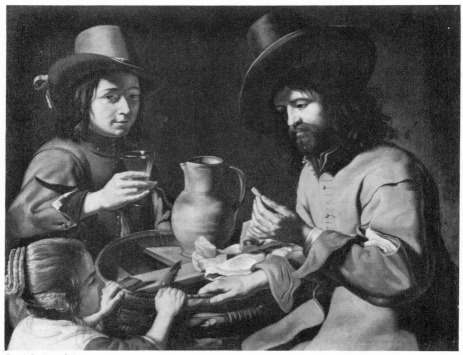

23b. MATHIEU LE NAIN: Peasant Meal

The most famous of Le Sueur's religious paintings in his day was the *St. Paul preaching at Ephesus* now in the Louvre, but originally given to Nôtre Dame by the Goldsmiths' Guild as one of their annual series of gifts known as " Mays." This shows the burning of the magic books of those " which used curious arts," while St. Paul preaches in front of the Temple of Diana and a negro kneels on the ground and blows the fire. To the modern spectator this picture makes small appeal. It is too obviously a pastiche put together from Raphael's *Death of Ananias* and *St. Paul at Athens*.

Le Sueur was greatly admired by Reynolds, who spoke of him as constituting with Poussin and Le Brun a colony from the Roman School to which he assigned rank above the Venetian, Flemish and Dutch. In our own time he has been the subject of some curious and harsh judgments. M. Henri Lemonnier classes him with the French *genre* painters, the Le Nain brothers, and the engravers Callot and Bosse. Sir Charles Holmes has written : " In Lesueur an intellectual temper similar to Poussin's was joined to a Raphaelesque sense of proportion and the resulting product is just redeemed from being colourless (his colour is his weakest point) by a certain rather frigid lead beauty "—a most strange comment on Le Sueur's colour. Ruskin described Le Sueur's religious pictures as " pure abortion and nuisance," and he described the Virgin and the saints in the *Virgin appearing to St. Martin* as " beautifully buoyant and graceful and tender, but not religious nor sublime."

4 SOME MINOR MEN

Among other painters who had public commissions at the period we must note François Perrier (1590-1650), who painted decorations for the Hôtel Lambert and the Hôtel de la Vrillière (now the Banque de France), and was the master of Le Brun (the Louvre has his *Acis and Galatea, Orpheus in Hades*, and *Aeneas and the Harpies*) ; Laurent de la Hire (1606-1656)—son of one Etienne de la Hire who painted in Poland—who worked for Richelieu and for Paris churches and the Hôtel de Ville, and painted the rare subject *Pope Nicolas V in 1449 opening the tomb of S. Francis of Assisi to verify the stigmata* (now in the Louvre) ; Jacques Stella (1596-1657), who went to Rome where he knew Poussin and worked for the Jesuits, and also painted a number of tiny miniatures to be worn as jewellery, before returning to Paris where he worked for Richelieu and religious houses and became a

King's Painter (Versailles has a *Triumph of Louis XIII* painted on lapis and the Munich Bavarian Museum a *Repentant Magdalen* painted on stone) ; Charles Errard (1606-1689) who also went to Rome and knew Poussin, then returned to Paris, where he decorated numerous *hôtels*, worked in the Louvre and Luxembourg palaces, painted a Goldsmiths' " May " for Notre Dame and the scenery for Mazarin's production of " Orpheus and Eurydice," became Director of the Academy, and finally returned to Rome as First Director of the newly founded French Academy in Rome ; Louis Testelin (1615-1665), pupil of Vouet, who painted Roman emperors at Fontainebleau and an *Apollo* on the ceiling of Anne of Austria's apartments, and was a close friend of Le Brun (Rouen Museum has his *Raising of Tabitha* painted as Goldsmiths' " May " for Notre Dame) ; Henri Testelin (1616-1695), also a Vouet pupil, who painted *Louis XIV as a child* (now at Versailles), drew up a synoptic table of Rules for Great Art for use in the Academy, was expelled from the Academy as a Protestant, and settled in Holland ; and Nicolas Pierre Loir (1624-1679), who worked for the royal palaces, designed hunting scenes for the Gobelins, and made many copies of paintings by Poussin which as early as the eighteenth century were already being sold as originals by the master.

5 THE INFLUENCE OF THE LOW COUNTRIES

Side by side with this production of pictures for royalty, the wealthy, and the Church, there was a more popular production of small easel pictures resembling the popular descriptive pictures of the Low Countries. Up to the seventeenth century popular descriptive art, produced in all countries, had generally been executed in cheap and fugitive materials. In Renaissance times art depicting scenes of everyday life was generally in the form of drawings or of prints on paper from wood blocks or copper plates. In France this tradition continued into the reign of Louis XIII ; Jacques Callot (1592-1635) made drawings and engravings describing tramps and gipsies, and he has left us mordant records of the pomp and the miseries of seventeenth-century war ; and Abraham Bosse (1602-1676) engraved scenes of French bourgeois life with sly humour. This genre art first invaded oil painting in the late sixteenth and the seventeenth century in the Low Countries, especially in Holland ; and it was not long before oil paintings of popular genre subjects began to be seen in Paris.

There was, moreover, a recognised Low Country colony in the region of St. Germain des Prés, where various painters whom Rubens had brought to Paris as assistants had established themselves. These Flemish and Dutch artists by the rules of the *Maîtrise* were not allowed to exhibit their work in Paris or trade in pictures ; only those who made terms with the *Maîtrise* or obtained royal protection were able to do so ; but the others could expose their work for sale at the St. Germain Fair, in February each year, because St. Germain des Prés, then outside the city, was a privileged place, with its own Guild of artists not controlled by the central *Maîtrise* in Paris.

At the St. Germain Fair, accordingly, the exhibition of little popular paintings by Dutch and Flemish artists was a regular feature. These pictures were mainly sold for trifling sums to the *petite bourgeoisie*; but when the Fair began to be visited by fashionable people from the new St. Germain and Luxembourg *hôtels*, a few rich dilettanti of independent taste also began to collect them ; and in the later years of the century—(in spite of the famous comment of Louis XIV, " *enlevez moi ces magots* ") —the serious collecting of Flemish and Dutch pictures very considerably increased.

The influence of the Dutch painters is plainly seen in the works of three most interesting French artists, the brothers Antoine, Louis and Mathieu Le Nain ; and that of another type of Low Country painter, Gerard Honthorst, is seen in the pictures by Georges de la Tour.

6 THE BROTHERS LE NAIN

ANTOINE LE NAIN

BORN LAON C. 1588 DIED PARIS 1648

Characteristic Pictures

London	National Gallery	A Woman and five Children (signed Lenain fecit 1642)
London	The Countess of Bute	The Studio
Glasgow	Art Gallery	Interior with figures
Paris	Louvre	Family Group (signed Le Nain fecit 1642)
Paris	Louvre	Portraits in an interior (signed Le Nain fecit 1647)

LOUIS LE NAIN

BORN LAON C. 1593 DIED PARIS 1648

Characteristic Pictures

London	National Gallery	Saying Grace
London	Victoria and Albert Museum	Landscape with figures (La Halte du Cavalier)
London	Duke of Rutland Collection	Peasants before their house (signed, and dated 1640 ?)
Petworth	Lord Leconfield Collection	Peasants and a strolling musician
Boston	Museum of Fine Arts (formerly Earl of Carlisle Collection)	Peasants before their house
Detroit	Institute of Arts	The village piper
Paris	Louvre	The return from haymaking. (La Charrette) (signed Le Nain fecit 1641)
Paris	Louvre	The peasant's meal (signed Le Nain fecit ano. 1642)
Paris	Louvre	Peasant family
Paris	Louvre	The forge
Paris	Louvre	Nativity. (La Crèche)
Paris	Louvre	The return from the baptism (signed Le Nain f. 1642)
Avignon	Musée Calvet	Portrait of a Nun (perhaps La Marquise de Forbin-Janson) (signed Aet. Suae 84. A° 1644 Lenain fⁱᵗ)
Lille	Museum	The open-air meal
Leningrad	Hermitage	The milkseller's family

MATHIEU LE NAIN

BORN LAON C. 1607 DIED PARIS 1677

Characteristic Pictures

London	Buckingham Palace	The young gamblers
New York	Metropolitan Museum	The mendicants [N1]
Chicago	Art Institute	Peasant family
Worcester (Mass.)	Art Museum	Children playing cards
Detroit	Institute of Arts	A peasant meal
Paris	Louvre	Tric-trac players
Paris	Louvre	The little card players
Paris	Louvre	Group of amateurs
Paris	Baronne de Berckheim Collection	The Corps de Garde (signed Lenain fecit 1643)
Paris	Sambon Collection	The gardener
Paris	Sambon Collection	The dancing lesson

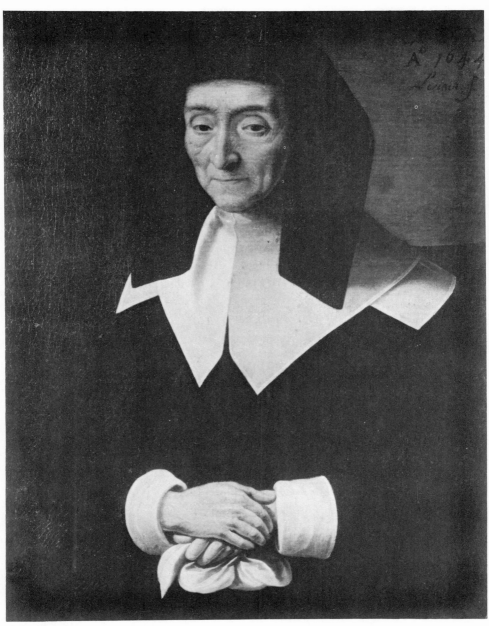

24. LOUIS LE NAIN: Portrait of a Nun

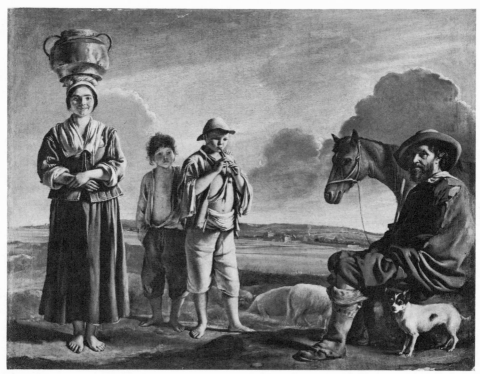

25a. LOUIS LE NAIN: La Halte du Cavalier

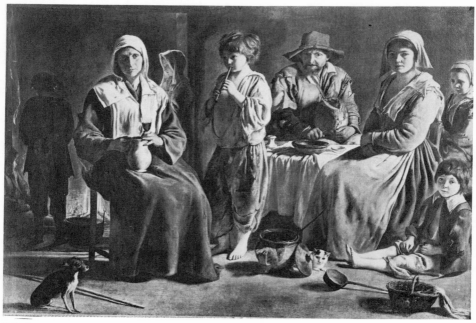

25b. LOUIS LE NAIN: Peasant Family

Paris	Dr. Mary Collection	Nativity (signed Le Nain f. 1674)
Rheims	Museum	Venus in the forge of Vulcan (signed Lenain fecit 1641)
Le Puy	Museum	Portrait of a young man
Laon	Museum	Portrait of a young man (dated 1646)
Dijon	Magnin Museum	Portrait of a man

There is an old tradition that the brothers Antoine, Louis and Mathieu Le Nain collaborated on all their pictures ; and till recently no attempt was made to distinguish the works of the three men. But in 1910 Sir Robert Witt, on the occasion of an exhibition of works by and ascribed to them at the Burlington Fine Arts Club, examined the exhibits and proposed a basis for each man's separate style ; and since then M. Paul Jamot has made an intensive study of the subject. I give above lists of the outstanding pictures as now divided among the brothers by these assumptions. It is, however, probable that the old tradition suggesting collaboration may be the truth in the case of some of these pictures. *The Village Piper* (Pl. 23a) in Detroit, for example, listed as by Louis, may be partly the work of one of his brothers.

On this basis Antoine Le Nain, the eldest of the three, painted little portrait groups. He had a shrewd and humorous eye but never attained to any great skill in the conduct of a picture. He was always defeated by problems of proportion ; the heads of the various figures in his groups are of different sizes, they are often too big for the bodies, and many of his figures appear to be dwarfs. Antoine never graduated in the Paris *Maîtrise*. But he acquired the rank of Master in the Guild of St. Germain and he doubtless frequented the St. Germain Fair and exhibited and sold his pictures there. We may assume that his brothers were in the same position till all three acquired Parisian reputations and were invited to join the Academy when in 1648 it was selecting members hostile to the *Maîtrise*.

Louis Le Nain was the oustanding artist of the three. His *Peasant Family* (Pl. 25b) and *Peasant Meal*, in the Louvre, are masterpieces. Here we have the Dutch descriptive art of the period lifted from the level of commonplace genre to the level of the Velasquez *Old woman frying eggs* in the Cook Collection at [N1] Richmond, which had been painted about a quarter of a century before.

Louis Le Nain also painted some outdoor groups in which again we find a dignity that is usually absent from similar Dutch

pictures. The Louvre has *The Return from Haymaking* of this character, and there is a fine *Landscape with figures* which the French critics call *La Halte du Cavalier* (Pl. 25a), in the Ionides Collection at the Victoria and Albert Museum in London. These outdoor subjects, especially *La Halte du Cavalier*, suggest that Louis Le Nain was acquainted with the work of his precocious contemporary Paul Potter, painter of the celebrated *Young Bull* in the Mauritshuis, The Hague. There is nothing in Louis Le Nain's technique which approximates to the technique of the majority of contemporary Dutch and Flemish painters who worked with a light touch and an oily brilliance of transparent colour. But Paul Potter's handling of paint was different. His touch was deliberate, the substance of his pigment was thick and opaque, and his colour was predominantly grey. In *La Halte du Cavalier* Louis Le Nain has handled his paint in just Paul Potter's way; and there is also a resemblance to the *Young Bull* in the general composition of the picture.[1]

But even making the maximum allowance for Louis Le Nain's debt to such Dutch pictures his works remain essentially individual, and essentially French. The gravity, the restraint, and the feeling in his work represent an aspect of the French spirit which is deeply rooted in the permanent simplicities of life. This aspect, which we find in another form in the pictures of Le Sueur, found no expression in the French decorative art of the seventeenth and eighteenth centuries. It reappeared in the eighteenth century in the pictures by Chardin and in the nineteenth in certain works by Paul Cézanne.

A number of portraits are ascribed to Louis Le Nain. Of these much the finest is the signed and dated Avignon *Portrait of a Nun* (Pl. 24).

Antoine and Louis Le Nain both died in 1648. Mathieu, the youngest brother, outlived them for nearly thirty years. He was to all intents and purposes an artist of the Dutch popular school. He painted portraits, including the clever *Portrait of a Youth* in the Laon Museum, genre pictures of young men playing tric-trac, bourgeois interiors, and so forth. The *Peasant Meal* (Pl. 23b) in the Detroit Institute of Arts and the *Tric-Trac Players* in the Louvre are typical of his genre work.

A large painting in the Louvre, the *Nativity* (*La Crèche*), attributed by M. Jamot to Louis Le Nain, and described in the

[1] This is a puzzling problem because Paul Potter's working life was from 1641 at the earliest (he was born in 1625). The *Young Bull* was painted in 1647.

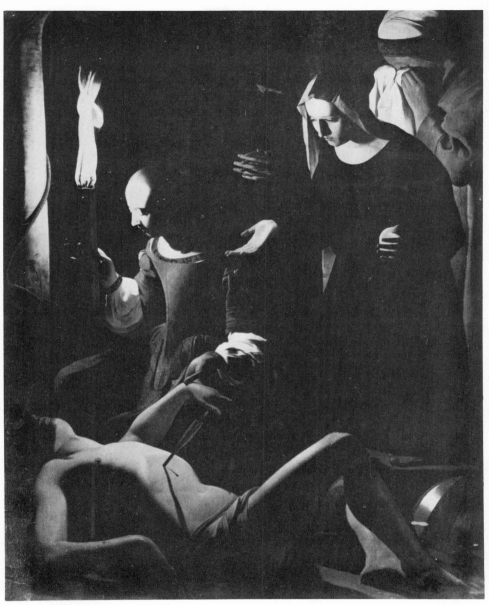

26. GEORGES DE LA TOUR : St. Sebastian mourned by Women

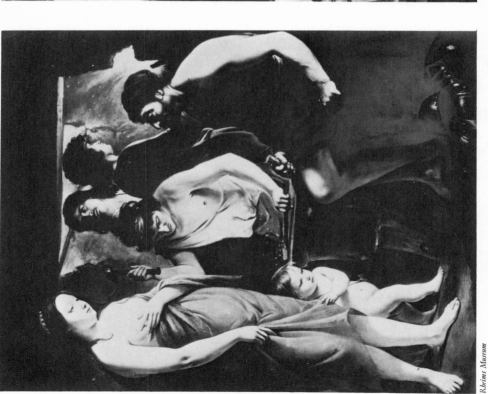

27a. MATHIEU LE NAIN: Venus in the Forge of Vulcan

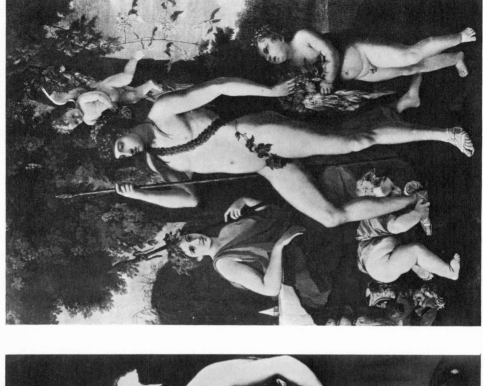

27b. NICOLAS POUSSIN: Bacchus and Erigone

Louvre Catalogue as " Attributed to Louis Le Nain," may also possibly be a work by Mathieu. It is a curiously eclectic picture in which we see a Virgin with a Rubens facial type, a young girl who resembles the favourite model of Caravaggio, and elements which seem Spanish. It demonstrates the variety of foreign styles with which the brothers had contact when they frequented the St. Germain Fair—since Italian and Spanish pictures as well as Dutch and Flemish doubtless found their way to the Fair.

The same applies to Mathieu Le Nain's curious *Venus in the Forge of Vulcan* (Pl. 27a) at Rheims, where with considerable gaucherie the artist has attempted a mythological composition which contrasts strangely with *The Forge* (in the Louvre) by his brother Louis on the one hand and with *The Forge of Vulcan* (in the Prado) by Velasquez on the other.

It is known that Mathieu Le Nain painted a portrait of Mazarin. But it is not now traceable.

7 IMITATORS OF THE LE NAIN

The Le Nain brothers had a number of imitators, some of whom were responsible for pictures at various times, and perhaps still, ascribed to them.

A contemporary, the Comte de Brienne, refers to " Bourdon and Michelin " as " dangerous copyists " who painted many " bambochades " (i.e. peasant genre pictures in the tradition of the Dutchman Pieter van Laer known as " Bamboche ") and sold them at the Saint Germain Fair as by the Le Nain brothers.

The Bourdon here referred to was Sébastien Bourdon, a skilful pasticheur who went to Italy and imitated the Italians and Poussin as well as the painters of bambochades (the National Gallery has his *The Return of the Ark* in the manner of Poussin which once belonged to Reynolds). Bourdon, born at Montpellier in 1616, was a foundation member of the Academy in 1648 and then, to escape the Fronde, went to Sweden where he was Court painter to Queen Christina from 1652 to 1654. He then went back to France where he sold pastiches to the banker-collector Jabach and got employment for various *hôtels*. He was starting on a commission for the Tuileries when he died in 1671.

The Michelin referred to was doubtless the Jean Michelin whose signature, with the date 1656, has recently been deciphered on *The Baker's Cart* in the New York Metropolitan Museum. This picture (previously listed cautiously in the catalogue as by a Le Nain Assistant) has admirable qualities and here too I seem

to see the influence of Spanish paintings which may mean that some pictures passing under the names of Spanish genre painters as well as some ascribed to the Le Nains may actually be his work.

It is not certain who Jean Michelin, painter of the New York picture, was. He may have been the Jean Michelin born at Langres in 1623 who was a member of the Academy in 1660, painted the signed *Adoration of the Shepherds* (in the Louvre), went to Hanover where he designed tapestries and painted miniature portraits, including a signed *Duke of Brunswick-Lüneburg* (Amsterdam, Rijks Museum), and was excluded from the Academy as a Protestant in 1681, after which he is said to have come to England and to have died in Jersey in 1696. But there seem to be records also of another Jean Michelin (1616–1670) and it may be he, and not the other, was the Le Nain pasticheur who painted the New York picture.

8 GEORGES (DUMESNIL) DE LA TOUR

BORN LUNÉVILLE BEFORE 1600 DIED LUNÉVILLE 1652

Characteristic Pictures

Paris	Louvre	Adoration of the Shepherds
Paris	Louvre	Denial of St. Peter
Paris	Louvre	S. Jerome
Paris	Louvre	The Magdalene with a skull (by rushlight)
Nantes	Museum	The Angel appearing to S. Joseph (signed Gs. de la Tour)
Nantes	Museum	S. Peter and the Serving Woman (signed G. de la Tour 1650)
Rennes	Museum	Mother and Child
Epinal	Vosges Museum	A young woman visiting a prisoner
Berlin	Kaiser-Friedrich Museum	St. Sebastian mourned by women [N1]
Paris	Private Collection	The card-sharper (signed)
Detroit	Institute of Arts	Little girl with a candle

This able artist had a great sense of drama. Two of his three known signed pictures are illumined by candlelight. The third, *The Cardsharper*, is a daylight piece.

In addition to the signed works, pictures now ascribed to him include in the first place the striking torchlight picture *St. Sebastian mourned by women* (Pl. 26), the Louvre candlelight *Adoration of the Shepherds* and other candlelight pictures in Epinal and Rennes. Among daylight pictures now ascribed to him by those anxious to build up his œuvre, the most important are two versions of *S. Jerome penitent* (Grenoble Museum and Bjoerk Collection,

Sweden), both ascribed by others to the Spaniard Mayno ; and the famous *Joueur de Vielle* (*Blind beggar with an instrument*) in Nantes which is ascribed by others to Zurbaran, Murillo, Velazquez and Rizzi.

Of the two signed pictures at Nantes *The Angel appearing to S. Joseph* is catalogued as *An old man asleep and wakened by a young girl* ; the girl or angel is in the foreground with her back to the spectator and the light which strikes on the profile face is shielded from view by her upraised arm. The *S. Peter and the serving woman* (catalogued as *The denial of S. Peter*) shows five soldiers playing dice grouped round a table with an invisible candle ; the servant holding a second candle, shielded by her hand, questions S. Peter. Both pictures are very red and disagreeable in colour. But the Berlin *St. Sebastian mourned by women* (Pl. 26) is outstanding in design and feeling ; and the same applies to the *Mother and Child* at Rennes.

The painter's real name was Georges de la Tour (as he signed his pictures) ; his son Etienne became Dumesnil de la Tour ; there is no evidence that his father was entitled to this name or used it ; but he is usually so referred to for convenience to distinguish him from the eighteenth-century pastellist.

It is clear that Georges de la Tour was acquainted with the works of the school of painters known in Italy as the *Tenebrosi*. The art of these painters was based in the first place on Raphael's night scene, *The Liberation of St. Peter*, in the Vatican, and in the second on the spotlight effects in certain pictures by Caravaggio ; and it was brought to the north by the Dutch painter, Gerard Honthorst, who went to Rome about 1610 and remained there till 1622, and was known as Gerardo della Notte (Gerard of the Night) because he painted candlelight pictures.

The resemblance of La Tour's works to certain pictures by Honthorst is very evident. But we can only guess at the relation between the two artists because we know next to nothing of La Tour's life.

The records only tell us that he was born in Lunéville where he died in 1652 ; that he was painter to the town of Lunéville in 1634 ; that he received commissions from Louis XIII, from the Governor of Nancy, and from Duke Charles IV of Lorraine ; and that he painted in 1644 a *Nativity* (perhaps the Louvre *Adoration*), in 1648 a *Saint Alexis*, in 1649 a *Saint Sebastian*, and at other times a *Denial of St. Peter* and other pictures of St. Sebastian.

He thus clearly had influential patrons one of whom may have

provided the money for a journey to Rome. If we put this pre-
sumed journey between 1615 and 1622 he might have met
Honthorst himself. Alternatively he may have visited Holland
and become acquainted with the works of Honthorst or his
followers in that way.

9 PORTRAIT PAINTERS

The most appreciated portrait painters of this period were the
cousins Henri de Beaubrun (1603-1677) and Charles de Beaubrun
(1604-1692), Philippe de Champaigne (1602-1674), Claude Lefebre
(1632-1675), and Robert Nanteuil (1625-1678).

The reputation of the de Beaubruns was immensely high all
through the century. In the early part of their career they painted
Louis XIV at the age of eight days, and Anne of Austria some
months before he was born—a commission from the English
Ambassador to celebrate the Queen's pregnancy which, after
many years of despair, was regarded as a miracle obtained by
special prayers (whence the painting of this picture and whence
also the first title of Louis XIV : *Dieudonné*). Most of the French
artists of the period came from the middle and artisan classes ;
but the de Beaubruns could boast a family tree, and they were
persons of polite and charming manners ; they flattered their
sitters, and their portraits appealed especially to Court ladies. Till
Henri died they seem to have worked in collaboration—one
presumably painting the faces and the other the draperies. In
their Court commissions they were evidently embarrassed by the
casual conduct of the ladies who neglected to keep appointments,
for a letter survives in which they complain to Colbert that unless
the King will be good enough to speak a word to certain ladies
to induce them to take the sittings more seriously they will not
be able to complete their work.

Most of the portraits by the de Beaubruns have now dis-
appeared or are labelled " French Seventeenth-Century School,"
but their manner can be studied in the Prado in Madrid, and in
two portraits in the Musée Condé at Chantilly, one of which
shows the celebrated *Duchesse de Longueville* whose beauty moved
her admirers to the most lyrical descriptions even after the small-
pox had played havoc with her *teint de perle*.

Philippe de Champaigne was born in Brussels, but as he worked
almost exclusively in France he is usually included in the French
School. He arrived in Paris at the age of nineteen and obtained
employment on the decorations of the Luxembourg Palace ; and

his work there appealed to Marie de Medicis who eventually attached him to her establishment which made him independent of the Parisian *maîtrise*. He continued to paint compositions and religious subjects all his life. But his real eminence was in portraits. As a portrait painter he introduced a realistic manner and impressed his contemporaries by the " lifelike " quality of the resemblance. He " modelled," as painters say, with vigour and completeness, more especially in his later years. He was admired above all other portrait painters by Richelieu, and he painted the famous full-length portrait of the Cardinal, now in the Louvre, and also the extremely interesting full-face and profile head studies now in the National Gallery in London. The head studies were painted for a Roman sculptor who made a bust from them, and they constitute a most valuable record of the Cardinal's real appearance. Two imposing groups, by de Champaigne, are now in the Louvre. The first represents the architects *François Mansart and Claude Perrault*, the second *La Mère Catherine-Agnès Arnaud et la Sœur Catherine de Sainte-Suzanne* (Pl. 22).

The picture of the nuns was painted in the convent of Port Royal in 1622 when the artist had to a large extent withdrawn from the official world and was frequenting the Jansenists by whom the institution had been founded. The younger nun on the *chaise longue* was the artist's daughter who had been attacked by fever and paralysis and given up by the doctors, when, as we read in the inscription, she was miraculously cured by the prayers of Mother Catherine-Agnès in a nine days' retreat.

Claude Lefebre was a pupil of Le Sueur and Le Brun. He was another favourite portrait painter of the Court where his sitters included the King and Queen and Colbert. He also painted the musician François Couperin (now at Versailles). The Louvre has his excellent *Portraits d'un précepteur et son élève*. From his style he may be presumed to have studied portraits by Van Dyck ; and there is an old tradition that he visited England.

Robert Nanteuil worked mainly as an engraver and pastellist. Louis XIV, Anne of Austria, Mazarin and Colbert sat to him. The Musée Carnavalet in Paris has his portrait of Mme de Sévigné.

10 FRENCH ARTISTS IN ROME

In all this artistic activity the two greatest French painters of the period took scarcely any part. Claude Lorrain and Nicolas Poussin both lived almost entirely in Rome. Claude was there

from 1627 till his death in 1682. Poussin was there from 1624
to 1640 and from 1643 till his death in 1665.

Rome at this time had large colonies of artists from Germany,
Flanders, Holland and France. The artists went there for the
most part in their youth at the expense of a patron to whom they
sent back specimens of their studies and for whom they made
copies of Old Masters and often collected *objets d'art*; others
worked their way to Italy by painting at various places on the
journey or rendering services to fellow travellers with means, for
such journeys were always made in groups of people who
travelled together for mutual protection. This method of travel
had obvious advantages for a young artist over the express-train
travelling or even the car-travelling of to-day; for it was
accomplished in short stages, the artists could survey the country
through which they travelled and form an acquaintance with
monuments in the towns and cities on the route. The journey
was in fact an education for an artist in itself.

Arrived in Rome the artists found themselves in an atmosphere
where they could not only study contemporary Italian painting
and have contact with the contemporary artistic thought of the
Italian and foreign intelligentsia, but where they were also able
to study the achievements of the Renaissance and the remains of
antiquity. In the Rome which these artists knew fragments of
ancient architecture abounded, sometimes upright, sometimes
lying on the ground. Claude and the Roman-ruin painters who
followed him did not invent the fallen pillars and deserted temples
that figure in their pictures, they actually saw them. Claude's
View of the Campo Vaccino, for example, is based on the Forum
as it appeared in his day when it was used as a cattle-market.

The seventeenth-century concepts of antique art were different
from our own. The artist in Rome in this period knew little of
and cared little for Greek art. The Parthenon and its sculptures
were unknown and the average seventeenth-century artist even if
acquainted with fifth-century and archaic Greek sculpture paid no
heed to them. The most admired statues in the Vatican collection
were the *Apollo Belvedere*, the *Laocoön*, and the *Farnese Hercules*.[N1]
Poussin, who penetrated more deeply into the antique spirit,
achieved a comprehension that was personal and unique.

After a few years in Rome the artists generally returned to
their own countries where, if they had been financed by patrons,
they were introduced by them to the fashionable world. Occa-
sionally they were able by their own paintings to attract the

attention of Italian dilettanti and make money and a local reputation in Rome; and more occasionally still they had so much success in Rome that they were able to establish themselves as permanent residents in the city—as happened in the case both of Claude and of Poussin.

In Paris in the first half of the century the majority of artists were still regarded as *fournisseurs* of decorative and ecclesiastical pictures who were expected to submit their designs to their employers and work in accordance with their employers' taste. In Rome both Claude and Poussin worked in complete independence; after a period of struggle they both succeeded in acquiring the liberty to paint what they pleased, to take their own time about their work, and to obey the dictates of their own æsthetic ideals. Many of their pictures were commissions; but their patrons left them a free hand. Paris could thus offer nothing that could tempt Claude and Poussin to abandon their independence, which marked the beginning of the modern concept of the artist's position; and when Poussin came into contact with the old Parisian attitude he soon desired nothing so much as to return to Rome—and this though Louis XIII and Richelieu were overwhelmingly gracious and placed at his disposal a comfortably furnished house where he found on his arrival a stock of fuel and a cask of excellent old wine.

II CLAUDE LE LORRAIN

BORN CHAMAGNE (VOSGES) 1600 DIED ROME 1682

Characteristic Pictures

London	National Gallery	Seaport at sunset
London	National Gallery	Landscape : Cephalus and Procris
London	National Gallery	Seaport. The Queen of Sheba
London	National Gallery	Seaport. St. Ursula
London	National Gallery	Echo and Narcissus
London	National Gallery	Aeneas at Delos
London	National Gallery	Landscape : Isaac and Rebecca (The Mill)
London	National Gallery	Landscape : David at the cave of Adullam
Philadelphia	J. G. Johnson Collection	Sunset on the bay
Boston	Museum of Fine Arts	Parnassus
Paris	Louvre	La fête villageoise
Paris	Louvre	View of the Campo Vaccino in Rome
Paris	Louvre	Seaport with sunset
Paris	Louvre	Seaport. The landing of Cleopatra
Grenoble	Museum	Italian landscape

Brussels	Museum	Landscape : Aeneas hunting
Berlin	Kaiser-Friedrich Museum	Landscape : Mercury and Argus
Munich	Alte Pinakothek	Landscape with cattle
Munich	Alte Pinakothek	The expulsion of Hagar
Munich	Alte Pinakothek	Hagar and Ismael in the desert
Munich	Alte Pinakothek	Seaport
Dresden	Museum	Landscape : Acis and Galatea
Dresden	Museum	Landscape : The flight into Egypt
Rome	Doria Gallery	Landscape : The mill (The wedding of Isaac and Rebecca)
Madrid	Prado	Port of Ostia : St. Paula departing for the Holy Land
Madrid	Prado	Roman ruins : The burial of St. Sabina
Madrid	Prado	Landscape : The finding of Moses
Madrid	Prado	Landscape : Tobias removing the liver of the fish
Madrid	Prado	Landscape : Peasants and cattle crossing a stream
Leningrad	Hermitage	Morning. Eliezer and Rebecca (?)
Leningrad	Hermitage	Midday. The rest on the flight
Leningrad	Hermitage	Evening. Tobias removing the liver of the fish

Claude Gellée, known as Claude le Lorrain or Claude Lorrain, was the son of obscure parents who both seem to have died before he was twelve. At that age he went to live with an elder brother at Freiburg-in-Breisgau who taught him engraving. At fifteen he attached himself to another relation, a dealer in lace, who was travelling to Italy. In Rome and Naples he obtained various employments—including, according to a contemporary biographer, employment as a pastry-cook—and he worked in the studios of a Cologne painter, Gottfried Wols or Walls, who taught him architectural perspective, and of Agostino Tassi (1565-1644).

He left Tassi's studio in 1625 and visited Venice. From there he worked his way through the Tyrol to Bavaria and finally back to his native town. Shortly afterwards we find him at Marseilles where he met the painter Charles Errard who was travelling with his father to Rome. Claude arranged to accompany them. He reached Rome again in 1627 and remained there, as noted, till he died.

In Rome he was an obscure figure of the foreign colony for some years. But gradually his work began to attract attention and he obtained some local commissions for decorations ; at the same time he painted easel pictures of seaports and views of

Rome. About 1630 his *Sea Port with a rising Sun* and *View of the Campo Vaccino* (both now in the Louvre) were bought by M. de Béthune, the French Ambassador. A few years later another patron appeared in the person of Cardinal Bentivoglio who launched him among the Roman dilettanti and introduced him to Pope Urban VIII who ordered four pictures. From about 1640 onwards he had continuous success. From the age of forty-five he sold everything he painted to eminent collectors all over Europe. In one year nineteen of his pictures were acquired by collectors in England alone. He worked till his death at the age of eighty-two. He never married. He left a proportion of his property to a little girl aged eleven whom he had adopted as his daughter.

Claude's *œuvre*, as we know it, consists of numerous pictures in museums and private collections, of hundreds of drawings (of which the British Museum has a great collection), and of the *Liber Veritatis*, a series of two hundred drawings, kept as records of his paintings, which belongs to the Duke of Devonshire.

The pictures fall into three types: (*a*) classical-picturesque presentations of seaports with figures; (*b*) classical-picturesque views of Rome with genre or other figures, influenced by Bamboche; (*c*) classical-picturesque landscapes with biblical, mythological, or pastoral episodes indicated by the figures.

I apply the word picturesque to Claude's paintings because the English word was invented in the eighteenth century to describe effects in nature which recalled the composition of his pictures, or the type of building which appears in them. In 1801 the celebrated art critic, Payne Knight, recommended the buildings in Claude's pictures to gentlemen desirous of building " picturesque " country homes; twenty-five years later in a book entitled *Landscape Architecture*, one Thomas Laing Meason engraved a series of such buildings for the gentlemen to choose from. I have added the word " classical " before the word " picturesque " to indicate the architectural character of Claude's compositions and to distinguish them from the pictures by Crome and Constable which later in the century caused English writers to describe thatched cottages and spreading chestnut trees as " picturesque." Claude's classical-picturesque style must be distinguished not only from the romantic-picturesque style of the " old English " painters, but also from the new Cubist-picturesque style which has appeared in our own day.

Most of, if indeed not all, Claude's seaports and views of Rome

were painted before 1650; and in connection with the seaports
we must remember that Agostino Tassi, with whom Claude
worked for nine years, had a reputation as a painter of ports and
shipping, and that he was himself a pupil of Paul Bril, the Flemish
landscape painter who painted a *Seaport* in the Uffizi (which is
founded on the port in Carpaccio's *Departure of St. Ursula* in
Venice). Paul Bril's *Seaport* in the Uffizi is reproduced as Pl. 58
in my *Dutch Painting*. In that book also I have discussed the
relation of Claude's seaport *The Embarkation of the Queen of Sheba*
(in the London National Gallery) to *Dido building Carthage*, painted
by Turner as an attempt to surpass it. *The Port of Ostia : St. Paula
departing for the Holy Land* (Pl. 33), painted with three others for
Philip IV of Spain in 1648, is a good example of Claude's work
in this field.

But though Claude did not invent the seaport and Roman-ruin
types of picture he perfected them and inspired numerous painters
all through the seventeenth and eighteenth centuries, notably
Panini in Italy and Hubert Robert in France.

His landscapes with small figures have had an even greater
influence on painting. They were the basis of the art of the Dutch
picturesque painters—both Pynacker and Berchem in the seven-
teenth century, and of that of Richard Wilson in England in the
eighteenth; in France they were known to Watteau and
Fragonard and to the landscape painters of the eighteenth century;
and after a period of neglect in the nineteenth century they have
again become a source of inspiration to artists of the present
day.[1]

The Dresden *Flight into Egypt* (Pl. II) is typical of these land-
scapes. Here we observe first magnificent woods on the left and
a river on the right; then in the foreground a girl in classical
drapery kneeling to fill her pitcher while a youth, similarly garbed,
plays a pipe to a shepherdess; then we note a herd of cattle
moving round this group to drink at a pool in the foreground;
and finally passing through the trees of the wood on the left we
see the Holy Family, with the Virgin mounted on the donkey,
pursuing their journey after resting by the stream. The sacred
episode which gives the title to this picture is thus but incidental
to the composition as a whole. This is a characteristic of Claude's
paintings; he was always mainly concerned with the construction
of an architectural picture in which the figures were regarded as

[1] But it must not be forgotten that the Flemish landscape painters at the turn
of the sixteenth to the seventeenth century were Claude's antecedents.

PLATE II

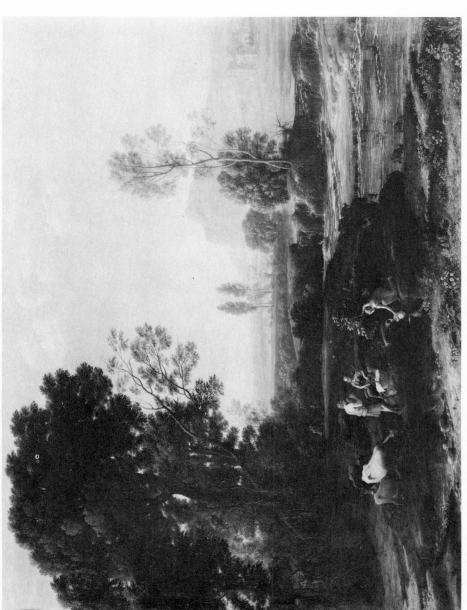

CLAUDE LE LORRAIN (1600-1682)
Landscape: The Flight into Egypt

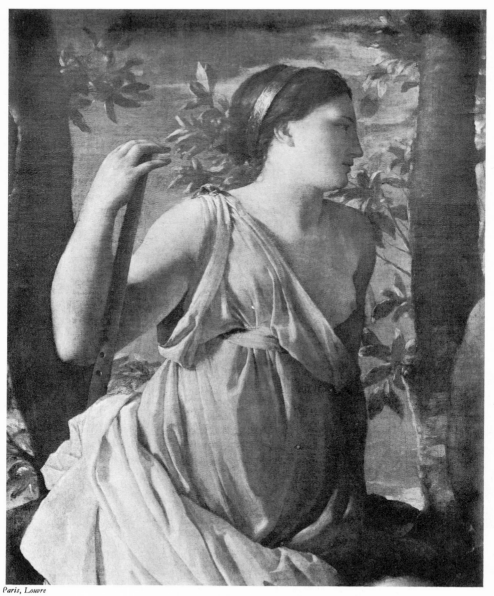

28. NICOLAS POUSSIN: Inspiration of the Poet (Detail)

details ; and he adopted the same procedure whether the episodes indicated by the figures were biblical, mythological or pastoral.

Claude employed assistants to paint the figures in many of his pictures. The figures in *The Port of Ostia : Departure of St. Paula* (Pl. 33) are attributed to Jacques Courtois. In the case of pictures which have been properly looked after the figures fuse perfectly with the surrounding landscape to which Claude doubtless " tied " them with final glazes himself. But in Claude's pictures in the Louvre, which have been shockingly neglected and stand in vital need of conditioning, the binding glazes seem to have perished and the figures " jump " forward from their surroundings.

We find genre touches in some of Claude's pictures. There is a laundry basket, for example, by the side of the shepherdess in the Dresden *Flight into Egypt* (Pl. II) ; in a landscape in the Prado, a shepherdess wading with cattle through a stream holds her petticoats above her knees in true peasant fashion ; in the *Rest on the Flight* in the Leningrad Hermitage the Virgin has by her side an ordinary *fiasco* of water or wine. Such genre passages may well be touches put in by Claude's assistants. But on the other hand Claude himself may be responsible, since his drawings prove him susceptible to many kinds of impression. Genre details are not found in the works of Poussin till the landscapes of the last period, such as the *Orpheus and Eurydice* and the Four Seasons.

" Claude," said Ruskin, " set the sun in heaven and was, I suppose, the first who attempted anything like the realisation of actual sunshine in misty air." This is almost the only word of appreciation which we can find among the fierce onslaughts on Claude's infidelities to nature which Ruskin inserted into *Modern Painters* and subsequent works. But Ruskin, in fact, missed the point of the light effects in Claude's pictures. For Claude's sun never shines from the vault of heaven but always radiates towards the spectator from a flat backcloth, and this backcloth serves to indicate one of the four delimitations of imagined space symbolised by the picture.

Claude had the classical concept of space. He reacted not so much to individual specific forms as to the formal relations of phenomena. This we observe clearly in many of his drawings which reveal a man who drew not in order to record individual boughs of trees or individual mounds of earth or rocks (though he occasionally did this also), but in order to arrive at greater comprehension of the formal movement of one bough in relation

to another and of one mound or rock to another. In his drawings he forestalled the modern Cubist-Classical Renaissance.

We know a good deal about Claude's methods of work from his friend the German artist, Joachim Sandrart, who accompanied him on sketching expeditions in the Campagna in the early years. Claude drew from nature in pen and wash ; he also made colour notes ; and he spent long hours in contemplation. But all his pictures were painted in his studio.

12 NICOLAS POUSSIN

BORN VILLERS, LES ANDELYS 1594 DIED ROME 1665

Characteristic Pictures

London	National Gallery	Cephalus and Aurora
London	National Gallery	Bacchanalian festival
London	National Gallery	Bacchanalian dance
London	National Gallery	Landscape with figures (Phocion)
London	National Gallery	The Golden Calf
London	National Gallery	Annunciation
London	Wallace Collection	Allegory of human life (The dance to the music of time)
London	Devonshire House	The shepherds in Arcady [N1]
London	Bridgewater House (Lord Ellesmere Collection)	The Seven Sacraments (Seven pictures) [N2]
Richmond	Cook Collection	Rape of the Sabines [N3]
Belvoir Castle	Duke of Rutland Collection	The Seven Sacraments (Seven pictures) [N4]
Knowsley Hall	Lord Derby Collection	The finding of Phocion
Dulwich	Gallery	The triumph of David
Dulwich	Gallery	The inspiration of Anacreon
Dulwich	Gallery	The nurture of Jupiter
Liverpool	Walker Art Gallery	Arcadian landscape [N5]
Dublin	National Gallery	Pietà
New York	Metropolitan Museum. Havemeyer Collection	Orpheus and Eurydice [N6]
Philadelphia	J. G. Johnson Collection	The baptism of Christ
Minneapolis	Institute of Arts	Moses defending the daughters of Jethro
Paris	Louvre	Forty-one pictures
Chantilly	Musée Condé	The Massacre of the Innocents
Chantilly	Musée Condé	The youth of Bacchus
Chantilly	Musée Condé	The Annunciation
Chantilly	Musée Condé	Landscape with two nymphs

Berlin	Kaiser-Friedrich Museum	Landscape with St. Matthew and angel
Munich	Alte Pinakothek	Midas before Bacchus
Schleissheim	Castle Museum	Apollo and Daphne
Vienna	Liechtenstein Gallery	The flight into Egypt
Madrid	Prado	David crowned by Victory
Madrid	Prado	Landscape with sarcophagus
Leningrad	Hermitage	Landscape with Polyphemus
Leningrad	Hermitage	Landscape with Hercules and Cacus [N1]
Leningrad	Hermitage	The triumph of Galathea
Stockholm	Museum	Bacchus and Erigone

Nicolas Poussin is now regarded by the French as one of the greatest of their artists and French critics rank him among the greatest artists of the world. The Louvre possesses forty-one of his pictures of all periods painted at different times of his life ; but nearly all these pictures are so obscured with dirt and discoloured varnish that we can only guess at their original appearance. To discover the range of Poussin's achievements it is therefore essential to supplement a study of the Louvre pictures by a study of others in galleries where the pictures have been properly cleaned and conditioned ; and this fortunately can be done since, outside the Louvre, there are at least a hundred in private collections and museums—though even in galleries where the pictures are properly looked after many now give us but a faint idea of their first appearance because he often used an Indian red ground and this in many cases has darkened the colours or completely worked through them.

From his biographers we have images of Poussin as an old man living peacefully in his house on Monte Pincio in Rome. We are told of his regular habits, his quiet labours, his morning and evening walks surrounded by pupils and admirers to whom he discoursed of art and life. But Poussin was not always old ; and we have but to look at his Louvre *Self Portrait* (Pl. 31) to realise that he was a man who knew no peace.

Poussin was fifty-six and at the height of his career when he painted this *Self Portrait*. It portrays an artist engaged on a gigantic intellectual task ; an artist who was consciously striving to create a microcosm of the universe itself.

Compare this *Self Portrait* with the self portrait painted by Poussin's greatest contemporary at almost the same age—or to be accurate when he was fifty-seven. In the picture known as *Rembrandt as an Old Man*, in the London National Gallery, we see

an artist who, with humorous pessimism, has accepted himself as a grubby prematurely decayed old drunkard ; an artist content to be a sensual intuitive muddling man. In Poussin's portrait we see a man who, with exalted unhumorous optimism, has tried to be more than mortal and to capture eternal secrets by the sheer force of his own mind. Under Poussin's picture we might set the title : " Portrait of a rationalist " and the legend :

> Sure, he that made us with such large discourse
> Looking before and after, gave us not
> That capability, that god-like reason
> To fust in us unused.

The facts of Poussin's career can be very briefly stated. He was born in a village in Normandy of humble uneducated parents. He was apprenticed to a local artist and later worked under various minor artists in Paris. After seeing drawings by Raphael and engravings from his pictures and those of other Italian masters he determined in spite of his poverty to make the journey to Rome. In a first attempt at the age of twenty-six he got as far as Florence. In a second some years later he only reached Lyons. At last in 1624 at the age of thirty he arrived in Rome where after a period of hardship culminating in illness he produced the earliest of his pictures that survive. In 1630 he married the daughter of a French *chef* and with her dowry he was able to buy the famous house on Monte Pincio. After this solution of the most pressing material problems he continued his work and began to build up his reputation in Italy. In 1640, in response to repeated official invitations, he returned to Paris. There he worked for Louis XIII and Richelieu and was put in charge of the decoration of the Long Gallery of the Louvre. But he found himself most ill at ease in the atmosphere of French official art ; and two years later he went back to Rome and worked there for the remaining twenty-three years of his life.

Poussin's work falls into four categories : (*a*) pagan and my-thological subjects including Bacchanals, (*b*) religious subjects, (*c*) history-pictures, (*d*) architectural pictures, including landscapes with incidental figures.

(*a*) All Poussin's pagan and mythological pictures (except one, his very last picture) and all his Bacchanals were probably painted before he was forty-five. They are the product of his sensibility and mind before he became the pedant of the historical composi-tions and the great architectural artist of his most significant and

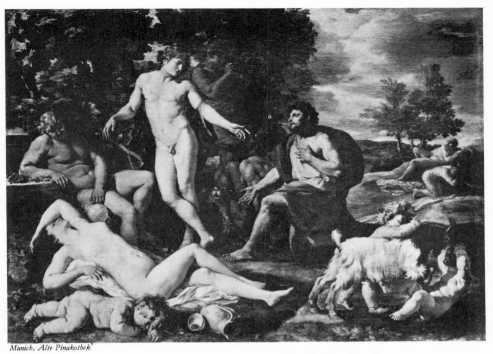

29a. NICOLAS POUSSIN: Midas before Bacchus

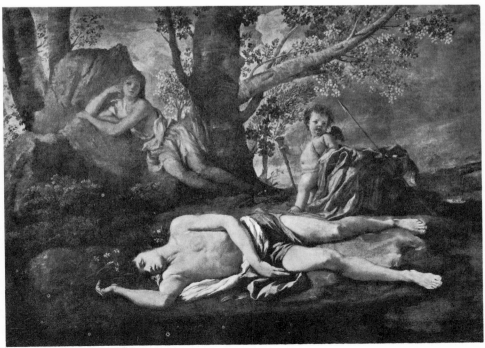

29b. NICOLAS POUSSIN: Echo and Narcissus

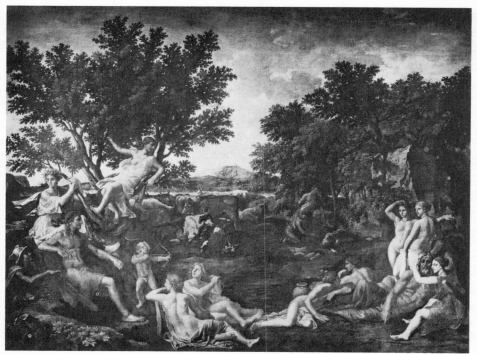

30a. NICOLAS POUSSIN: Apollo and Daphne

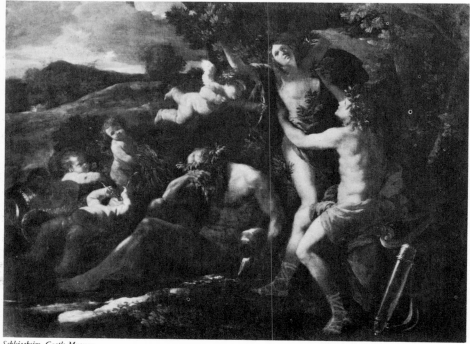

30b. NICOLAS POUSSIN: Apollo and Daphne

personal works ; and to the superficial observer they are the most attractive of all his pictures.

I reproduce five pictures in this Category : *Bacchus and Erigone* (Pl. 27b), the Louvre *Echo and Narcissus* (Pl. 29b), the Schleissheim *Apollo and Daphne* (Pl. 30b), the Munich *Midas before Bacchus* (Pl. 29a) and the Louvre *Apollo and Daphne* (Pl. 30a). The first, now in the Stockholm Museum, is one of Poussin's earliest pictures and it demonstrates that from the outset he was profoundly attracted by antique sculpture. The lovely *Echo and Narcissus* dates, with the Dulwich *Nurture of Jupiter* and *Inspiration of Anacreon*, from this same period (1624-26) when the artist, newly arrived in Rome, was studying the Italian masters, notably the Carracci and Domenichino (whose studio he frequented), and Titian, for whom he was beginning to acquire a burning admiration which led him in 1629 to copy the *Ariadne in Naxos*, and probably other pictures in the same series, then in Cardinal Ludovisi's Palace in Rome. Titian painted this series for the Duke of Ferrara ; it consisted of the *Bacchus and Ariadne* in the London National Gallery, the *Feast of the Gods* (begun by Bellini and finished by Titian), now in the Washington National Gallery of Art, the *Ariadne in Naxos*, sometimes called a *Bacchanal*, and the *Worship of Venus*, now in the Prado, Madrid ; Cardinal Ludovisi presented the *Ariadne in Naxos* and the *Worship of Venus* to Philip IV ; Poussin's copy of the *Ariadne in Naxos* is now in the National Gallery of Scotland in Edinburgh.

To Titian's influence we must attribute the series of Bacchanals (in the Louvre, London National Gallery and elsewhere) which Poussin painted in the next few years. The influence is also clearly seen in the Schleissheim *Apollo and Daphne* (Pl. 30b). But Poussin's personality nevertheless is felt all over the Schleissheim picture ; for here we perceive for the first time his desire to create an art of a microcosmic character, his desire to make his picture a symbolic equivalent of some aspect of life as a whole. In this picture all the ages of man are symbolised ; it shows us childhood, maturity and old age ; and maturity, as in all Poussin's works, is symbolised by man and woman at the age of love. At the same time we observe the artist's preoccupation with antique sculpture in the figure of the old man that personifies the river—a figure that occurs again and again in Poussin's works.

The same microcosmic aim, this time with the addition of contrasts of character, is seen in the Munich *Midas before Bacchus* (Pl. 29a). Antique sculpture has here been drawn upon for

Bacchus ; but the recumbent figure is derived from Titian's *Ariadne in Naxos*, and other echoes of the figure in Titian's *Ariadne in Naxos* occur in the *Sleeping Venus* (Dresden), *Venus and Satyrs* (London National Gallery) and the *Bacchanal* in the Louvre, all painted at this time. Poussin's other pictures of this period influenced by Titian include the *Youth of Bacchus* (Chantilly), various pictures of Cupids (based on Titian's *Worship of Venus*), the Leningrad *Tancred and Hermione* and *Rinaldo and Armida*, the Louvre *Triumph of Flora*, Lord Carlisle's *Triumph of Bacchus*, the Madrid *David crowned by Victory*, and the London National Gallery *Cephalus and Aurora*.

Poussin's pagan pictures are sensual. But we must distinguish between Poussin's sensuality at this time and the sensuality of Titian. In Titian's pagan pictures we meet a care-free sensuality freely and openly expressed in the most richly sensuous language that the art of painting has ever yet achieved. In Poussin's pagan pictures we have an inhibited sensuality which comes to us distilled through a mind that knows it for what it is ; and this distillation is set down in a language of almost scientific accuracy and restraint. For this reason some of Poussin's pagan pictures have an insidious, because disguised, erotic character that we never find in pictures by Titian.

The distilled erotic quality in these pagan pictures by Poussin must also be ascribed to some extent to his study of antique sculpture. Poussin was perfectly conscious of the distilled animalism in Greek and the distilled lust in Roman sculpture and he accepted both. But at the same time he looked to paganism to contribute to the microcosmic art he was seeking to create.

Poussin's pagan pictures differ in fact from other pictures of pagan subjects in the Christian world. The Venetian painters of these subjects were hedonists, and their pictures were contributions to the enjoyment of the Renaissance concept of life. Mantegna and Botticelli were humanists, and their pictures were contributions to the enjoyment of the Renaissance concept of literature. The painters of the School of Fontainebleau were decorators, and their pictures were contributions to royal grandeur. But Poussin was a pictorial architect and a philosopher. He asked paganism to reveal not only its obvious remains but the secrets of formal harmony and rhythm which Poussin believed its artists had captured ; he asked paganism to provide him with material for the architectural picture.

Reynolds said that Poussin's mind was " naturalised in anti-

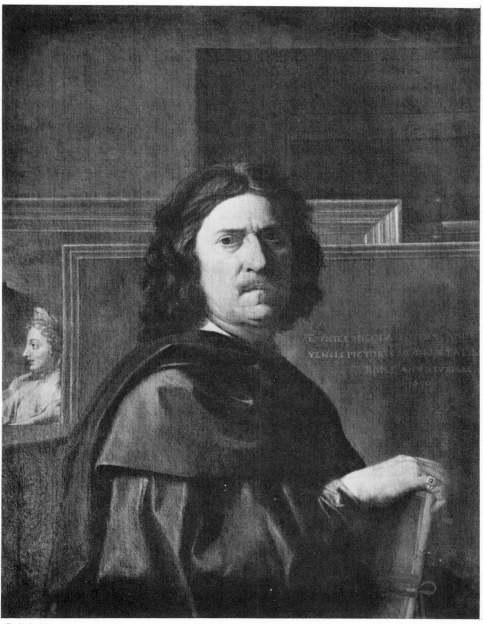

31. NICOLAS POUSSIN : Self portrait

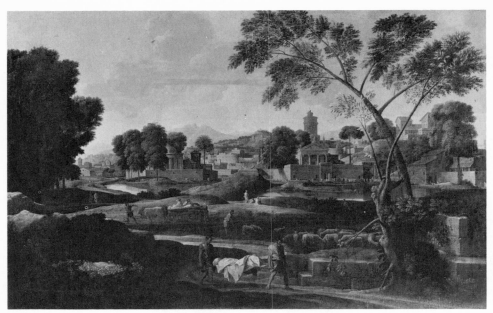

32a. NICOLAS POUSSIN: Funeral of Phocion

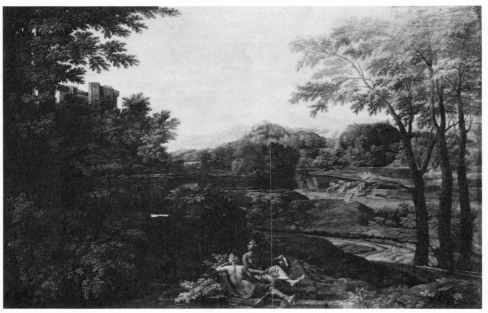

32b. NICOLAS POUSSIN: Landscape with Nymphs

quity." He was right. But the antique world into which Poussin penetrated was not the real pagan world but an ideal pagan world of his imagination—a world of austere perfection which was quite different from the ideal pagan world imagined by the hedonists and decorators who thought of the antique world as a place more agreeable to live in than the world they knew.

The climax of Poussin's pagan pictures is the Louvre *Apollo and Daphne* (Pl. 30a), his very last work painted after he had abandoned these subjects for just on twenty-five years. From what can be seen of this picture, through the especially thick layers of filth which at present obscure it, we can realise that Poussin here assembled as it were the whole cast of players in his pagan pictures and set them in a landscape where in the middle distance we see a herd of cows. The microcosm which he had been seeking was thus enriched at the last moment by new material. Poussin was paralysed in hand and legs when he put the last touches to this painting which epitomises, though it may not achieve, the lofty ideal which he had been seeking all his life.

(*b*) Poussin's pictures of religious subjects fall into three types —ecclesiastical, historical and architectural. The pictures of the first type were painted in the ecclesiastical-decorative manner of Vouet and the other French eclectic painters of the time. The *Flight into Egypt* in Vienna is a good example. The pictures of the second and third types belong, properly speaking, to his historical and architectural styles.

(*c*) Poussin's historical pictures were the foundation of the whole school of *peinture d'histoire*, or as the English writers of the eighteenth century called it " history-painting," which was so much discussed and so highly esteemed from the second half of the seventeenth till the middle of the nineteenth century when the Impressionist movement threw it completely overboard.

The history-picture was a reconstruction of some dramatic episode of the past ; it was the concoction of a *tableau vivant* on canvas, the crystallisation as it were of a moment in a play. At the same time—and here it differed from the true tradition of Christian religious narrative art—it was expected to be a demonstration of the painter's technical powers. In history-painting moreover the illustrative-dramatic content was expected to take precedence over all others.

In his history-pictures Poussin sometimes selected biblical subjects and sometimes episodes from the history of ancient Rome ; the two famous series of the *Seven Sacraments* which now

belong respectively to the Duke of Rutland and Lord Ellesmere [N1] are examples of the one type, the two versions of the *Rape of the* [N2] *Sabines*, one in the Louvre and the other in Sir Francis Cook's [N3] collection at Richmond (Pl. 35b), are examples of the other.

The first category of Poussin's history-pictures also includes the *Massacre of the Innocents* (Chantilly), the Dulwich *Triumph of David*, the Louvre *Plague in Ashdod, Moses and Aaron's Rod, Woman Taken in Adultery, Israelites collecting Manna*, and *Judgement of Solomon*, and the Leningrad *Esther before Ahasuerus*; the second also includes the Louvre *Saving of Pyrrhus, Camillus and the Schoolmaster* and *Death of Saphira* and the Leningrad *Continence of Scipio*.

Reynolds said that Poussin was a pedant and in another passage he refers to his work as " dry." These judgements are merited by these history-pictures in which Poussin was at pains to be accurate in archæological details and in which the dramatic content is without the sap of life. For just as in Poussin's pagan pictures we get distilled sensuality so in his history-pictures we get distilled drama. In Poussin's pictures of slaughter, plague and famine we look in vain for the fine frenzy of Tintoretto and Delacroix or the moving intuition of Rembrandt; in their stead we have scenes of passion and movement frozen to frightful immobility as by some instantaneous act of God.

But in these pictures, so tedious to modern eyes, Poussin, in fact, was again attempting to achieve a microcosm; he was aiming at the expression of the whole range of human passions and emotions by gesture and expression. He failed. But the attempt is not to be despised—and indeed among Poussin's history-pictures there are at least two in which he seems to me to have achieved the synthesis of human emotions at which he was aiming : the *Weeping over the Dead Christ*, in Dublin, and *The Last Supper*, at Bridgewater House.

In his own day Poussin's history-pictures were supremely highly rated. They were the real basis of the Academic concept of Great Art which was formulated into doctrine by the French Academy in its early years. Poussin had paid attention to archæological detail, therefore, said the Academicians, such detail was essential to Great Art ; Poussin had a box in which he disposed cardboard figures to establish the composition of his history-pictures, therefore the disposition of figures as on a stage must be accepted as a law ; each figure in Poussin's history-pictures makes a definite gesture and each face has its definite expression ; therefore, in Great Art, every figure must strike an attitude and make a grimace.

If Poussin had never painted any of his history-pictures the world might have been spared many thousands of miles of dreary Academic art.

(*d*) To the modern student it is Poussin's architectural pictures that make the deepest and most direct appeal. From these pictures the influence of Titian's paganism and the illustrative-dramatic ideal of the history-pictures are alike excluded. The central content of these works is their formal harmony and unity. They partake of the character of architecture and the character of music. There are no gestures here to indicate emotions, no facial expressions.

In some of these pictures in his architectural manner there are even no eyeballs within the eyes. The æsthetic gain of this omission is made manifest when we compare one of these pictures with an engraving made from it where the engraver has sought to improve it by putting in the eyeballs, thereby bringing the figures to life and killing the picture. A picture where the eyeballs are thus omitted is the celebrated *Eliezer and Rebecca* in the Louvre, which was later the subject of many discussions at the Academy *Conferences*. An Academician, who mistook this for one of Poussin's history-pictures, complained that he had omitted the ten camels which, we read in the Bible, Eliezer had brought with him and to which Rebecca herself supplied water; but Le Brun replied, from the same point of view, that the camels were properly omitted because the subject of the picture was an offer of marriage and as such it depicted " *une entrevue galante et polie* " at which *bienséance* demanded that no camels should be present. The frieze-like composition of Poussin's picture is in fact based on the Hellenistic painting known as the *Aldobrandini Wedding* which he had copied twenty years before; and the stance of the famous figure of the girl by the well is derived from a figure in that work.

Poussin arrived at his final architectural pictures by successive stages and he was working towards them all his life. *The Golden Calf* (London : National Gallery) is at once the last of the Bacchanals and a stage in the architectural progress; the *Dance* in the Wallace Collection (otherwise called *An Allegory of Human Life*, or *Fame, Pleasure, Wealth and Poverty dancing to the Music of Time*), the Louvre *Inspiration of the Poet* (Pl. 28), *Shepherds of Arcady* and *Finding of Moses* are others.

The final achievement is heralded by a later *Finding of Moses*, also in the Louvre, where the figures are set in a landscape that stretches back to a remote horizon. For, in his last phase, Poussin tried to achieve a microcosm with the aid of landscape. His pictures of this phase are landscapes in which the figures are reduced to the small size that we find in the landscapes by Claude. But Poussin's architectural landscapes bear only a superficial resemblance to Claude's classical-picturesque art. Claude's landscapes *advance* by a few simple planes from the flat wall at the back of the picture which, as noted, radiates the light. Poussin's landscapes *recede* from the front of the picture by a great number of subtly modulated and related planes to an infinite distance, and the light is diffused all over the picture. I reproduce two examples of such architectural landscapes by Poussin, the Louvre *Funeral of Phocion* (Pl. 32a) and the Chantilly *Landscape with two Nymphs* (Pl. 32b), where the characteristics of the spatial organisation can be plainly seen.

The most important of Poussin's final architectural landscapes, apart from the two I reproduce, are the Louvre *Orpheus and Eurydice* and *Landscape with Diogenes*, the Leningrad *Landscape with Polyphemus* and *Landscape with Hercules and Cacus*, the Prado *Landscape with three men*, Lord Derby's *Finding of Phocion* and the London National Gallery *Landscape with figures (Phocion)*.

I must mention one other aspect of Poussin's achievements, one further attempt to achieve the microcosmic goal. The Louvre has four very celebrated pictures which he painted in the last years of his life for the Duc de Richelieu (whose son wagered and lost them to Louis XIV at tennis). These are called *Spring (The Earthly Paradise)*; *Summer (Ruth and Boaz)*; *Autumn (The Return from the Promised Land)*; and *Winter (The Deluge)*. In these pictures Poussin tried to combine history-painting with architectural landscape. The small figures here are not incidental as in Claude's pictures and Poussin's own landscapes, they have illustrative-dramatic significance and their gestures once again express the gamut of human emotions from the tranquil love of man and woman in the *Earthly Paradise* to the extremity of fear and horror in *The Deluge*. The architectural content of these pictures suffers from the illustrative-dramatic interest that pervades them ; but considered as history-pictures they rank as Poussin's most expressive works.

Hundreds of pictures were formerly ascribed to Poussin. These included works by his imitators and followers, copies by his pupils,

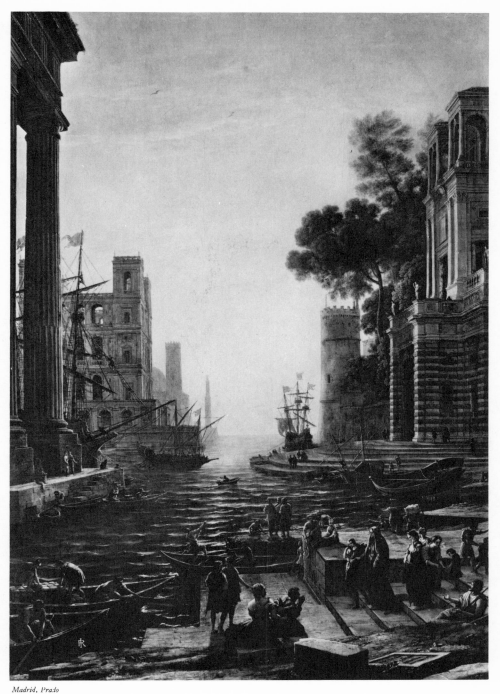

33. CLAUDE LE LORRAIN: The Port of Ostia: Departure of St. Paula

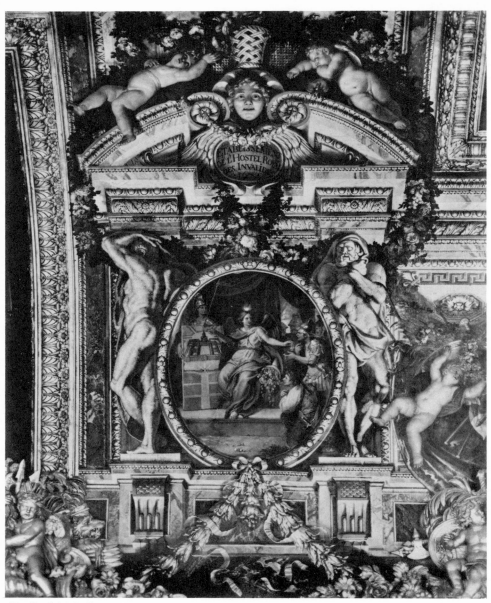

34.　CHARLES LE BRUN : Detail of Ceiling

copies by students at later dates, and forgeries. Gaspard Dughet, known as Gaspard Poussin, who was Poussin's brother-in-law, was the most important of his followers. Sebastien Bourdon, already referred to as also an imitator of Le Nain, was among his imitators.[1]

[1] For working purposes I have followed the chronology suggested by O. Grautoff in his book on Poussin (Munich, 1914). The student should however also consult W. Friedlander's article in the Thieme-Becker Dictionary.

Louis XIV was five years old when he became King in 1643. He was just under twenty-three when, in 1661, after Mazarin's death he undertook the government of France himself. He was forty-six when he married Mme de Maintenon after the death of the Queen. He was seventy-seven when he died in 1715.

His reign thus falls into three periods. The first, the period of his minority, was the Age of the Cardinals which produced the paintings just recorded. The second was the period of his young manhood from 1661-1684. The third was the period when he developed into the grim and imposing god-emperor worshipped with complicated ceremonial by a Court of ten thousand people at Versailles.

We tend to think of Louis XIV as the Pharaoh of the last period and to forget that he did not take up his residence at Versailles till 1682 when the really brilliant period of his reign was almost at an end. In all fields the dazzling period was from 1661-1684. The successful wars were over by 1678. Colbert, who reorganised France for the King's glory, died in 1683. From the age of twenty-three to the age of forty-six Louis XIV was the *Roi Soleil*. It was not till later that he became the terrible *Louis-le-Grand*.

As the *Roi Soleil* Louis XIV took his duties seriously and worked hard at the business of the State. But at the same time he was the centre of a splendid and not yet oppressively pompous Court. Though *Grand Amoureux*—(who has not read of his successive favourites, Mlle de la Vallière with her intriguing limp, Mme de Montespan, Mlle de Fontange ?)—he was neither debauched nor vicious ; *Grand Seigneur*, rejoicing in his eminence, he led the Court in a continuous series of brilliant entertainments ; devoted to music, dancing, the ballet, and the play, he was the patron of Molière and Lully, and he himself took part in masques and pageants for which he carefully rehearsed.

To the student of French painting the Court entertainments of the *Roi Soleil* are important because they were closely connected with the decorative taste of the time and because artists were employed both on the theatrical productions and on the fêtes and also in turn drew material from both. Theatrical performances have had indeed great influence on painting from the time of the

early Church performances to the Russian Ballet of our own day. The heavenly regions peopled by sacred figures on the top stage of the old ecclesiastical plays became the vault of heaven peopled with the same figures in the vaults of Jesuit-Baroque churches ; but meanwhile, in secular painting, the heavenly regions had become the abode of the gods and goddesses of antiquity and eventually Venus and Cupid replace the Virgin and Child as the normal denizens of the region above the clouds. In Louis XIV's theatrical performances the most elaborate scenic effects were produced by ingenious and complicated machinery ; the sun and the moon rose or set shedding golden or silver radiance ; and pagan gods and goddesses moved through the air on clouds as we see them in Baroque and eighteenth-century pictures.

Mazarin, who loved pageantry, and always moved abroad in state, had set a standard also in theatrical matters in 1647 when he produced Rossi's *Orfeo* at the cost of 500,000 ecus. (I cannot give an equivalent in our present-day money, but the sum was considered grossly extravagant and attacked as such by Mazarin's enemies.) This took place at the Palais Royal ; the mechanical effects which enabled the gods to sing in mid-air were the work of Mazarin's favourite machinist Torelli ; and the scenery and costumes were entrusted to the painter Errard. Louis XIV had tried to surpass this with the *Ballet de la Nuit* produced in the Salle du Petit-Bourbon in 1653 when Torelli brought a whole choir down from heaven on a cloud, and a house burst into flames before the eyes of the astonished Court ; in this ballet, which represented various episodes between sunset and sunrise, there were forty-three " entries," several of which were acted by the King himself, who had been coached by Lully. The new epoch opened with a still more ambitious performance—the *Hercule Amoureux* performed in the Tuileries in 1662 ; this lasted six hours and the King made several " entries " accompanied by Le Grand Condé ; but the mechanical operations this time were on such a scale that the noise of the machines completely drowned the music and ruined the effect.

Such spectacles continued all through this period and they culminated in the *Triomphe de l'Amour* given before the Court at St. Germain in 1681. In this the Dauphin and the Dauphine appeared and Mlle de Nantes, the seven-year-old daughter of the King by Mme de Montespan, performed a dance with castanets. (The *Triomphe de l'Amour* was given again later in the same year at the Opera in Paris when for the first time professional women

dancers appeared in opera; the innovation was due to Lully.)
The first great outdoor fête of the *Roi Soleil*, which was known as
Le Carrousel, was held in 1662 on the *place* which perpetuates its
name. The King, Monsieur, Le Grand Condé and the Prince de
Conti appeared respectively as a Roman Emperor, a King of Persia,
an Emperor of the Turks and a King of the Americans; they
wore fantastic jewelled costumes and plumed helmets and led the
Court in processions which included as minor performers negroes,
monkeys and bears. Other fêtes took place at Saint-Germain, at
Fontainebleau, and at Versailles, then still the small château of
Louis XIII. The first Versailles fête has also remained in history.
It was given for Mlle de la Vallière in 1664 and was known as
Les Plaisirs de l'Ile enchantée. It lasted nine days and the entertain-
ments consisted of elaborate pageants, ballets and aquatic diver-
sions with marine monsters and nymphs and performances of
Molière's *Tartufe* and *La Princesse d'Elide.* Detailed descriptions
of this fête and others at Versailles can be found in John Palmer's
Molière. Here is one passage: " At nightfall the candles about
the arena were lit. Lully entered with his troop of musicians.
Then came the four seasons: spring, on a Spanish horse, Made-
moiselle du Parc, in a green habit embroidered with silver and
flowers; summer, on an elephant, richly decked, the Sieur du
Parc; autumn, on a camel, the Sieur de la Thorillière; winter,
on a bear, the Sieur de Béjart; finally, Pan, the Sieur de Molière
himself, upon a moving mountain of rocks and trees, and with him
Mademoiselle Béjart as Diana, offering to the Queen and her
ladies in poetic numbers, the fruits and meats of a splendid colla-
tion, served in the lists. Lining the barrier leaned the nobility of
France, in helmets and plumes, as when they had jousted that
afternoon, assembled to see their sovereign feed." Here is another:
" Molière had for his stage an entire garden complete with Satyrs,
busts, fountains, terraces and a navigable waterway. . . . The
King went to supper in a gigantic arbour that beggared all previous
descriptions. Its decorations included an artificial mountain with
Pegasus atop, from between whose feet fell a cascade which formed,
after much intermediate playfulness, four rivers, frequent with
falls and losing themselves in small brooks upon lawns of moss.
The nine Muses were naturally present with Apollo and his lyre."

For this life of pageantry and *panache* the young King was now
to devise a more imposing setting. He had visions of magnificent
palaces where the triumphal chariots of the processions would be
permanent thrones and the pageants would be painted on the walls.

He began his building enterprises, which were to assume vast proportions, with the continuation of the Louvre and the rebuilding of the Gallery of Apollo. The next stage was a vision of a palace at Versailles where all the business of the State and the pleasures of the Court might be permanently assembled round the person of the King.

Versailles was begun about 1670. The King examined every plan and every detail of the galleries and staircases, the sculpture and paintings, the gardens, the fountains, the grottoes and the lakes. Nothing was too large or too small for his attention. If the plan was complicated he listened with patience while it was explained. He delighted especially in the fountains. He would himself turn the taps in the engine-house and make no complaint of becoming wet. He was still, we must remember, in the early thirties, enthusiastic and young.

For the execution of the Versailles concept Louis XIV had the aid of Colbert who made the King's service in all branches the centre of focus for all the energies of France. All the artistic talent of the moment was enlisted for this vast undertaking. The architects Le Vau, Mansart, Robert de Cotte had armies of assistants ; Le Nôtre had an army of gardeners to carry out his projects for the gardens and the park ; and in the field of interior decoration there was an army of sculptors and painters who obeyed the instructions of the remarkable personality Charles Le Brun, whose career we must now consider.

2 CHARLES LE BRUN

BORN PARIS 1619 DIED PARIS 1690

Characteristic Pictures

Dulwich	Gallery	Horatius Cocles defending Rome
Dulwich	Gallery	Massacre of the Innocents
Paris	Louvre	Holy Family (La Bénédicité)
Paris	Louvre	The Crucifixion with the angels
Paris	Louvre	Christ in the desert served by angels
Paris	Louvre	Alexander and the family of Darius
Paris	Louvre	The entry of Alexander into Babylon
Paris	Louvre	The Elevation of the Cross
Paris	Louvre	The entry into Jerusalem
Paris	Louvre	Meleager and Atalanta
Paris	Louvre	Equestrian portrait of Chancellor Séguier
Paris	Louvre (Gallery of Apollo)	Neptune and Amphitrite, Evening, Night

Versailles	Galerie des Glaces	Series of pictures symbolising the glory of Louis XIV
Versailles	Salons de la Guerre et de la Paix	Ceilings
Florence	Uffizi	Jephtha's daughter
Florence	Uffizi	Self portrait
Berlin	Kaiser-Friedrich Museum	The Banker Jabach and his family
Lyons	Museum	Actions de grâces de Louis XIV (with portraits of the King and Colbert)
Leningrad	Hermitage	Christ on the Cross

Charles Le Brun was the artist whom Louis XIV and Colbert required at a particular juncture ; he served their purpose and he saw to it that they also served his. He had great facility in painting, and as a decorator he had organising abilities that approached genius. He was also an arrivist of the very first order.

He was the son of a sculptor who apprenticed him at the age of thirteen to François Perrier. In Perrier's studio he made a drawing of Louis XIII on horseback which his father, who was working for the Chancellor Séguier in his *hôtel*, showed to his patron. The Chancellor, impressed by the boy's evidently precocious talent, arranged for Vouet, who was then decorating his library, to take him into his studio. Le Brun soon quarrelled with Vouet and, resolving on the first step in his arrivist career, he painted an allegory of the glory of Richelieu and presented it to the Cardinal himself. This bold move was rewarded ; Richelieu commissioned him to paint other pictures and introduced him to the King. Before he was nineteen he was a *peintre du roi*.

Le Brun now realised that the next move must be the traditional journey to Italy. He knew how much of the respect paid to Poussin by the King and the Cardinal in 1640 was due to the reputation which Poussin had acquired in Rome. He took steps to meet Poussin and to express his homage. By 1642 when Poussin was returning to Rome Le Brun had arranged to accompany him, and he had persuaded the Chancellor Séguier to provide the money.

In Italy, two years later, he painted *Horatius Cocles defending Rome* (now in the Dulwich Gallery), a deliberate attempt to rival Poussin. He painted this secretly, exhibited it anonymously, and scored a great success in the artistic world of Rome. He was now impatient to conquer Paris to which he returned in 1646.

As a *peintre du roi* of the last reign Le Brun had no difficulty in getting an appointment among the painters in the new King's establishment. But a position in the ranks was intolerable to a

man of his ambition ; and he set to work to found a new organisation of artists—a Royal Academy—of which he determined to be the first Director.

While engaged in negotiations and intrigues about the foundation of the Academy he obtained commissions to paint altarpieces for churches and convents and two pictures in the " May " series commissioned by the Goldsmiths' Guild for Nôtre Dame. His success in the ecclesiastical paintings reached the ears of Anne of Austria, the Queen Regent, who sent for him and described a vision which had come to her in sleep. Le Brun transferred the vision to canvas and placed it in the Queen's oratory. We can see it to-day entitled *The Crucifixion with the angels* in the Louvre.

At the same time he was doing decorative work in several *hôtels* including the Hôtel Lambert where he found Le Sueur at work and quarrelled with him ; and he was cultivating the friendship of the richest and most influential collectors and amateurs, and painting their portraits. The excellent group *The Banker Jabach and his family* (now in Berlin) was painted for the Cologne banker Jabach who was established in Paris in a magnificent *hôtel* with a great collection of pictures (later acquired by the King) ; Le Brun's group was painted about 1660 ; in the background there is a mirror in which the painter at his easel is reflected ; *Las Meninas*, where Velasquez made such ingenious use of mirrors, was painted in 1656.

Le Brun's first great chance came when he attracted the attention of Nicolas Fouquet, the charming, cultivated and fabulously wealthy *Surintendant des Finances* who eventually engaged him at a handsome salary to direct the decorations at his Château de Vaux. Here Le Brun had an opportunity of organising decorative works on a large scale. He covered the Surintendant's apartments with allegorical compositions depicting the glory of the owner ; he designed splendid fêtes with *tableaux vivants*, transformation scenes, and fireworks ; and he founded Fouquet's private tapestry factory and supplied designs to the craftsmen.

At Vaux moreover he met Mazarin, and through Mazarin he was personally presented to Louis XIV for whom he painted the *Alexander and the family of Darius* now in the Louvre. A great deal of this picture was painted in the actual presence of the King and the assembled Court ; the King was so excited at this *tour de force* that he gave him his portrait in miniature surrounded with diamonds as a reward.

It was Le Brun who designed the celebrated fête at Vaux in

September 1661 which was attended by Louis XIV and followed by the fall and disgrace of Fouquet who, the gossips said, had been rude to Mlle de la Vallière when she refused his advances. The fête took place six months after the death of Mazarin and the King's assumption of the government. Le Brun perceived that a new era was starting and that Colbert, whom he had also met at Vaux, was now the rising star. The day after Fouquet's arrest he made Mme Colbert the present of a drawing. Six months later he was *Premier peintre du roi*.

Le Brun now flung himself with enthusiasm into the service of Colbert and the King. For Colbert he decorated the Château de Sceaux and designed its fountains and gardens. For the King he designed the costumes in the Carrousel pageant and in other entertainments and painted designs for tapestries of which the gigantic *Alexander entering Babylon* (Pl. 35a), now in the Louvre, is an example. Then came work in the Louvre itself—the magnificent decoration of the *Galerie d'Apollo* ; and finally came Versailles.

With the experience of Vaux behind him Le Brun approached the execution of the King's projects for Versailles with masterly assurance. He decorated what must have been the superb Grand Staircase (now only known to us in drawings), and the *Salons de la Guerre et de la Paix*, and the *Grande Galerie des Glaces* which survive. The paintings on the ceiling of the *Galerie des Glaces* (Pl. 34) represent his chief pictorial achievements. They consist of thirty compositions each symbolising a moment of glory in the King's career. Here we see Mercury proclaiming the King's assumption of government to the world at large, the King resolving to chastise the Dutch, the King as conqueror of the Franche-Comté and so forth : all pictorial equivalents of the King's " entries " in the ballets and pageants of the day.

At Versailles Le Brun was decorative dictator. The sculptor Coysevox, who was responsible for the gilt bronze trophies on coloured marbles and other sculpture in the *Galerie des Glaces*, worked under his direction. Le Nôtre's gardens follow Le Brun's plan for the gardens at Vaux. Le Brun designed fountains in the lakes, and the *Grotto of Tethys*, an apartment with fountains and a triple apse covered with shells and filled with sculptured groups of mythological figures, based on the *Grotto of Apollo* at Frascati. His activity and that of his assistants and collaborating artists was prodigious. But he also found time to work for the King's " hermitage," the Château de Marly, which developed to a miniature Versailles, and to direct and make designs for the Gobelins

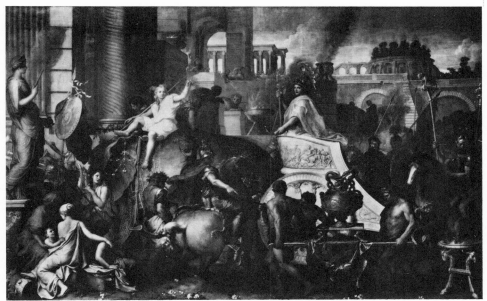

Paris, Louvre

35a. CHARLES LE BRUN: Alexander entering Babylon

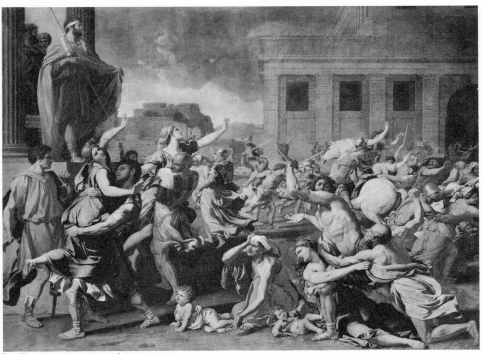

New York, Metropolitan Museum of Art

35b. NICOLAS POUSSIN: Rape of the Sabines

36. CHARLES LE BRUN: Illustrations to lecture: Human and Animal Heads

factory which produced not only tapestries but furniture, plate and objects of luxury of all kinds, including the celebrated silver furniture which filled the *Galerie des Glaces*.

Le Brun worked for twelve years at Versailles. But before his labours were completed the day of his dictatorship was done. Colbert, who, as *Surintendant des Bâtiments*, was his official chief, died in 1683. Le Brun had made many enemies in the time of his success and immediately his powerful supporter was removed they combined to dethrone him. The new *Surintendant des Bâtiments* was one of his enemies. The painter Mignard was another. The King himself had seen his projects carried out and he was no longer so concerned with the artists ; he was moreover on the threshold of the Pharaoh period ; the icy hand of Mme de Maintenon had fallen on his heart. In these new conditions Le Brun's authority in all quarters was gradually undermined. His orders were countermanded even at the Gobelins where hitherto he had personally engaged the whole personnel and directed every detail of the work. He met the situation with his customary astuteness. He observed that the King was becoming pious, that an orthodox religious movement was in the air. He therefore let it be known that he had drunk the cup of worldly success and found it worthless and that he had replaced it by the spiritual refreshments of religion. He owned, in addition to his houses in Paris and Versailles, a magnificent estate at Montmorency. To this estate he now retired and began a series of pictures of the Life of Christ. The Louvre *Adoration of the Shepherds*, *Entry into Jerusalem*, *Christ Bearing the Cross*, *Elevation of the Cross*, all in the theatrical ecclesiastical style launched in France by his old master Vouet, represent this last phase of his activity. In 1690 he was working at a *Last Supper* when he died.

3 THE ROYAL ACADEMY OF PAINTING AND SCULPTURE

The *Académie royale de peinture et sculpture* was founded nominally in 1648 ; but for various reasons it did not function with regular authority till 1661 when Colbert became officially its patron. It owed its existence and its organisation to several causes : (*a*) the growing friction between various categories of artists and the *Maîtrise*, (*b*) the personal ambition of Le Brun, (*c*) Colbert's concept of the function of the arts.

(*a*) Up to 1648 the French artists were all either (i) members of the old Guild of St. Luke, the *Maîtrise*, which employed the usual Guild system of apprenticeship culminating after the production

of a diploma work (known as a *chef d'œuvre*) in the rank of Master, or (ii) artists attached to Royal or noble establishments or protected by some Royal licence, or (iii) " pirates " with no official status.

The rules of the *Maîtrise* were strict. Till the rank of Master was granted no student was allowed to exhibit or trade in his work ; the *Maîtrise* had the right to prosecute in cases of infringement of its rules and it frequently did so. It also had the right to prosecute foreign and other " pirates " and such artists had to sell their work in clandestine ways or at the St. Germain Fair as already noted.

From very early times, as noted, there had been artists with the title of *valet de chambre* attached to the Lord Chamberlain's department in Royal, princely and noble households. These appointments, in the seventeenth century, were granted or sold to painters as distinctions which carried with them exemption from prosecution by the *Maîtrise* and the right to food and lodging in the Royal household. The posts were obtained by favour, and holders often solicited their continuation for their sons. (Thus Molière's father who was *valet-tapissier* to Louis XIII, concerned with the duty of looking after the King's furniture both in Paris and when he travelled, secured the reversion of the title for his son, who retained it without fulfilling the duties.)

In addition to the artists who were *valets de chambre* in these households, there had always been others attached to the personal staffs of the Kings, Queens, Princes, and so forth. Such artists were given the title of *peintre du roi* or *peintre de la reine* or *peintre ordinaire* ; they received an official licence or *brevet*, and they were also known for this reason as *brevetés* and *brevetaires*. They were all subject to the authority of the *Premier peintre du roi* of the moment, and were given annual salaries and lodgings in the Louvre or Tuileries.

There were also various other categories of artists exempted by licence from the authority of the *Maîtrise*. From the time of Henri IV onwards it had been possible to buy the title of *Maître* from the Crown which was accustomed to sell a certain number of such titles on the occasion of royal marriages, births or other festive occasions. The artists who held such titles were known as *Maîtres de lettres* as opposed to the masters elected by the *Maîtrise* who were known as *Maîtres de chefs d'œuvre*. There were also artists among the tradesmen who supplied the Court and followed it on travel ; an artist of this kind whose position was only semi-official would describe himself presumably as *fournisseur du roi*—

to indicate a position equivalent to a tradesman to-day with a
" By Royal Appointment " sign above his door.

The friction between the artists who derived their status from
the *Maîtrise* and those who derived it in one way or another from
the Crown had been growing ever since the time of Henri IV
and it came to a head under Louis XIII. The *Maîtrise* complained
that the granting and selling of the various types of licence had
become an abuse and a scandal. The licensees charged the *Maîtrise*
in the first place with a desire to exercise a tyrannical monopoly
and in the second with degrading the status of the artist by making
him subject to a system properly applicable only to tradesmen
and artisans ; the first charge against the *Maîtrise* was an old
grievance, the second represented the new concept of the artist as
an independent member of a liberal profession which Claude and
Poussin had already adopted in Rome.

(*b*) I have already referred to Le Brun's part in the foundation
of the Academy. At a critical point in his career the *Maîtrise* had
brought the quarrel to a head by applying to Mazarin for
strengthened powers against the *brevetés*. As a *breveté* Le Brun
was attacked, and he was too clever to remain content with a
defensive action. He realised that negotiations for a new founda-
tion would bring him into contact with influential quarters and
that in a new organisation he might be able to take a leading place.
He therefore intrigued for the new foundation. But the Academy
was of no real service to him till Colbert also saw in it an instrument
for his own purposes.

(*c*) Colbert's concept of the function of the arts was simple.
" *C'est à l'aune des monuments qu'on mesure les rois* " he said and he
might have added that in his faith the grandeur of a country was
measured in foreign countries by the grandeur of its King. For
Colbert the arts were a means of creating monuments to enhance
the glory of Louis XIV and thereby of France. He believed in
art as an instrument of national propaganda. At the same time
he believed in organisation in this field as in every other. He
supported the Academy with Le Brun at the head and brought it
to life by becoming an active patron because he wanted a body
of men who would organise art on official standards for the
King's service under the control of a dictator responsible to
himself. He had no doubts about the possibility of establishing
fixed standards—and no doubt that an official organisation could
produce artists capable of attaining to standards once efficiently
laid down.

Colbert proceeded on the same principle in the other arts. He founded the Royal Academy of Music (which also controlled dancing), with Lully as dictator ; the Royal Academy of Architecture, which he called on to invent a new Order to be known as the French Order ; the Royal Academy of Science ; and the Royal Academy of Inscriptions ; and he contemplated an *Académie royale de spectacles* to centralise control and raise the standard of *carrousels, joutes, luttes, combats, défilés, chasses d'animaux sauvages et jeux d'artifice*, and a concession was actually granted to a blackguard, Henri Guichard, who planned to poison Lully because he could not get permission from him to accompany his spectacles with music. (The *Académie française* was an earlier foundation—the work of Richelieu.)

Le Brun took advantage of Colbert's simplicity in this respect to defeat his rivals. The Academy once effectively established he set to work to make things unpleasant for artists outside its ranks. The Academy ran its own art school. Le Brun obtained an ordinance which prevented the *Maîtrise* from running another and prescribed fines and imprisonment for any individual artist who did so.

Another ordinance directed all the *brevetés* (*peintres du roi* and others) who had not joined the Academy of their own volition to join forthwith or forfeit their privilege of immunity of prosecution by the *Maîtrise*. This second ordinance was directed against Le Brun's rival the painter Mignard who was a *breveté* and who had refused to join the Academy in a position inferior to Le Brun. Charles Errard was another dangerous rival ; Le Brun had him shipped off as First Director of the branch of the French Academy which Colbert had just founded in Rome. Vouet by this time was no longer a rival as he had died, as noted, in 1649.

But though Colbert allowed Le Brun to use him for his purposes he was also determined to use him and the Academy for his own. He had entrusted the Dictatorship of Art to the Academy ; he now called upon the institution to define the art which it existed to control and propagate. The result was the celebrated series of Academy *Conferences*, or Discourses in which the Academicians endeavoured to formulate rules for the creation of Great Art. These *Conferences* were delivered at meetings of the Academy attended by the members, by students, sometimes by the public, and sometimes by Colbert himself. The lectures were followed by discussions and, if considered worthy by Colbert, they were subsequently published.

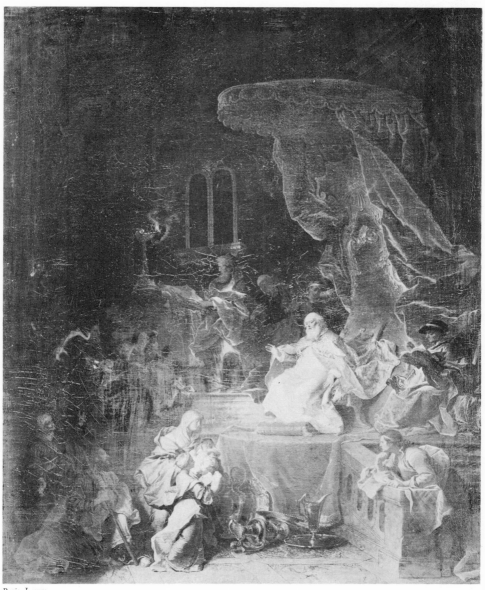

37. HYACINTHE RIGAUD: Presentation in the Temple

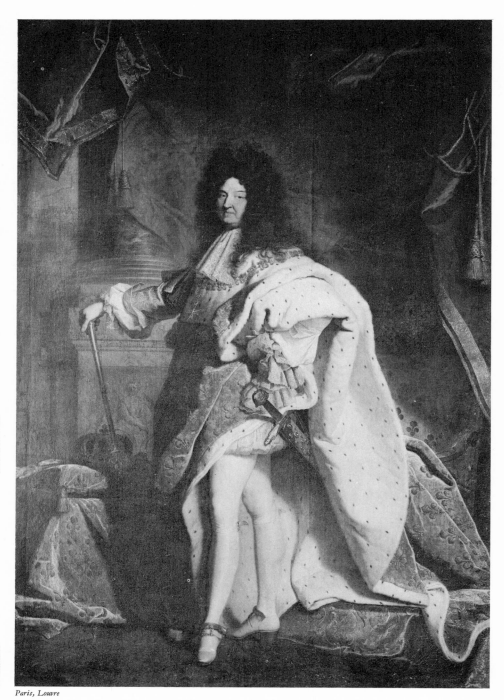

38. HYACINTHE RIGAUD: Louis XIV at the age of sixty-two

Le Brun's own *Conferences* were interesting and ambitious. In one he discussed human physiognomy in its relation to the physiognomy of animals ; his illustrations to this lecture, some of which I reproduce (Pl. 36), are preserved in the Louvre. In another *Conference*, taking the *Traité des passions de l'âme* by Descartes as a basis, he tried to work out rules for the correct delineations of all human passions and sentiments in art. Other *Conferenciers* discussed the relative importance of colour and drawing in pictures ; and the principle that in art *le vraisemblable* is *le vrai* was laid down by Sébastien Bourdon, already referred to as an imitator (if not indeed a forger) of pictures by the Le Nain and also of works by Poussin.

The Academicians who argued in favour of colour instanced Titian and Rubens ; those who argued in favour of drawing instanced Raphael and Poussin.

As concrete examples of these and other masters they were able to point to the pictures in the splendid Royal collection which was then accessible to all artists, students and visitors to the Louvre. The organisation and immense extension of the Royal collections was also Colbert's work. The collection inherited from previous sovereigns, which included the Italian pictures acquired by François I, had been increased by the acquisition of many works from the collection of Fouquet and that of Mazarin, which contained many of the pictures previously owned by Charles I. Colbert was responsible for these acquisitions and he continued to buy right and left on the King's behalf. He imported shiploads of antiques and Italian pictures from Rome, and he took advantage of every opportunity at home to buy others—often at very low prices fixed by Le Brun as expert. In 1671 the banker Jabach was ruined, and Colbert acquired for the King a hundred of his pictures and five thousand drawings for a nominal sum. When the Comte de Brienne, another notable collector, was ruined, he stepped in again. In ten years he acquired six hundred and forty-seven of the pictures now in the Louvre. At the same time it was intimated that the King would welcome gifts of pictures, and many fine works were acquired in this way. Of the twenty-nine pictures by Poussin in the collection of Louis XIV three were gifts, five were acquired from the painter Herault, and twelve were won at tennis by the King from the young Duc de Richelieu, who had inherited them from his father and staked them on a game. In 1681 Colbert had the King's collection brought from the various palaces and assembled in the galleries of the Louvre

arranged to receive them. They included sixteen pictures by Raphael, six by Correggio, ten ascribed to Leonardo, eight to Giorgione, twenty-three by Titian, eighteen by Veronese and fourteen by Van Dyck. In 1709 the collection numbered two thousand four hundred pictures available for study by the French artists—(the English National Gallery was founded with thirty-eight pictures in 1824).

Meanwhile after prolonged discussions, dealing largely with the history-pictures of Poussin, the Academy decided that all the problems had been solved; and it instructed Louis Testelin to draw up synoptic tables of Rules for Great Art. This *Table de Préceptes* was duly compiled and published in 1675; and it was followed by another work by R. de Piles, who drew up tables allotting comparative marks to the great artists under various heads. Perfection was represented by twenty marks, and the tables included the following assessments :

	Composition	Drawing	Colour	Expression
Le Brun ..	16	16	8	16
Michelangelo	8	17	4	8
Rubens ..	18	13	17	17
Poussin ..	15	17	6	16
Titian ..	12	15	18	6
Rembrandt..	15	6	17	12

The Authoritative Doctrine thus established was doubtless a source of satisfaction to Colbert. But it served no other purpose, and could serve no other, because fixed standards have no meaning in the case of the activity called art.

4　PIERRE MIGNARD

BORN TROYES 1612　　　DIED PARIS 1695

Characteristic Pictures

London	National Gallery	La Marquise de Seignelay as Thetis with Achilles and Cupid
Paris	Louvre	The Virgin with the grapes
Paris	Louvre	Jesus and the Woman of Samaria
Paris	Louvre	The Road to Calvary
Paris	Louvre	The Grand Dauphin and his family
Paris	Louvre	Mme de Maintenon
Paris	Louvre	Self portrait
Paris	Eglise du Val de Grâce	" Gloria " in the vault
Paris	Comédie-Française	Molière as César

Chantilly	Musée Condé	Molière
Chantilly	Musée Condé	Cardinal Mazarin
Chantilly	Musée Condé	Louis XIV
Versailles	Museum	Marie de Bourbon as a child
Versailles	Museum	Louis XIV crowned by Victory
Versailles	Museum	Catherine Mignard, Comtesse de Feuquières, as Fame, holding a trumpet and a portrait of the artist
Narbonne	Museum	S. Carlo Borromeo giving communion to the plague-stricken
Nîmes	Museum	Portrait of a magistrate
Aix	Museum	Mars and Venus
Avignon	Museum	Mme de Montespan and the Duc de Maine
Elle	Museum	Mme de Maintenon and her niece
Florence	Uffizi	Mme de Sévigné
Leningrad	Hermitage	The Magnanimity of Alexander

When Le Brun desired to sweep all the artists of consequence into the Royal Academy and thereby establish his authority above them, one important artist, Pierre Mignard, resisted him ; and as already noted Le Brun obtained from Colbert an ordinance by which Mignard as *breveté* was called upon to join. But Mignard flatly refused, and Colbert himself, with the Royal authority behind him, could not dissuade him from his decision. " *Monsieur*," Mignard replied to Colbert, " *le roi est le maître, et s'il m'ordonne de quitter le royaume je suis prêt à partir. Mais sachez bien qu'avec ces cinq doigts, il n'y pas de pays en Europe où je ne sois plus considéré, et où je ne puisse faire une plus grande fortune qu'en France.*"

Mignard and Le Brun had been enemies since the days when they were fellow-students in Vouet's atelier. Mignard was there in 1625. He went to Rome in 1635, and painted a series of Madonnas of the character of the Louvre *Virgin with the Grapes* which are known as *Mignardes*. There too he painted the *S. Carlo Borromeo* picture (in competition with Pietro da Cortona) now in the Narbonne Museum.

In Rome he also won a great reputation as a portrait painter. Three Popes, Urban VIII, Innocent X (who was subsequently painted by Velasquez) and Alexander VII sat to him ; and Poussin in a letter dated 1648 refers to him as the best portrait painter at the time in Rome although he describes the heads in his paintings as " *froides, fardées, sans force ni vigueur.*"

The reputation of Mignard " *le Romain*," as he was then called, extended to France, and in 1656 Louis XIV recalled him to Paris. He arrived in France in the following year and stayed some months with his brother Nicolas Mignard (who was also a painter)

at Avignon. There he met Molière, who had been performing at Béziers and Dijon, and there doubtless he painted the celebrated portrait *Molière as César* in " *La Mort de Pompée* " which belongs to the Comédie Française. Molière was under forty at the time of this first meeting ; and he is evidently still young in the portrait. In the equally famous portrait at Chantilly he appears older and rather weary, and the picture was probably painted in Paris about ten or fifteen years later.

Mignard left Avignon on receipt of an urgent summons from Mazarin to paint a portrait of the King to be sent to Madrid in connection with the negotiations for the hand of the Infanta Marie-Thérèse. Mignard painted the picture in a few days and won thereby the favour of Mazarin, the King, the Queen Mother, and the new Queen herself. Henceforward, even during the triumph of Le Brun, he remained a favourite portrait painter in Court circles ; and he was also commissioned by the Queen Mother to paint the vault in the Church of the Val-de-Grâce which she had dedicated " *A Jésus naissant et à la Vierge Mère* " as a thankoffering for the birth of Louis XIV, which as already recorded was regarded by the pious as a miracle. Mignard's painting is a circular composition of two hundred figures of saints fantastically foreshortened adoring the Trinity in a central circle of clouds and angels' heads ; in an intermediate circle we see Anne of Austria herself in adoration. The vault is a supreme example of the Jesuit style of ecclesiastical decoration. As is well known it evoked a panegyric from Molière who was evidently inspired as much by friendship for Mignard and hostility to Le Brun as by the actual work, when in *La Gloire de Val de Grâce* he wrote :

> *Toi qui, dans cette coupe à ton vaste génie*
> *Comme un ample théâtre heureusement fournie*
> *Es venu déployer les précieux trésors*
> *Que le Tibre t'a vu ramasser sur ses bords,*
> *Dis-nous, fameux Mignard, par qui te sont versées*
> *Les charmantes beautés de tes nobles pensées . .*

Addressing Colbert directly he wrote :

> *Attache à tes travaux dont l'éclat te renomme*
> *Les restes précieux des jours de ce grand homme.*

and he followed this with a sly attack on Le Brun :

> *Les grands hommes, Colbert, sont mauvais courtisans*
> *Peu faits à s'acquitter des devoirs complaisans.*
>
> *Souffre que, dans leur art s'avançant chaque jour,*
> *Par leurs ouvrages seuls ils te fassent leur cour.*

After the defiance of Le Brun in the matter of the Academy Mignard became the official leader of the artists of the old *Maîtrise*; he rallied all Le Brun's enemies and awaited the moment for his revenge.

He had, in fact, to wait some time, for while Colbert lived he could really do nothing, though in 1677 while Le Brun was working at Versailles, he scored a success with the decorations of Monsieur's Château de St. Cloud which the King inspected and admired. Mignard's day came when Louvois who succeeded Colbert as *Surintendant des Bâtiments* commissioned him to work at Versailles itself. There he painted decorations in the *Petits appartements* and in *La Petite Galerie*; and, when the King asked Le Brun to visit these apartments and give his opinion on Mignard's work, conditions had so altered that Le Brun thought it more prudent to forget the Royal command.

His last challenge to Le Brun was *The Magnanimity of Alexander* (now in Leningrad) which was commissioned by Louvois to rival Le Brun's picture of the same subject and is proudly signed " Mignard pinxit 1689 aetatis suae 77."

When Le Brun died in 1690 Mignard succeeded to all his honours. He became *Premier peintre du roi*, Director of the Academy and of the Gobelins factory, and at the age of eighty-five, just before he died, he undertook a commission for a painting in the vault of the Invalides.

A full-length portrait of Mignard, painted either completely by himself or by a pupil from a head by Mignard, and representing him seated in his studio, was presented by Mignard to the Academy when he became Director. The pose and the disposition of the accessories in the picture are deliberately the same as those in the portrait of Le Brun by Largillière which the Academy already had upon its walls. The pictures, which record the hatred and rivalry between the two men, can be seen in the Louvre.

Mignard excelled as a portrait painter. His *Portrait of a Magistrate* in the Nîmes Museum (dimly perceived though it is through the dirt which now covers the whole surface of the picture) is a work of acute observation, sensibility and great skill. His *Portrait of Mazarin* at Chantilly is also excellent; we can believe as we look on this effigy the tales of the Cardinal's avarice and of the hatreds which he inspired. Another admirable performance is the Louvre portrait of *Mme de Maintenon as Sainte Françoise* painted two years before the artist died for the *Maison d'Education* at St. Cyr where the former governess of Mme de Montespan's children

was playing the fairy godmother to a lot of miserable girls. The charming picture in the London National Gallery *La Marquise de Seignelay as Thetis with Achilles and Cupid* (Pl. 40a) doubtless represents the sitter as she appeared in some masque or theatrical diversion, probably with her children.

5 LOUIS XIV—THE LAST PHASE

The last twenty-five years of the reign of Louis XIV were a period of gloom. France was depressed by the failure of the later wars and exhausted by the sacrifice of over a million lives. The religious persecutions that followed the Revocation of the Edict of Nantes (1685) filled thinking people with horror, and when the population was not suffering for religion it was suffering from brutal repressions of political revolts or the tyranny of the King's soldiers billeted in the country between campaigns—(a tyranny which was not however new, for Mme de Sévigné wrote in 1676 : " *Voici qu'arrivent les troupes pour les quartiers d'hiver ; ils s'en vont chez les paysans, les volent et les dépouillent. . . . Ils mirent l'autre jour un petit enfant à la broche . . .*").

The Court itself was equally gloomy. The wars, the entertainments and the building of the palaces had emptied the treasury. "*J'ai trop aimé les bâtiments*" Louis XIV confessed on his deathbed, and he might have added luxury and luxurious objects. But now all was changed ; in 1690 the silver furniture and appointments from Versailles were sent to be melted into money at the Mint. Life at Versailles had become an onerous ritual without sparkle or gaiety. Molière and Lully were both dead. The King himself was a sick man ; nothing of the old world remained to him but Lully's music which he still had performed at all times and seasons—during the *lever*, at dinner, in chapel, at supper, and while he went to bed.

Mme de Maintenon contributed to the prevailing gloom. She was an open enemy of the arts. She disapproved of the King's devotion to music. She countermanded the importation of the copy of a Titian because it had nude figures ; she had the nudes in Gobelins tapestries decently draped or dressed. She also tried to abolish the opera and the ballet and succeeded in creating a new type of didactic performance an example of which, *Le Triomphe de la Raison sur l'Amour*, was played in 1696 to a dejected Court which remembered the glories of *Le Triomphe de l'Amour*.

All this brought about a corresponding change in the field of painting. The Italian tradition fell out of favour ; the pagan gods

and goddesses were dethroned; religious subjects became *de rigueur*; and when Le Brun's pupil Charles de La Fosse (1636-1716) painted *The Finding of Moses* (Louvre) in the last year of the century the women are depicted not in classical draperies but in complete dresses, and beneath them—for the first time in the art of the century—they are evidently wearing stays.

The monument of doctrine constructed on the basis of Poussin's history-pictures and the Italian masters by the Academy was soon challenged. It was now the fashion to look to the pictures of the Low Countries for inspiration. This happened partly because these painters were felt to be more in keeping with the new attitude to art, partly because after the death of Le Brun there was a reaction against the Academy as such, and partly because in the wars many French notables had visited the Low Countries and brought back Dutch and Flemish pictures for their own collections. Le Grand Condé bought pictures in Holland, and brought Flemish and Dutch artists to Chantilly. The Duc de Richelieu replaced his Poussins by a set of pictures by Rubens. In 1710 the Van Dycks of religious subjects in the royal collection were placed in the private apartments of the King.

Many aspects of Dutch and Flemish art are reflected in the French pictures at the turn of the century. Jean Jouvenet (1644-1717) imitates Rubens in his *Descent from the Cross* and the Dutch painters of church interiors in his *High Altar of Nôtre Dame* (both in the Louvre); still-life pictures of flowers and so forth in the Dutch and Flemish traditions begin to make their appearance; Charles Desportes (1661-1743) paints sporting dogs and hunting scenes in the manner of his Flemish master Nicasius and of Snyders, and is commissioned by the King to record the rare animals in the royal menagerie; and of the two leading portrait painters of the period, Nicolas de Largillière and Hyacinthe Rigaud, the first appears after an apprenticeship in Antwerp and the second is influenced not only by Rubens but also by Rembrandt, hitherto ignored in France and not represented in the King's collection.

6 HYACINTHE RIGAUD

BORN PERPIGNAN 1659 DIED PARIS 1743

Characteristic Pictures

Philadelphia	J. G. Johnson Collection	Self portrait
Paris	Louvre	The Presentation of Jesus in the Temple

Paris	Louvre	Louis XIV at the age of sixty-two
Paris	Louvre	Marie Serra, the artist's mother
Paris	Louvre	J. F. P. de Créqui, Duc des Lesdiguières, as a child
Paris	S. Eustache	The curé L. Delamet
Paris	S. Eustache	The curé J. F. Secousse
Versailles		Louis XV, aged five
Versailles		Elizabeth Charlotte, Dowager Duchess of Orleans
Versailles		Portrait of Mignard
Cherbourg	Museum	The financier Montmartel and his wife
Aix	Museum	Gaspard de Gueydan with bagpipe
Aix	Museum	Mme de Gueydan
Perpignan	Museum	Portrait of the artist
Perpignan	Museum	Christ on the Cross
Perpignan	Museum	Cardinal de Bouillon opening the sacred door in 1700
Reims	Museum	Louis XV in 1722
Munich	Alte Pinakothek	Christian III, Duke of Zweibrücken
Dresden	Gallery	King August III as Elector of Saxony in armour with negro attendant
Vienna	Liechtenstein Gallery	Prince Wenzel-Liechtenstein
Madrid	Prado	Louis XIV in armour
Stockholm	Gallery	Charles XII in armour

Hyacinthe-François-Honoré-Mathias-Pierre-Martyr-André-Jean Rigau Y Ros, known as Rigaud, was a magnificently competent painter of portraits. We owe to him the splendid portrait of *Louis XIV at the age of sixty-two* (Pl. 38)—the portrait which has fixed our image of the Pharaoh of the last period, who has been aptly described as the greatest actor of royalty in history.

Rigaud was the son of a tailor. After working for some years in Perpignan, Montpellier and Lyon he arrived in Paris in 1681. He was launched on his career in 1688 when he painted a successful portrait of Monsieur, the King's brother. Before he was done he had painted countless Court portraits and five Kings, Louis XIV, Louis XV, Charles XII of Sweden, Philip V of Spain, and Augustus III of Poland. He had an army of assistants in his studio whom he employed as specialists for drapery and other accessories and as makers of replicas. He did not go to Italy—a fact significant of the change of taste.

In Rigaud's works we can distinguish two manners. In the first the Baroque flamboyance of Rubens is adapted to express the grandeur and pomposity of the notables of the period and those who desired to be portrayed as notables. *The Financier Montmartel*

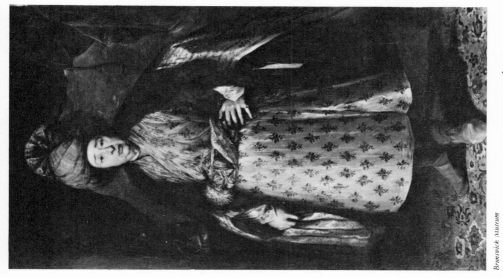

39b. NICOLAS LARGILLIÈRE :
J. B. Tavernier

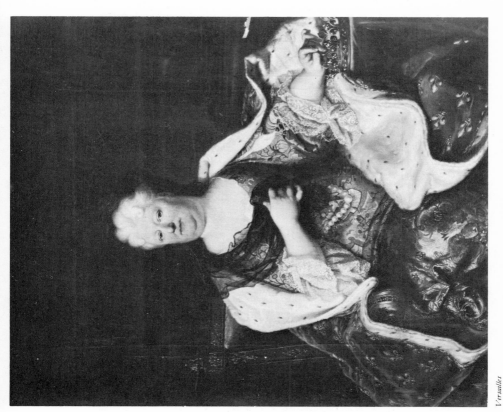

39a. HYACINTHE RIGAUD :
Elizabeth Charlotte, Dowager Duchess of Orleans

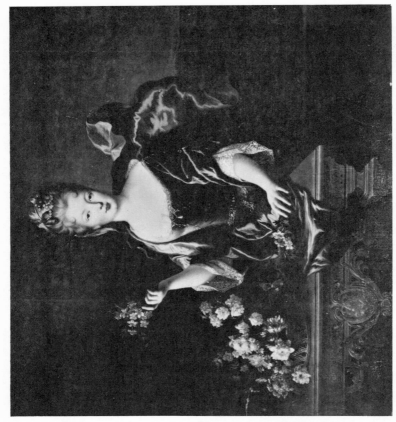

40a. PIERRE MIGNARD:
La Marquise de Seignelay as Thetis with Achilles and Cupid

40b. SCHOOL OF LARGILLIÈRE: Duchess of Orleans

and his wife at Cherbourg is an example of this manner; the portraits *Gaspard de Gueydan with bagpipe* and of his wife in the Aix Museum, and *Prince Wenzel-Liechtenstein,* surrounded by a veritable tornado of curtains, in the Liechtenstein Gallery in Vienna, are others.

Later, as noted above, Rigaud set out to emulate Rembrandt, and we see the influence of the Dutch master in the Louvre picture *Presentation in the Temple* (Pl. 37) which he painted in the year of his death and left in his will to Louis XIV. Rigaud tried, of course, to improve on Rembrandt, especially in the portraits, and to adapt Rembrandt's technical procedures to what doubtless seemed to him more distinguished and worthy ends—just as the Dutch painter, Van der Werff (1659-1722), tried to improve on Rembrandt's *Christ shown to the People* (in a picture reproduced in my *Dutch Painting*). And in this connection it must be remembered that many Dutch painters towards the end of the century borrowed in their turn from French art; Van der Werff himself was influenced by Claude and Poussin, and Gerard de Lairesse was influenced by Poussin and Le Brun.

Rigaud's production was very large. Like Reynolds, he kept careful records of his commissions and from these we learn that he painted from thirty to forty portraits every year.

7 NICOLAS DE LARGILLIÈRE

BORN PARIS 1656 DIED PARIS 1746

Characteristic Pictures

London	National Portrait Gallery	The Old Pretender aged seven and his sister aged three
London	National Gallery	Princess Rákóczi with a negro attendant
London	Wallace Collection	Louis XIV and his heirs
New York	Metropolitan Museum	Portraits of Baron and Baroness de Prangins
Paris	Louvre	The Provost of the Merchants and the Sheriffs of Paris (Sketch)
Paris	Louvre	Portrait of Le Brun
Paris	Louvre	The President de Laage
Paris	Louvre	Portrait of the artist with his wife and daughter
Chantilly	Musée Condé	The actress Mlle Duclos
Chantilly	Musée Condé	Marie de Laubespine (?)
Chantilly	Musée Condé	A gentleman of the house of Condé
Aix-en-Provence	Museum	Mme de Gueydan as a Naiad

Amiens	Museum	The Provost of the Merchants and the Sheriffs of Paris (Sketch)
Amiens	Museum	Still life
Orleans	Museum	Still life
Nantes	Museum	Joseph Delaselle, Merchant of Nantes
Berlin	Kaiser-Friedrich Museum	Jean Forest
Brunswick	Museum	J. B. Tavernier
Brunswick	Museum	Count K. D. von Dehn
Florence	Uffizi	James Stuart the Old Pretender and his sister, Louisa, as children
Leningrad	Hermitage	Sketch for *Banquet offered to Louis XIV on his convalescence 1687*

Largillière is a painter's painter. He captured the secrets of the sheen and glitter of Van Dyck's painting and the lustre of Lely's and transformed them to something lighter and more engaging still. In Rigaud's pictures, even when the disposition of the drapery is most flamboyant, the touch is rather heavy and the paint substantial ; but Largillière spread the colour as a thin fluid and while it was still wet he brought it to life with incisive touches of shadow and with little spots of glittering high light. We see his method to perfection in the Amiens sketch chronicled in my list above.

The Amiens painting, and those in the Louvre and Leningrad, are sketches for large compositions (destroyed in the Revolution), which Largillière painted for the Hôtel de Ville in Paris. The subjects included *The Provost of the Merchants and Sheriffs of Paris deliberating on the banquet given to Louis XIV on the occasion of his convalescence Jan. 30 1687* ; *The marriage of Louis XIV's grandson the Duc de Bourgogne with Marie Adelaide de Savoie 1697* ; and *The Coronation of the Duc d'Anjou as Philip V of Spain 1701*. The civic dignitaries who gave him these commissions played a considerable rôle when Paris began to create its own life in spite of the absence of the King and the Court at Versailles—(for during the Versailles period the King only came to Paris to attend the inauguration of his statues in the *Place des Conquêtes* (*Place Vendôme*) and the *Place des Victoires*, which were built to receive them ; the *Porte St. Denis* and the *Porte St. Martin* were built to celebrate his victories in Germany and Holland at a time when he was not yet established at Versailles).

In two portraits at Chantilly, the so-called *Mme de Laubespine* and *Gentleman of the House of Condé*, the light touch of Largillière's sketches has been to some extent sacrificed, as in many of his

finished pictures, to completeness of representation. In the male portrait—where the wig is blond, the coat red and the drapery orange—we see the influence of Van Dyck both in the composition and the colour. In the other, a later work, we have the white powdered face, with blue shadows, the rouged cheeks, the brilliant eyes and brows, and the powdered hair which we associate with portraits of the age of Louis XV.

The Brunswick full length *J. B. Tavernier* (Pl. 39b), in a Persian robe, is among his finest portraits. Interest also attaches to his still life paintings of game, fruit and so forth which are preserved in the French provincial museums noted in my list above. For here we see Largillière as the forerunner of the great French still-life painter Jean-Baptiste Chardin.

Largillière was born in Paris but he was brought up in Antwerp where his father had affairs. There he was apprenticed to a Flemish landscape and genre painter and employed on painting flowers, game and fish in his master's works. At the age of eighteen he went to England where he became an assistant to Lely and painted the drapery in many of his pictures. He returned to Paris about six years later and remained there—(except for a flying visit to England to paint James II and his Queen)—till his death at the age of eighty-seven in the middle of the reign of Louis XV. He was a professor in the Academy from 1710 and director from 1738. He amassed a considerable fortune and lost most of it in 1720 in the crash of the East and West India Companies, floated in Paris by the celebrated Scottish banker, John Law, who had founded the *Banque royale* in 1716, and introduced Bills of Exchange into France.

Largillière's reputation has suffered from the numerous pictures by his followers which are frequently ascribed to him. But these School pictures have their own qualities. The *Duchesse d'Orléans* (Pl. 40b), at Versailles, is typical of the more attractive of such works.

PLATE III

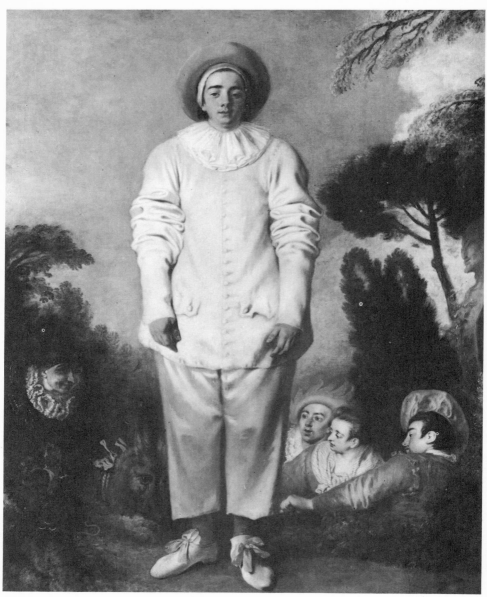

ANTOINE WATTEAU (1684-1721)

Gilles (Italian Comedians)

PART FOUR

THE EIGHTEENTH CENTURY

A. ANTOINE WATTEAU

1 WATTEAU'S FRIENDS
2 WATTEAU'S LIFE
3 WATTEAU'S ŒUVRE
4 WATTEAU'S ART
5 WATTEAU'S CHARACTER
6 WATTEAU'S FOLLOWERS

B. THE AGE OF LOUIS XV AND LOUIS XVI

1 THE LOUIS XV STYLE
2 PORTRAIT PAINTERS
3 PASTELLISTS
4 GENRE PAINTING
5 JEAN-BAPTISTE-SIMÉON CHARDIN
6 THE ACADEMY AND THE SALONS
7 FRANÇOIS BOUCHER
8 LA POMPADOUR AND LA DU BARRY
9 JEAN HONORÉ FRAGONARD
10 TABLEAUX DE MODES
11 LOUIS-LÉOPOLD BOILLY
12 JEAN-BAPTISTE GREUZE
13 FRENCH EIGHTEENTH-CENTURY LANDSCAPE
14 MMES VIGÉE-LE BRUN AND LABILLE-GUIARD

THE EIGHTEENTH CENTURY

A. ANTOINE WATTEAU

I WATTEAU'S FRIENDS

Paris, as a city with a distinctive spirit, was born at the beginning of the eighteenth century. When the second decade opened, the Versailles Court, vicious and brutal beneath its outward pomp and gloom, was performing its last ceremonies. But Paris was preparing for the moment of release. There new values and new standards of luxury and life were in course of evolution, and a new generation of art patrons was beginning to appear.

The new patrons, for the most part self-made men, or the sons of such men, were an important factor in the new Parisian civilisation ; genuine lovers of the arts, they stood both for the amenities and the decencies of wealthy bourgeois life ; and they were unaffected by the wild pursuit of pleasure and the hysterical speculations that broke out on the advent of the Regency.

The names of several of these men live in history as the friends and patrons of Watteau.

The first name is that of Pierre Crozat, who was known as Crozat *le curieux* (i.e. " the collector "), and also as Crozat *le pauvre*, to distinguish him from his still wealthier brother, Antoine Crozat, who had the monopoly of trade with Louisiana and was known as Crozat *le riche*. Pierre Crozat had been at first associated with his brother in business and finance but at the age of forty-three he retired and bought himself the office of *Trésorier de France*. He was fifty when Watteau was brought to his notice, and he then owned, as a country estate, the Montmorency park and château which had formerly belonged to the painter Charles Le Brun (and was later to shelter Jean-Jacques Rousseau, when it belonged to the Duc de Luxembourg). Crozat improved the gardens and extended the château ; he also built the *petit château* where Rousseau was lodged and where " *dans une continuelle extase* " at the beauty of his surroundings he worked at *Emile* ; and it was this same beauty that enchanted Watteau.

In Paris Crozat had a magnificent *hôtel* (which the architect Cartaud had taken ten years to build) and here he housed an astonishing collection of works of art. He had acquired what remained of Jabach's collection after Colbert had made his selection for Louis XIV, and he had also acquired pictures which had

belonged to Vasari. He had an immense number of drawings by Italian, Dutch and Flemish masters, some antique sculpture, and fourteen hundred engraved gems preserved in cabinets made at the Gobelins by Boulle. He continued to add to his treasures all his life ; agents bought for him in London, Antwerp and Rome, and he himself travelled to inspect and acquire the finest things ; when he died he had five hundred pictures and nineteen thousand drawings. Crozat was also an amateur of music, and his musical parties were attended by the most cultivated elements in the new Parisian society. Philippe d'Orléans, the Regent, was among his friends, and at Crozat's house he forgot his wine and his women and his exhausting orgies and revealed his passionate interest in works of art which was equal to Crozat's own. The Orléans collection in the Palais Royal included Italian, Dutch, Flemish and French works from the collections of Christina of Sweden (who had some pictures which had belonged to Charles I of England), of Richelieu, of the Marquis de Seignelay (Colbert's son), and of M. de Chantelou, who had one set of *The Sacraments* by Poussin ; in 1723, among his four hundred and ninety pictures, nearly all of the first importance, Philippe d'Orléans had six works by Raphael, as many by Correggio, and twenty-five by Titian ; his son mutilated a Correggio on the plea of piety ; his grandson kept the whole collection in storage ; then Philippe Egalité to raise money for political propaganda in 1792 sold the whole collection which came to England ; the Dutch and Flemish sections passed to various collections ; the French and Italian sections were acquired by the Duke of Bridgewater and most of the pictures can still be seen in London at Bridgewater House. Crozat, Watteau's friend and patron, had a hand in the making of this Orléans collection, for when he went to Italy in 1715 he was commissioned by Philippe d'Orléans to buy for him.

The name of Jean de Jullienne is also closely associated with that of Watteau. Jullienne was an amateur painter, engraver and musician. At the same time he was the managing director of a flourishing factory attached to the Gobelins to which he supplied textiles dyed an orange-scarlet colour which was a secret and monopoly of the firm. Later he became de Jullienne, and the owner of the business which had belonged to his uncle.

Jullienne began collecting pictures from an early age. He had a marked preference for works of the Dutch and Flemish Schools and owned paintings by Rembrandt, Terborch, Metzu, Wouwerman and Rubens, as well as some by Correggio, Veronese and

Claude. He was twenty-one when he met Watteau, who was then the same age.

Another friend and patron, the Comte de Caylus, was a man of rather different calibre. He was a nobleman by birth and a soldier by profession. At the age of fifteen he fought at Malplaquet. When peace came he retired from the army and became an amateur painter and engraver. He engraved a number of Watteau's pictures, and delivered a *Conference* at the Academy, which is a main authority for the details of the artist's life and throws valuable sidelights on his temperament and character. Like Jullienne he was about Watteau's own age when he made his acquaintance.

The help and patronage of these wealthy amateurs was reinforced by the interest of certain professional men of letters and certain artists. The names of Pierre-Jean Mariette (publisher, art historian, engraver, collector, and an intimate in Crozat's circle), of Antoine de la Roque (who wrote operas and later edited the *Mercure de France*), of Nicolas Henin (*Intendant ordonnateur* of the King's Buildings and gardens, amateur artist and engraver who drew from the model with de Caylus and Watteau in rooms taken by de Caylus), must be mentioned in the first category ; those of La Fosse, Oppenordt, Vleughels and probably of Ch.-Antoine Coypel and Largillière must be mentioned in the second. Finally, there were two art dealers—Sirois and his son-in-law Gersaint—whose names have been immortalised through their association with the artist.

It is important for us to-day to realise Watteau's debt to these friends and patrons, because he was the first original French artist who worked in Paris in a situation comparable with that of the original artist in the modern world to-day. Claude and Poussin, as noted, had achieved a position of artistic independence ; they had done this without help from the general public which knew nothing about them, and they had been able to do it because they lived in Rome, to which the world's richest dilettanti then habitually looked when they wanted to buy pictures. Watteau had to capture his artistic independence in Paris itself ; and he too received no help from the general public which knew nothing of his existence and nothing of his work till after his death.

Watteau's contribution to the world's art was made possible by the men I have described. They discovered him, they rescued him from hack work, and they supported him with money though association with them—as I point out in the section headed

" Watteau's Character "—was often rather trying to the artist's nerves.

2 WATTEAU'S LIFE

Antoine Watteau was born in Valenciennes in 1684. He was the son of a *maître couvreur et charpentier* (master tile and slate worker and carpenter). He was poor and obscure till the age of twenty-five. He died of consumption at the age of thirty-seven in 1721.

He arrived in Paris at the age of eighteen. Before that he had worked as an apprentice in the studio of a local artist. In Paris he earned his living for a time by painting little pictures of saints for a dealer who employed a number of hack painters and sold their productions to peasants for small sums. From this hack-labour he escaped to the studio of Claude Gillot (1673-1722) with whom he remained for some years ; Gillot was a Fleming who designed for the theatre, painted stage scenes (including probably the Louvre *Scène des deux carrosses*) and illustrated books. When Watteau left Gillot he attached himself to another artist, Claude Audran, who was Keeper of the Luxembourg Palace where he had charge of the pictures which Rubens had painted for Marie de' Medicis. In the Luxembourg he drew in the park and studied Rubens and made drawings from his works. While still with Audran, in 1709, he competed for the Prix de Rome and was defeated by one Antoine Grison who never attained to fame. Then, after a visit to his native Valenciennes, he met the art dealer Sirois who bought some of his easel pictures, installed him in his house, and introduced him to Crozat who at once recognised his talents and commissioned him to paint four panels in his dining-room.

In the Hôtel Crozat Watteau found Oppenordt who was acting as Crozat's domestic architect and decorator, and Charles de La Fosse who had painted the ceiling of the main gallery of the *hôtel* and was installed there (with his wife and niece), as curator of Crozat's collections. Through the influence of La Fosse he was introduced to the Academy which elected him *agréé* in 1712—an important service because till then, as he never attempted to graduate in the *Maîtrise*, he was still a " pirate " liable to prosecution if the *Maîtrise* considered it worth while.

Watteau now established himself as an independent artist with a youth named Jean-Baptiste Pater from Valenciennes as his pupil and assistant ; and in 1715 Jullienne appeared and began to buy his pictures.

In 1716 La Fosse died and Watteau accepted an invitation from Crozat to occupy the apartment thus vacated in his house. On this second visit to the Hôtel Crozat, Watteau lived in conditions of luxury; he met all the influential dilettanti of the time, and he was able to examine Crozat's great collections at his leisure. From the *hôtel*, moreover, he could escape when he pleased to Montmorency, and draw and wander in the park.

But Watteau only accepted Crozat's hospitality for about a year. In 1717 we find him again in the house of Sirois painting the Louvre *Embarquement pour l'île de Cythère*, the *tableau de réception* which he had to present to the Academy before he could become *académicien* and *peintre du roi*. A year later he left Sirois and went to live with the artist Nicolas Vleughels who had a house in the Saint Victor quarter; the air there, it was hoped, would be beneficial to his health.

In the autumn of 1719 he went to London, probably to consult a distinguished physician, Dr. Richard Mead. He remained in London for about nine months and had success with his pictures. But during this period there occurred in Paris the Law crash which affected his financial position, and he was only saved from disaster by Jullienne who was looking after his affairs in his absence—a service recorded by Watteau in a drawing preserved in the Oxford Ashmolean Museum.

In the summer of 1720 he returned to Paris and lodged with the art dealer Gersaint, who had married the daughter of his old friend Sirois; for this host he painted the celebrated shop-sign *L'Enseigne de Gersaint*, and he renewed relations with Jullienne and with Crozat who was giving parties " to meet " Mme Rosalba Carriera, the Venetian pastellist.

In the following year he left Paris for a country house which had been lent him at Nogent-sur-Marne. There he was visited by Gersaint, by Jullienne, and other friends; there he summoned his old pupil, Jean-Baptiste Pater, with whom he had lost touch in recent years, that he might give him some final instruction and advice; and there, after destroying some of his pictures and drawings which he considered erotic, and painting a *Christ on the Cross* as a present for the local *curé*, on 12th July, 1721, he died.

3 WATTEAU'S ŒUVRE

Characteristic Pictures

London	Buckingham Palace	La Surprise
London	National Gallery	The Guitar Player (La Gamme d'Amour)

London	Wallace Collection	The Music Lesson (Pour nous prover que cette belle)
London	Wallace Collection	Gilles and his Family (Sous un habit de Mezzetin)
London	Wallace Collection	Harlequin and Colombine (Voulez-vous triompher des belles)
London	Wallace Collection	The Champs Élysées
London	Wallace Collection	Fête in a Park (Les Amusements Champêtres)
London	Wallace Collection	The Music Party (Les Charmes de la vie)
London	Wallace Collection	The Halt during the Chase (Le Rendezvous de Chasse)
London	Wallace Collection	La Toilette
London	Soane Museum	The Marriage Contract (L'Accordée de Village)
Dulwich	Gallery	The Ball (Plaisirs du Bal)
Althorp	Lord Spencer Collection	Comédiens Italiens
Edinburgh	National Gallery of Scotland	Fêtes Vénitiennes
Glasgow	Art Gallery	The Encampment (Détachement faisant alte)
Glasgow	Art Gallery	Breaking up the Camp (Départ de troupe)
Boston	Museum of Fine Arts	La Perspective
New York	Metropolitan	Le Mezzetin
New York	Metropolitan (Bache)	Comédiens Français (Five figures)
Paris	Louvre	L'embarquement pour l'île de Cythère
Paris	Louvre	Gilles
Paris	Louvre	L'Indifférent and La Finette (Pendants)
Paris	Louvre	Jupiter et Antiope
Paris	Louvre	Pastorale (Le Berger Content)
Paris	Louvre	Assemblée dans un parc
Paris	Louvre	L'Automne
Paris	Louvre	Le Faux Pas
Washington	National Gallery	Comediens Italiens
Paris	Formerly Weill Collection	La rêve de l'artiste [N1]
Chantilly	Musée Condé	L'Amour désarmé
Chantilly	Musée Condé	Le Mezzetin
Chantilly	Musée Condé	L'Amante inquiète
Berlin	Kaiser-Friedrich Museum	L'Amour au théâtre Italien
Berlin	Kaiser-Friedrich Museum	L'Amour au théâtre Français
Berlin	Kaiser-Friedrich Museum	Assemblée galante
Berlin	Charlottenburg	L'Enseigne de Gersaint

Berlin	Castle Museum	L'embarquement pour l'île de Cythère
		La Danse (Iris c'est de bonheur) [N1]
Berlin	Charlottenburg	Les Bergers [N2]
Berlin	Charlottenburg	L'Amour Paisible
Potsdam	Sans-Souci	La Mariée de Village
Potsdam	Sans-Souci	Récréation Italienne
Dresden	Museum	Réunion Champêtre
Dresden	Museum	Plaisirs d'Amour
Madrid	Prado	L'Accordée de Village

The cataloguing of Watteau's *œuvre* began soon after his death because de Jullienne at once set about compiling a record in the form of engravings. This monumental work produced at Jullienne's expense and known as the *Recueil Jullienne* consists of more than five hundred plates after pictures and decorations (including many which have now disappeared); it is invaluable as a guide to the tones and compositions of the pictures; but unfortunately it provides no information about the dates when they were painted.

The *Recueil Jullienne* was followed by a *Catalogue raisonné* of Watteau's works, published in 1875 by Edmond de Goncourt who was responsible for the rehabilitation of Watteau in France where he had been neglected since the Revolution.

In 1912 Dr. H. Zimmermann published an illustrated photographic record of Watteau's paintings in the *Klassiker der Kunst* series and attempted a chronological arrangement; Dr. Zimmermann restricted himself to pictures still preserved but even so his list is incomplete and many pictures in private collections are omitted.

In 1921-1929 MM. Dacier and Vuaflart published a new edition of the *Recueil Jullienne* with a catalogue, and historical notes—a splendid contribution to art history; and in 1928 M. Louis Réau compiled another catalogue listing two hundred and seventy-nine pictures, seventy-two selected drawings, and ten engravings, which was published in M. Louis Dimier's *Les Peintres français du XVIIIième Siècle*.

I have used all these compilations as accompaniments to my study of Watteau's pictures; and I have suggested a chronology in the comments which follow. But the student must remember that as regards most of Watteau's pictures all datings are purely conjectural.

Watteau's earliest surviving easel pictures probably date from the years when he worked with Gillot and Audran, and they

consist partly of genre pictures in the Flemish tradition and partly of theatrical subjects treated in a way which was henceforth to be known as Watteau's way but which may have been to some extent the invention of Gillot. In any case it is certain that Gillot introduced Watteau not only to the theatre properly so called (Gillot worked for the opera) but also to the performances in the Parisian Fairs which Gillot frequented and with which he also had professional connections. At these Fairs the Italian Comedy was performed by Italian and French actors. Between 1697 and 1716 the actors were all French as the Italians were banished at that time ; this happened because in the Italian Comedy the conventional figures—Harlequin, Scapin, Pierrot, Pantalon, Mezzetin, Scaramouche, Colombine, the Doctor—indulged in much impromptu topical dialogue ; in one of their performances in 1697 called *La fausse prude* references to Mme de Maintenon were made or implied and Louis XIV banished all Italian players in order that " *le sexe* " which had applauded " *des indécences qui étoient comme des insultes solennelles faites à sa pudeur* " might henceforward be protected. The Italian Comedians were recalled by the Regent in 1716. The Franco-Italian character of the performances at the Parisian Fairs in the interval is recorded in the legend under Simonneau's engraving (begun by Watteau himself) of Watteau's *La Troupe Italienne* where we read :

> Les habits sont Italiens
> Les airs françois, et je parie
> Que dans ces vrays comediens
> Git une aimable tromperie
> Et qu'Italiens et françois
> Riant de l'humaine folie
> Ils se moquent tout à la fois
> De la france et de l'italie.

Thus Watteau himself saw first the French Comedians and, after 1716, the Italians, while Gillot had seen the Italians also before their expulsion and is believed to have made drawings of scenes at their departure. We do not know if Watteau frequented the theatre proper before he had the entrées provided by Gillot. We know that he saw Dancourt's " Les Trois Cousines " and made the acquaintance of the actress who played " La Pèlerine," the leading part (because his drawing of her in the part is engraved in the *Recueil Jullienne*), but it is not certain whether he saw the play when it was first produced in 1702 or when it was revived in 1709. In any case the experience inspired *L'Embarquement pour*

l'île de Cythère because the play ended with a ballet-cortège and the song :

Venez à l'île de Cythère
En pèlerinage avec nous
Jeune fille n'en revient guère
Ou sans amant ou sans époux.

Both Gillot and Audran worked as decorative artists in the style then known as " grotesque." This style of decoration goes back to Hellenistic painting. It then appears in Nero's *Domus Aurea* and the Christian catacombs. When antique decorations of this kind were unearthed in the Renaissance they were called *grotteschi* because the buildings in which they were found were known as grottoes ; the thrones and canopies of Apollos and Aphrodites then became the thrones and canopies of Madonnas and saints ; in the hands of Gillot and of Audran, the thrones and canopies once more receive their original inhabitants. It is recorded that Watteau became skilful in this " grotesque " decoration and executed a number of decorative commissions ; but no such paintings survive, though we know from the *Recueil Jullienne* that in his hands the thrones and canopies received pastoral figures including young women in swings, or Italian comedians, and in some cases the ornamental framework is adorned with birds or monkeys, and includes the shell or *rocaille* motive which we associate with the Louis XV style but which seems to have first appeared in decoration in the work of Oppenordt who, as noted, was employed in the Hôtel Crozat when Watteau went there to paint the dining-room panels.

Of other decorative work by Watteau in this period we know only that he produced a series in the Chinese style for the Château de la Muette where the Regent's daughter, the Duchesse de Berry, held drunken orgies from 1716 till her death three years later. The taste for *chinoiserie* in French decoration had been introduced by Mazarin who had a collection of Chinese lacquer work and porcelain ; some French lacquer work in the Chinese style was done at Versailles as early as 1655 and there were three manufactories devoted to it in Paris at the end of the seventeenth century. When Watteau worked for La Muette he had before him a collection of Chinese drawings which had been sent to Paris by some Jesuit missionaries and had greatly intrigued the amateurs who saw them. There also exists a drawing by Watteau of a Chinaman from life (Albertina, Vienna).

As noted above some of Watteau's first easel pictures were

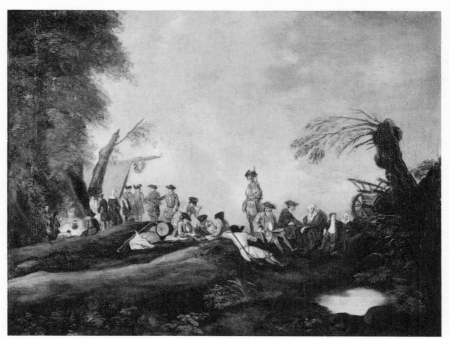

41a. ANTOINE WATTEAU: Détachement faisant alte

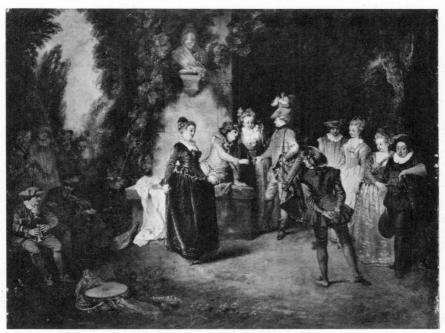

41b. ANTOINE WATTEAU: L'Amour au Théâtre Français

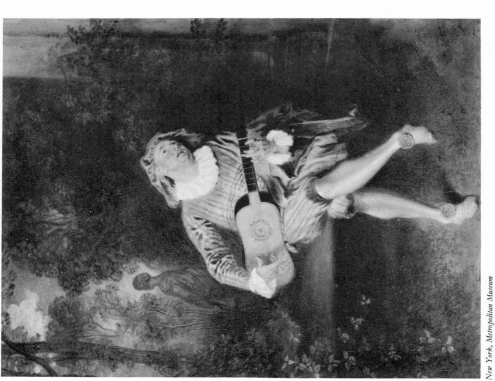

42a. ANTOINE WATTEAU: Le Mezzetin

42b. ANTOINE WATTEAU: La Finette

genre and picturesque-genre subjects. These were in the Dutch-Flemish tradition of *cortegaardjes* or camp scenes, in the manner of Palamedes Stevens, Wouwerman and so forth. The Glasgow *Détachement faisant alte* (Pl. 41a) is an example of this style which ,was soon developed, through study of other Low-Country painters, to a personal type of picturesque-genre seen in *L'Accordée de Village* in the Soane Museum, London. All through the eighteenth century Watteau was referred to as "*peintre flamand,*" and this Low-Country basis to his art is readily comprehensible. For in the first place he was in fact a Fleming ; his parents were Flemish (as Valenciennes became French only six years before he was born), and his first instructors, including Gillot himself, were also Flemish. Moreover, as a "pirate" Flemish artist, not attached to the Parisian *Maîtrise*, and not yet attached to the Academy, he naturally began by consorting with Flemish artists in Paris and thus became familiar with the Franco-Low-Country production for the popular market. In the second place, it must be remembered, there was now a vogue for the Low-Country styles among Parisian collectors and that the dealer Sirois, when he bought Watteau's early pictures and encouraged him to paint more in the same manner, was catering for this taste. *L'Accordée de Village* was actually one of the first of his pictures bought by Jullienne, who especially favoured the Low-Country schools.

In his first theatre pictures—such as *L'Amour au Théâtre Français* (Pl. 41b) and the Edinburgh *Fêtes Vénitiennes*—we get keen individual characterisation of the figures which, in fact, are all portraits. This portraiture is explained by Watteau's method of work which was the same all through his life. He never painted from nature but constructed all his pictures from his collection of drawings consisting partly of his own and other copies of drawings by the Old Masters which he kept in portfolios, and partly of his own drawings done from nature (both out of doors and in his studio), which he kept in bound sketch-books. As studio properties he had a number of theatrical and other costumes, and the figures in his pictures were painted from drawings of his friends and acquaintances dressed up in these properties. The comedians in his Italian Comedy pictures were thus, for the most part, not drawn from real Italian or even real Franco-Italian comedians ; and the figures in his *Fêtes* were the result of similar procedures.

The identity of some of the figures in the pictures of this period is known. The male dancer in the *Fêtes Vénitiennes* is Watteau's friend, the painter Vleughels. The sitter for the girl dancer in

this picture is the same as for the dancer in *L'Amour au Théâtre Français* ; she appears also in *Troupe Italienne* (*Les habits sont Italiens*), and in *La Finette* (Pl. 42b). She may have been the daughter of Sirois who married Gersaint in 1718. The *Mezzetin* in *Sous un habit de Mezzetin*, catalogued as *Gilles and his Family* in the London Wallace collection, is Sirois himself ; the women are doubtless members of his family.

In the year which Watteau spent in the Hôtel Crozat he became, artistically, more widely educated. From Crozat's treasures he absorbed the secrets of the Old Masters—especially the secret of the Venetian contribution to æsthetic. When he arrived he had with him his studies after Rubens made in the Luxembourg Palace ; when he left he carried away his copies of landscape and figure drawings by Van Dyck, Bassano, Titian, Veronese and a number after Domenico Campagnola (a Venetian of the School of Giorgione and Titian) to whom he professed his particular indebtedness.

Watteau's work in the next period was certainly influenced by Giorgione's *Concert Champêtre*, which is now in the Louvre and was later to influence Manet. In *La Perspective* (Pl. 45a) in Boston the group on the ground is the equivalent of the central group in Giorgione's picture and the light standing figure on the left is the equivalent of Giorgione's standing nude. Giorgione's picture after being owned successively by the Duke of Mantua and Charles I passed to Jabach's collection ; it was among the pictures acquired by Louis XIV in 1671. Watteau presumably saw it in the royal collections to which, of course, he could have obtained access through Crozat. On the other hand certain scholars ascribe the *Concert Champêtre* to Domenico Campagnola. It is possible that the drawing for this picture was among those by Campagnola which Watteau copied, for it is known that he admitted particular indebtedness to this artist.

In the pictures produced between the end of 1716, when he left the Hôtel Crozat, and his departure for England three years later, we see the effects of his drawings from nature in Paris and at Montmorency and of his copies of the Old Master drawings. Watteau used both types of drawing with equal freedom. In the Boston *La Perspective* (Pl. 45a), the building seen through the trees is the entrance pavilion of the Château de Montmorency. In *Plaisirs du Bal*, at Dulwich, we see the influence of Veronese, and a dog taken from one of the Rubens' panels in the Luxembourg. In the London Wallace Collection, *Les Charmes de la vie*, we have a view of the Champs Elysées and the Chaussée d'Antin

43. ANTOINE WATTEAU: Drawing

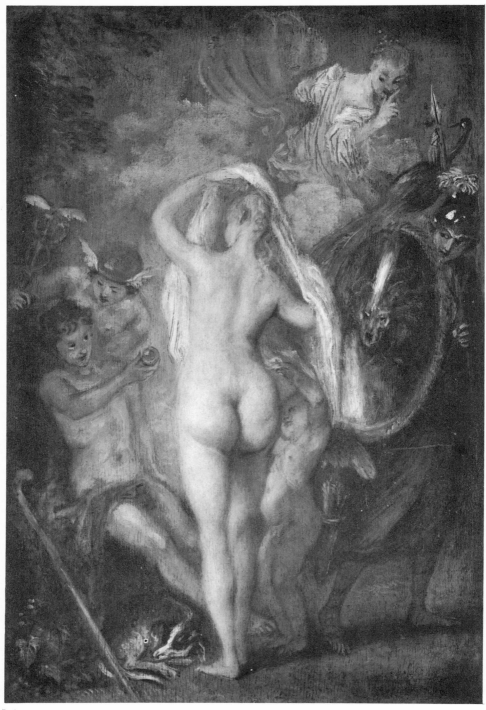

44. ANTOINE WATTEAU : Judgement of Paris

in the distance, and a dog which comes from another picture in the Rubens' series. Watteau, in fact, used the same sketch-books and portfolios all through his career, and figures and details re-occur in pictures of all periods.

His study of the Old Masters also fired him with ambitions to paint pictures with nude figures. This he did sometimes on the basis of Old Master drawings. Thus *L'Amour désarmé* in the Musée Condé at Chantilly is from a drawing by Veronese, now in the Louvre, which belonged to Crozat. But he was moved also to make his own drawings from the figure and for that he had to find a model. In Paris at this time there were no professional female models for the nude, and only male figure models were used in the Academy's school. Every artist who wanted to draw the female figure from life had to find a model among his own acquaintance. Watteau found one (who, tradition has it, also acted as his servant) and thereafter the next aspect of his *œuvre* begins.

Watteau's favourite model up to this period had been the girl dancing in the Edinburgh *Fêtes Vénitiennes*, who was *petite* with a little round head and snub nose, and has been immortalised as *La Finette* (Pl. 42b). This girl who, as noted, was possibly the daughter of Sirois, does not appear to have sat to him for the figure. She has been charming but *gauche* ; amiable but, as far as posing went, capable of nothing more than holding out her skirts at the angle directed, or sitting in an obvious pose. But with the new model it was a different matter ; the problem here was to note with sufficient speed the hundreds of delightful attitudes which she unconsciously assumed (Pl. 43). This new model appears in the Louvre *Judgement of Paris* (Pl. 44), in which Watteau captured the finer essence of the art of Rubens. She is a magni-ficently tall blonde, with a long neck and a straight nose. It is clear that she had what artists call the " sense of pose " ; and that Watteau delighted in every turn of her head, in her simple but proud carriage as she stood erect, in her habit of sitting on the ground, and in every one of the perfectly balanced attitudes into which she was, as artists say, continually falling. We see her also as the central figure in the Louvre *L'Embarquement pour l'île de Cythère* which was painted in 1717, and thereafter heads and figures painted from the hundreds of drawings which he made from her abound in his pictures. We see her in the Louvre *Le faux pas* and in the Chantilly *L'Amante inquiète*.

Watteau had now arrived at the personal and characteristic style which we associate with his name. In the next two years he

painted a number of his most celebrated *Fêtes* including the Wallace Collection *Amusements Champêtres* (Pl. 45b) and *Champs Elysées*, and the Dresden *Réunion Champêtre* and *Plaisirs d'Amour*.

To this period we can also assign a new series of Italian Comedy pictures, for which Watteau may have used drawings made from the real Italian Comedians who had now returned to Paris ; Lord Spencer's group of five figures, *Comédiens Italiens*, was probably painted in this way, and so probably was the celebrated *Gilles* (Pl. III).

There are hardly any records of the pictures which he painted in England. But we know of two which belonged to Dr. Mead— a *Comédiens Italiens* and *L'Amour paisible*, known as *Pastoral Conversation* to distinguish it from *L'Amour paisible* in Potsdam. The first, now in the Washington National Gallery of Art (Pl. 46b), is a composition of fifteen figures grouped on a stage with architectural setting. The second, also in America, shows six large figures in a landscape. In both the main figures are evidently portraits and the Louvre has a life-sized head of an old man with flowing forked beard, catalogued as *Portrait d'un anglais*, which is ascribed to Watteau and believed to have been painted in England. M. Gillet writes of this portrait : " *Cette tête a une physionomie de vieux marin, un regard de gin et d'eau salée fait songer à quelque loup de mer.*" I have not noticed this myself. The gin and salt water effect has also escaped M. Jamot who believes the picture to be a portrait of Dr. Mead.

In England to-day rich people encourage imaginative artists by commissioning them to paint " speaking likenesses " of themselves and their relations. In Watteau's day it was probably the same. In England he was probably driven to portraiture ; and on his return to Paris his friends alleged that he had become avaricious. Thus of the English visit de Caylus writes : " *Il y fut assez accuelli et ne laissa pas de faire ses affaires du côté de l'utile,*" and Gersaint writes that there " *il commença à prendre le goût pour l'argent,*" though previously " *son désintéressement etoit si grand que plus d'une fois il s'est fâché vivement contre moi, pour avoir voulu lui donner un prix raisonnable de certaines choses . . .*" Whereas of his earlier period de Caylus relates that he gave a wig-maker two pictures for a wig and was worried afterwards lest he had not given him enough.

Tendencies to portraiture and direct genre, combined with a large scale in the figures, either for this reason or some other, mark the pictures ascribed to the last year after the return from England. These pictures include the Berlin *L'Enseigne de Gersaint*

(where modish actuality appears for the first time), and the portrait of the little girl *Iris c'est de bonheur avoir l'air de la danse*, known as *La Danse* (Pl. 46a).

Many of Watteau's pictures are in bad condition. *Plaisirs du Bal*, at Dulwich, is a ruin ; *L'Accordée de Village*, in the Soane Museum, is very much and very badly repainted. The Louvre *L'embarquement pour l'île de Cythère* has suffered not only deterioration but also deliberate damage, because, as it was Watteau's *Tableau de réception* it belonged to the Académie royale and when that institution was abolished by David, it hung in the new official art school (directed by David himself) and was then so little esteemed that it was used as an " Aunt Sally " by the students who pelted it with *boulettes de mie de pain*. In many cases Watteau himself was largely responsible for the deterioration of his pictures. We know from de Caylus that he neglected to clean his oilpot and palette, that he used badly prepared canvases and too much oil with his colours, and that he resorted to the bad practice known among painters as " oiling out " when a half-completed picture had " sunk in." But some of his pictures are nevertheless in reasonably good condition ; and these, fortunately for English students, include most of the lovely Wallace Collection examples.

Watteau's *œuvre* has had an enormous influence both on painting and on decoration. The influence is seen for example all over both French and foreign decoration and tapestries in the eighteenth century. It was mainly an indirect influence—because it came through the engravings in the *Recueil Jullienne* and through the works of Watteau's followers ; but it was partly direct because as a result of the *Recueil Jullienne* Watteau's pictures were collected in the second half of the eighteenth century by the King of Prussia known as Frederick the Great and by other German princes and also in Russia. The influence came directly to England in the eighteenth century from the paintings by Watteau seen in the collection of Dr. Mead (and later, of course, from the Wallace Collection) and indirectly through the *Recueil Jullienne* to English tapestries. Thus at Ham House near London there is a set of tapestries made from these engravings (one of which reproduces *La Cascade* in the Wallace Collection) ; these tapestries signed " Bradshaw " were made in the tapestry factories at Fulham and Exeter founded in 1748 by a French capuchin P. Norbert, known as Parisot, who employed craftsmen trained at the Gobelins and they are often erroneously described as Mortlake. In English painting Watteau's influence is directly seen in the work of Hogarth

(who owned a picture by or ascribed to him and was obviously acquainted with the engravings), and also in certain works by Gainsborough. Thus Watteau's portrait *Antoine de la Roque* or the engraving from it is evidently the compositional basis of Gainsborough's *Mr. Plampin* ; and it is worth noting that whereas the attitude in Gainsborough's picture seems arbitrary, it has significance in Watteau's because the sitter was lame, having had his leg shattered at Malplaquet.

4 WATTEAU'S ART

C'est un peintre . . . qui imite à merveille la nature.

Etienne Jeaurat,[1] 1729.

Il a réussi dans les petites figures qu'il a dessinées, et qu'il a très bien groupées ; mais il n'a jamais rien fait de grand, il en étoit incapable.

Voltaire, *Le Temple du Goût.*

Le goût qu'il a suivi est proprement celui des bambochades.

D'Argenville, *Abrégé de la vie des plus fameux peintres,*
1745.

N'aiant aucune connoissance de l'anatomie, et n'aiant presque jamais dessiné le nud, il ne sçavoit ni le lire, ni l'exprimer . . . Cette insuffisance dans la pratique du dessin le mettoit hors de portée de peindre ni de composer rien de héroïque ni d'allégorique, encore moins de rendre les figures d'une certaine grandeur . . . Les dégoûts qu'il prenoit si souvent pour ses propres ouvrages, partoient de la situation d'un homme qui pense mieux qu'il ne peut exécuter . . . Au fond, il en faut convenir, Wateau étoit infiniment maniéré.

Le Comte de Caylus. Lecture on Watteau to the Royal Academy of painting and sculpture 3 Feb., 1748.

Je donnerais dix Watteau pour un Téniers.

Diderot, *Pensées détachées sur la peinture, c.* 1760.

Watteau is a master I adore. He unites in his small figures correct drawing, the spirited touch of Velasquez with the colouring of the Venetian school.

Sir Joshua Reynolds.

I have learned more from Watteau than from any other Painter.

J. M. W. Turner, R.A.

Watteau, ce carnaval où bien des cœurs illustres,
Commes des papillons, errent en flamboyant,
Décors frais et légers éclairés par des lustres
Qui versent la folie à ce bal tournoyant.

Baudelaire, *Les Phares,* 1857.

[1] A genre and decorative painter (1699-1789) who engraved a number of Watteau's works.

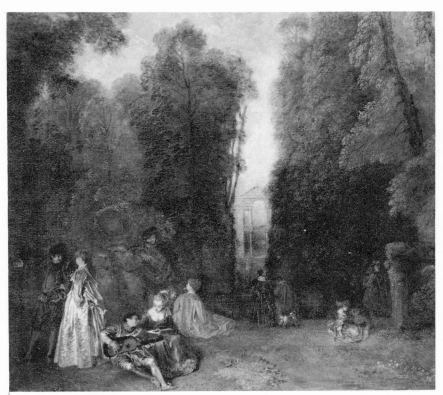

45a. ANTOINE WATTEAU: La Perspective

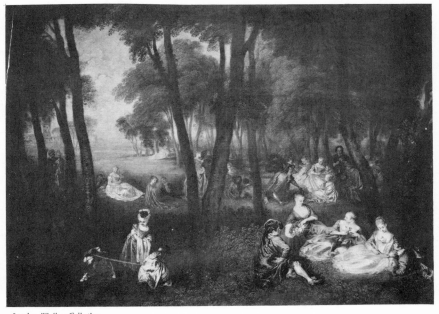

45b. ANTOINE WATTEAU: Les Amusements Champêtres

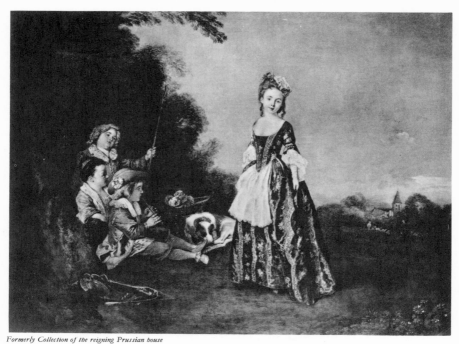

46a. ANTOINE WATTEAU: La Danse

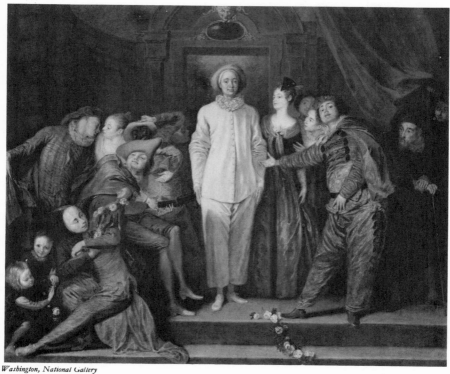

46b. ANTOINE WATTEAU: Les Comédiens Italiens

Le grand poète du XVIII^e siècle est Watteau.
<div style="text-align:right">Edmond and Jules de Goncourt, 1860.</div>

The French . . . have never produced a single great painter. Watteau, their best, is still a mere room decorator.
<div style="text-align:right">Ruskin, 1878.</div>

That impossible or forbidden world which the mason's boy saw through the closed gateways of the enchanted garden.
<div style="text-align:right">Walter Pater, 1887.</div>

Son défaut, c'est de voir le monde comme une scène de l'Opéra, éclairée aux feux de Bengale, de n'être ni passionné ni ému, de se jouer à la surface des choses.
<div style="text-align:right">Salomon Reinach, 1904.</div>

Il sent qu'il va mourir.
<div style="text-align:right">Elie Faure, 1920.</div>

Cette œuvre . . . était l'illustration de l'état d'âme d'un phtisique caractérisé . . . Une maladie est un état, ce n'est pas nécessairement une tare. Elle peut exalter autant que paralyser . . . Il est permis de penser que sans elle ni Watteau, ni Mozart, ni Chopin . . . n'eussent été tels que nous les admirons.
<div style="text-align:right">Camille Mauclair, 1920.</div>

Pictorial visions of a world devoted to beauty and idle dalliance.
<div style="text-align:right">Sir Charles Holmes, 1927.</div>

It is possible to exaggerate the permanent æsthetic value of his painting, as it is easy to read into it more spiritual and psychological significance than is really there. . . . With happy carelessness he scatters his little figures, like so many glittering butterflies, along the grass under his feathery trees, rarely troubling about the exact proportion of the groups to the background, and never about the formal geometry of design.
<div style="text-align:right">Sir Charles Holmes, 1927.</div>

Watteau's art must be judged by the pictures painted from 1716 to 1720—the finest of his *Fêtes* such as *L'Embarquement pour l'île de Cythère* and *Les Amusements Champêtres* (Pl. 45b). Those pictures were described in his own day as *Fêtes galantes* and we must know what the term then meant if we are properly to understand them.

The word *galant* has acquired a pejoratory significance from its use in connection with the type of French print of the later eighteenth century known as *estampe galante*. In Watteau's day the word *galant* had not yet acquired this association with dainty lasciviousness. It was used to describe the new cultural values of the most refined sections of Parisian society.

When Watteau was received by the Academy he was described

as *peintre des fêtes galantes*. No artist had ever been so described before because Paris had never known a *vie galante* till it was created there by the *noblesse d'affaires* represented by men like Crozat and Jullienne and the ladies of their world. The particular qualities by which Parisian civilisation is still to a great extent characterised to-day were born at the very moment that Watteau was painting his pictures. La Finette as transformed by Watteau was the first " Parisienne," and the afternoon parties in the park at Montmorency, which Watteau attended, were the first expression of a culture that was about to call for the exquisite applied arts of the Louis XV and Louis XVI styles. Watteau's sensibility was stirred by contact with this civilisation which was all the more attractive because it was still a civilisation in the bud, a civilisation which had not yet revealed the imperfections of the flower.

I have referred above to the influence of Giorgione's *Concert Champêtre* on Watteau's work. Watteau, I think, responded to this picture not only on account of its pictorial and æsthetic qualities but also because the Venetian civilisation symbolised by Giorgione was parallel to the Parisian civilisation by which Watteau himself was surrounded in Crozat's park. An artist can do nothing till he perceives, actually or in imagination, an aspect of life that holds his attention ; he is sterile till he feels himself part of an actual or imagined world which he can contemplate with fascinated interest. Having found such a world he has to retain his faith in it, and to do this he turns to the past for evidence that men have been intrigued by such a real or imagined world before. Giorgione appeared at the moment when the new-rich Venetians and their sons were turning their backs on business and seeking a new civilisation in villas on the mainland, where for the first time in Venetian history they could lie upon the grass beneath the shade of trees ; and he sublimated this new amenity. When Watteau saw *Concert Champêtre* he had found the precedent he was seeking.

I say that Giorgione " sublimated " the civilisation which surrounded him, because the *Concert Champêtre* is not a *record* of a social gathering in a Venetian garden, as for example Van Loo's *Déjeuner de Chasse* (Pl. 49b) is a record of a social gathering at Fontainebleau ; and it was this sublimation that appealed to Watteau who knew that the ladies in Venetian gardens did not habitually wander nude, just as we know that Crozat's guests at Montmorency were infrequently, if ever, garbed in the clothes from Watteau's property-wardrobe or the costumes of mummers

at Fairs. Watteau saw that Giorgione's picture symbolised the
ideal conclusion of a civilisation which (we now know), in fact,
concluded in the society that Napoleon kicked into the sea ; and
we can see that Watteau's pictures symbolised the ideal conclusion
of a civilisation which in fact concluded in the society that was
exterminated by the Revolution and the guillotine.

In our day Watteau's pictures appeal, as they appealed in their
own day, to the bourgeois spirit in its least Philistine aspect. The
bourgeois when he is a Philistine resents all art except popular art
which is produced to achieve contact with his familiar experience.
When he is not a Philistine he wishes to be transported by means
of art from the realities of every-day life to a world " devoted to
beauty and idle dalliance." But he makes it a condition that this
ideal world shall be one in which he can imagine himself a regular
inhabitant. The imaginative bourgeois can project himself into
Watteau's *Fêtes galantes* ; but he cannot project himself into the
pastoral and mythological world of Boucher ; therefore he prefers
Watteau to Boucher.

But Watteau's pictures also appeal to those who ask art to
provide a microcosmic concept as a means of focussing life as a
whole. These spectators enjoy the generic character of the little
figures in Watteau's pictures and their relation to the woods and
parks in which they move. To escape from the frets and fears of
our age to Watteau's *Amusements Champêtres*—where generic
figures seem to have achieved a perfect and simple adjustment to
surrounding life—is to capture, for a moment, a sense of propor-
tion, and with it refreshment and repose.

5 WATTEAU'S CHARACTER

Watteau's biographers from de Caylus to M. Camille Mauclair
have insisted on his waywardness and his restless discontent.
De Caylus describes Watteau's personality as follows : " *Il étoit
de moienne taille, il n'avoit point du tout de phisionomie, ses yeux n'indi-
quoient ni son talent ni la vivacité de son esprit. Il étoit sombre, mélan-
colique, comme le sont tous les atrabilaires, naturellement sobre et incapable
d'aucun excès. La pureté de ses mœurs lui permettoit à peine de jouir
du libertinage de son esprit, et on s'en apercevoit rarement dans ses
discours* " ; and he assumed that his discontent was due to know-
ledge that his productions fell short of the standards of the
Academic " Grand Manner." Gersaint's description reads :
" *Watteau étoit de moyenne taille et d'une foible constitution, il avoit le
caractère inquiet et changeant, il étoit entier dans ses volontés, libertin*

d'esprit, mais sage de mœurs ; impatient, timide, d'un abord froid et embarrassé, discret et réservé avec les inconnus, bon, mais difficile ami ; misantrope, même critique malin et mordant, toujours mécontent de lui même et des autres et pardonnant difficilement ; il aimoit beaucoup la lecture ; c'étoit l'unique amusement qu'il se procuroit dans son loisir ; quoique sans lettres, il décidoit assez sainement d'un ouvrage d'esprit."

The explanation of Watteau's discontent, his irritability, his depressions, his flight from the Hôtel Crozat, and his flight from the kind offices of his other friends, can be explained, I fancy, by the eternal opposition between the original creative artist and the personnel of both the bourgeois and the social-artistic worlds. Watteau owed his existence as an independent artist to the friendship of contemporary *dilettanti* ; without their aid his poverty might have kept him a hack assistant to other painters all his life. But the friendship, in which from their good nature these *dilettanti* enveloped their patronage, was a source of continual irritation. Watteau's reason reminded him of his debt to Crozat and Jullienne, but he could never feel at home in the company of men who, after all, were millionaires with a sense of values that were inevitably foreign not only to Watteau " the mason's boy " but also to Watteau the painter of *Amusements Champêtres* and *L'Embarquement pour Cythère*. From the millionaires Watteau might escape to Sirois and Gersaint, well-meaning *petits bourgeois* of moderate means ; but there again Watteau, the artist, was out of touch with an environment which regarded pictures, at bottom, as a means of making money ; though we know that in their affection for Watteau neither Sirois nor Gersaint ever stressed this point of view.

De Caylus, who never appreciated the real character of Watteau's art, has nevertheless provided us with the key to his character. In the rooms which he hired as studios, where he drew with Henin and Watteau from the model, Watteau, he tells us, " *si sombre, si atrabilaire, si timide, et si caustique partout ailleurs, n'étoit plus alors que le Wateau de ses tableaux ; c'est à dire l'auteur qu'ils font imaginer, agréable, tendre et peut être un peu berger.*" It was only when Watteau was working that he could forget his benefactors—Crozat, Jullienne, Sirois, Gersaint, and de Caylus himself who was paying for the studio ; and it was because Watteau could only feel at ease in the sublimation of the world around him that he gave that world his delicately sublimated images of itself.

47.　NICOLAS LANCRET: Mlle. Camargo dancing

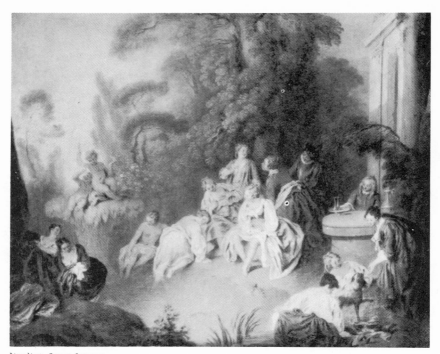

48a. JEAN-BAPTISTE PATER: Le Bain

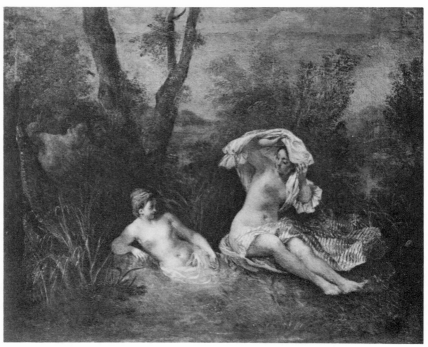

48b. NICOLAS LANCRET: Les deux Baigneuses

6 WATTEAU'S FOLLOWERS

The best known of Watteau's followers were Jean-Baptiste Pater and Nicolas Lancret.

Jean-Baptiste Pater (1695-1736) was a native of Valenciennes and he worked, as noted, in Watteau's atelier about 1713. Watteau eventually quarrelled with him and he returned to Valenciennes. There, since he had had some success with his pictures in Paris, he refused to submit a work to the local Guild of Luc to qualify as *maître*, and when he began to offer his pictures for sale the Guild prosecuted him as a *fraudeur de l'art de la peinture*, and it also prosecuted his father, a well-known local sculptor, as an accomplice. Pater and his father appealed from Court to Court and lost every appeal. In the end, driven out of Valenciennes, Pater returned to Paris. This was about 1719. In the following year, he was summoned by Watteau to Nogent and from that time till his death, sixteen years later, he continuously produced pictures in the manner of his master. He was received into the Academy in 1728 as *peintre de sujets modernes*—his subjects being mainly *fêtes galantes* and picturesque military camp scenes.

Pater's pictures are often impregnated with a delicate blue haze and seem at first slighter, more ethereal, and less realistic than Watteau's. But in spirit they are really more actual. They depict fragments of the life of the time with an eye that is almost journalistic. The ethereal quality is technical; the spiritual quality is genre.

His work stands, in fact, half-way between Watteau's pictures and the *estampes galantes*. In Pater's pictures the lovers make more daring advances, and the ladies who sit before their mirrors while their maids adjust their hair, or bathe so discreetly in a lake, are often hoping that some adventurous young gallant is concealed behind the curtains or among the trees. The Louvre and the London Wallace Collection have pictures by Pater where gallants in fact are so concealed. In the Louvre picture, moreover, the genre character of Pater's imagination is seen in the gesture of the maid who warms some undergarments by the fire ; the gesture would never have occurred to Watteau.

The most important collections of Pater's work are in the Potsdam Palaces and the London Wallace Collection. There are others in the Louvre, at Valenciennes, at Angers and in the National Gallery of Scotland. I reproduce an example from a private collection in New York (Pl. 48a).

Nicolas Lancret (1690-1743) was a Parisian and a fellow pupil

with Watteau in the atelier of Claude Gillot. He continued re-
lations with Watteau, who was six years his senior, for a number
of years, until, tradition has it, Watteau quarrelled with him when
Jullienne had bought two of his pictures exhibited in 1714 in
the open-air picture shows on the Place Dauphine—(this show
was held every year on Corpus Christi Day and the procession
terminated at an altar ; the walls of all the adjacent houses and
shops were hung with carpets and draperies from an early hour
in the morning and pictures by Old Masters and contemporary
artists were attached to them ; the exhibition lasted only till the
ceremony was over and then the draperies and pictures were re-
moved ; the pictures which Lancret exhibited there in 1714 are
said to have been mistaken for the work of Watteau himself).

Lancret's pictures are sometimes discordant in colour ; but he
was a more capable representational draughtsman than Pater and
his figures often show a solidity which appeals to admirers of
genre art. *Les deux baigneuses* (Pl. 48b) shows this aspect of his
draughtsmanship.

Like Pater, he brought Watteau's art back to the genre level ;
and he also carried on the actuality and modishness which appeared
in Watteau's *Enseigne de Gersaint*. He painted a number of Italian
Comedy pictures in imitation of Watteau and also a number of
pictures representing contemporary stage favourites such as the
dancer *La Camargo* (Pl. 47) and her rival La Salle. He may have
met both dancers in the *salon* of the collector Titon de Tillet, who
entertained dancers from the Opera and adopted Corneille's niece.
Of the rivalry between La Camargo and La Salle, Voltaire wrote :

> *Ah ! Camargo, que vous êtes brillante !*
> *Mais que Salle, grands dieux, est ravissante !*
> *Que vos pas sont legers, et que les siens sont doux !*
> *Elle est inimitable, et vous toujours nouvelle.*
> *Les Nymphes sautent comme vous,*
> *Et les Grâces dansent comme elle.*

The National Gallery, Washington, has *La Camargo dancing with
her partner Laval* with landscape background and an elegant
company as spectators.

Lancret appears as genre painter, pure and simple, in *La Malice*
(Dublin: National Gallery of Ireland) and *Le Valet Galant* (Lenin-
grad : Hermitage). He is seen at his best in *The Hunt Luncheon*
(Pl. 49a) in the Detroit Institute of Arts, a sketch for *La Collation
après la Chasse* (formerly at Potsdam) ; and it is interesting to
compare this with Carle van Loo's capable but rather prosaic

Déjeuner de Chasse (Pl. 49b) painted for Fontainebleau and now in the Louvre.

At his worst Lancret achieved a final metamorphosis of Watteau's style to purely journalistic genre. The celebrated *Déjeuner de jambon* (now in the Musée Condé at Chantilly) depicts a scene of drunkenness and gluttony which takes us back to the eating-and-drinking art of seventeenth-century Holland. But the gluttons and drunkards in Lancret's picture are no longer peasants or members of the *petite bourgeoisie*—they are persons of " quality " continuing the tradition of the Regent's gluttonous and drunken suppers. This *Déjeuner de jambon* was one of four pictures for the *petits cabinets* at Versailles arranged for Louis XV, who, following the taste of the time, neglected the great galleries and preferred small apartments in the Palace and in the Grand Trianon (which Louis XIV had built for Mme de Maintenon). The other three panels were painted by Jean François de Troy ; one of them, *Le Déjeuner d'huîtres*, preserved at Chantilly, is as much a scene of gluttony as Lancret's picture.

Another Watteau follower who may indeed have begun as a Watteau pupil was Pierre Antoine Quillard (1701 ?-1733). He was introduced as a prodigy to Louis XV by Cardinal Fleury, and was second to Boucher in the Prix de Rome competition in 1723. Quillard went to Portugal where he painted altarpieces for churches and decorations for palaces ; and was made Court painter by John V. A *Fête galante in a Park* signed and dated 1730 in the Duke of Cadaval's collection in Portugal is a key-picture for his works in Watteau's manner ; and a number of such subjects— some previously ascribed to Watteau—are now ascribed to him.

After the publication of the *Recueil Jullienne* Watteau's style was widely imitated. Quillard, as just noted, took it to Portugal ; and Norblin de la Gourdaine (1745-1830) made dainty *pastiches* from it in *gouache* (Pl. 50) which he carried to Poland where he worked for Court circles for some thirty years ; and it appears in countless paintings on French eighteenth-century furniture (exported all over Europe), and in countless upholstery designs and tapestries.

I THE LOUIS XV STYLE

Louis XV, great grandson of Louis XIV, was born in 1710. He was five years old when he succeeded, and he was thirteen when the Regent died in 1723.

His reign, from the standpoint of the art-historian, can be divided into three sections : (*a*) the Regency and the period from 1726 to 1743, when France was ruled by Cardinal Fleury, (*b*) the period of the influence of Mme de Pompadour, 1745 to 1764, and (*c*) the final period of Mme du Barry, 1769 to 1774.

The growth of Paris as a social centre was encouraged by the Regent, who installed himself in the Palais Royal and the King in the Tuileries. The theatre, the opera and the public masked balls instituted at the Opera in 1716 now became features of social life. The masked balls, to which the public paid for admission, were indeed the idea of the Regent who himself attended them ; they proved so lucrative that others were instituted in the galleries of the *Académie française* in the Louvre. Later the arcades of the Palais Royal and the boulevards, with the first cafés, became *rendez-vous* of fashion. The cafés, a development of the old cabarets of ill-repute, were at first tea and coffee houses ; the purveyance of " soft " drinks was then, as now, so fantastically profitable that the number of cafés soon increased ; in 1723 there were 400 in Paris, in 1788 there were 1,800. Under the Regency also, many private mansions were constructed by the new rich, who included the Crozats and Jullienne already mentioned, and this continued in the period of Fleury.

The taste was now for smaller houses and more intimate apartments ; ladies of a frivolous turn of mind had their boudoirs for flirtations and others had their Salons where they entertained artists and men of letters. The seventeenth-century Salons were destroyed by Molière's *Les précieuses ridicules.* The Salons now founded continued all through the eighteenth century and were an important factor in the development of the free thought of an age which began with the tradition of Colbert's King-State-Socialism and passed viâ Voltaire to the Back-to-Nature Individualism of Jean-Jacques Rousseau.

In these circumstances, as a hundred years earlier, the owners of the new *hôtels* required artists and craftsmen, and the King also

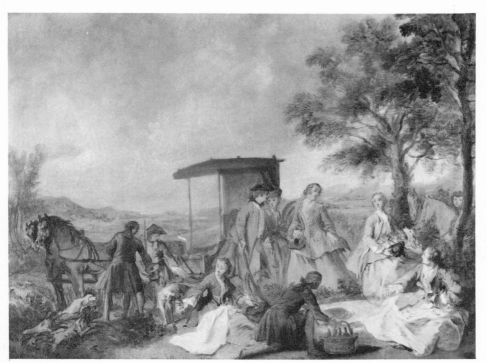

49a. NICOLAS LANCRET: The Hunt Luncheon

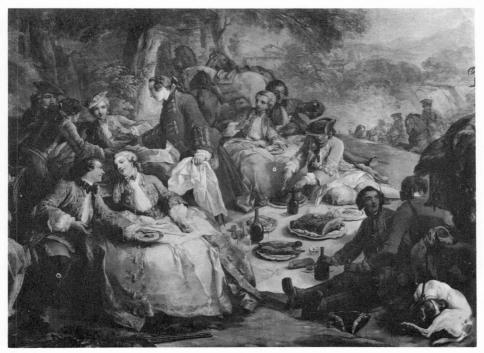

49b. CARLE VAN LOO: Déjeuner de Chasse (detail)

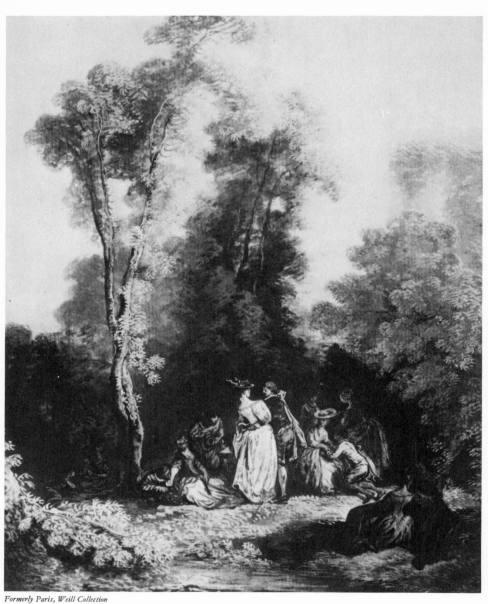

50. NORBLIN DE LA GOURDAINE: Fête Galante

required them for the new small apartments in his residences. The Louis XV or *rocaille* style in architecture and the applied arts, which had really begun at the end of the reign of Louis XIV and was definitely launched under the Regency, was the result of these demands.

The characteristics of this style are well known because from France it was exported to and imitated by every country in the civilised world. It was a style which used the minimum of straight lines in the architecture and in the furniture and appointments designed to go with it. Its essential feature was the Chinese broken curve, which was soon developed to characteristic shell and foliage forms. Chinese *motifs* occur indeed all over the marquetry in French furniture of this period. I have referred to Oppenordt as a pioneer of the *rocaille* style. Other pioneers of the style were Just Aurèle Meissonier, Robert Martin and Charles Cressent.

The vast production of applied art from this period to the end of the old régime was possible because the organisation of French art effected by Colbert and Le Brun was still in existence. The Gobelins factory had passed through serious depression at the end of the reign of Louis XIV, and had at one time been closed, but it now recommenced the manufacture of applied art—especially of tapestry which was also produced in the associated factory at Beauvais. In 1738 the Sèvres porcelain factory (which was moved to Sèvres in 1756) was established at Vincennes ; and various new establishments of cabinet-makers obtained official patronage about the same time. There was no lack of skilled operatives because institutions, with royal protection, trained them all over France, until the whole organisation was abolished in the Revolution.

2 PORTRAIT PAINTERS

We are so accustomed to associate the age of Louis XV with the *rocaille* style in applied art and with the decorative painting by François Boucher which went with it that we are apt to forget that the age also produced some excellent portraiture. Rigaud and Largillière both practised right up to the advent of Mme de Pompadour, since Rigaud, as noted, lived till 1743 and Largillière till 1746 ; and the same period witnessed the rise and first successes of Jean-Marc Nattier, and the portrait painting of Subleyras, Pesne, Aved, Dumont and Tocqué, and much of the work of the pastellists La Tour and Perronneau.

Jean-Marc Nattier (1685-1766) began his career with a commission from Louis XIV to engrave the Rubens panels in the

Luxembourg. In 1717 he made a journey to Amsterdam with the ambassador of Peter the Great and painted the Czar, who was then in that city, and the Czarina, then at The Hague. In Holland he studied the works of Rembrandt and he afterwards adapted some of Rembrandt's effects of light and some of his compositional *motifs* to his own ends. In his portrait *Madame Victoire as Diana* (Pl. 51b) at Versailles, for example, we see in the background the rock aperture which figures in the background of many of Rembrandt's pictures, a *motif* which Rembrandt himself took over from Lastman and Pynas (*cf.* my *Dutch Painting*). The same Rembrandtesque background appears in Nattier's *La Madeleine* in the Louvre. Nattier's portraits of the Czar and Czarina, formerly in the Winter Palace, are now in the Leningrad Hermitage Museum. In Amsterdam Nattier also painted *The Battle of Pultava* for the Czar. This picture was believed lost, but it has been discovered since the Russian Revolution in the castle of Sytchevka and transferred to the Moscow Museum.

On his return to Paris from Holland he lost most of his money in the Law crash but he recovered by creating a vogue for an allegorical type of portrait in which he painted the first favourites of Louis XV and other ladies in Court circles.

Nattier was not, of course, the inventor of the allegorical portraiture of ladies in French art. We have already noted such portraiture among the productions of the School of Fontainebleau ; Jean Nocret the Elder (1618-1671) had painted *Louis XIV, Queen Maria-Thérèse, Monsieur the King's brother, and Henrietta Maria, widow of Charles I of England* as Olympian deities in a fantastic composition (Versailles) ; Mignard's portrait of the *Marquise de Seignelay as Thetis* (Pl. 40a) painted in 1691 was a little different as it doubtless recorded some actual charade ; but Largillière had painted *Mme de Gueydan as a Naiad* (Aix-en-Provence Museum) and other such pictures in Nattier's own day, and Raoux also painted a number of society ladies in this manner. It was, however, unquestionably Nattier who launched the vogue for this type of portraiture at this period.

Commissioned by the Queen, Marie Leczinska, to paint her daughter Madame Henriette, he produced the celebrated full-length *Mme Henriette playing the violoncello* (Versailles). Thereafter he became the official Court painter of the Princesses.

Nattier sometimes painted his sitters in the actual fashions of the day. His *Mlle Beaujolais* (Pl. 51a), for example, at Versailles, is a charming embodiment of the rose-and-lace aspect of French

civilisation at this time. No painter has recorded this aspect with more sympathy, delicacy and skill.

At his best he achieved very charming pearly tints in his flesh painting. He had a large collection of sea-shells which he studied for their form and colour—(collections of shells were very fashionable in Paris at this time ; Boucher also had one).

Reynolds who was in Paris in 1752 and again in 1771 possibly had Nattier's three-quarter-length portrait of the Queen (now at Versailles) in his mind when he painted *The Countess of Albemarle* (London National Gallery) in 1757-1759.

Pierre-Hubert Subleyras (1699-1749) went to Rome at the age of twenty-eight and remained there for the rest of his life. He painted mostly religious pictures for Italian churches and occasionally still life and genre subjects. His real talent, however, was for portraiture as can be seen in his *Pope Benoit XIV*, now in the Musée Condé at Chantilly. The Art Museum at Worcester (Mass.) has another example of his talent in this field—a portrait of *Maria Tibaldi*, the miniature painter, whom he married.

Antoine Pesne (1683-1757) was another artist who lived most of his life abroad, as he became Court painter to the King of Prussia. His portrait of Frederick the Great is in the Kaiser [N1] Friedrich Museum in Berlin. There too is his *Self Portrait with his two daughters*, signed and dated 1754. The Rouen Museum has his portrait, *The Artist's Daughter* (Pl. 55b), which Reynolds may also have seen. The Art Museum at Worcester (Mass.) has his portrait *The engraver F. G. Schmidt*, and the Louvre his *Nicolas Vleughels*.

Pesne also painted a portrait of Frederick the Great's favourite bitch " Byges " and, as Voltaire tells us, a Priapian composition, designed by the King himself, for the King's private dining-room. Frederick wrote a poem in his honour which began :

> *Quel spectacle étonnant vient de frapper mes yeux*
> *Cher Pesne, ton pinceau t'égale au rang des dieux.*

Jacques-André-Joseph Aved (1702-1766), son of a doctor of Douai, was brought up in Amsterdam. He was impressed at an early age by the art of Rembrandt and eventually owned eight of his pictures and a complete set of his etchings. His portrait of *Mme Crozat*, painted in 1741 and now in the Montpellier Museum, may also have influenced Reynolds. Aved was intimate with and had an influence on Chardin.

Jacques Dumont (1701-1781) was a minor history-painter in the Academic tradition. His name is preserved by the Louvre

group of eleven figures, *Mme Mercier, the nurse of Louis XV, exhibiting the King's portrait to her family*, which is a faithful record of bourgeois costumes and types in the year 1731 when it was painted.

Louis Tocqué (1696-1772), painter of the charming *Mlle de Coislin* (London, National Gallery), went to St. Petersbourg in 1757 where he painted the Empress Elizabeth, and then to Copenhagen where he painted King Frederick V. He was a great ambassador for French culture and many Russian and Danish students went to Paris to study as a result of his travels.

3 PASTELLISTS

The vogue for pastel portraits was started under the Regency by the Venetian pastellist Rosalba Carriera, who came to Paris in 1719-20 and stayed in the house of Pierre Crozat. Before Rosalba's time there had been a number of French artists who specialised in pastel. Robert Nanteuil had used the medium in the seventeenth century and he was followed by Joseph Vivien (1657-1725), who was drawing bold pastel portraits in the Rigaud manner when Rosalba arrived. But the light touch, the piquant distortions of drawing, and the vaporous colour in the Venetian artist's work appealed to those who wanted dainty ornamental portraits for their boudoirs, and after Rosalba's return to Venice the fashion which she had started was continued by Nattier and given a new significance by La Tour and Perronneau.

Maurice-Quentin de La Tour (1704-1788) was the son of a precentor at St. Quentin. He ran away to Paris at the age of fifteen to become an artist, and after the usual apprenticeship to various artists and a certain amount of travelling in search of work, including a visit to London, he began, about 1730, to get commissions for pastel portraits in Paris.

In 1737 the Academy organised the first Salon of the reign, and there La Tour exhibited two portraits which attracted attention. Three years later he staggered the Salon public with his full-length pastel portrait, *The President of the Chambre des Enquêtes du Parlement*, one Gabriel Bernard de Rieux. From this date onwards he had continuous success ; he drew pastel portraits of the King, the Queen and the Dauphin ; and his full-length *Mme de Pompadour*, now in the Louvre, was a feature of the Salon of 1755.

La Tour was a splendid workman and a man of a downright character. Many stories are related of his independent attitude in

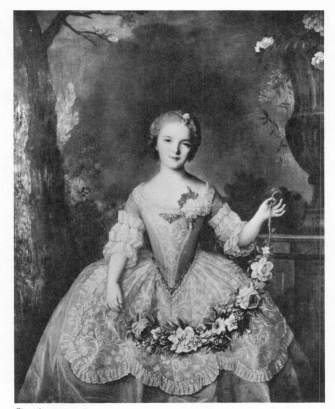

Chantilly, Musée Condé

51a. JEAN-MARC NATTIER: Mlle. Beaujolais

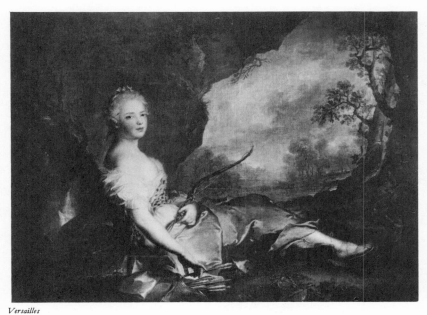

Versailles

51b. JEAN-MARC NATTIER: Mme. Victoire as Diana

52b. JEAN-BAPTISTE PERRONEAU: Le Comte de Bastard

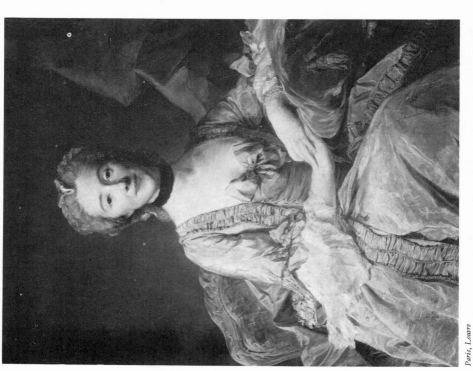

52a. JEAN-BAPTISTE PERRONEAU: Mme. de Sorquainville

dealing with his sitters and also of the originality and independence of his life, which culminated in madness in his last years. On one occasion, for example, a financier sent his servant to La Tour to explain that he was unable to come to a sitting. La Tour, who was sitting at his easel waiting to begin work, flew into a rage, comprehensible to all artists, and forced the servant to sit instead of his master. He then sent the portrait of the servant to the Salon and refused to continue the original commission.

La Tour made all his sitters come to the studio which had been allotted to him in the Louvre. He made an exception, however, in the case of Mme de Pompadour, whom he drew at Versailles ; but he astonished the Marquise by undoing his shoe-buckles and taking off his garters, collar and wig that he might be at his ease before commencing work, and when the King entered during a sitting he refused to continue work as he never drew with a third person in the room. He also refused to complete portraits of the Princesses because they had failed to keep appointments for sittings.

He received large sums for his portraits and he amassed a great fortune, part of which he spent on founding scholarships for artists and in benefactions to his native town. He never married and was for many years the lover of Marie Fel (Pl. 53b), the opera singer, who sang Colette in Jean-Jacques Rousseau's *Devin de Village*. He drew a portrait of Rousseau, the study for which is preserved at St. Quentin.

La Tour's art was well calculated to attract attention under the new conditions of public exhibition inaugurated by the Salons, where the first essential of success in portraiture, as in other fields, was the power to produce a work that would destroy its immediate neighbours by superior vitality and vigour. His pastels possess these qualities in a superlative degree. No portrait painter has surpassed him in vigorous and accurate delineation ; no painter has ever made faces that seem more astonishingly vital or more obviously " speaking likenesses " ; and as the colours in all his portraits are bright and the tones what painters call " pitched up," any La Tour portrait in any exhibition arrests even the most listless visitor at once.

La Tour's talents are seen at their best in the series of studies preserved in the Museum at St. Quentin. From the study, *The Painter Claude Dupouch*, we know not only the sitter's exact features but also exactly the hours that have passed since he last shaved—rather inadequately—his lips and chin. In *The Actor*

Manelli (Pl. 53a), we cannot escape the fascination of the dark quivering eyebrow and the amazing smile framed between the white of the wig and the pink of the tie on the blue and gold coat. What face in the history of portrait-painting is more memorable than *Marie Fel*? What camera could have told us more of the French professional man of the period in his own home than La Tour tells us in *The Lawyer Pierre-Louis Laideguive* (Pl. 54)? For La Tour quite consciously attempted to suggest environment not only in accessories but also in the actual faces in his pastels. In this connection he wrote: " *Il n'y a dans la nature, ni par consé-quent dans l'art, aucun être osif. Mais tout être a dû souffrir plus ou moins de la fatigue de son état. Il en porte l'empreinte plus ou moins marquée. Le premier point est de bien saisir cette empreinte . . .*"

Jean-Baptiste Perronneau (1715-1783) was a man of different calibre from La Tour and he had a very different career. Retiring by nature, in no sense a good business man, tentative in his approaches both as an artist and as a man, he never captured the favour of the great and spent his time wandering in the French provinces, in Holland, and even as far as Russia, doing pastel portraits for a livelihood, and when he arrived in a provincial town he used to send the town crier to announce in the market-place his address and his prices for portraits.

As a portraitist he is less downright and categoric than La Tour and the quality of his touch suggests a sensibility that appeals to many collectors to-day. For students of English painting he is, moreover, an especially interesting artist because he stood, in a sense, in much the same relation to La Tour that Gainsborough stood to Reynolds. I reproduce his delicately seen oil-painting *Mme de Sorquainville* (Pl. 52a), now in the Louvre, and his expressive pastel *Le Comte de Bastard* (Pl. 52b), formerly in the collection of M. David Weill. The London National Gallery has a poor example, *Girl with a Kitten*, and the St. Quentin Museum has his pastel portrait of La Tour.

4 GENRE PAINTING

The influence of Rembrandt, already noted in portraits by Rigaud, Nattier and Aved, also appears in the French genre pictures of the eighteenth century. This influence is evident, for example, in the *Jeune fille lisant une lettre* (Pl. 56b) and *Jeune fille et sa grandmère* (Pl. 56a) by Jean Raoux (1677-1734), an eclectic artist who also painted history and decorative pictures, *fêtes galantes* and allegorical portraits. Raoux visited Italy and England. But

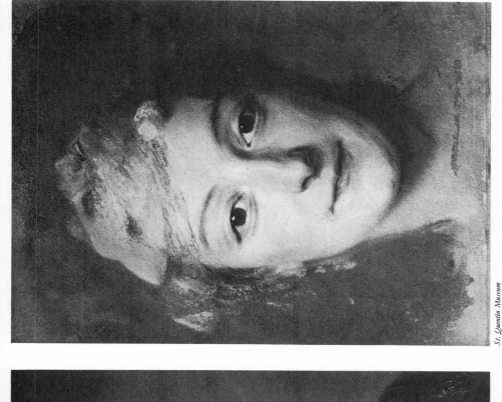

St. Quentin Museum

53b. MAURICE-QUENTIN DE LA TOUR: Mlle. Fel

St. Quentin Museum

53a. MAURICE-QUENTIN DE LA TOUR: The Actor Manelli

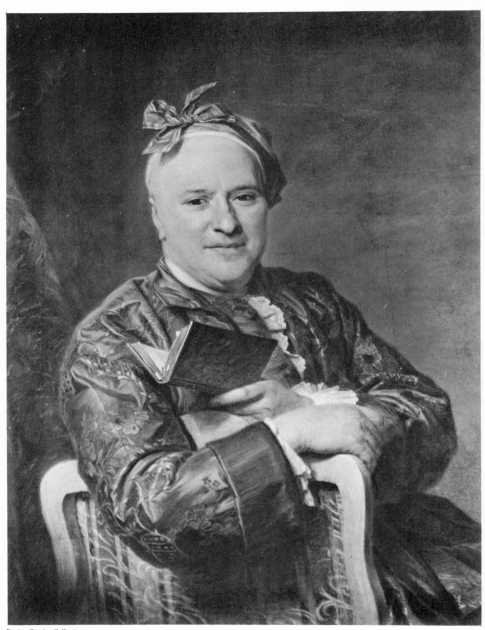

54. MAURICE-QUENTIN DE LA TOUR: The Lawyer Laideguive

there is no record that he visited Holland, and the Rembrandt influence may have come to him viâ Nattier (and Rembrandt's etchings). As an allegorical portraitist he is well seen in the signed *Mlle Prévost as a Bacchante* (Tours Museum), where the opera dancer in the foreground is " supported " by a number of other bacchantes dancing by a lake.

We see the Rembrandt influence also in the work of Alexis Grimou (1678-1733), who was actually known as *le Rembrandt français*, though his *Toper* (Pl. 55a) in Worcester (Mass.) shows us that he had also looked at Judith Leyster and other Dutch painters of that school. Signed examples of his work are in the Dulwich Gallery and the Louvre.

The paintings by Raoux and Grimou are softer and less categorically descriptive than those of the Dutch genre painters and they are less profound than those of Louis Le Nain and of Chardin, the outstanding French genre painter of the age and one of the most interesting of the eighteenth-century French artists to the student of to-day.

5 JEAN-BAPTISTE-SIMÉON CHARDIN

BORN PARIS 1699 DIED PARIS 1779

Characteristic Pictures [1]

London	National Gallery	Still life : Wine bottle, glass and bread
London	National Gallery	The Lesson (La petite Maîtresse d'Ecole) [2]
Richmond	Sir Francis Cook Collection	Laundress with boy blowing bubbles (La Blanchisseuse) [3]
Edinburgh	National Gallery of Scotland	Still life : Kitchen utensils and eggs
Glasgow University	Hunterian Museum	The Scullery Maid (La Récureuse)
Glasgow University	Hunterian Museum	The Potman (La Garçon Cabaretier)
Glasgow University	Hunterian Museum	Drinking tea (Une dame prenant son thé)

[1] For complete lists of Chardin's pictures the student is referred to Georges Wildenstein's *Chardin*, which contains a catalogue and also records all the known facts of his life and career. Walter de la Mare has written a beautiful interpretation of his art in Faber Gallery " Chardin."

[2] Dublin, National Gallery of Ireland, and Washington, National Gallery, have similar pictures.

[3] There are other versions in the Stockholm Museum and the Leningrad Hermitage.

New York	Metropolitan Museum	Still life : Preparations for a breakfast [N1]
New York	Frick Collection	La Serinette
New York	Chester Dale Collection	Still life : Jug and peaches [N2]
Boston	Museum of Fine Arts	Still life : Kitchen table
Boston	Museum of Fine Arts	Still life : Teapot, pear and grapes
Philadelphia	J. G. Johnson Collection	Old Man with a light
Philadelphia	J. G. Johnson Collection	Old Woman in a studio
Philadelphia	J. G. Johnson Collection	Girl Drawing
Philadelphia	J. G. Johnson Collection	Seven still-life pictures
Chicago	Art Institute	Still life : Joint of meat and other objects
Detroit	Institute of Arts	Still life : Hare and other objects
Paris	Louvre	Still life (La Raie)
Paris	Louvre	Still life (Le Buffet)
Paris	Louvre	Portrait of J. A. J. Aved (Le Souffleur)
Paris	Louvre	L'Enfant au toton
Paris	Louvre	Jeune homme au violon
Paris	Louvre	La Mère Laborieuse [1]
Paris	Louvre	La Bénédicité [2]
Paris	Louvre	A monkey as painter
Paris	Louvre	Self-portrait (pastel)
Paris	Louvre	The artist's wife (pastel)
Paris	Louvre	Twenty still-life pictures
Berlin	Charlottenburg Castle	Lady reading a letter
Berlin	Charlottenburg Castle	La Pourvoyeuse [3]
		La Ratisseuse [4]
Berlin	Kaiser-Friedrich Museum	Le Jeune Dessinateur
Carlsruhe	Museum	Five still-life pictures
Vienna	Liechtenstein Gallery	The Admonition (La Gouvernante) [N3]

[1] There are other versions of this picture in the Stockholm Museum and Leningrad Hermitage.

[2] There is a second version of this picture in the La Caze Collection in the Louvre and others in the Stockholm Museum and Leningrad Hermitage.

[3] There are other versions in the Louvre, the Liechtenstein Gallery in Vienna, and in the Schleissheim Castle Museum.

[4] In the collection of the former reigning Prussian house. There are other versions in the Munich Alte Pinakothek, and the Liechtenstein Gallery in Vienna.

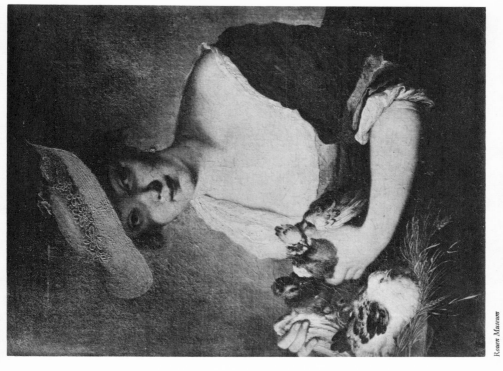

55b. ANTOINE PESNE: The Artist's Daughter

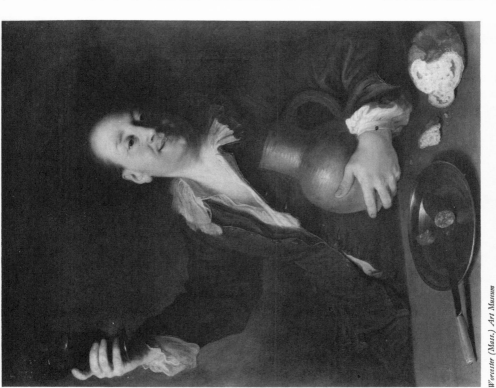

55a. JEAN GRIMOU: The Toper

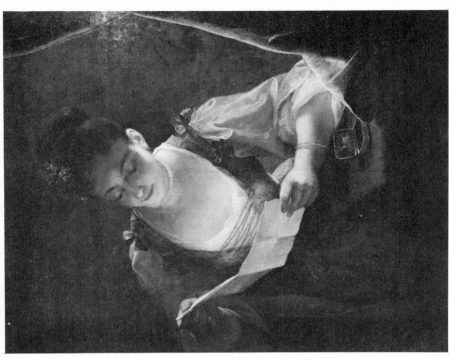

Paris, Louvre

56b. JEAN RAOUX : La Liseuse

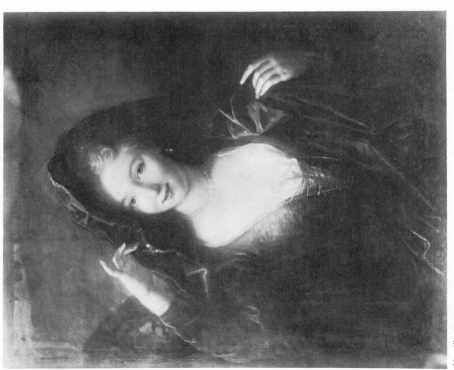

Marseilles Museum

56a. JEAN RAOUX : Jeune fille et sa grandmère

Vienna	Liechtenstein Gallery	La Garde attentive [N1]
Stockholm	Museum	Le Dessinateur
Stockholm	Museum	La Toilette du Matin
Stockholm	Museum	Les Amusements de la vie privée
Stockholm	Museum	L'Econome[1]
Stockholm	Museum	La Fontaine [2]
Leningrad	Hermitage	Les Tours de Cartes[3]

Chardin was the son of a Parisian cabinet-maker and was apprenticed in his youth to various academic painters. Later he was associated, as noted, with the Rembrandt lover, J. A. J. Aved, from whom he acquired an enthusiasm for Dutch painting which lies at the root of his art. In his twenties he began to exhibit at the Place Dauphine, already referred to in connection with Lancret. There in 1728 he attracted attention with two large still-life pieces—rather more Flemish than Dutch in technique—*La Raie* and *Le Buffet*, both now in the Louvre. He joined the *Maîtrise* and at the same time applied for election to the Academy where—thanks largely to the enthusiasm of Largillière—he was *agréé* and made a member as *peintre de fleurs, fruits et sujets à caractères* at the age of twenty-nine. Largillière, an enthusiast for Flemish art, actually mistook Chardin's pictures for Flemish works of the seventeenth century and he became Chardin's champion when he discovered their authorship.

He now painted the portrait of Aved where we clearly see the influence of the Rembrandt etchings in Aved's collection (which may have included the portraits of Jan Uytembogaert the Remonstrant, of Cornelis Anslo and Arnold Tholinx), and he began the series of genre pictures of bourgeois life which made his reputation.

The genre pictures consist of (*a*) studies of children engaged in simple amusements, drawing, building *tours de cartes* and so forth, (*b*) studies of ladies engaged in recreations, and (*c*) studies of domestic life—women engaged in household duties or looking after their children. The types overlap in point of time. The Leningrad *Les Tours de Cartes* (Pl. 58) is an example of the first type ; *Les Amusements de la vie privée*, in Stockholm, is an example

[1] This picture which was damaged by fire has not been exhibited since 1885.

[2] There are other versions of this picture in the London National Gallery and in Sir Francis Cook's collection in Richmond.

[3] There are other versions of this subject in the Louvre, London National Gallery and Washington National Gallery.

of the second; *The Admonition* (*La Gouvernante*) (Pl. V), in Vienna, *La Toilette du Matin*, in Stockholm, *La Récureuse* (Pl. 57) and its companion piece *Le Garçon Cabaretier*, in Glasgow, and *Le Bénédicité*, in the Louvre, are examples of the third.

After 1750 Chardin entirely abandoned figure subjects and for the last twenty-five years he painted nothing but still life in which he had always been interested.

Chardin married in 1731. His wife died four years later. In 1744 he remarried. His second wife had small private means but he himself never amassed money and he was happy when in 1754 he was granted a pension by the King and when in 1755 he was given the salaried post of treasurer of the Academy; he was happier still when two years later he was accorded lodgings in the Louvre.

He first made his reputation by the genre pictures of domestic subjects which he exhibited in the Academy's Salons. On the appearance of pictures like *La Gouvernante* (Pl. V), *La Toilette du Matin* and *Les Amusements de la vie privée* he was hailed by the dilettanti as a painter of *tableaux de modes*. His pictures were bought and commissioned for the Royal collections of Russia, Sweden and Prussia, for that of Prince Liechtenstein of Vienna, and for that of Louis XV. They were also bought by a few private French collectors and by one or two in England—including Dr. William Hunter, whose acquisitions are now in the Hunterian Museum in the University of Glasgow.

But in spite of his success in this field Chardin painted scarcely more than thirty genre subjects; there are less than a hundred genre pictures in his whole *œuvre* and of these two-thirds are replicas, which he exhibited sometimes ten or even twenty years after the original picture.

Thus *La Récureuse* was first shown in 1738 and a replica was shown in 1757. *La Bénédicité* was first shown in 1740 and replicas were produced in 1746 and 1761. The replicas, some of which show variations, were presumably painted from first sketches in oils retained in the studio, since Chardin, it is recorded, did not make many or detailed drawings. Herbert Furst suggests in his *Chardin* that he kept the originals painted from nature, and sold replicas sometimes wholly or partly executed by his pupils.

The public which visited the Salons greatly admired Chardin's genre pictures; but they did not buy them—they bought engraved reproductions, for small sums, instead. As I have already pointed out much of Watteau's influence on the art of the eighteenth

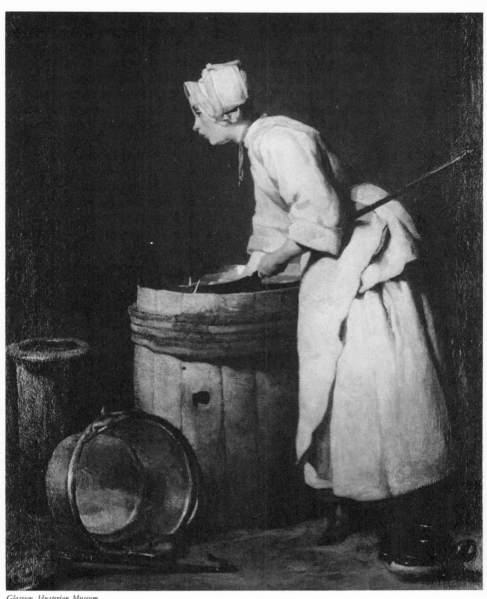

57. JEAN-BAPTISTE-SIMÉON CHARDIN: La Récureuse

PLATE V

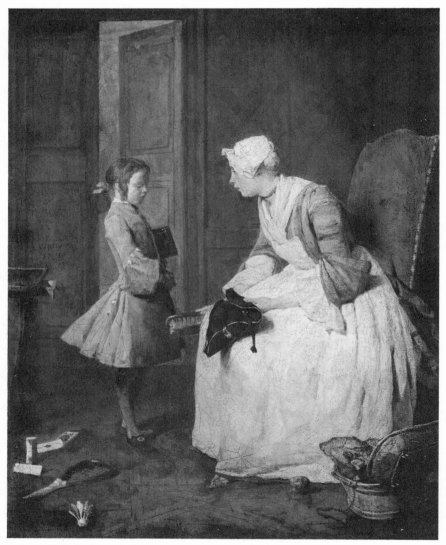

Ottawa, National Gallery of Canada

J. B. S. CHARDIN (1699-1779)
The Admonition (La Gouvernante)

century had been due to the dissemination of engravings reproducing his work. But in Watteau's case the engravings were made after his death ; in the case of Chardin they were made soon after each genre subject was exhibited. They thus represent the beginning of a system which reached a climax in the Victorian age in England when popular artists in the Academy's exhibitions vied with one another to attract the print-buying public and when W. P. Frith, R.A., demanded and received in one case £5,250 for a picture with the copyright to engrave, and £1,500 in another for the copyright alone—sums which must be quadrupled to obtain equivalents in present money. Chardin, however, was not the man to see the commercial possibilities of this situation ; he seems to have made little or no money from engravings after his pictures though there was in fact something like a " craze " for them in his lifetime—a craze not restricted to France, for plates after Chardin's pictures were engraved in his day by German and English mezzotinters and an engraving after *Les Tours de Cartes* was given away with *The British Magazine* in January 1762 (though in Academic circles in England Chardin was not then admired).

The Salon public admired Chardin's domestic pictures exclusively for their subjects. As a contemporary put it : " *Il ne vient pas là une femme du Tiers état qui ne croie que c'est une idée de sa figure, qui n'y voie son train domestique, ses manières, ses occupations journalières, sa morale, l'humeur de ses enfants, son ameublement, sa garderobe.*" The publishers of the engravings fully realised the nature of their appeal to the *petite bourgeoisie* and they placed descriptive verses beneath the prints to give the subjects additional interest.

Thus under Lepicié's engraving of *La Gouvernante* (*The Admonition*) (Pl. V), we read :

> Malgré le Minois Hipocrite
> Et l'Air soumis de cet Enfant,
> Je gagerois qu'il prémédite
> De retourner à son Volant.

Under Lepicié's engraving of *Le Bénédicité* :

> La Sœur, en tapinois, se rit du petit frère
> Qui bégaie son oraison,
> Lui, sans s'inquiéter, dépêche sa prière,
> Son apétit fait sa raison.

Under the engraving of *La Toilette du Matin* by Le Bas :

> Avant que la Raison l'éclaire,
> Elle prend du Miroir les avis Séduisans
> Dans le désir et l'Art de plaire
> Les Belles, je le vois, ne sont jamais Enfans.

The still-life pictures to which Chardin devoted himself after the age of fifty did not interest the Salon public as much as his genre pictures had done, and they were not engraved ; but they were admired nevertheless as *trompe l'œil* realism.

It is not difficult to project ourselves into the attitude of the French bourgeois admirers of Chardin's work in his own time. We can recapture it by opening the door of any *loge de concierge* in an unpretentious French apartment house to-day. There we can see the concierge herself mending her child's frock, or adjusting it as the child leans against her knee, while the hot-pot simmers on the fire and on the table lie a work-basket, a rabbit, eggs, onions, fruit and cheese. There we can see, and smell, domestic life as it was known to and enjoyed by Chardin's admirers—and indeed by Chardin himself. For Chardin worked and was happy in just such an interior as this. All he asked of life was warmth, sustenance and quiet human company. He lived within four walls and never felt the urge to paint fields or trees ; he never even desired to look out at them ; you will find no window in any of his domestic pictures. As my knowledge goes there are only two pictures by Chardin which show windows—*La Serinette* and its companion piece *L'Économe*, and in both these pictures (which belong not to the domestic series but to the earlier series of ladies' recreations) only fragments of the windows are seen in sharp perspective at the side. In Dutch and English genre interiors, on the other hand, windows and vistas through them are regular features. Even Van Ostade, who painted the most sordid interiors, showed windows which were frequently open. Compared with Dutch pictures of the same subjects Chardin's interiors are ob-viously stuffy and dusty. The French taste for small stuffy rooms, which began at this time with the scented boudoirs of the rich, still continues to some extent in all classes. The French have never suffered from the claustrophobia of the English, who are never really happy except in the open air. It is this claustrophobia, of course, which explains the English affection for landscape painting and the prevalence of landscape backgrounds in English portraiture from the time of Hogarth to the present day.

The French bourgeois of the eighteenth century divined with pleasure *le père* Chardin himself behind his pictures ; and they took to their hearts this man who obviously cared not a straw if things were left undusted provided that he was not disturbed by cleaning and never harassed by a draught—this typical French

bourgeois, for whom it would be a pleasure to prepare the *déjeuner* of *soupe à l'oignon, omelette,* and *civet de lièvre.*

But though we can project ourselves into the minds of Chardin's contemporaries we know now that they only partly understood him as an artist ; we know now that Chardin himself was never exclusively interested in the subjects of his pictures and that in his still-life studies he was not concerned with painting *trompe l'œil* cherries to deceive the birds. The de Goncourts wrote of *La Toilette du Matin* : " *L'ombre de la nuit commence à s'en aller de la pièce. Sur la toilette, encombrée de désordre, la chandelle qui a éclairé le lever et le commencement de l'habillement brûle encore, décrivant dans l'air des ronds de fumée. Un peu de jour tombant de la fenêtre, glisse sur le parquet entre-croisé, et va mettre une lueur argentine, là-bas, sur l'encoignure où pose une pendule marquant sept heures. Au-devant de la ventrue bouilloire d'eau chaude, du tabouret portant le gros livre de messe de la maman, la mère en coqueluchon noir, la jupe au retroussis, arrange des deux mains sur la tête de sa fille le nœud de sa fanchon, tandis que la petite, impatiente de sortir, et déjà le manchon à une main, coule de côté les yeux vers la glace, en retournant la tête et en se souriant à demi. Le Dimanche, tout le Dimanche bourgeois, tient dans cette toile.*" But we realise to-day that even this delightful appreciation describes only one aspect of the painter's achievements.

The developments of French painting at the end of the nine-teenth century have taught us to recognise an artist's preoccupation with formal problems for their own sake when we encounter it. We have learned the nature of that preoccupation, and we realise that Chardin when he painted *Les Tours de Cartes* (Pl. 58) was possibly more interested in architectural problems of formal re-lation than in the genre scene that gives the title to the picture ; and that the diagonal movements in the beautifully composed *Amusements de la vie privée* must have given him great satisfaction and delight. This, we now realise, was why Chardin was always so deeply interested in still-life painting and why eventually he abandoned all other subjects in its favour. But his contemporaries could not understand this. They regarded Chardin as an eccentric, almost as a trifler, who painted, as they said, " *que pour son amuse-ment.*"

Chardin nevertheless did not push his attitude to its conclusion. If we compare his *Still life* (Pl. 59a), in Boston, with some glittering Dutch *trompe l'œil* production, we see how far he has advanced from this elementary goal ; but if on the other hand we compare a work by Chardin with Cézanne's still-life paintings we see how

much further Cézanne advanced towards the logical conclusion of Chardin's approach.

Chardin's fame has suffered various mutations. Widespread in his own day, both in France and other countries, it disappeared in France at the end of the eighteenth century and was not revived till the de Goncourts published their enthusiastic essays in the eighteen-sixties. In England in his own day Chardin was not taken seriously by the Academic artists, though engravings after his works were known ; he is not, for example, referred to in the Discourses of Reynolds. He was equally neglected all through the nineteenth century ; his name is not mentioned in the thirty-seven volumes of the works of Ruskin ; he was overlooked by the brilliant amateurs of French eighteenth-century painting who formed the London Wallace Collection ; and he was not represented in the London National Gallery until 1888 when Lord Savile presented the admirable signed *Still life : Wine bottle, glass and bread* (now catalogued as by " Imitator of Chardin "), which has inspired De la Mare to a delicate poem.

Chardin had a number of followers and imitators who all missed the architectural aspect of his work. The most successful was Michel-Bernard-Nicolas Lepicié, son of François-Bernard Lepicié, who engraved a number of Chardin's pictures. Lepicié's imitations of Chardin's genre pictures stand in the same relation to the originals as Lancret's pictures stand to those of Watteau. He was purely a genre painter. His pictures of children were essentially popular. The Lyons Museum has a little boy crying called *L'Enfant en pénitence* which is characteristic. The Louvre has *Le Petit dessinateur*, a good example, said to depict his young pupil Carle Vernet. The London Wallace Collection has *Une femme montrant à lire à une petite fille* and also *Une femme allaitant son enfant* which is one of his best works. In the picture called *La demande accordée* in the Cherbourg Museum Lepicié has imitated Greuze. Chardin's still-life pictures were imitated by, among others, Mme Vallayer-Coster (1744-1818), who also painted portraits.

6 THE ACADEMY AND THE SALONS

The fixed doctrine of Great Art which the Academy had formulated in its early days for Colbert had been challenged, as I have noted, when the work of Rubens, Rembrandt and other painters of the Low-Country Schools began to exercise a general influence on French painting. But the doctrine, though challenged, had never been officially denied ; and early in the eighteenth

century it was revived and transformed by the main caucus of the Academicians into the doctrine of the Grand Manner in History-painting—a confused eclectic concept involving indiscriminate imitations of Rubens and the later Italian Masters.

All through the eighteenth century the " history-painters," who included the painters of decorations with allegorical and mytho-logical subjects, were the most highly-ranked artists in the Academy. Only the history-painters were given the higher offices in the Academy and the professorial posts in its art school; and when artists like Watteau and Chardin were made Academicians they were specifically described as belonging to a different rank.

The Grand Manner in History-painting was the sole subject of instruction in the art school, and the Academy's *prix de peinture* were awarded exclusively for history-compositions. The subject when Watteau competed unsuccessfully was *David accordant le pardon de Nobal à Abigaïl qui lui apporte les vivres*; the subject when Boucher competed was *Evilmérodach fils et successeur de Nabucho-donosor délivrant Joachim des chaînes dans lesquelles son père le retenait depuis longtemps*. The first *prix de peinture*, known as the *Prix de Rome*, carried with it the Academy's authorisation for the journey to Rome and a further course of study in the French Academy in that city, where the directors were successively Watteau's friend Nicolas Vleughels (1724), J. F. de Troy (1738), Natoire (1752), Noel Hallé (1775), J. M. Vien (1775), and Lagrenée l'aîné (1781).

Sometimes, when the Academy had funds, the prize also carried a subsidy for the journey. But the Academy's finances in the first half of the century were very precarious and it is probable that funds for the prize-winner's journey were frequently collected from private patrons. To remedy this unsatisfactory situation the King agreed in 1748 to the establishment of *l'Ecole royale des élèves protégés*, a special class under the direction of the Academy to which only the prize winners were admitted; the students in this class were financed by royal scholarships while they prepared themselves for the visit to Rome by passing examinations in Bossuet's *Histoire Universelle*, Rollin's *Histoire ancienne*, Calmet's *Histoire des Juifs* and the works of Herodotus, Thucydides, Homer, Virgil, Ovid and so forth; if they qualified they received a further royal subsidy in Rome itself. While at the *École des élèves protégés* the students had the privilege of sending a picture each year to Versailles to be inspected by the King and thus had opportunities of finding favour in Court circles.

The Academicians, to justify the Academy's existence, had

always, of course, been forced to claim that history-painting was an activity that could be taught and that they themselves were the only people who could teach it ; and they had made good this claim by teaching the activity to their own sons and relations who became Academicians in their turn.　Thus Louis Boullogne (1609-1674) was followed by his sons Bon Boullogne (1649-1717) and Louis de Boullogne (1654-1733), and two women painters of the same name were made Academicians in 1669 ; Noel Coypel (1628-1707) was followed by his sons Antoine Coypel (1661-1722), and Nicolas Coypel (1690-1734), and by Antoine's son, Charles-Antoine Coypel (1694-1752) ; Jacob van Loo (1614-1670) who had come to Paris from Amsterdam in 1662 was followed by Louis Abraham van Loo (1640-1712), whose sons Jean-Baptiste van Loo (1684-1745) and Carle van Loo (1705-1765) were followed in their turn by Jean-Baptiste's sons Charles-Amédée van Loo (1715-1795) and Louis Michel van Loo (1707-1771), and Carle's son J. C. Denis van Loo (1743-1821).　When the art of painting is conceived as the art of producing a certain kind of picture and as a procedure that can be taught there is nothing to prevent any intelligent person from learning to produce it.　This was demonstrated by these dynasties of French Academic history-painters and decorators, and it had been demonstrated before by the popular genre painters in Holland.

In this way the Academicians were able to keep the commercial advantages of the Academic monopoly in their own families for several generations ; and these commercial advantages were considerable, because many lucrative commissions were still being given by churches for paintings in the Jesuit-baroque tradition, and many others, as lucrative, were being given for decorative panels in the financiers' new *hôtels*.　The Academicians had made it their business to discredit the old *Maîtrise*, which was now regarded as the refuge of the incompetent, and all the commissions in the eighteenth century fell into their hands.

Students who wish to read details of the Academy's rules and procedures in Paris and in Rome will find the subject exhaustively treated in Jean Locquin's *La Peinture d'Histoire en France, 1747-1785*.　But the subject makes dreary reading.　For most of these Academic history-painters and decorators appear quite uninteresting to-day.　Carle van Loo was undoubtedly competent and he was much respected by his pupils ; he departed from the Grand Manner to paint the *Déjeuner de Chasse* (Pl. 49b) for Fontainebleau. Jean François de Troy (1679-1752), who also deserted the Grand

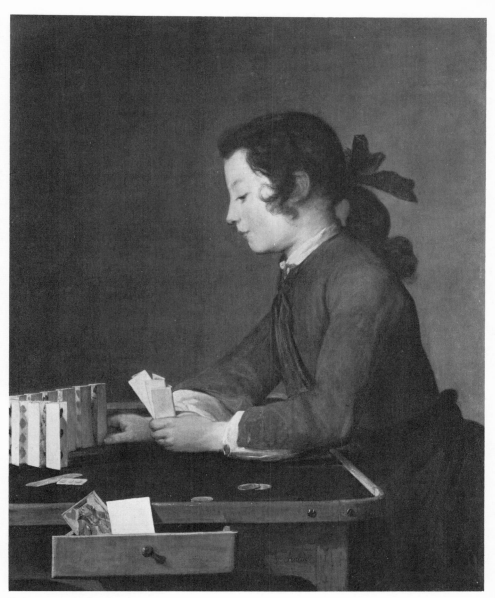

58. JEAN-BAPTISTE-SIMÉON CHARDIN: Les Tours de Cartes

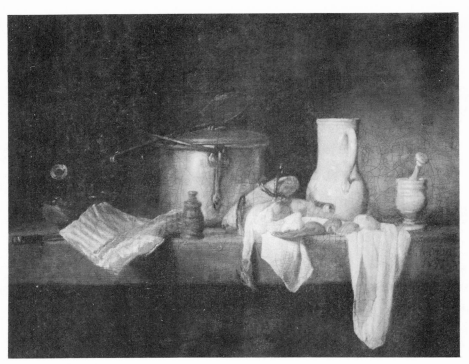

59a. JEAN-BAPTISTE-SIMÉON CHARDIN: Still life

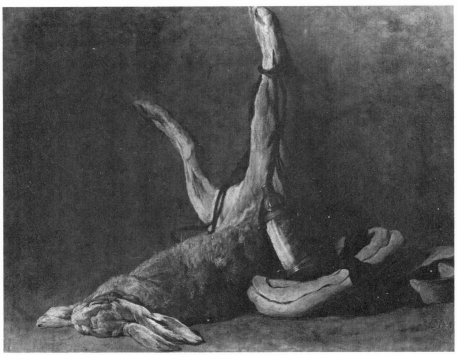

59b. JEAN-BAPTISTE-SIMÉON CHARDIN: Still life with Hare

Manner to paint the *Déjeuner d'huîtres* now at Chantilly, was a coarse-minded man as we can see in his *Bathsheba at the Bath* in Angers and he was not above pornographic *double entente* in some of his pictures. Nicolas Coypel's *Innocence et l'Amour* now in the Louvre forestalled all the Venus and Cupid pictures of the English eighteenth-century school. François Le Moyne (1688-1737), who committed suicide, evolved a very attractive recipe for flesh painting which he transmitted to his pupil François Boucher. The work of many of these artists became attractive when it was translated into tapestry at the Gobelins and Beauvais.

The Salons

The Academy had held one or two Salons in the seventeenth century. It held others in 1704 and 1727. In 1737 the function was annual till 1751 (though there was no exhibition in 1744); after 1751 it was held every two years until the Revolution. There were no other public exhibitions in Paris at this time except the annual open-air shows on Corpus Christi Day on the Place Dauphine already referred to in connection with Lancret and Chardin. The Salons were held in the Louvre and only Academicians and *agréés* were allowed to show their pictures—a condition which continued till the Revolution. To make room for the Salons, the magnificent Royal collections of Old Masters were removed from the Louvre and dispersed in various apartments at Versailles where they were not accessible to the public or students, though privileged artists, presumably, could visit them. In 1750 as the result of the publication of a protest against the inaccessibility of the Royal collections the King ordered a hundred of his most notable pictures to be transferred to the Luxembourg where, with the Rubens panels, they were on view to the public on two days of the week and to artists on the others.

The biennial Salons had far-reaching effects on the history of painting. They created a public which had contact with art for a few hours every two years and which formed its standards from that casual contact; and they induced the artists to covet the approbation of this ill-educated public. Chardin, intent on the solution of his architectural problems, could turn a deaf ear to the Salon public's applause. But Chardin was an exception in his age. His colleagues worked for this new kind of applause and were delighted when they obtained it.

At the same time the Salons created the professional art critic. The public felt lost in what they regarded as a multitude of pictures,

134 FRENCH PAINTING

though the eighteenth-century Salons only contained about two or three hundred; and professional students of art history and men of letters began to write articles in journals and periodicals and to publish pamphlets to help the more intelligent sections of the public to understand and assess the exhibits and to enable the others to talk about the " pictures of the year."

The most celebrated of the eighteenth-century art critics was Denis Diderot, the philosopher who edited the celebrated Encyclopædia. He wrote his first Salon article in 1759 and he continued for twenty years. Diderot as an art critic anticipated Ruskin and Tolstoy. He held that a picture should contribute to public morality and to the appreciation of the domestic virtues. He was a great admirer of Chardin and he praised his still-life paintings for their verisimilitude in representation. But he failed to appreciate Boucher and he was bluffed by Greuze.

7 FRANÇOIS BOUCHER

BORN PARIS 1703 DIED PARIS 1770

Characteristic Pictures

London	National Gallery	Le Billet Doux
London	National Gallery	Pan and Syrinx
London	Wallace Collection	Shepherd piping to shepherdess
London	Wallace Collection	The Modiste (Le Matin)
London	Wallace Collection	The Visit of Venus to Vulcan
London	Wallace Collection	Cupid a captive
London	Wallace Collection	Venus and Mars surprised by Vulcan
London	Wallace Collection	The Judgement of Paris
London	Wallace Collection	Summer and Autumn Pastoral
London	Wallace Collection	The Rising of the Sun
London	Wallace Collection	The Setting of the Sun
London	Wallace Collection	Mme de Pompadour
London	Wallace Collection	Jupiter surprising Callisto
London	Victoria and Albert Museum	Mme de Pompadour
Edinburgh	National Gallery of Scotland	Mme de Pompadour
Glasgow	Art Gallery	The Muse of Painting
New York	Metropolitan Museum	The Toilet of Venus
New York	Frick Collection	Mme Boucher
New York	Frick Collection	The Seasons (Four panels)
New York	Frick Collection	Eight decorative panels
Boston	Museum of Fine Arts	The Halt at the Fountain

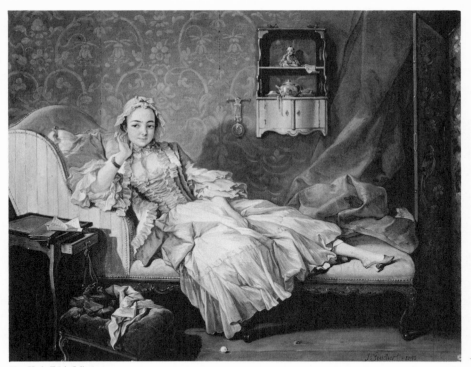

60a. FRANÇOIS BOUCHER: Mme. Boucher

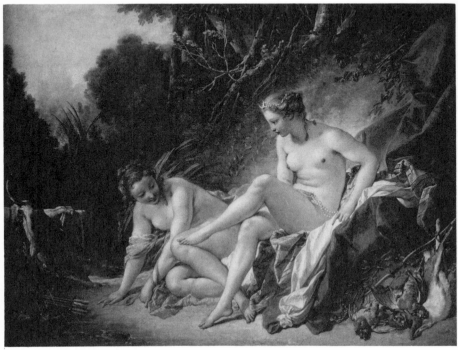

60b. FRANÇOIS BOUCHER: The Bath of Diana

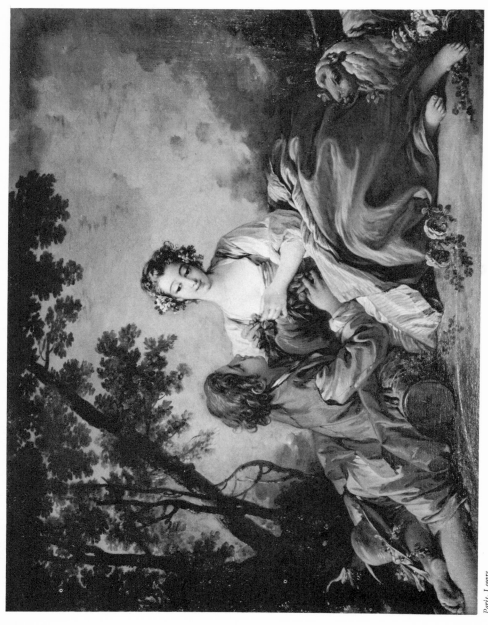

61. FRANÇOIS BOUCHER : La Musette (The Bagpipe)

Boston	Museum of Fine Arts	Going to Market
Detroit	Institute of Arts	The Birth of Venus
Paris	Louvre	Venus ordering arms for Aeneas from Vulcan
Paris	Louvre	Rinaldo and Armida
Paris	Louvre	Pastoral decoration (Le nid)
Paris	Louvre	Pastoral decoration (Les charmes de la vie champêtre)
Paris	Louvre	Interior with figures (Le Déjeuner)
Paris	Louvre	The Bath of Diana
Paris	Louvre	Portrait of a Young Woman
Paris	Louvre	Sleeping Shepherdess
Paris	Louvre	The Bagpipe (La Musette)
Paris	Louvre	The Forge of Vulcan
Paris	Louvre	The Rape of Europa
Paris	Louvre	The Toilet of Venus
Paris	Louvre	Venus disarming Cupid
Paris	Louvre	Landscape : The Mill
Paris	Louvre	Landscape : The Bridge
Paris	Louvre	Venus receiving arms for Aeneas
Paris	Louvre	Cephalus and Aurora
Paris	Musée Cognacq	La Belle Cuisinière
Besançon	Museum	Eight Chinese compositions
Amiens	Museum	Tiger Hunt
Amiens	Museum	Crocodile Hunt
Amiens	Museum	Landscape décor for a stage scene
Berlin		Venus, Mercury and Cupid
Vienna (?)	Formerly private collection	Mme de Pompadour [N1]
Munich	Alte Pinakothek	Girl on a Sofa
Stockholm	Museum	The Birth and Triumph of Venus
Stockholm	Museum	The Toilet of Venus
Stockholm	Museum	The Modiste (Le Matin)
Stockholm	Museum	Leda
Leningrad	Hermitage	The Rest on the Flight into Egypt
Washington	National Gallery	Venus consoling Love
Washington	National Gallery	Mme Bergeret

François Boucher was the most clear-headed of the French eighteenth-century Academicians. He reduced the prevailing chaotic concepts of the Grand Manner to a simple decorative formula and within that formula he produced most admirable results.

His father, one of the despised painters of the *Maîtrise*, apprenticed him at the age of seventeen or earlier to François Le Moyne who had just become an Academician. Boucher is said to have remained only a few months with Le Moyne but he learned from him an attractive system of flesh colouring. From Le Moyne he

went to the studio of the engraver Jean-François Cars, where he became an expert engraver and designer of book illustrations and decorations ; and he soon attracted the attention of de Jullienne who commissioned him to engrave a number of plates in the Watteau series. At the age of twenty-one he competed for and won the Prix de Rome, and three years later he went to Italy where he looked at the pictures of the Italian masters purely in relation to the work which he himself was intending to do later. In Venice he saw not only works by Titian and Veronese but also some by Tiepolo who was then about thirty-five and already hailed in Venice as the heir to the great Venetian decorative tradition. In Rome he evidently studied the *Rape of Europa* (now in the Colonna Gallery) by Francesco Albani (1578-1660), whose pictures in the French Royal collection, *The Toilet of Venus* and *Venus and Vulcan*, may already have been known to him. Boucher decided that by studying Raphael and Michelangelo he would be diverted from his own aim and he accordingly avoided their works. Years later, when Fragonard went to see him before leaving for Italy, he warned him that with his particular talent he must also pay no attention to Raphael and Michelangelo : "*Je te le dis en confidence amicale,*" he said to Fragonard, "*si tu prends ces gens-là au sérieux tu es f . . .*"

Back in Paris, in 1731, he secured election to the Academy with his *Rinaldo and Armida* (influenced I fancy by Titian's *Diana and Actæon* now at Bridgewater House, London, but then in the Palais Royal), and he began to develop his own style in decorative pastorals and allegories and also in genre.

Le Nid and *Les charmes de la vie champêtre* (commissioned at this period by Louis XV for Fontainebleau and now in the Louvre) are characteristic of his pastoral style which is well seen at the Wallace Collection and in *La Musette* (Pl. 61), painted as an overdoor.

The allegorical style appears in the Stockholm *Birth and Triumph of Venus* and the charming *Bath of Diana* (Pl. 60b), where Boucher's graceful formula for the female figure is already perfected.

The genre style appears in one aspect in *La Belle Cuisinière* (Musée Cognacq, Paris), where the boy and girl actors of the pastoral decorations act the same charade in a kitchen ; and in another aspect in the Louvre *Le Déjeuner* and the Stockholm *The Modiste* which were probably influenced by engravings after Hogarth, published in Paris in 1745, as is pointed out in the

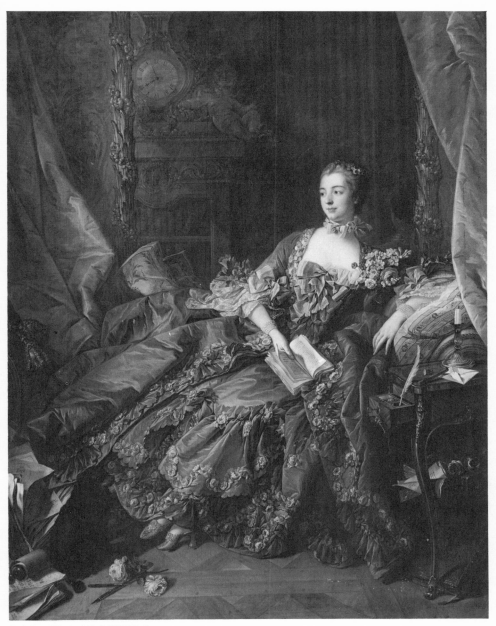

62. FRANÇOIS BOUCHER: Mme. de Pompadour

PLATE IV

FRANÇOIS BOUCHER (1703-1770):
Madame de Pompadour

Edinburgh, National Gallery of Scotland

catalogue of the Wallace Collection where there is a smaller version of the picture.

To these genre paintings we must assimilate *Mme Boucher* (Pl. 60a), now in the Frick Collection, New York, a dainty portrait of his young wife whom he had married at the age of thirty in 1733—(she was of a bourgeois family and then seventeen, she was also an amateur artist, and the Glasgow *Muse of Painting* which depicts a young woman with an artist's palette may have been painted from her). Boucher did not long remain faithful ; he was very promiscuous, but there is no evidence that he ever cared for any other woman. Incessantly occupied with his prolific artistic production he amused himself for brief hours with professional girl models, who had now appeared in the Parisian art world, and professional light women whom he did not admit into his life. Mme Boucher is said to have consoled herself with the Swedish Ambassador, the Comte de Tessin, who bought Boucher's *Birth and Triumph of Venus* from the Salon of 1740 and commissioned *The Modiste* which was to typify " Morning " in a series of pictures representing different hours of the day.

Boucher painted in these various categories all his life and at the same time he produced landscapes, two of which are in the Louvre.

At the beginning of the seventeen-forties he was presented to Mme de Pompadour, then Mme Lenormand d'Etiolles, and for many years he was her favourite artist. He painted her portrait on several occasions (Pls. IV and 62) ; for her Château at Bellevue he devised a Chinese boudoir and a bedroom decorated with panels of *mythologie galante* ; for her bathroom he painted the *Toilet of Venus*, possibly the picture now in the Metropolitan Museum in New York ; and for her chapel he painted an *Adoration of the Shepherds*.

Boucher painted, in fact, a number of religious subjects, including a *Nativity* also for Mme de Pompadour, which was shown in the Salon of 1748. The Leningrad Hermitage has his *Rest on the Flight*, where the sacred characters are surrounded by lambs which seem to have escaped from one of his pastoral decorations, and angels indistinguishable from his habitual Cupids.

In addition to his other work he was incessantly occupied all his life with the painting of pictures to be translated into tapestry at the Gobelins and Beauvais factories of which he became Director in 1755 on the death of J. B. Oudry (1686-1755), with whom he had worked for a number of years. Oudry himself was an able

painter who excelled at depicting hunting scenes with dogs, etc., in the Flemish tradition of Snyders which had appeared in French eighteenth-century painting in the work of Desportes. Louis XV was devoted to hunting, and Oudry, who designed upholstery for furniture and a whole series of large tapestries, *Les Chasses de Louis XV*, was his favourite painter. His genre landscape work was also much admired by the Queen. In 1736 Oudry issued commissions for a series of exotic hunting tapestries to be executed at Beauvais, and Boucher produced for the purpose in 1737 and 1738 the *Chasse au tigre par les Turcs* and *Chasse au crocodile* now in the Amiens Museum, where we can also see three others of the series : the *Chasse à l'autruche par les Turcs* by Carle van Loo, the *Chasse au lion* by de Troy, and the *Chasse au lion et au tigre en Chine* by Pater. These pictures which anticipate the work of Delacroix were originally in the *petits appartements* or *cabinets* at Versailles together with Lancret's *Déjeuner de jambon* and the feasting pictures by de Troy. Boucher also painted, for Beauvais tapestry, a series of Chinese subjects now preserved in the Museum at Besançon ; these compositions represent a Chinese marriage, a Chinese dance, an audience with the Emperor of China, fishing in China and so forth. The colour in Boucher's pictures eventually became rather mechanical as a result of this continual painting for tapestry. But the tapestries gained because he tended more and more to use colours which corresponded with the dyes. The effect of his association with Oudry is seen in *The Bath of Diana* (Pl. 60b), where the dogs, probably painted from a drawing supplied by that artist, rather destroy the unity of an otherwise perfectly unified picture.

The *Rising of the Sun* and *Setting of the Sun*, painted in 1753 when Boucher was at the height of his powers, were intended for Gobelins tapestries ; but the tapestries were never executed and Mme de Pompadour obtained the pictures for her collection. They were followed the next year by *The Visit of Venus to Vulcan*, *Cupid a Captive* (Pl. 99a), *Venus and Mars surprised by Vulcan* and the *Judgement of Paris*, painted for Mme de Pompadour's boudoir at the Hôtel de l'Arsenal and intended for the special entertainment of Louis XV. These four panels were later objected to, as indecent, by Louis XVI ; after various travels they were acquired by Lord Hertford and they are now in the Wallace Collection, where the *Rising of the Sun* and the *Setting of the Sun* hang on the Grand Stair.

Boucher also designed scenery and costumes for the private

theatricals with which Mme de Pompadour entertained Louis XV, and he worked for the Opera and the theatres. The scenery at the Opera, which at this time was in the Palais Royal, was in the hands of the celebrated Servandoni who designed the most fantastic *rocaille* and Chinese " sets," with ingenious effects of lighting, for sixty operas. Boucher worked with him and designed the scenery and costumes for the *Indes Galantes* in 1743 and for other performances in 1746 and 1747. In 1752 Boucher designed for the Opéra Comique which was then a theatre erected at the Saint Laurent Fair. In 1754 he designed for a theatre at the Saint Germain Fair. In 1764, when Servandoni left the Opera to execute still more elaborate scenic effects at the Théâtre des Tuileries, he designed a further series of productions for the Opera. The Museum at Amiens has one of his theatrical designs—a landscape *décor*.

At the apex of his career he was *Premier peintre du roi* and Director of the Academy. He had a studio in the Louvre where he kept a collection of prints, including twenty etchings by Rembrandt, and other collections of bronzes, porcelain, shells, butterflies and all kinds of precious and semi-precious stones. He was a very amiable man and very accessible and kind to students. He was the first artist to exhibit red and black drawings of heads, nudes and so forth in the Salon, and they proved so great a success that they aroused the jealousy of the print-sellers.

In his old age he suffered from the change in public taste which caused the success of Greuze. Diderot in his accounts of the Salons attacked him in terms which would not be tolerated in art criticism to-day. Of Boucher's exhibits in the Salon of 1765, when he was over sixty, Diderot for example wrote : *Je ne sais que dire de cet homme-ci. La dégradation du goût, de la couleur, de la composition, des caractères, . . . a suivi la dépravation des mœurs. . . . Que peut avoir dans l'imagination un homme qui passe sa vie avec les prostituées du plus bas étage ? . . . J'ose dire que cet homme ne sait vraiment ce que c'est que la grâce ; j'ose dire qu'il n'a jamais connu la vérité ; j'ose dire que les idées de délicatesse, d'honnêteté, d'innocence, de simplicité, lui sont devenues presque étrangères ; j'ose dire qu'il n'a pas vu un instant la nature, du moins celle qui est faite pour intéresser mon âme, la vôtre. . . . Toutes ses compositions font aux yeux un tapage épouvantable : c'est le plus mortel ennemi du silence que je connaisse. . . . Dans toute cette innombrable famille, vous n'en trouverez pas un à employer aux actions réelles de la vie, à étudier sa leçon, à lire, à écrire, à tiller du chanvre."*
A strange passage in which the words " *c'est le plus mortel ennemi du*

silence " intended to contrast Boucher's art with that of Chardin which, as noted, Diderot admired, are valuable art criticism.

Boucher's production was enormous. He painted hundreds of pictures and made a great many skilful drawings some of which are prettily erotic. His work is the result of a brilliant cold intelligence which achieved a graceful and consistent stylisation of the human figure considered as a unit in a decorative design. In his finest decorations he is a master of scale ; the units which compose his pictures are not only architecturally satisfactory in scale in relation to one another, but they are also satisfactory in relation to the units of scale in *rocaille* architecture and furniture. His paintings must not be judged as easel pictures ; they must be judged as part of the *ensemble* of a room decorated in the Louis XV style. And in this connection it is important to remember that pictures in Louis XV rooms were generally hung either above the panels (which often contained mirrors) or over the doors. This explains the vogue of Nattier's decorative portraits and also the character of certain paintings by Fragonard. When a picture by Boucher was placed on a level with the eye it never had its own frame within the panel but filled the whole panel and was framed by it ; if Boucher had used Watteau's scale of decorative units his paintings would have made the *rocaille* motifs in the architecture and furniture look coarse.

In his later years Boucher worked entirely without models, as we know from Reynolds who said in his Twelfth Discourse : " Our neighbours, the French, are much in this practice of *extempore* invention, and their dexterity is such as even to excite admiration, if not envy ; but how rarely can this praise be given to their finished pictures ! The late Director of their Academy, Boucher, was eminent in this way. When I visited him some years since in France, I found him at work on a very large picture, without drawings or models of any kind. On my remarking this particular circumstance, he said, when he was young, studying his art, he found it necessary to use models ; but he had left them off for many years. Such pictures as this was, and such as I fear always will be, produced by those who work solely from practice or memory, may be a convincing proof of the necessity of the conduct which I have recommended. However, in justice I cannot quit this painter without adding that in the former part of his life, when he was in the habit of having recourse to nature, he was not without a considerable degree of merit—enough to make half the painters of his country his imitators ; he had often grace and

beauty, and good skill in composition ; but, I think, all under the influence of a bad taste : his imitators are indeed abominable."

During the Revolution Boucher's art was, of course, frowned upon as typically *vieux régime* ; and his reputation was in more or less complete eclipse in France till Edmond and Jules de Goncourt published a book on him in 1862. Modern appreciations include André Michel's monograph which has a catalogue by L. Soullié and Ch. Masson (1907), and books by Pierre de Nolhac (1907) and M. Fenaille (1925).

8 LA POMPADOUR AND LA DU BARRY

Mme de Pompadour was interested in art. As Mme Lenormand d'Etiolles, before she met the King, she had her salon where she entertained artists and men of letters ; and she was herself an amateur artist and took lessons in drawing and engraving from Boucher.

Her name is so much associated with the *rocaille* style that it is sometimes assumed that she was responsible for its success. But, as I have noted, the style was already launched in the Regency ; and by the middle of the century its flamboyant excesses—especially as vulgarised in stage decoration—were the object of hostile criticism among people of taste.

Mme de Pompadour, in fact, played a part in the campaign against the excesses of *rocaille*, and used her influence to renew appreciation of antique art. This was not difficult because the fashionable world in Paris was much interested in the excavations at Herculaneum and Pompeii which began in 1748 and brought to light many objects used in daily life by the ancients of kinds then unknown ; and there was much discussion of compilations relating to ancient art produced by Mariette and de Caylus (whom we have met as Watteau's friends) and of Winckelmann's *Gedanken über die Nachahmung der Griecheschen Werken* which was published in 1754 and translated into French. When Winckelmann published his *Geschichte der Kunst des Alterthums* ten years later it was also widely read in France. It was in these circumstances that, in 1749, Mme de Pompadour sent her brother, who was later made Marquis de Marigny, to Italy to study classical architecture and antique remains. Marigny was accompanied by Nicolas Cochin, engraver and official designer of ceremonies and spectacles at the French Court, who was a bitter opponent of *rocaille* and published pamphlets against it ; and when Marigny returned to Paris and became *Surintendant des Bâtiments*—(an office which still represented the

central official patronage of art as in the time of Colbert)—the classical style known as "Louis XVI" was virtually launched. Before Mme de Pompadour died in 1764 the Parisian architects were beginning to build and to make furniture in this style, and in the fashionable world the classical and Pompeian styles were so popular that even jewellery and snuff-boxes and the coiffures of fashionable women were "*à la Grecque*." The craze for imitating the ancients which culminated in the *Directoire* and Empire styles, thus really began in the last quarter of the reign of Louis XV.

Mme de Pompadour's taste in pictures is revealed by her appreciation of Boucher. She regarded the Academicians' Grand Manner in History-painting as tiresome and expressed her opinion to the artists themselves. But in Boucher she recognised a real stylist ; and a mind as clear and free from scruples as her own.

This is not the place to describe the character of this dominating woman. But I must draw attention to the aspects of her personality with which, we learn from her portraits, she desired posterity to be acquainted.

La Tour's pastel portrait, now in the Louvre, was painted when she was thirty-four and had already been the King's mistress for ten years. Here she holds a sheet of music in her hand, a viola is on a chair behind her, a portfolio of drawings is at her feet, and on a table by her side stand Diderot's Encyclopædia, Voltaire's *Henriade* and other books together with an engraving signed *Pompadour sculpsit*.

Boucher's full-length portrait (Pl. 62) was painted the year after. In this she sits surrounded with objects of the finest contemporary craftsmanship ; behind her a mirror reflects her book-case surmounted with a clock ; her official seal lies on the table by her side ; a portfolio and her drawing crayon are on the floor at her feet ; she has just looked up from her book and like her pet spaniel she has resigned herself to sit for her portrait.

It is clear that La Pompadour desired us to remember her as a woman of parts.

MME DU BARRY

Louis XV spent vast sums of public money on the encouragement of Mme de Pompadour's culture and pleasures and on the series of her luxurious establishments. He did the same to support the extravagance of Mme du Barry, who had no culture to speak of, but who was much prettier than La Pompadour as can be seen from her portrait (Pl. 71a) by Mme Vigée-Le Brun.

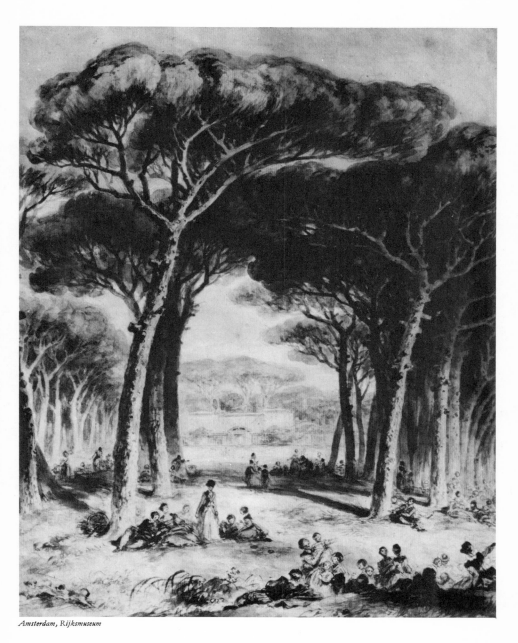

63. JEAN-HONORÉ FRAGONARD: Les Pins à la Villa Pamphili (Drawing)

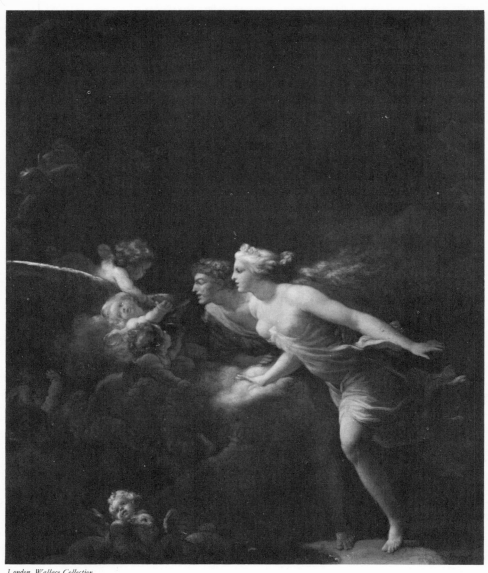

64. JEAN-HONORÉ FRAGONARD: La Fontaine d'Amour

For Mme du Barry the architect Ledoux added a pavilion in the purest " Louis XVI " style to the Château de Louveciennes ; and the finest productions of the French craftsmen found their way to Louveciennes and the new favourite's establishments in Paris. As Lavisse puts it : *" Elle aimait les meubles en bois blanc satiné, ornés de tableaux de porcelaine, les meubles garnis de bronze doré, les commodes plaquées en ébène, les étagères de laque, les étoffes riches, les bibelots rares, les ivoires, les biscuits de Sèvres, les miniatures et les camées. Chaque matin, à sa toilette, défilaient les fournisseurs, des joaillers . . . les couturières . . . des marchands d'étoffes, des marchands de dentelles . . . les coiffeurs. . . . Elle faisait la mode à Paris et dans toute l'Europe."*

In her early days, as a shop assistant, Mme du Barry had come into contact with an artist in the person of Mlle Adelaide Labille, the portrait painter. She now began to acquire pictures. She bought Van Dyck's great full-length portrait of *Charles I* (now in the Louvre) which she described as a *portrait de famille* because some Dubarrys were related to some Stuarts. She also acquired the celebrated *Cruche cassée* (now in the Louvre) by Greuze, and a nude, which she kept curtained, by Van Poelenburg ; she commissioned François-Hubert Drouais (1727-1775), a fashionable portrait painter (well represented in the London and Washington National Galleries), to paint overdoors at Louveciennes and she sat to him for her portrait ; and finally she commissioned a series of panels from an artist then known as " le petit Frago " in the world of Parisian fashion and pleasure.

9 JEAN HONORÉ FRAGONARD

BORN GRASSE 1732 DIED PARIS 1806

Characteristic Pictures

London	National Gallery	The Happy Mother
London	National Gallery (Gulbenkian Collection)	L'île d'amour [N1]
London	Wallace Collection	The Gardens of the Villa d'Este (Le petit Parc)
London	Wallace Collection	The Souvenir (Le Chiffre d'Amour)
London	Wallace Collection	The Fountain of Love (La Fontaine d'Amour)
London	Wallace Collection	The Swing (L'Escarpolette)
London	Wallace Collection	A boy as Pierrot
London	Wallace Collection	A young scholar

London	Wallace Collection	The Schoolmistress (Dites donc, s'il vous plaît)
New York	Metropolitan Museum	La Cascade
New York	Metropolitan Museum	L'Allée ombreuse
New York	E. R. Bacon Collection	Le Serment d'Amour,[1] [N1]
New York	H. C. Frick Collection	Le Rendez-vous (L'Escalade)
New York	H. C. Frick Collection	La Poursuite (La Surprise)
New York	H. C. Frick Collection	Les Souvenirs (Les Confidences)
New York	H. C. Frick Collection	L'Amant Couronné
New York	H. C. Frick Collection	L'Abandon
Detroit	Institute of Arts	Aurora (Decorative sketch)
Paris	Louvre	Le grand prêtre Corésus se sacrifie pour sauver Callirhoé
Paris	Louvre	Le Vœu à l'Amour[2]
Paris	Louvre	La Leçon de Musique
Paris	Louvre	Bacchante Endormie
Paris	Louvre	La Chemise enlevée
Paris	Louvre	Baigneuses
Paris	Louvre	La Musique
Paris	Louvre	L'Etude
Paris	Louvre	Portrait de fantaisie
Paris	Louvre	L'Inspiration
Paris	Musée Cognacq	L'heureuse Fécondité
Paris	Jacquemart André Museum	Le Début du modèle
Paris	Formerly Weill Collection	La Lettre [N2]
Paris	Formerly Weill Collection	Taureau blanc à l'étable [N3]
Paris	Formerly Weill Collection	L'Inutile résistance
Paris	Formerly Weill Collection	Le rêve du sculpteur
Paris	Formerly Weill Collection	Les pins à la villa Pamphili (Drawing) [N4]
Paris	Formerly Weill Collection	Danse des enfants dans le parc (Drawing)
Paris	Formerly Weill Collection	Les pétards (Drawing) [N5]

[1] There is another version of this picture in the Tours Museum.
[2] This is a sketch for the picture in the Orléans Museum.

Paris	Formerly Weill Collection	Danae (Drawing)
Paris	Formerly Weill Collection	Le Maître de danse or Qu'en dit l'Abbé (Drawing)
Paris	Charley Collection	Jeune fille à la fontaine
Paris	Banque de France	La Fête de St. Cloud
Paris	Wildenstein Collection	Sketch for Le Verrou
Paris	Pillet-Will Collection	La Main Chaude
Paris	Pillet-Will Collection	Le Cheval fondu
Grasse	Cathedral	Le Sauveur lavant les pieds à ses apôtres
Amiens	Museum	Le Berceau
Amiens	Museum	Les Lavandières
Besançon	Museum	Mme Fragonard (Drawing)
Lille	Museum	Adoration des Bergers
Leningrad	Hermitage	The Stolen Kiss (Le Baiser à la dérobée)
Leningrad	Hermitage	La Famille du Fermier
India	H. H. Gaekwar of Baroda Collection	Le Verrou

(a) Fragonard's Life

Jean-Honoré Fragonard, son of a merchant of Grasse, was brought at the age of fifteen to Paris by his father who had lost most of his money in bad investments. Articled to a notary, he showed no talent for law but considerable talent for drawing, and he was taken to Boucher who recommended him to apprentice himself to Chardin. After a period in Chardin's *atelier* he again showed his work to Boucher who now employed him as an assistant. In 1752, at the age of twenty, he won the Academy's *Prix de Rome* and entered the *École des élèves protégés*; and in 1754 and 1755, according to custom, he sent pictures to Versailles to be inspected by the King—one being a subject from the story of Psyche, the other *Le Sauveur lavant les pieds à ses apôtres*.

In 1756 he went, with a royal scholarship, to Rome, where after two years in the French Academy he met Jean-Claude de Saint-Non, a rich Abbé who preferred the rôle of amateur engraver and patron of the arts to a career in the world of politics or the Church, and who chanced at this time to be in Rome. Saint-Non adopted Fragonard as his protégé and invited him to the Villa d'Este, at Tivoli, which had been lent him by the Modenas who then owned it; at the same time he invited the landscape painter, Hubert Robert, who was Fragonard's friend.

Fragonard was Saint-Non's guest for a year or more; and at

his expense he visited Venice, where he studied Tiepolo's works (as Boucher had done), and Naples, where he studied decorative paintings by Solimena (1657-1747) then much admired.

In 1761 he returned to Paris and was made an Academician and given a studio in the Louvre for *Le grand prêtre Corésus se sacrifie pour sauver Callirhoé*, which was a "picture of the year" in the Salon of 1765 and was bought by Marigny as *Surintendant des Bâtiments* for translation into tapestry at the Gobelins. But though bought, the picture was not paid for ; one of his friends wrote to Marigny imploring him to make a payment on account because owing to the delay the artist was "*obligé de se livrer à des ouvrages peu conformes à son génie*" ; but Fragonard was still kept waiting (he had in fact to wait for eight years) and meanwhile he was desperately in need of money. He began, therefore, to paint little pictures of *sujets galants et grivois* which appealed to the rich people —though the artist's friends regarded them as lamentable "potboilers."

About this time he executed some commissions for ecclesiastical pictures, including the *Adoration des Bergers* now at Lille, and others for decorations in private *hôtels* ; and then good fortune appeared in the person of the immensely rich financier, Bergeret de Grancourt, *Trésorier général de la généralité de Montauban*, collector and amateur artist, who became his friend and protector. The next step was the decoration of apartments in the luxurious *hôtels* of fashionable kept women, and Fragonard now became a well-known figure in a world of fantastic pleasure and extravagance, and *persona grata* with the most celebrated of these women—the dancer La Guimard, of whom Portalis writes : "*Elle avait trois soupers différents par semaine, l'un composé des premiers seigneurs de la cour, l'autre d'auteurs et d'artistes ' qui viennent amuser cette Muse'* . . . *Au troisième, véritable orgie, étaient invitées les filles les plus séduisantes, les plus lascives. . . . Les parades de son théâtre de Pantin, célèbres par leur grivoiserie, n'étaient pas moins suivies. Les plus jolies filles de Paris y venaient avec les adorateurs, et si une honnête femme s'y glissait par curiosité, ce n'était qu'en loge grillée.*" La Guimard, it is recorded, was a light and agile dancer but in figure too thin for the taste of the time. "*Il ne lui manque,*" it was said, "*que des grâces plus arrondies dans certaines parties—de son rôle.*" When Fragonard met her she was the mistress of the Prince de Soubise, who employed the architect Ledoux (then about to build the Pavillon de Louveciennes for Mme du Barry) to build her a *hôtel* in Paris. Later when La Guimard's fortunes waned she organised

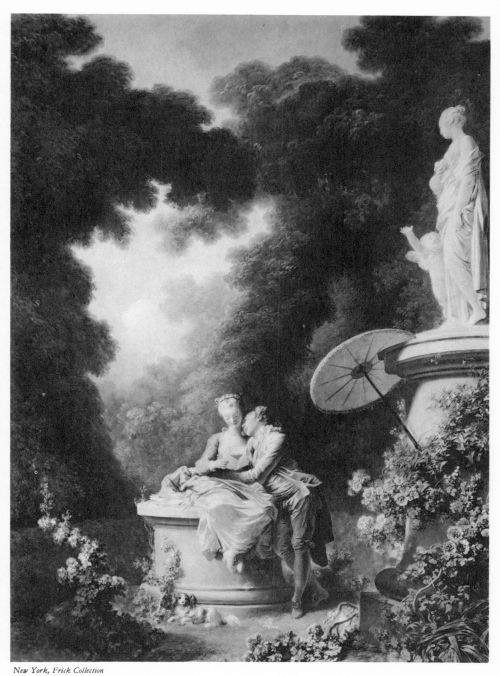

New York, Frick Collection

65. JEAN-HONORÉ FRAGONARD: Les Souvenirs (Les Confidences)

PLATE VI

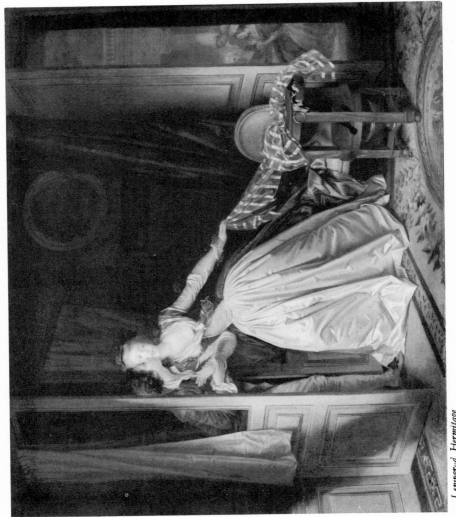

Leningrad, Hermitage

J. H. FRAGONARD (1732-1806): The Stolen Kiss (Le Baiser à la dérobée)

a public lottery for the *hôtel* and all the objects of luxury (including the paintings by Fragonard and Louis David) which it contained. Though many people doubtless bought large numbers of tickets the winner was a lady of fashion who had bought only one.

Meanwhile, the family Gérard, unsuccessful perfumers of Grasse, who had some connection with his own family, had sent him as a pupil Marie-Anne Gérard, aged seventeen, who showed talent for miniature painting—just as the Pater family of Valenciennes had sent Pater to Watteau ; and in 1769, when he was thirty-eight, he found himself hesitating between marriage with Marie-Anne Gérard and the continuation of a life where he would pass as *amant de cœur* from one kept woman to another. He chose respectability and a quiet life ; and he married Mlle Gérard in that year.

Thus protected he accepted and executed two important commissions in the next three years. The first was a series of panels for La Guimard, with whom he quarrelled before the work was completed. The second was a series of panels in the Pavillon de Louveciennes commissioned by Mme du Barry, who refused to hang them when they were completed and hung pictures by J. M. Vien (to whom I refer later) in their place.

In 1773 Fragonard and his wife were taken by Bergeret de Grancourt on a tour in Italy, Austria and Germany. The journey lasted about nine months ; the company travelled in two coaches ; the first contained Bergeret and a mysterious lady (said to be Mme Bergeret's *femme de chambre* whom he married after Mme Bergeret's death) and Fragonard with his wife ; the second contained Bergeret's son and a *chef* ; Bergeret's valet and his son's man travelled ahead as couriers. Bergeret kept a diary of this tour which is most entertaining. Extracts are given by Portalis and also in *Fragonard*, by Virgile Josz. At the end of the journey there was friction between Fragonard and his host and when they returned to Paris Fragonard brought an action against him to obtain possession of a number of drawings which Bergeret had retained. Bergeret lost the action and crossed out of his diary all flattering references to Fragonard whom he now described as a poltroon. Later the two men were again on terms of friendship.

Fragonard was back in Paris at the end of 1774. His establishment in the Louvre now consisted of himself, his wife, a daughter of four, and his wife's sister Marguerite Gérard, aged thirteen, who had come from Grasse soon after his marriage. A son was born in 1780. In the period between 1774 and the Revolution

he used his own family as models for genre pictures, and he developed an *amitié amoureuse* with Marguerite Gérard when she grew up and became successively his pupil, his assistant, and a genre artist winning successes of her own. After 1767 Fragonard made no attempt to secure official patronage or the applause of the general public by exhibiting in the Salons. He exhibited his work in his own studio where he sold from the easel. He was thus the first eighteenth-century painter who defied the Academicians—Greuze who abstained from the Academy after 1769 being the second.

When Fragonard quarrelled with La Guimard and left his panels unfinished, an ambitious young artist, Louis David, asked and obtained his permission to complete them. This gesture on the part of Fragonard stood him in good stead when the Revolution arrived; for David, then art-dictator, protected him; he was allowed to retain his studio in the Louvre and he was appointed *Président du Conservatoire* of the *Musée national des arts* thanks to David who recommended him in a report to the Revolutionary Government which said: *"Fragonard a pour lui de nombreux ouvrages; chaleur et originalité, c'est ce qui le caractérise; à la fois connaisseur et grand artiste, il consacrera ses vieux ans à la garde des chefs d'œuvre dont il a concouru dans sa jeunesse à augmenter le nombre."*

In his prosperous days Fragonard had made a good deal of money. But when the *rentes sur l'Etat* were reduced his income became almost nothing, and though he made efforts to paint pictures in the prevailing spirit he was too old to secure success in a new field.

In 1806 Napoleon suppressed all the artists' lodgings in the Louvre; and Fragonard had to leave the studio which he had occupied for forty years and move his family and property elsewhere. He was then seventy-four. He died the same year of cerebral congestion after eating an ice in a café when he was hot from a long walk.

(b) Fragonard's Œuvre

The recorded works of Fragonard consist of about five hundred paintings, a great many drawings, and some miniatures, illustrations and etchings. The dates of a few works are fixed; the exact chronology of the others is a matter of conjecture. The de Goncourts produced the first modern account of his work in 1865. The Baron de Portalis published his splendid *Fragonard, sa vie et son œuvre* with a detailed catalogue in 1889; but there are

very few dates in his catalogue and many of the pictures have changed hands since his time. Modern books include monographs by de Nolhac (1906) and G. Grappe (1929).

Fragonard before his first journey to Italy was an imitator of Boucher. In Italy, as Saint-Non's guest, he drew monuments and ruins, and the gardens of the Italian villas, and he painted a few pictures of similar subjects, including *Le petit Parc* in the Wallace Collection and *La Cascade* and *L'Allée ombreuse* in the New York Metropolitan Museum (formerly Bache Collection). The style of his work at this period shows the influence of Claude, as can be seen in the delicately formalised drawing *Les Pins à la Villa Pamphili* (Pl. 63).

In Paris between 1762 and 1769 he produced a series of pictures which can be grouped round the Academy success of 1765, *Le grand prêtre Corésus se sacrifie pour sauver Callirhoé*. The drawing in the *Corésus* is rather simple and severe with few of the impetuous curves that characterise his later drawing. We find the relatively severe drawing in all the pictures here grouped round the *Corésus* ; we also find, in all of them, the use of the same models and the same studio properties.

For the *Corésus* the models used were a tall blonde girl and a rather short young man with curly hair—(Fragonard himself was under the average in height and the male figures in his pictures tend to be short) ; and it is clear that the studio at this time contained a wreath of artificial flowers often used on the heads of the figures.

The girl model appears in the Wallace Collection *Le Souvenir* (a picture suggesting that Fragonard was acquainted with engravings after Reynolds), and both models appear in *Le Baiser à la dérobée* (Plate VI) known as *The Stolen Kiss*, in *Le Verrou*, in the Wallace Collection *La Fontaine d'Amour* (Pl. 64), where the figures wear the *Corésus* wreath, in two of the panels painted for Mme du Barry, *L'Abandon* and *Les Souvenirs* (Pl. 65), and in *Le Contrat* which was a pendant to *Le Verrou*.

In addition to the *Corésus* wreath, the studio properties at this time included a little round table (seen in *Le Baiser à la dérobée* and converted into the altar in the *Corésus*) and a white satin dress worn by the models in *Le Baiser à la dérobée*, *Le Verrou*, *Le Contrat*, *L'Abandon* and *Les Souvenirs*. A home-made shot-silk mantle is worn over the dress in *Le Baiser à la dérobée* ; this was taken off the dress and used as the young man's dressing-gown in *Le Contrat*, which was probably painted a little later because the dress has been

renovated by the addition above the tight sleeves of a puffed over-sleeve and the insertion of a new frilled *modestie*.

Other pictures in the *Corésus* group are *Le Vœu à l'Amour* in Orléans, for which there is a delightful sketch in the Louvre, *Le Serment d'Amour* in the Bacon Collection in New York, and *Le* [N1] *rêve du sculpteur*, formerly in the collection of M. David Weill, a picture said to have been painted for Mme de Pompadour and therefore produced before 1764.

The impetuous note in Fragonard's drawing begins to be apparent in the sketch for *Le Verrou* and it is still more clear in the group of works that come next. In these we see another model, a *petite brunette*, who posed for the lively figures in *Les Pétards* (Pl. 66a)—young girls terrified by fireworks let off by a boy through a skylight in their bedroom—and for the paintings *La Chemise enlevée* and the *Baigneuses* (Pl. 66b) in the Louvre. *La Chemise enlevée* is a sketch for an easel picture; it is in typically bad Louvre condition but it is still possible to see that it was painted with great delicacy of handling and colour. The *Baigneuses* on the other hand, which is coarse both in handling and colour, was certainly an overdoor panel and intended to be seen at a distance. The four pictures *La Musique*, *L'Etude*, *Portrait de fantaisie* and *L'Inspiration* (two of which bear the date 1769 written on the back) are similarly coarse in handling and also overdoors.

In *Les Pétards* (Pl. 66a) we observe much the same attitudes as in the *Baigneuses* (Pl. 66b), and in *Les Pétards* there is a remarkable dog which was about the studio at this time. This dog appears in the *Leçon de Musique* in the Louvre, where the seventeen-year-old Marie-Anne Gerard, lately arrived from Grasse, is trying to play the piano; it may have belonged to La Guimard as it figures again in a full-length portrait of the dancer, where the artist, working in his old Boucher manner, has painted a Boucher Cupid aiming an arrow at the lady's foot.[1]

We find a return to Boucher (who began, we must not forget, as an engraver of works by Watteau) in the famous decorative panel *Les hazards heureux de l'escarpolette* (*The Swing*) and in the five panels painted for Mme du Barry. The six pictures form a group in themselves dating from 1765 to 1772.

The subject of the du Barry series is known to have been *Le progrès de l'amour dans le cœur des jeunes filles*. The traditional order

[1] This picture is reproduced in de Nolhac's *Fragonard*. I do not know its present whereabouts.

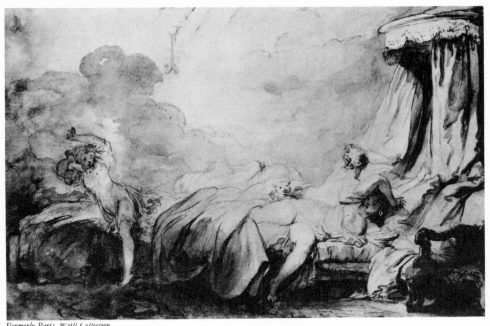

66a. JEAN-HONORÉ FRAGONARD: Les Pétards (Drawing)

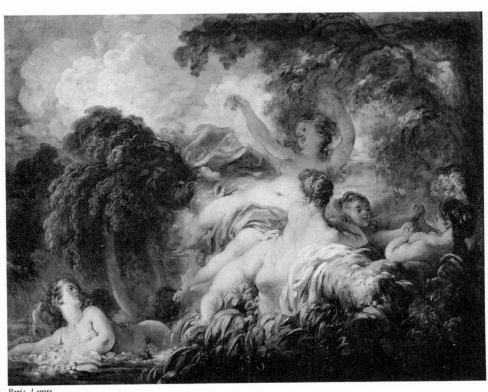

66b. JEAN-HONORÉ FRAGONARD: Baigneuses

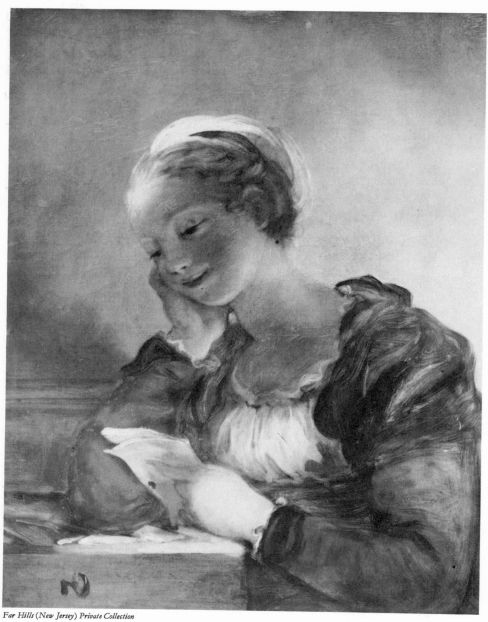

67. JEAN-HONORÉ FRAGONARD: La Lettre

of the panel is : (1) *La Poursuite*, also known as *La Surprise*, (2) *Le Rendez-vous*, also known as *L'Escalade*, (3) *Les Souvenirs*, also known as *Les Confidences* (Pl. 65), (4) *L'Amant Couronné*, (5) *L'Abandon*.

The reason that these pictures were rejected remains obscure. It has been suggested that the faces in *Le Rendez-vous* resembled Mme du Barry and Louis XV and that this offended the King. But there was, I think, another reason. I believe that Mme du Barry or the King saw an offensive double meaning in one of the pictures and rejected the whole series without giving an explanation.

I believe that the correct order for the pictures is : (1) *L'Abandon* which should be called *Le Désir*, for why should Fragonard paint Mme du Barry as *deserted* by the King—at the very moment of her triumph ? ; (2) *Les Souvenirs* which should be *Les Confidences* (Pl. 65), (3) *La Poursuite*, (4) *Le Rendez-vous* which should be *L'Escalade*, (5) *L'Amant Couronné*. Thus arranged we get a continuous design illustrating a story ; and the last picture *L'Amant Couronné*, where the young couple are posing to the artist, is the calling in of Fragonard to record the " happily ever after " ending. In his studio, however, Fragonard actually began, I think, with *Le Désir* (*L'Abandon*), *Les Confidences* (*Les Souvenirs*) and *L'Amant Couronné*, because the tall blonde still appears in all three pictures wearing her satin dress of which the sleeves have not yet been altered. In these pictures, moreover, we see the old studio property, the *Corésus* wreath, and the lute, the music book and the boy's suit and ruffle of the Louvre *Leçon de Musique*. *L'Abandon* is not a finished picture but a sketch in monochrome with touches of red. This does not mean, however, that it was necessarily the last from the illustrative standpoint or the last to be produced. In *L'Escalade* and *La Poursuite* the model would seem to be Mme Fragonard wearing the satin gown, with the new puffed sleeves of *Le Contrat* and the old tight undersleeves now cut completely away, as she also wore it when posing for *La Leçon de Musique*. All this of course is speculative as Fragonard like Watteau painted mainly from drawings which he might use after the model who sat for the drawing was no longer available. But he also sometimes painted direct from nature ; *La Leçon de Musique* for example was obviously painted in this way ; *Les Pétards* (Pl. 66a) and *Baigneuses* (Pl. 66b) on the other hand both contain a figure copied from the same study.

On his Italian journey with Bergeret in 1773 Fragonard made

a great many drawings mostly of *bambochade* character ; he probably painted few if any pictures. But *Les Lavandières* in the Amiens Museum I take to be a sketch done in three-quarters of an hour on this Italian tour.

Fragonard's work of 1775-1779 after his return from the tour shows the influence of his study of Rembrandt in the German and Austrian collections visited with Bergeret. He was already acquainted with Dutch pictures which he could have seen in many collections in Paris, and the spot-light effect derived from Rembrandt had already appeared in the sketch for *Le Verrou* and other works ; but at this period the Rembrandt influence is so strong that Portalis has assumed that he visited Holland.

This Rembrandtesque manner is seen in *La lettre* (Pl. 67) and *La résistance inutile* (Pl. 68a), and also in genre pictures like *La famille du fermier* in the Leningrad Hermitage and the *Taureau blanc à l'étable*. *La fête du St. Cloud* in the Banque de France, and the sketches for parts of it in two private collections, also belong to this period.

The attractive picture *L'île d'amour* on loan at the London National Gallery from the Gulbenkian Collection was painted in[N1] the seventeen-eighties and records a fête given at Chantilly by the Prince de Condé to the Archduke and Archduchess of Russia in the summer of 1782. On that occasion the Duchesse de Chartres and the Princesse de Lamballe appeared as *batelières de l'île d'Amour*, and these ladies are therefore among the little figures in the ornate boat in the right foreground of the picture (which, incidentally, is sometimes titled *Fête à Rambouillet*, apparently in error).

For the remainder of his career Fragonard painted genre pictures of domestic and rural subjects, making use of the *bambochade* drawings from the Bergeret tour. The Wallace Collection *The Schoolmistress* (*Dites donc, s'il vous plaît*) (Pl. 68b), where we see Mme Fragonard and his son, aged about three, as models, is one pleasant example ; the London National Gallery *The Happy Mother* is another.

(c) Fragonard's Art

Fragonard was an artist with great gifts ; and his gaiety is irresistible. The verve, the spontaneity, the wit and the delicacy in drawings of the character of *Les Pétards* were something new in French painting and in these qualities he has never been surpassed. His more impetuous oil paintings also appeal to those who

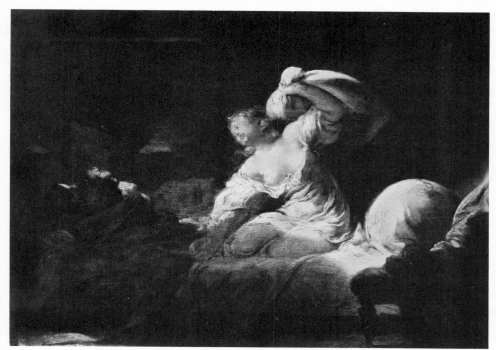

68a. JEAN-HONORÉ FRAGONARD: La Résistance Inutile

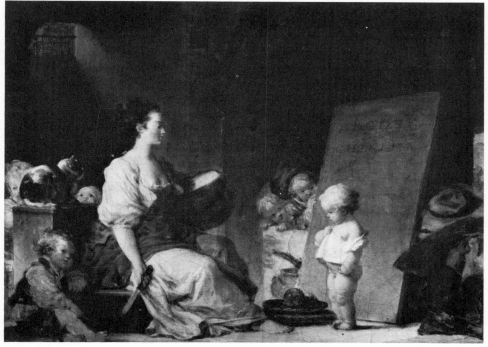

68b. JEAN-HONORÉ FRAGONARD: The Schoolmistress

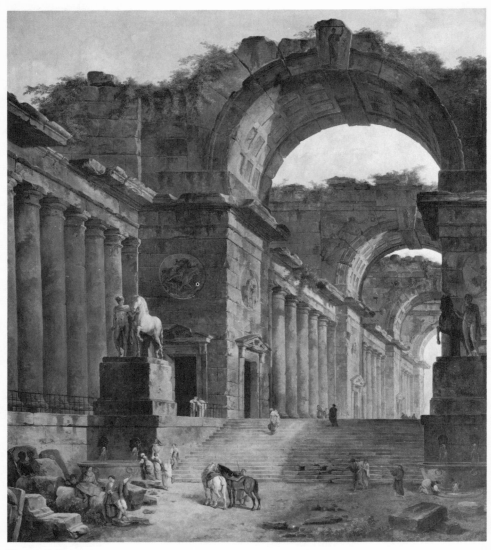

69. HUBERT ROBERT: Les Fontaines

enjoy facility and virtuosity of touch. But compared with Boucher he was fundamentally a decorator ; and compared with Watteau his art is obvious and occasionally vulgar. He was a painter of easel pictures who began as a lyric poet, who developed into the ancestor of *La Vie Parisienne* draughtsmen, and ended as a painter of genre.

In the period when Fragonard stood at the parting of the ways Diderot wrote of him : " *On prétend que l'appât du gain l'a détourné d'une belle carrière et qu'au lieu de travailler pour la gloire et la postérité, il se contente de briller dans les boudoirs et les gardes-robes.*" This criticism was to some extent justified. There can be no doubt that Fragonard took the line of least resistance. In *La Fontaine d'Amour* (Pl. 64), painted, I am convinced, before the *Corésus*, there is an abstract lyrical quality in the movement from which those of us who saw Pavlova and Mordkin's first entrance in their Bacchanalian dance recapture the same thrill. The lyrical movement that blows across *La Fontaine d'Amour* occurs again in the Louvre sketch for *Le Vœu à l'Amour* ; and it is present in a slower tempo in *Le Baiser à la dérobée* (Pl. VI). But already in the sketch for *Le Verrou* the movement has become *rubato* ; when we get to *Les Pétards* (Pl. 66a) and *Baigneuses* (Pl. 66b) the lyrical quality has gone.

Fragonard's spirit when he drew *Les Pins à la Villa Pamphili* (Pl. 63) was still modest ; it had idealism when he painted *La Fontaine d'Amour* : it became irresponsible when he frequented La Guimard and the gay world ; and it became bourgeois when he married. Perhaps he was most himself in the irresponsible period ; and it may be that when, at the crisis, he took the line of least resistance, he was right.

10 TABLEAUX DE MODES

The eighteenth century in France was marked by the prevalence of engravings known as *gravures de modes* representing fashionable clothes on figures in appropriate surroundings. Engravings of this kind had been produced all over Europe in the seventeenth century and Jacques Callot and Abraham Bosse, already mentioned, were among the French exponents. Watteau himself drew a number of fashion plates (engraved in the *Recueil Jullienne*), and the tradition culminated in *Le Monument du Costume*, delightful plates announced as a " *Suite d'Estampes, pour servir à l'histoire des mœurs et du costume des François dans le dixhuitième siècle*" which

were published in instalments between 1774 and 1783 and perfectly fulfilled the advertisement.

These engravings, and the dainty and entertaining *estampes galantes* sublimating the easy morals of French social life of the period, are outside my subject. But I must mention the names of the engravers Nicolas Delaunay (1739-1792), Robert Delaunay (1749-1814), Pierre-Philippe Choffard (1730-1809), Jean-Baptiste Simonet (1742-1810), François Dequevauviller (1745-1807) and the colour printers, J. F. Janinet (1752-1814) who invented an unsuccessful hot-air balloon, C.-M. Descourtis (1753-1826), and P.-L. Debucourt (1755-1832) who made brilliant drawings for many of his prints and retired to the country in the Revolution and bred rabbits.

Exquisite *gouache* drawings and water-colours were made for these engravings and colour prints by Moreau le jeune (1741-1814) who designed the most spirited of the plates for *Le Monument du Costume*, Pierre-Antoine Baudouin (1723-1769), Augustin de Saint-Aubin (1737-1807), Gabriel de Saint-Aubin (1724-1780), Nicholas Lavreince (1737-1807), and S. Swebach-Desfontaines who drew *La Café des Patriotes* where the Jacobins used to congregate in the Revolution.

Paintings of the character of the *gravures de modes* had been a feature of Dutch seventeenth-century production, and Terborch and Metsu had achieved popular success with their illusionist texture painting of satin skirts and fur-trimmed jackets which they painted on lay figures. When Chardin's paintings of domestic subjects appeared they were ranked by the dilettanti as the continuation of this tradition, and some of the early pictures by Fragonard were regarded in the same way.

In the Dutch *tableaux de modes* there was hardly any action. But the French artists soon began to give their pictures of this kind the additional interest of movement and incident and their *tableaux de modes* eventually developed into records of contemporary life and manners as spirited and full of incident as the engravings.

The last artist whose name is associated with this school is Louis-Léopold Boilly : he was essentially an oil painter—though he occasionally drew for the engravers—and his work and career, both highly significant of the period, must be separately considered.

II LOUIS-LÉOPOLD BOILLY

BORN LA BASSÉE 1761 DIED PARIS 1845

Characteristic Pictures

London	Wallace Collection	The Dead Mouse
London	Wallace Collection	The visit returned
London	Wallace Collection	The Sorrows of Love
Washington	National Gallery (Chester Dale)	In a painter's studio
Paris	Louvre	Réunion d'artistes dans l'atelier d'Isabey
Paris	Louvre	L'Arrivée de la Diligence
Paris	Louvre	Les Amateurs d'Estampes
Paris	Louvre	L'Averse
Paris	Louvre	Seven portraits
Paris	Musée Cognacq	Lucile Desmoulins
Paris	Musée Cognacq	L'Enfant au fard
Paris	Musée Cognacq	La Jeune mère déçue
Paris	Musée Cognacq	La Moquerie
Paris	Musée Cognacq	La Mère en courrace
Paris	Musée Cognacq	L'Innocent
Paris	Musée Cognacq	La Serinette
Paris	Musée Cognacq	Les Saltimbanques
Paris	Musée Carnavalet	Départ des conscrits en 1807
Paris	Musée des Arts décoratifs	L'Atelier de Houdon
Chantilly	Musée Condé	Une partie de dames au Café Lamblin
Rouen	Museum	Portrait of Boieldieu
Lille	Museum	Marat porté en triomphe
Lille	Museum	Studies for L'Atelier d'Isabey

Boilly, son of an ornamental sculptor of La Bassée, earned his living from eighteen to twenty-three by painting portraits in the provinces ; he is said to have produced three hundred in Arras alone. Arriving in Paris in 1784 he painted *tableaux de modes* which were generally *risqués*, and sometimes indecent by reason of a *double entente*. In the Terror he was denounced as an indecent painter of the old régime and he escaped the guillotine by beginning *Marat porté en triomphe* (now at Lille) before the inquisitors arrived at his studio. Having weathered the storm he became a recorder of social life under the Directorate, the Consulate, the Empire and the Restoration, and he also continued to paint portraits and from time to time *tableaux de modes* more or less in his old manner.

Boilly's social pictures are the forerunners of the journalistic descriptive paintings of the nineteenth century. In *L'Arrivée de la diligence* (Pl. 70b), painted in 1803, now in the Louvre, we see

a young wife embracing her husband who has just arrived by the *diligence*; a nursemaid holds one of the lady's children in her arms and blows the nose of another; in other pictures we see old cronies playing chess in a café and people caught in a rainstorm in the streets of Paris—a picture which makes an interesting contrast with *Les Parapluies* (in the London National Gallery) by Renoir; and *Les Saltimbanques* in the Musée Cognacq shows us open-air acrobats and the crowd watching them—in the old tradition of *The Quack Doctor* started in Holland by Bamboche and carried on by Jan Steen and others.

We see, in fact, the influence of the Dutch seventeenth-century pictures in all Boilly's work; and he revived the Dutch tradition of portrait groups of men united by occupation or office, which had already appeared in French art in the work of Largillière. His *Atelier d'Isabey* in the Louvre, which was painted in 1798, is a brilliant piece of collective portraiture and a most interesting record of the continuation of the artists' life in their Louvre quarters all through the Revolution. Another group *L'Atelier de Houdon* (in the Musée des Arts décoratifs) shows the sculptor at work on a portrait bust with the sitter on the throne and the sitter's wife and daughters watching; Houdon's famous statue of *Voltaire* (now in the Musée Fabre at Montpellier) is at the back of the studio.

Boilly gave his paintings the remarkably smooth polished finish which we associate with some of the Dutch pictures and which we encounter again in certain pictures by Ingres. He is said to have invented some optical device to assist him in representational imitation. It was possibly some instrument of the kind used by the Dutch painter Gerard Dou or some contrivance of the *camera oscura* kind such as Canaletto used in the eighteenth century.

As he always delineated costume with great accuracy, and worked over a period when it changed several times, his pictures have considerable value from that point of view.

12 JEAN-BAPTISTE GREUZE (1725-1805)

In the second half of the century there was a reaction in certain sections against the *estampes galantes* and the *tableaux de modes* and it became fashionable to adopt Diderot's attitude and ask a picture to tell a moral tale. The " simple life " ideas of Jean-Jacques Rousseau were also fashionable, and genre pictures showing the presumed domestic happiness of peasants in rustic interiors were much admired.

Fragonard in his later genre pictures was thus working to achieve contact with a growing taste, but as he did not exhibit his genre paintings in the Salons he never experienced the popular success which Greuze achieved with his *L'Accordée de Village* in the Salon of 1761.

Greuze was the son of a builder of Tournes, near Mâcon, and he was apprenticed to a painter of Lyons who brought him to Paris; he remained obscure till at the age of thirty, in 1755, he submitted a genre picture to the Academicians and was *agréé* and allowed to exhibit *Un père de famille qui lit la Bible à ses enfants* in the Salon. He was taken to Italy by one of the dilettante Abbés of the time, and there he met and fell in love with a young Italian Countess to whom he was giving lessons in drawing. Marriage being out of the question he returned to Rome in sentimental mood and fell a victim to a bookseller's daughter whom he married in 1769. Mme Greuze, he soon discovered, was a shrew; she was also, as he discovered later, a harlot; but she was pretty, as we know from a long series of pictures.

L'Accordée de Village, now in the Louvre, was unfinished when the Salon of 1761 opened and it arrived six days before the exhibition closed. For these six days—as the de Goncourts put it, "*c'était une acclamation, une émeute d'enthousiasme, un prodigieux succès.*" The picture represents an old peasant handing a money bag to a young man whom he has just accepted as the betrothed of his daughter who is seen with her mother and various sisters on the other side of the peasant interior. The picture, in character, is a scene in a third-rate melodrama; but its false sentiment was well calculated to appeal to the Salon public, as it appealed to Diderot who hailed Greuze as the fulfilment of his own art principles. "*C'est vraiment là,*" he wrote, "*mon homme que Greuze . . . c'est la peinture morale. Quoi donc! le pinceau n'a-t-il pas été assez et trop longtemps consacré à la débauche et au vice? . . . Courage, mon ami Greuze, fais de la peinture morale et fais-en toujours comme cela. . . .*"

In the same Salon Greuze exhibited *Mme Greuze en vestale*; and his genre pictures in the next few Salons were accompanied by examples of those " fancy " heads and figures of young girls with which his name is most widely associated. The London Wallace Collection has a number of well-known examples of this aspect of his work, of which *La Prière du Matin* in the Musée Fabre, at Montpellier, is also characteristic.

In 1767 the Academicians, jealous of his success, refused to allow him to exhibit as he had not yet painted his *tableau de réception*.

He therefore painted an agreed subject : " *L'Empéreur Sévère reproche à Caracalla, sons fils, d'avoir voulu l'assassiner dans les défilés d'Ecosse, et lui dit : ' Si tu désires ma mort, ordonne à Papinien de me la donner avec cette épée.' "* The Academicians then elected him— but in the inferior category of *peintre de genre*, which excluded him from the higher offices in the Academy. This so incensed him that he abstained from exhibiting at the Salons and organised exhibitions in his own studio (which Marigny had granted him in the Louvre). In this he was following the example of Fragonard who was among his friends. The Salon public flocked to Greuze's studio exhibitions where many of his best-known pictures, in- cluding *La Cruche cassée,* were first shown. *La Cruche cassée,* bought by Mme du Barry, as noted, passed to the Louvre when Mme du Barry's property at Louveciennes was nationalised in the Revolution.

Greuze believed in keeping his name before the public ; he wrote letters to the newspapers explaining " how the idea came to him " for a subject-picture or protesting against unfavourable references to his pictures. He made a great deal of money out of the sale of his pictures and engravings from them. But his capital, like Fragonard's, disappeared in the Revolution ; and he had not Fragonard's advantage of David's protection. In 1801 we find him writing to the Minister of the Interior : " *J'ai tout perdu, hors le talent et le courage. J'ai soixante-quinze ans, pas un seul ouvrage de commande.*" In the hope of scoring a popular success he now broke his resolution and began to send pictures again to the Salons ; but the triumph of *L'Accordée de Village* was not repeated ; and he was almost destitute when he died in 1805.

Greuze, in my judgement, was a detestable artist. He was coarse and stupid in his genre subject-pictures in which he never approached the contact with real simplicities that we find in the works of Louis Le Nain and Chardin ; and in his " fancy " heads and figures he was lecherous.

13 FRENCH EIGHTEENTH-CENTURY LANDSCAPE

French landscape painting under the old régime showed few signs of the collapse into the imitative naturalism of the Dutch tradition that was to appear in the nineteenth century. The collapse, it is true, was heralded by Oudry in *La Ferme* (painted in 1751 and now in the Louvre), which represents a farmhouse and farmyard with animals treated purely as genre and was accurately described in the old Royal inventory as " *un tableau*

dans le genre flamand." But most of the eighteenth-century painters held fast to the picturesque-classical tradition in landscape and they reinforced the mechanical vision of their eyes to architectural perception.

Boucher's landscapes and landscape settings in his compositions were organised with the same cold intellectual clarity that we find in his other work. There is no haphazard imitation of casual appearance in *Le Moulin* in the Louvre or *Le Moulin de Charenton* at Orléans; all the units in these pictures are consistently formalised and architecturally disposed.

Watteau, after his first genre period, gave style to his landscapes by studying Venetian drawings, and in a picture like the Wallace Collection *Amusements Champêtres* (Pl. 45b) he contributed a new space-concept of his own. Fragonard, who started in the Claude tradition, also made a contribution in his massing of verdure in the Louveciennes panels (Pl. 65) and in *La Foire de St. Cloud*.

Apart from these artists who used landscape to some extent incidentally, there were others, especially in the second half of the century, who specialised in this field. Of these the outstanding names are Joseph Vernet, Louis-Gabriel Moreau and Hubert Robert.

Joseph Vernet (1714-1789) was sent to Italy by a patron at the age of nineteen, and he developed there as a painter of decorative landscapes and marines in the manner of Claude. He was recalled to Paris by Mme de Pompadour in 1745 and Marigny commissioned him to paint a series of views of French ports. Fifteen of these views, which exhibit a fine decorative serenity, can be seen in the Louvre. Vernet's Italian pictures, in which he often anticipated Romantic landscape by suggesting drama and mood, were bought by rich men as decorative panels for Louis XVI rooms. The Louvre has several examples which entered the museum as nationalised treasures when the owners emigrated during the Revolution.

Louis-Gabriel Moreau (1740-1806), known as Moreau l'aîné, to distinguish him from his brother of *Monument du Costume* fame, specialised in views in the regions round Paris. His admirable *Vue des coteaux de Bellevue* in the Louvre, where little figures in the foreground give the sense of scale to majestic trees, is characteristic of the small number of his pictures that survive.

Hubert Robert (1733-1808) was taken at the age of twenty-one to Italy by the French Ambassador. He worked in the French

Academy in Rome and under Claude's follower Panini. He became a friend of Fragonard and with him, as noted, a protégé of the Abbé Saint-Non. He painted decorative pictures of Roman ruins with genre figures of *lavandières* and so forth in the Bamboche-Claude tradition; and he sometimes recorded actual scenes in a decorative way. When he returned to France he received numerous commissions from owners of Louis XVI rooms with which his pictures admirably accorded. His work also appealed to the Russians of the Court of Catherine the Great and scores of his pictures decorated Catherine's palace, Tsarskoe Selo. In 1792 he was arrested as a suspect but he managed to escape the guillotine and to secure a post with his old friend Fragonard on the staff of the Museum.

Hubert Robert exhibited immense fertility in decorative composition. His output was very large but he never repeated himself. He had a light touch and his pictures are agreeable in colour. I reproduce *Les Fontaines* (Pl. 69), now in the Art Institute of Chicago.

14 MMES VIGÉE-LE BRUN AND LABILLE-GUIARD

In the seventeenth and eighteenth centuries both in Holland and in France there were many women painters who imitated the various pictorial tendencies of their day; and just before the Revolution there were two women painters, Mme Labille-Guiard and Mme Vigée-Le Brun, who had rival reputations as portrait painters in Paris.

In the field of portraiture they had to compete with H.-P. Danloux (1753-1809) whose excellent *Louis-Henry-Joseph de Bourbon* at Chantilly was painted in England (whither Danloux fled from the Revolution) and shows the influence of Reynolds and Lawrence; Joseph Boze (1744-1826), painter of the celebrated full length of Mirabeau making his defiant reply to Dreux-Brézé (now in the Carnavalet Museum in Paris), who worked all through the Revolution and also painted portraits of Napoleon and Louis XVIII; J. S. Duplessis (1725-1802), who painted the charming *Mme Lenoir* in the Louvre and a portrait of *Franklin* of which [N1] versions are preserved in the Musée Carnavalet in Paris and in the Museum of Boston; Antoine Vestier (1740-1824), painter of the Carnavalet portrait of the adventurer *Latude* holding the rope-ladder with which he escaped from the Bastille after thirty-five years' imprisonment, and of pleasing portraits of women in the Metropolitan Museum, New York, the Museum at Bristol

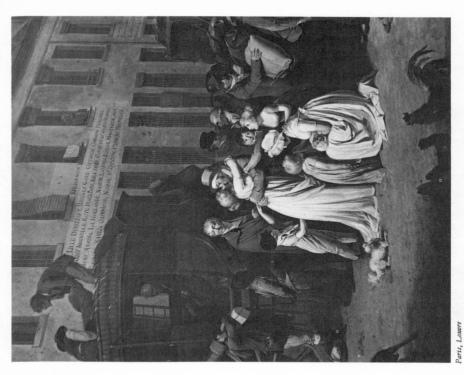

Paris, Louvre

70b. LOUIS-LÉOPOLD BOILLY: L'Arrivée de la Diligence (detail)

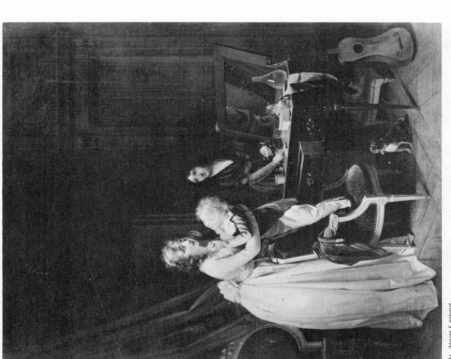

Paris, Musée Cognacq

70a. LOUIS-LÉOPOLD BOILLY: L'Enfant au fard

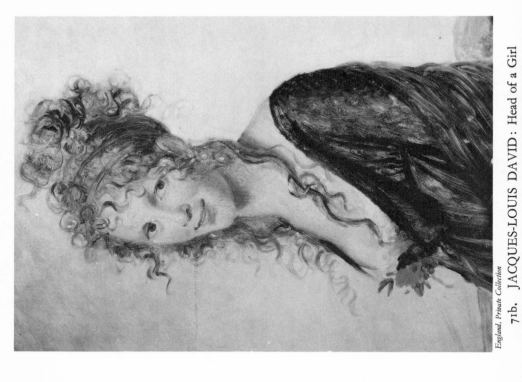

England, Private Collection

71b. JACQUES-LOUIS DAVID: Head of a Girl

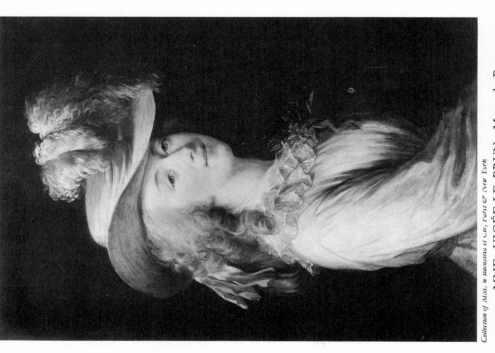

Collection of MM. W. Wildenstein et Cie, Paris & New York

71a. MME. VIGÉE-LE BRUN: Mme. du Barry

(England) and in the Louvre ; and J. Ducreux (1737-1802), who was La Tour's only pupil and was sent to Vienna to paint Marie-Antoinette's portrait. F. H. Drouais (1727-1775), the favourite Court painter at the end of the reign of Louis XV, and Louis Tocqué (1696-1772), who was Nattier's son-in-law and another favourite portrait painter in the second half of the reign of Louis XV, were both dead before Mme Labille-Guiard and Mme Le Brun began to attract attention.

Mme Adelaide Labille-Guiard (1749–1803) was the daughter of a Parisian shopkeeper who supplied " *dentelles, rubans et jolies fanfreluches* " to the Court ; and in her youth she formed a friendship with Mme du Barry who was then an assistant in the shop. She studied painting under F. A. Vincent (1746-1816) who painted the portrait of Fragonard's friend Bergeret which is now in the Museum at Besançon. She married one Nicolas Guiard, divorced him, and then married Vincent.

Clever and ambitious, she made friends with many of the Academicians and painted their portraits ; in 1783, at the age of thirty-four, she was made an Academician, and she then waged a campaign to secure the admission of women painters to the professorial posts from which they were excluded, and to abolish the then existing limit to the number of women members. She had a considerable number of young women pupils, two of whom are seen in the striking full-length picture (Pl. 72b), which I reproduce. She received commissions from members of the Royal Family and was made *peintre de Mesdames*, a post which, it will be recalled, had been held by Nattier. When the Revolution came she remained in Paris and was on terms of friendship with Robespierre who wrote to her in 1791 : " *On m'a dit que les grâces voulaient faire mon portrait. Je serais trop heureux d'une telle faveur si je n'en avais senti tout le prix.*"

Mme Labille-Guiard worked in oil and pastel with efficiency and vigour, but her vision was rather prosaic. The critics of her day continually compared her with Mme Le Brun and many regarded her as the superior artist.

Mme Labille-Guiard's portrait *Mme Elizabeth* painted in 1787 is at Versailles ; it depicts the princess on a terrace with a child and a parrot, and shows the influence of Reynolds. Her pastel portraits of *Vincent* and *J.-J. Bachelier* are in the Louvre ; the Musée Cognacq in Paris has the excellent *Comtesse de Cipierre*.

Mme Elizabeth Vigée-Le Brun (1755-1842), the favourite painter of Marie-Antoinette, lived through the Revolution, the

Empire and the reign of Louis XVIII. She was the daughter of the pastellist Louis Vigée (1715-1767), who drew the pastel portrait of *Mme de Pompadour en pèlerine* which dates from 1745 and represents the sitter in what is believed to be the costume she wore when she first met Louis XV at a *bal masqué* in that year ; the Comédie Française has Vigée's pastel *Mlle Dangeville* and the museums of Tours and Orléans have others. His daughter worked under him and then with various artists including Greuze and Joseph Vernet. At an early age she began to exhibit and have success ; at twenty she married Jean-Baptiste Le Brun, a picture dealer, who became the father of the little girl who figures in the two well-known double portraits *Mme Le Brun and her daughter* in the Louvre.

In contrast to Mme Labille-Guiard, who was short, *trapue* and pugnacious, Mme Le Brun was amiable and graceful, a good hostess and a woman with a sense of humour. Her portraits were not such good likenesses as those of Mme Labille-Guiard, but they were more attractive pictures, and her sitters liked the brightly rouged cheeks and the vivacious elegance with which she presented them. As a result she found herself " taken up " by Parisian society as a brilliant new artist and a personality with charm. In 1779 she received her first sitting from the Queen and was appointed her *peintre ordinaire* ; she then painted the celebrated *Marie Antoinette with a rose*, *Marie Antoinette in velvet* and *Marie Antoinette and her children* (Pl. 72a) which are now at Versailles. Marie-Antoinette refused to sit to Mme Labille-Guiard. She was exactly the same age as Mme Le Brun and became her personal friend ; they used to sing duets together in the intervals of work at the portraits. The King was delighted with the portrait of the Queen and her children : " *Je ne me connais pas en peinture*," he said to the artist, " *mais vous me la faites aimer* "—a more pleasant remark for an artist to hear than " I know nothing about painting but I know what I like."

In 1783—the same year as her rival—she became an Academician. The Academy, to mark the difference in social status of its members from that of members of the old *Maîtrise*, had made a rule that no member could be directly or indirectly connected with dealing. As the wife of a picture dealer Mme Le Brun was therefore not eligible for membership. But the rule was waived by order of the Queen. Her diploma picture, an allegorical composition of two figures, *La Paix ramenant l'Abondance*, is now in the Louvre ; and her composition in the next Salon caused Diderot to write :

" *Lorsque je vois Mme Le Brun peindre l'histoire, je crois voir la massue d'Hercule soulevée par la main des Grâces.*"

For the next four years she continued to paint portraits ; just before the Revolution broke out she painted the portrait *Mme du Barry* (Pl. 71a) for Louveciennes ; in her old age she published her *Souvenirs* where she states that Mme du Barry at this period used no rouge and spent most of her time visiting the local poor. In 1789, feeling herself suspect as a friend of the Queen, Mme Le Brun left France. She was almost penniless though she had made considerable money by her portraits. The money, it would seem, was spent by her husband who looked after her business affairs. She divorced him before leaving France ; he remained in Paris and acted as saleroom agent for the Government's purchases at art sales during the Revolution.

During the Revolution Mme Le Brun travelled, painting portraits and, it is said, landscapes in Italy, Austria, Germany and Russia. She had no difficulty in making money as she had introductions to the Courts and the wealthiest people wherever she went. In Naples she painted several portraits of Lady Hamilton in Nattier's allegorical tradition.

In 1802 she returned to Paris but she refused to be introduced to Napoleon and, finding herself ill at ease in the new Parisian society, she crossed to England where she stayed three years. In 1805 she reconciled herself to the idea of the Imperial régime and went back to Paris where she painted portraits at Napoleon's Court. Later she bought herself a house at Louveciennes where she died at the age of eighty-seven.

Mme Le Brun's reputation was very high in her day. James Northcote, pupil of Reynolds, has recorded an amusing incident in connection with the exhibition of some of her portraits in London. " As I had not conceived that it was worth any painter's trouble to go to see them," he writes, " I had not gone ; but was glad when I found that he (Reynolds) had seen them that I might have the opinion of so great a judge. I said, ' Pray what do you think of them, Sir Joshua ? ' ' That they are very fine,' he answered. ' How fine ? ' I said. ' As fine as those of any painter,' was his answer. ' As fine as those of any painter, do you say ? do you mean living or dead ? ' When he answered me rather briskly, ' Either living or dead.' I then, in great surprise, exclaimed, ' Good G—— ! what, as fine as Vandyke ? ' He answered tartly, ' Yes, and finer.' I said no more, perceiving he was displeased at my questioning him. I mention the above circumstance to show

his disinclination to oppose the popular opinion, or to say anything against the interest of a contemporary artist : as it was not his intention to mislead me, but only to put a stop to my enquiries."

Mme Le Brun's comments on the work of Reynolds were more critical : " *Ils sont,*" she wrote, " *d'une excellente couleur qui rappelle celle de Titien, mais, en générale, sont peu terminés, à l'exception des têtes.*"

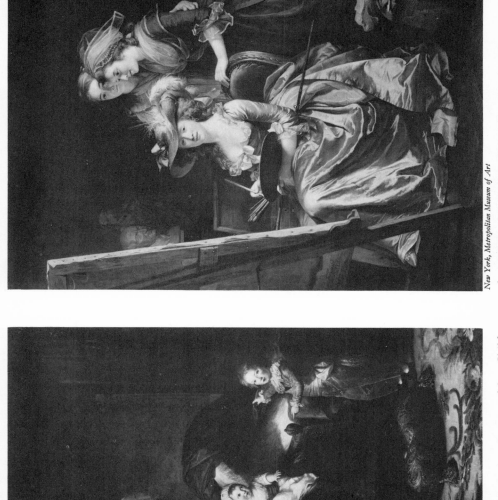

Versailles

72a. MME. VIGÉE-LE BRUN: Marie Antoinette and her Children

New York, Metropolitan Museum of Art

72b. MME. LABILLE-GUIARD: Self portrait with her Pupils

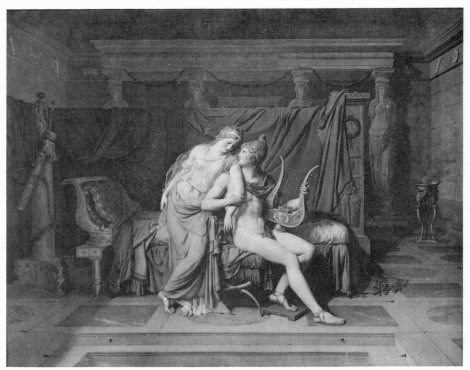

73a. JACQUES-LOUIS DAVID: Paris and Helen

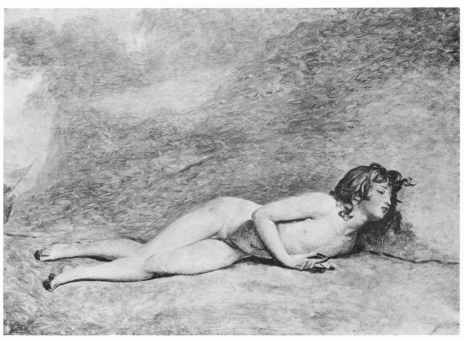

73b. JACQUES-LOUIS DAVID: Death of Bara

PART FIVE

FROM THE REVOLUTION TO THE SECOND EMPIRE

FROM THE REVOLUTION TO THE SECOND EMPIRE

I THE REVOLUTION

In the last years of the old régime when *sujets grivois* and genre pictures of the type of Greuze's *L'Accordée de Village* were popular, the number of painters considerably increased. This happened because it required little skill to paint such pictures well enough to satisfy a Salon public that asked nothing from the painter but the power to tell an anecdote in paint. With this increase in the number of painters the supply of such pictures began to exceed the demand and the painters began to protest against the Academy's tyranny and to complain that they had " nowhere to exhibit " their productions.

The complaint at the time was largely justified, for the Salons were limited to the works of *agréés* and members ; other artists could still only show in the discredited exhibitions of the *Académie de St. Luc*, i.e. of the old *Maîtrise*, and, on one day a year, in the old open-air exhibition on the Place Dauphine which was now known as *l'exposition de la jeunesse*.

In these circumstances a club called *La Société des Amis des Arts* was founded ; this had a gallery in the Hôtel Bullion and there semi-public exhibitions were held to which collectors were invited. It was there that artists like Mme Labille-Guiard and Boilly first attracted attention.

When the Revolution broke out the discontented artists became more articulate and in 1791 *L'Assemblée Nationale* decreed that the Salon should be open to everyone. As a result the 1791 Salon contained twice as many pictures as the Salon of 1789, and the number of pictures shown in the Salons steadily increased all through the Revolution. Thus in 1789 three hundred and fifty pictures were shown in the closed Salon ; in 1791 seven hundred and ninety-four were shown in the first open Salon ; in the Salon of 1793—the year of the Terror—there were over a thousand exhibits ; in 1795 there were over three thousand.

In 1792, when David was virtually Art Dictator of the Republic, he was petitioned by a group of artists to abolish the *Académie royale de peinture et sculpture* and also the provincial Royal Academies of the old régime. David had a report prepared and in the following year the Academy was abolished and with it all the old organisations

for training craftsmen in the French provinces that had existed since the days of Colbert.

In the place of these organisations the Revolutionary Government set up a *Commune générale des Arts* to direct contemporary production and give employment to artists, as private patronage had now ceased, and on David's proposal they founded open competitions for patriotic pictures to be purchased by the State.

The Government also founded a *Musée national des Arts* (to which, as noted, David appointed Fragonard) to inventory and direct the conservation of the nationalised works of art from the royal palaces, from churches, and from the houses of *émigrés*. The majority of the pictures which now form the Louvre Museum are nationalised property from these three sources. The first public museum of sculpture and applied art was arranged in a former convent in the year of the Terror by Alexandre Lenoir who rescued Goujon's *Diane Chasseresse* and countless other works from destruction.

The Government further set aside a sum for the purchase of works of art at private sales in order to prevent the flight of fine works to foreign countries ; and in the year of the Terror, on David's proposal, they bought from this fund pictures by Rubens and Jordaens, and Rembrandt's *Holy Family* known as *Le Ménage du Menuisier* (now in the Louvre), which was bought on behalf of the Government by the picture dealer Le Brun (Mme Vigée-Le Brun's divorced husband) at the sale of the property of the Duc de Choiseul-Praslin, deceased.

In 1795 the old Royal Academy was replaced by the *Institut National* which included a new *Académie de la littérature et des Beaux Arts* as a section ; and this eventually became the *Académie des Beaux Arts*. The artists known as *Membres de l'Institut* corresponded to the Members of the old Academy and soon formed themselves into a caucus in the old way.

The revival of the " antique " in architecture, painting and the applied arts, which took place during the Revolution, and culminated in the celebrated Directoire style in clothes, is very widely known. This classical revival had really begun, as noted, under Mme de Pompadour, but in the days of the Revolution it was greatly developed because the " antique " styles were then given topical significance through their association with the supposed Republican virtues of antiquity.

In painting, this classical revival found a first champion in Joseph Marie Vien (1716-1809), an Academic decorator under the

old régime whose work replaced Fragonard's panels at Louve-
ciennes. Under Louis XV he was Director of the *École des élèves
protégés* and under Louis XVI he was Director of the Academy in
Rome. Returning to Paris he was made *Premier peintre du roi* in
1789 and claimed to be the originator of the return to the classical
style. In 1796 at the age of eighty he won a prize in one of the
open competitions organised by the Directorate. In 1800 Napoleon
made him a member of the Senate and Commander of the Legion
of Honour, and at a great dinner given in his honour David and
his pupils hailed him as the regenerator of French art.

The classical revival found a still more powerful champion in
Louis David, who employed the famous cabinet-maker Georges
Jacob to build furniture copied from Greek vases for his classical
pictures.

2 JACQUES-LOUIS DAVID[1]

BORN PARIS 1748 DIED BRUSSELS 1825

Characteristic Pictures

London	Private Collection	Head of a Girl
New York	Metropolitan Museum	Mlle Charlotte du Val d'Ognes [N1]
New York	Metropolitan Museum	Portraits of the chemist Lavoisier and his [N2] wife
Philadelphia	Johnson Collection	Portrait of a Youth
Washington	National Gallery (Chester Dale)	Mme Hamelin
Paris	Ecole des Beaux Arts	Erasistratus discovering the cause of the sickness of Antiochus
Paris	Louvre	Minerva, Mars and Venus
Paris	Louvre	Portraits of M. and Mme Pécoul
Paris	Louvre	Belisarius as a beggar recognised by one of his soldiers
Paris	Louvre	The Vow of the Horatii
Paris	Louvre	Paris and Helen
Paris	Louvre	Brutus, First Consul, in his home, after condemning his two sons to death
Paris	Louvre	Fragment. Le Serment du Jeu de Paume
Paris	Louvre	La Marquise d'Orvilliers
Paris	Louvre	Mme Chalgrin
Paris	Louvre	View of the Luxembourg Garden

[1] David's grandson J. L. David wrote a book, *Le peintre Louis David*, which
should be consulted by students for details about David's life and his minor
pupils. For a catalogue of David's works the student is referred to Cantinelli's
Jacques-Louis David 1930.

Paris	Louvre	Catherine Tallart
Paris	Louvre	Portraits of M. and Mme Sériziat
Paris	Louvre	The Sabines
Paris	Louvre	Mme Récamier
Paris	Louvre	The Coronation of Napoleon
Paris	Louvre	Léonidas at Thermopylæ
Paris	Louvre	The three ladies of Ghent
Paris	Comédie Française	Mlle Joly
Paris	Bibliothèque Nationale	Portrait of Michel Lepeletier de Saint-Fargeau
Paris	Marquis de Ganay Collection	Pope Pius XII and Cardinal Caprara
Versailles		Bonaparte at the St. Bernard
Versailles		The Distribution of the Eagles
Avignon	Musée Calvet	Death of Bara
Lyons	Museum	La Maraîchère (La Tricoteuse)
Besançon	Museum	Portrait Drawings for the Coronation
Brussels	Museum	The Death of Marat
Brussels	Museum	Mars disarmed by Venus and the Graces
Brussels	Museum	The flautist F. Devienne
Le Mans	Museum	Michel Gerard and his family
Poland	Branicki Collection	Count Potocki on Horseback
Leningrad	Hermitage	Phaon, Sapho and Cupid

(a) David's Life

Louis David was the son of a Parisian tradesman; he was brought up by two uncles of whom one was a builder and the other an architect. His early drawings were taken to Boucher who recommended Vien as a first teacher.

At the age of eighteen he entered the Academy's art school and there year after year he competed without success for the *Prix de Rome*. In 1773 after the fourth failure he attempted suicide. He was then twenty-four. Some of his biographers ascribe his later abolition of the Academy to the hatred of that institution which he acquired at this time.

It was after this period of frustration that he asked and received Fragonard's permission to complete his panels in La Guimard's *hôtel*.

In 1774 he competed once again for the *Prix de Rome* and won it; and he set off for Italy with his old master Vien who was going to take up his appointment as Director of the Academy in Rome.

David was twenty-seven—unusually old for a scholarship winner —when he arrived in Rome; but perhaps for that reason the impressions he received there were the more profound. He remained for three years and when he returned to Paris he had

determined to bring French painting back to the point where it
had been left by Poussin.

In Paris he began at once as a history-painter, and by 1784 he
was a member of the Academy with a studio in the Louvre. In
that year the Comte d'Angivilliers who had succeeded Marigny
as *Surintendant des Bâtiments* commissioned from him *The Vow of
the Horatii* (*Le Serment des Horaces*), which is now in the Louvre.

David determined to make this picture a demonstration of his
passionate reaction against both the genre and the decorative
traditions of French eighteenth-century art. He had married in
1791 the daughter of the King's contractor for the Louvre ; in
the course of painting the *Horatii* he decided that he could only
achieve the real classical severity in the atmosphere of Rome ;
his father-in-law provided the money, and with his wife and a
pupil-assistant he returned to Rome.

Le Serment des Horaces when finished was exhibited in the artist's
studio in Rome and created a sensation. But in the Salon of 1785
in Paris it was " skied." Nevertheless it attracted attention and
was bought by the King. Thus encouraged David returned to
Paris and painted *The Death of Socrates*, which was shown in the
Salon of 1787.[1]

The Louvre *Paris and Helen* (Pl. 73a), a private commission, was
painted in 1788 and exhibited in the Salon of 1789 together with
the celebrated *Brutus* (Louvre), which was another commission
from d'Angivilliers on behalf of the King. The full title of the
Brutus as exhibited at the Salon was *Brutus, Premier Consul, de
retour en sa maison après avoir condamné ses deux fils qui s'étaient unis
aux Tarquins et avaient conspiré contre la liberté Romaine. Les licteurs
rapportent leurs corps pour qu'il leur donne la sepulture.* The original
commission had been for a scene from the life of Coriolanus.
David tried various compositions without success and eventually
changed the subject on his own initiative but without any political
idea. The picture shows the wife and daughters of Brutus struck
with horror at the lictors bearing the two corpses. Brutus sits
in shadow in the foreground. The group of the woman and the
two girls based on the antique *Niobe* has passages of grace. David,

[1] All David's biographers state that Reynolds spent ten days in the Salon
contemplating this picture and pronounced it faultless. But this is an error.
Reynolds was not in Paris in 1787. The eulogy referred to appeared in a
London newspaper article called " The State of the Arts in Paris," written
by a Paris correspondent in October 1777. (Cf. Whitley's *Artists and their
friends in England* 1700-1799.)

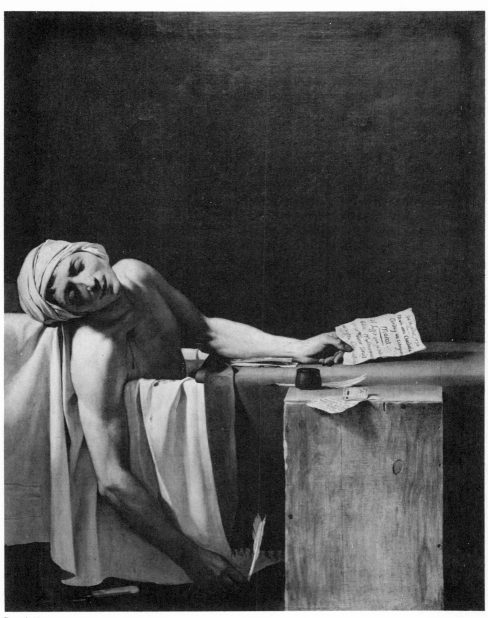

74. JACQUES-LOUIS DAVID: Death of Marat

PLATE VII

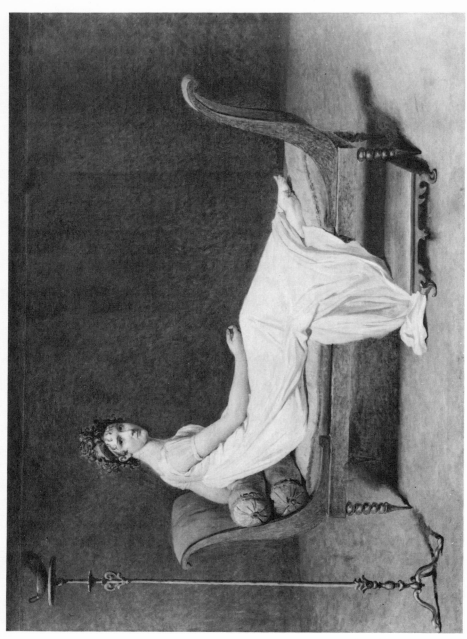

JACQUES-LOUIS DAVID (1748-1825): Madame Récamier

as noted, had the furniture in the picture specially made in the antique style but on the table he has placed a homely work-basket and a reel of wool.

When the 1789 Salon opened, the Revolution had already begun; the doors were guarded by Academy students acting as *gardes nationaux*. The *Brutus*, imposing in itself, was aided in its effect by the subject which in the eyes of the excited public seemed to have topical significance and to exalt the self-sacrifice of Republican patriots. D'Angivilliers had tried to exclude it from the Salon but the veto arrived too late; and David found himself almost by accident acclaimed as the Painter of the Revolution.

It was therefore to David that the Jacobins turned with a commission for a Revolutionary propaganda picture : *Le Serment du Jeu de Paume*, and they allotted him a church as a studio in which to produce it. But David never completed this picture because most of the personages represented became suspect when he was half-way through his work. A portion of the project is in the Louvre.

In 1792 David became a Deputy in the Convention, a member of the *Comité de l'Instruction* and of the *Commission des Arts* ; and for two years he was virtually Art Dictator of the Republic. In this capacity, in addition to the abolition of the Academy and the organising work already recorded, he designed Revolutionary propaganda fêtes and processions, he suggested a new civil costume based on " l'Etrusque, le Grec ou le Romain," and he painted propaganda pictures recording the deaths, for the Republic, of Lepeletier de Saint Fargeau, of Marat and of the boy Bara.

In these pictures all the Revolutionary victims are represented nude in accordance with the classical doctrine. *Marat* (Pl. 74) is shown in his bath as David saw him shortly after Charlotte Corday had delivered the blow. *Bara* (Pl. 73b) who was actually in uniform at the time of his death, lies naked on the ground and presses a tricolor cockade to his breast.

After the fall of Robespierre in 1794, David himself became suspect ; he was attacked in the Convention, arrested, and kept for four months in the Luxembourg Palace (then used as a prison). In the following year he was arrested a second time and again imprisoned for three months. In prison he painted a *View of the Luxembourg Garden* from his window and began a design for a large composition depicting the Sabine women intervening to stop war. On his release he retired from politics and was given a studio by the Directorate. There he painted *The Sabines* and

exhibited it in his studio from 1799 till 1804. He charged for admission to see this picture and made in gate-money 70,000 francs (which I am unable to translate into present money); in a manifesto handed to visitors he stated that in demanding gate-money for the inspection of a picture in his own studio he had precedent in the practice of the English Royal Academicians—(he would not have been allowed to do this in the old days of the *Académie royale* which actually expelled a member who attempted it).

Napoleon, as First Consul, went to the studio to see *The Sabines* and when he became Emperor he appointed David *Premier peintre de l'Empereur* and commissioned him to paint a series of pictures recording Imperial ceremonies, two of which, *The Coronation of Napoleon in Notre Dame* known as *Le Sacre de Napoléon 1er*, and *The Distribution of the Eagles*, were painted between 1805 and 1809. For the actual portraits of the Emperor in these pictures David had to rely on his memory (and presumably sketches) because Napoleon refused to sit to him for the purpose, wishing, after the manner of dictators, to be idealised not literally portrayed.

Under the Empire, David tried to become Art Dictator for a second time. But he was now over sixty; he no longer had the fire and energy of his earlier years; and he was unable to compete with the opposing interests. He accordingly abandoned the attempt and buried himself in the composition of another large history painting, the *Leonidas before Thermopylæ*, on which he worked in 1812 and 1813.

At the Restoration of the Bourbons in 1814 David sent all compromising pictures from his studio into the country, and he was left undisturbed. During the Hundred Days he received a visit from Napoleon to see the *Léonidas*, and in a moment of enthusiasm he signed the *Acte additional* for which he was exiled in 1816 by Louis XVIII. He spent the remaining nine years of his life in Brussels.

(b) David's Art

David's work has found many admirers since the Cubist-classical Renaissance, because he really was a champion of the classical concept. Some modern artists look back to David above the personal expressions in nineteenth-century Romantic and Impressionist pictures just as David himself looked back to Poussin over rococo art and the official productions of the eighteenth-century Grand Manner.

We must not forget that he was a contemporary of Fragonard

whom he regarded as a gifted but degenerate artist whose pictures represented self-indulgence. *Point d'emportement du pinceau* was his motto. He excluded all parade of handling, all suggestion of facility from his work. He desired, like Poussin, to instil the serenity of antique art into his pictures. He sought continually the generic image. He endeavoured to thrust actuality on one side.

But David never attained to the architectural heights of Poussin's outstanding works. He never achieved a coherent space-concept. He had a classical concept of forms but not of form.

Moreover, there was something doctrinaire—that came from his environment—in David's passion for the classical ideal. Poussin was a philosopher obsessed with a desire to create a microcosmic image. David was a fanatic obsessed with a hatred of rococo and Academic art.

David's work, like Poussin's, is often described as cold and dry. But in truth David, like Poussin, was passionate and sensual and like Poussin he distilled this sensuality through his mind. This quality appears in his *Bara* (Pl. 73b) and it also appears in some of his portraits, especially those left unfinished.

These portraits pulse with vitality beneath a brush that was always held in check. This controlled vitality is especially evident in the unfinished portrait *Mme Récamier* (Pl. VII), or in a sketch like the *Head of a Girl* (Pl. 71b). The man who painted these sketches was not obviously lecherous like Greuze but he also was not cold or dry.

David possibly was more true to himself in his portraits than in any other aspect of his work. *The Sabines* and the *Léonidas before Thermopylæ*, both huge pictures, are magnificent efforts, but they represent above all an exercise of will and we feel that the artist, in spite of high intentions, is really working in a field beyond his powers. In his portraits, on the other hand, and in *Le Sacre de Napoleon I*ᵉʳ the artist has fulfilled his intentions. He has not taken the line of least resistance—he never succumbed to that— but he has aimed at a goal which with an effort he could reach. *Le Sacre de Napoleon I*ᵉʳ, which contains scores of full-length life-size portraits, was indeed a notable achievement ; he was nearly sixty at the time of the commission ; when he had decided on the composition he had the figures made in wax and disposed in a box as Poussin had done for his compositions ; for each head he made a portrait drawing which was transferred " squared up " to the canvas and painted in by an assistant while he sat in an armchair and issued his instructions. Afterwards he finished each

head himself. *Le Sacre de Napoleon I*er and *La Distribution des Aigles* were painted in the Église de Cluny which was converted into a studio by the Imperial government for the purpose.

(c) David's Character

David's biographers have fought hard battles about his character. He has been represented as an arrivist, a turncoat, a second Charles Le Brun who made the times serve his personal ambition. He has also been presented as a coward who betrayed his friends, and a sadist who insulted the dead body of Charlotte Corday and delighted in the slaughter of the guillotine. On the other hand, he has been presented as a man of intense enthusiasms who flung himself with fanatical zeal into one cause after another —first into the creation of classical art, then into the purification of France by the Revolution, and finally into the glorification of Napoleon.

There are facts to support all these contradictory estimates. David voted the death of the King; he made no efforts to save his artist friends Peyre and Sedaine from execution. The sitter for one of his warmest, most sympathetic portraits, the *Mme Chalgrin* in the Louvre, was a daughter of Joseph Vernet the landscape painter; David's picture was painted in the year of the Terror; a few months later she was accused of theft and guillotined and David did nothing to assist her.[1]

There can be no doubt that David worked side by side with Robespierre in the days of the slaughter by the guillotine; and he used to sit outside a café and make drawings of the victims being driven to their doom. There still exists a drawing *Marie-Antoinette on her way to the scaffold*—an unforgettable pen sketch which David drew (as we know from the inscription upon it) from a seat in a window reserved for spectators of the procession; and Mrs. Siddons, the actress, told the sculptor Nollekens that she was in a room with David when a *rapporteur* announced that eighty

[1] Madame Chalgrin was accused as an accomplice in thefts from the Château de la Muette (which had been nationalised with its contents) because she shared an apartment with a daughter of the concierge (curator) of this former palace (where, it will be recalled, Watteau had painted *chinoiseries* in the time of the Duchesse de Berry's riotous occupation). The inquisitors found fifty pounds of candles in this apartment and this was held to prove the guilt of Mme Chalgrin, of the concierge's daughter and of her mother who were all guillotined. Virgile Josz suggests in his *Fragonard* that David's desertion of Mme Chalgrin was an act of vengeance because she had refused his advances when sitting for her portrait.

people had been guillotined that morning and David exclaimed, " No more ? "

These are facts. But they are facts which must be read in the light of the hysteria of the period. They can be easily chronicled. But they cannot be lightly judged.

Perhaps the key to David's psychology may be found in the character of Evariste Gamelin in Anatole France's *Les Dieux ont soif* which draws a convincing picture of·the period as a whole.

3 THE FIRST EMPIRE AND A.-J. GROS

When Napoleon became Emperor in 1804 he called for a new style to decorate his palaces and the residences of Josephine ; and the *style Empire* which resulted was the last phase of the antique revival which we have followed in its various forms. The furniture and decoration in this style though sumptuous and elaborate were coarse in execution, because the French skill in craftsmanship had been destroyed when David abolished the provincial organisations in which the craftsmen had been trained. It was one thing for Napoleon to order the resumption of the skilled work of the old régime and to desire to renew the revenue that came to France from export of applied art ; it was another for designers like Fontaine and Percier to try to revive French craftsmanship without skilled workmen, especially at a period when machines were beginning to displace hand labour in so many ways.

In the field of painting I have already noted Napoleon's use of Louis David's power to paint propaganda pictures on a large scale. Napoleon's concept of the painter's art was much the same as that of Louis XIV ; he regarded painting as a means of celebrating his own career ; and he was quite determined that his artists should represent him not as he was but as a new Augustus Cæsar or Alexander the Great. In his youth he sat once to David for three hours on the eve of his departure for Egypt (in 1799), but as Emperor he refused to sit to anyone. " *Qu'avez-vous besoin de modèle ?* " he said to David. " *Croyez-vous que les grands hommes de l'antiquité aient posé pour leurs portraits ? Qui se soucie de savoir si les bustes d'Alexandre sont ressemblants ? Il suffit que nous ayons de lui une image conforme à son génie. C'est ainsi qu'il convient de peindre les grands hommes.* " In 1803 Ingres who was twenty-three and Greuze who was seventy-eight both received commissions from provincial municipalities for portraits of Napoleon as First Consul. Napoleon refused to sit to either. But he allowed them to come

together to the Palais of Saint Cloud and to look at him for a few minutes.

Napoleon believed in art not only as a means of propaganda but also as a means of education and refinement for the masses. He turned all the artists out of the apartments in the Louvre (where artists had been lodged since the time of Henri IV) and completed the installation of the galleries as a National Museum which had been begun in 1793 ; and side by side with the national treasures he exhibited art treasures which he had brought back after his victories in Italy and elsewhere. This additional *Musée Napoleon* could be seen in the Louvre until the great pictures it contained were returned to their countries of origin by the Allies after Waterloo.

The pictures which Napoleon brought back from Italy had been chosen by an artist, Antoine-Jean Gros (1771-1835), a pupil of David, who was attached to Napoleon's staff and afterwards painted pictures of his triumphs. Gros painted *Bonaparte au pont d'Arcole* (now in the Louvre) in 1796 and exhibited it in the Salon of 1801 ; Napoleon had the picture engraved by the Venetian Giusseppe Longhi who was launched by the success of this plate. Gros also painted *Bonaparte visite les pestiférés de Jaffa* (now in the Louvre) in 1804, and the splendid *Napoléon sur le champ de bataille d'Eylau* (also in the Louvre) in 1807. Although a pupil of David he was a Romantic at heart and his pictures, which are vigorous in handling and full of emotive movement, herald the Romantic reaction against David's art. In his later years Gros suffered from melancholia and he eventually committed suicide by drowning himself in three feet of water.

4 PIERRE PRUD'HON

Pierre Prud'hon (1758–1823) who painted the well-known portrait *The Empress Josephine* (now in the Louvre), was another artist of consequence at this period. He was born in the reign of Louis XV and lived through the Revolution, the Empire and the reign of Louis XVIII. He had a distressing life, which included only a few years of prosperity, and his last days were clouded by a tragedy.

Prud'hon was the son of a mason of Cluny and he spent his youth as a provincial artist doing various kinds of hack painting and drawing for a living. At the age of nineteen he contracted a marriage of honour with a young woman of the people who plagued him for forty-five years and was finally locked up in a

maison de santé after she had forced her way to the Empress to
complain about her husband. In 1782 he won a provincial travelling
scholarship and went to Rome where he remained doing engraving
and other work for seven years.

On his return to Paris he found himself without friends at the
time of the Revolution and he made a meagre living by engraving
and book illustrations. But in 1804 a friend, who was Préfet de
la Seine, commissioned from him *La Justice et la Vengeance divine
poursuivant le Crime* to hang in the criminal court of the Palais de
Justice in Paris, and this picture, now in the Louvre, made his
reputation in the Salon of 1808.[1]

As a result of this success he obtained commissions for portraits
at the Court of Napoleon and he painted *Le Triomphe de Bonaparte*
(a sketch for which is now in the Museum at Lyons). He also
painted a *Venus and Adonis* (now in the London Wallace Col-
lection) in which the nude Venus is traditionally supposed to have
been drawn from the Empress Marie Louise to whom he gave
drawing lessons, and a nude portrait (now in the Beskow Col-
lection, New York) of Napoleon's sister Pauline Borghese, who
also sat nude for the sculptor Canova.

The period of Prud'hon's success at the Imperial Court coincided
with the beginning of a romantic affection for his pupil and
imitator Mlle Constance Mayer, a young lady of independent
means who went to live with him and help him with his pictures.
In 1821 when she was forty-six Mlle Mayer became hysterical and
cut her throat with one of Prud'hon's razors before her mirror.
Prud'hon never recovered from the blow. He died two years
afterwards and was buried in her grave.

Prud'hon's pictures have many attractive qualities. In Italy he
acquired an enthusiasm for Correggio and still more for Leonardo
da Vinci of whom he wrote " *Pour moi je n'y vois que perfection et
c'est là mon maître et mon héros . . .*"

His charming portrait *Mme Dufresne* (Pl. 82a) shows the melli-
fluous line and twilight chiaroscuro which he imparted to his work
as a result of this enthusiasm; and this picture also indicates, I
fancy, that he was acquainted with engravings after portraits by
the masters of the English eighteenth-century school.

In his subject pictures Prud'hon brought back the Cupid and

[1] This picture is now in a scandalous condition due partly to the artist's
use of bitumen and a noxious medium of his own invention and partly to
the Louvre authorities' criminal negligence in refusing to clean and condition
their pictures.

Psyche, and the Venus and Adonis, of French painting in Boucher's day. But he portrayed the traditional figures in the soft light and shade used by Leonardo's early followers. His pictures moreover were not intended to be decorative panels to accord with a decorative style in interior decoration ; they were conceived as lyric poems in paint existing in their own right. Prud'hon's subject pictures show what Fragonard's art might have become if he had pursued the lyric vein of *La Fontaine d'Amour* (Pl. 64), which he afterwards abandoned.

In Rome Prud'hon was intimate with the sculptor Canova and his friendship, I fancy, had an influence on his work ; it probably induced him to paint his figures as marble statues in black and white without yellow in the carnations ; and it may be that we must ascribe to the same influence the mincing grace of the raised little finger which disfigures his otherwise graceful *Enlèvement de Psyche* in the Louvre.

The caucus of the Institute exerted all its influence against Prud'hon's success and refused to admit him till 1816 when he was nearly sixty.

His *Assumption of the Virgin* (now in the New York Metropolitan [N1] Museum) was painted for the Tuileries Chapel in that year.

5 PAINTING UNDER LOUIS XVIII

In the reign of Louis XVIII (1814-1824) the outstanding artists were the pupils of David and of Jean-Baptiste Regnault (1754-1829).

Regnault lived in Rome for some years and was the painter of the *Three Graces* (now in the Louvre), a group which resembles the celebrated *Three Graces* by Raphael (now at Chantilly), itself based on an antique group in the library of the cathedral at Siena.

Regnault's most notable pupil was Pierre-Narcisse Guérin (1774-1833) who painted Napoleonic propaganda pictures that can be seen at Versailles, and, later, pictures which were influenced by David and the French classical drama as performed at the *Comédie Française*. The Louvre has his *Retour de Marcus Sextus, Phèdre et Hippolyte, Aurore et Cephale, Clytemnestra,* and *Aeneas relating the woes of Troy to Dido.*

David had a large art school from the time he exhibited his *Brutus* till he finally left Paris for Brussels, and the principles which he inculcated became nominally the basis of French official painting as represented by the Institute. But the Institute's concept of classical art soon became little more than a prejudice in favour of classical subjects with nude and draped figures and an insistence

on smooth surface-painting with a show of detail in the representation. This degenerate pseudo-Davidian tradition persisted all through the nineteenth century ; it can be seen in the work of Gérôme (1824-1904), and occasionally in the official salons of Paris to this day.

The real Davidian tradition was, however, continued to some extent by Puvis de Chavannes (1824-1898) who executed mural decorations for the Panthéon, the Sorbonne and the Hôtel de Ville in Paris, for the Library at Boston, and for a number of French provincial towns. Puvis went twice to Italy and his *Summer* (in the Cleveland Museum), which has passages that also occur in the Hôtel de Ville decorations in Paris, shows that he was susceptible to the charm of Luini's *Bathing Nymphs* in Milan.

David's outstanding pupils, apart from Gros, already mentioned, and Ingres, whose work will be separately considered, were Girodet de Roucy Trioson (1767-1824) and François-Pascal-Simon Gérard (1770-1837).

Girodet was the painter of *Le Sommeil d'Endymion* and *Atala mise au tombeau*, both now in the Louvre. In *Atala mise au tombeau* he tried to combine the Davidian tradition with motifs and chiaroscuro taken from Rembrandt. He also painted official Napoleonic pictures for Versailles.

Gérard painted *Psyché reçoit le premier baiser de l'Amour* (Louvre) in 1798 and thereafter he became the favourite portrait painter of the Courts of Napoleon, Louis XVIII, Charles X and Louis-Philippe. Many of his portraits can be seen at Versailles.

During the Empire and the Restoration titles were given to successful artists ; Gros, Gérard, Regnault and Guérin were all made barons.

The Napoleonic propaganda pictures created a taste among the Salon public for history-pictures with figures in contemporary clothes ; but when the Bourbons returned in 1816 the official attitude encouraged the painting of history-pictures with subjects taken from the earlier history of France in order to stress the idea that the new régime had restored the continuity of French history interrupted by the Revolution and Napoleon. Pictures representing episodes from the career of Henri IV and other sovereigns, and painted illustrations of subjects taken from works of literature dealing with past periods, now began to appear side by side with pictures of classical subjects in the Davidian tradition.

France had been more or less isolated from the time of the Revolution to the fall of Napoleon, but with the Restoration of

the Bourbons contact was established with other countries, and foreign literature became the rage ; as Sir Charles Holmes has put it, " Goethe, Scott and Byron among the moderns, Dante and Shakespeare and Cervantes among the older writers took the place of Livy and Plutarch." This new movement was known, with a fine absence of pedantry, as *le style troubadour*; and later it was known, with equal inaccuracy, as *le style moyen-âge*.

David saw his pupils one after another succumb to the new *troubadour* subjects. The first successes in the new style were scored by a group of artists from Lyons known as the *école de Lyons* who included Pierre Revoil (1776-1842) and Fleury Richard (1777-1852), who had both been trained to paint classical subjects in David's school. Revoil's *Un Tournoi au XIV Siècle*, now in the Lyons Museum, a picture which might have been produced by certain Academic artists in Paris or London in 1912, was actually produced in 1812. Richard's *Vert-Vert*, a work of the same character, which can also be seen at Lyons, was painted before 1822.

But David knew that the tradition of Poussin and his own concept of classical style could not be compassed by the average mind. He foresaw the transformation of his classical concept into the pseudo-classical dogma of the Institute and he also foresaw the growth of the " *troubadour* " movement. In 1808 he wrote : " *Dans dix ans, l'étude de l'antique sera délaissée. J'entends bien louer l'antique de tous côtés et, quand je cherche à voir si on en fait des applications, je découvre qu'il n'en est rien. Aussi, tous ces dieux, ces héros seront remplacés par des chevaliers, des troubadours chantant sous les fenêtres de leurs dames au pied d'un antique donjon. La direction que j'ai imprimée aux beaux-arts est trop sévère pour plaire longtemps en France.*"

But though he could forgive what he held to be degeneration in lesser men he could hardly forgive when he observed its appearance in the work of his most gifted pupil Jean-Auguste-Dominique Ingres ; and if he did not actually impede this remarkable artist he certainly refrained from assisting him in any way.

6 J. A. D. INGRES[1]

BORN MONTAUBAN 1780 DIED PARIS 1867
Characteristic Pictures

London	National Gallery	Oedipus and the Sphinx
London	National Gallery	M. de Norvins

[1] For a full account of the life and work of Ingres the student is referred to his biography by Henry Lapauze which reproduces four hundred paintings and drawings.

London	National Gallery	Roger delivering Angelica
London	National Gallery	Mme Moitessier
New York	Metropolitan Museum	Portrait of a Man [N1]
New York	Metropolitan Museum	Portraits of M. and Mme Le Blanc
New York	Metropolitan Museum	Portrait Drawing : Lady and Boy
New York	Metropolitan Museum	Portrait of Cherubini [N2]
New York	Frick Collection	La Comtesse d'Haussonville
Cleveland	Museum of Arts	Portrait drawing
Paris	Louvre	Mme Rivière
Paris	Louvre	Mlle Rivière
Paris	Louvre	Philibert Rivière
Paris	Louvre	Oedipus and the Sphinx
Paris	Louvre	La baigneuse
Paris	Louvre	La Grande Odalisque
Paris	Louvre	Roger delivering Angelica
Paris	Louvre	Christ giving the keys to St. Peter
Paris	Louvre	Pius VII in the Sistine Chapel
Paris	Louvre	The Apotheosis of Homer
Paris	Louvre	François Bertin
Paris	Louvre	Cherubini and the Muse
Paris	Louvre	The Virgin with the Host
Paris	Louvre	Jeanne d'Arc
Paris	Louvre	La Source
Paris	Louvre	Le bain turc
Paris	Baroness James de Rothschild Collection	Raphael and La Fornarina
Paris	Duc d'Orléans Collection	Le Duc d'Orléans
Paris	Duchesse de Broglie Collection	La Princesse de Broglie [N3]
Chantilly	Musée Condé	Self portrait
Chantilly	Musée Condé	Mme Devaucay
Chantilly	Musée Condé	Stratonice
Chantilly	Musée Condé	Vénus Anadyomène
Chantilly	Musée Condé	Francesca da Rimini
Angers	Museum	Francesca da Rimini
Bayonne	Musée Bonnat	Francesca da Rimini
Bayonne	Musée Bonnat	Mme Devaucay
Bayonne	Musée Bonnat	Baigneuse
Bayonne	Musée Bonnat	Charles X
Bayonne	Musée Bonnat	Portrait drawings
Autun	Cathedral	The Martyrdom of St. Symphorien
Montauban	Musée Ingres	Jesus among the doctors
Montauban	Musée Ingres	View from the Villa Medici
Montauban	Musée Ingres	View of the Villa Borghese

Montauban	Musée Ingres	Numerous drawings
Montauban	Cathedral	Le vœu de Louis XIII
Puy	Museum	Philemon and Baucis ; drawing
Rouen	Museum	La Belle Zélie
Aix-en-Provence	Museum	Jupiter and Thetis
Toulouse	Museum	Virgil reading the Aeneid to Augustus
Nantes	Museum	Mme de Senonnes
Brussels	Museum	Virgil reading the Aeneid to Augustus (fragment)
Liége	Museum	Napoleon as First Consul

Ingres is one of the most puzzling figures in the whole history of French art. He could be Classical and Romantic, formal and naturalistic, ascetic and lascivious, majestic and absurd, all in the same picture. At his best he was unquestionably a great artist ; at his worst he touches the lowest Academic depths. One thing only is clear as we study his pictures year by year throughout his long life of unusual productivity—and this is that he became gradually less of an artist with each succeeding year. His finest and most intriguing pictures which include the *Jupiter and Thetis* and the portrait *Mme Rivière* (Pl. 75) were all painted before he was thirty-five. He was still working at the age of eighty-two ; he ended as alternately a pedant and a degraded photographic eye ; and yet this extraordinary artist produced right at the end of his career *Le bain turc* now in the Louvre—a picture compounded of the rhythmic grace of the early period and senile concupiscence.

Ingres was the son of a versatile artist of Montauban who made architectural and garden sculpture and painted miniatures ; he became a pupil in David's art school at the age of sixteen, and kept himself by playing the violin in the orchestra of a theatre in the evenings. In 1801, at the age of twenty-one, he was awarded a *Prix de Rome*, but as no funds were forthcoming for the scholarship he had to wait for five years before receiving a grant for the journey to Italy.

Within these five years he painted for the municipality of Liège, *Napoleon as First Consul, Napoleon as Emperor* for the *Corps législatif*, the *Self portrait* now at Chantilly, and *Mme Rivière* (Pl. 75).

He went to Rome in 1806 and remained there till 1820. He then lived for four years in Florence. He was thus in Italy for eighteen years ; and there he kept himself, and later his wife and mother as well, by making portrait drawings in pencil of the character of *A Lady and a Boy* (Pl. 76). He charged small fees for these portrait drawings and his sitters came from all classes. They included

artists and musicians, members of the French colony in Rome, and foreign visitors to the city (the Musée Ingres, at Moutauban, has a double drawing of Lord and Lady Cavendish-Bentinck). They also included members of the *petite bourgeoisie* of Rome many of whom were sent to his studio by a friendly barber. Ingres drew his sitters singly, in pairs, and in groups. He elaborated the heads and lightly indicated the whole or half-length figures. The Musée Ingres at Montauban and the Musée Bonnat at Bayonne have many characteristic examples of these drawings.

In Rome Ingres looked at the Renaissance masters, especially Raphael, rather than at the antique sculpture which was recommended in David's school ; but he also must have studied antique cameos and we can perceive this influence in the basso-relievo effect of *Jupiter and Thetis* in the Aix Museum, which he sent to the Paris Salon in 1811 when he was thirty-one.

The *Jupiter and Thetis* is probably the most characteristic of all Ingres' pictures and the artist himself retained a preference for it all his life. But it was badly received at the Salon and found no purchaser. To critics accustomed to the Davidian tradition all Ingres' early pictures appeared " Gothic." Thus his *Mme Rivière* (Pl. 75), when exhibited in the Salon of 1806, had been denounced as an affected return to the Gothic primitives and the same charge was made against the *Jupiter and Thetis*. Thus *L'Académie des Beaux Arts* wrote : " *Cet artiste semble plutôt s'efforcer à se rapprocher de l'époque de la naissance de la peinture qu'à se pénétrer des beaux principes qu'offrent les plus belles productions de tous les grands maîtres de l'art, principes dont on ne saurait s'écarter impunément . . .*" and the article then criticised the drawing of the torso of Jupiter and the left leg of the kneeling nymph.

Delacroix's comment on Ingres in his early years was nearer the mark ; Ingres, he said, was " *un Chinois égaré dans Athènes* " ; and indeed there is something Chinese in the rhythmic flow of line and in the tactile values of the *Jupiter and Thetis* and also in *Mme Rivière*.

Also, of course, the *Jupiter and Thetis* is more a Romantic than a classical picture. The distortions of natural forms which characterise it are more in the nature of Romantic distortions to stress the emotivity of fragments than in the nature of classical distortions determined by concerns with architectural form.

But the *Jupiter and Thetis* is nevertheless not purely a Romantic picture ; its formal character is hybrid ; and it shows a strange

mixture of lyric rhythm and the pseudo-tragic grandeur of the operatic stage.

In 1812 Ingres painted *Virgil reading the Aeneid to Augustus*, a finely imagined history-picture in the Davidian tradition. The celebrated nude known as *La Grande Odalisque* was painted in 1814 and was sent to the Salon of 1819. This picture, which resembles the nudes of the French Renaissance School of Fontainebleau, shows that Ingres had been studying Bronzino and the Italian masters who influenced that school, and the same quality appears in *Raphael and La Fornarina* painted in 1814, and in the *Francesca da Rimini* (Pl. 77) at Chantilly, which I assume to have been painted at the same time.[1]

La Grande Odalisque received a hostile reception at the Salon. Once more Ingres was attacked as a Gothic artist but this time he was called "a Gothic artist of the school of Cimabue," and he was reminded that Gothic paintings of the Cimabue character were "*sans harmonie*" and that "*tout peinture sans harmonie est barbare.*" The picture was a commission from Queen Caroline Murat of Naples who was unable to take delivery after the Napoleonic collapse in 1814. It found no purchaser at the Salon. In *La Grande Odalisque* we can already perceive the direction in which the artist was about to degenerate. The figure, compared with those in the *Jupiter and Thetis*, is over-modelled, and in the actual painting there is a good deal of unpleasant surface polish. The equally celebrated *Mme de Senonnes*, now in the Nantes Museum, is a truly Gothic picture where the artist has aimed at *trompe l'œil* imitation of trumpery details and textures in the lady's dress and jewellery and at highly polished smoothness in the face and hands. *Mme de Senonnes* anticipates the Daguerrotype by which Ingres was undoubtedly much influenced in his later years. But it falls far short of the highest achievements in this method of painting; the jewellery would be seen to be clumsily painted if compared with the mirror and the beads on the wall in Jan Van Eyck's picture *Jan Arnolfini and his wife* in the London National Gallery—or with the nails in the chair of Vermeer's *Lady standing at the Virginals* in the same museum.

In 1817 Ingres received a commission to paint a *Christ giving the Keys to Peter* for the church of *Santa Trinità dei Monti* in Rome. His picture, an incredibly dreary Raphaelesque *pastiche*, now in the

[1] The version of this picture at Angers which lacks the rhythmic quality and the formal distortions of the Chantilly version is dated 1819. Ingres often repeated his pictures with substantial variations at long intervals of time.

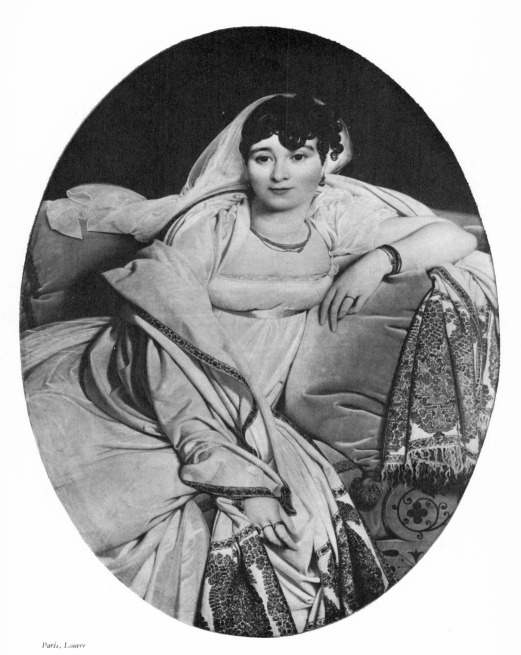

75. J. A. D. INGRES : Mme. Rivière

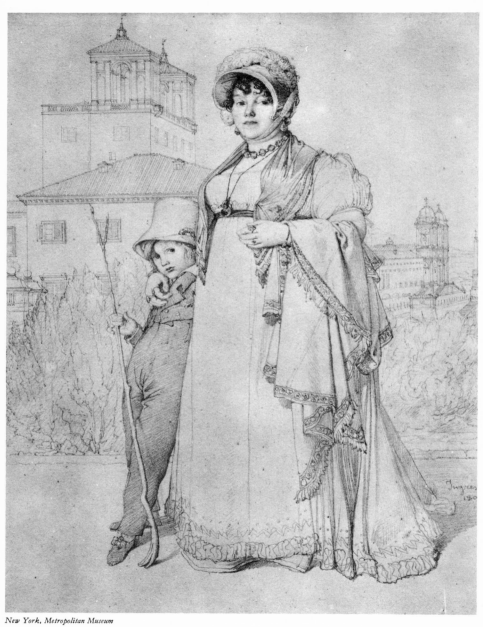

76. J. A. D. INGRES: Portrait Drawing: A Lady and a Boy

Louvre, was completed in 1820; it was much admired in Rome and its success procured him a commission for *Le Vœu de Louis XIII* for the Cathedral of Montauban. This picture represents Louis XIII in a fleur de lys mantle kneeling before a Raphaelesque Virgin; it can still be seen in Montauban Cathedral.

In 1824 Ingres returned to Paris and exhibited *Le Vœu de Louis XIII* in the Salon. This time he scored a triumph; he received congratulations from all sides; he was invited to join the Institute; and he was given the Legion of Honour by Charles X.[1]

Le Vœu de Louis XIII, as a subject from French history of the past, was in the taste of the period as already noted; and Ingres, who seems to have been aware of this orientation, brought to Paris at the same time a number of other pictures in this " *troubadour* " style. They included *Henri IV playing with his Children, The Entry of Charles V to Paris, François I at the deathbed of Leonardo da Vinci, Philip V and the Marshal of Berwick, Pius VII in the Sistine Chapel* (Louvre) and the 1819 Angers version of the *Francesca da Rimini* to which I have referred above.

He now received commissions for the portrait *Charles X* (Musée Bonnat, Bayonne), for the *Apotheosis of Homer*, originally painted for the ceiling of a gallery in the Louvre and now exhibited on the wall, and for the *Martyrdom of St. Symphorien* for the Cathedral at Autun. He also had commissions for portraits.

The years of his adversity were thus over. Money flowed into his pockets. He sold the engraving rights of his " *troubadour* " pictures; and he opened an art school which continually increased in size.

As David was now dead and Delacroix had begun to show his tumultuous Romantic paintings in the Salons, Ingres—so long decried as Gothic—now found himself hailed as champion of the Davidian classical tradition, and even his complete failure to achieve a classical picture in the *Apotheosis of Homer* was hailed as a success. He accepted the position and became a pedant of the Institute from which he helped to exclude Delacroix for twenty-seven years.

In 1834 he returned to Rome as Director of the Academy and remained there till 1841. His *Stratonice* was painted at the end of this period in Rome. He spent the final period of his life in Paris. The climax of his career was the *Exposition Universelle* of 1855,

[1] The Louvre has a picture *Charles X distributing the awards in the Salon of 1824* by F. J. Heim (1787-1865) in which *Le Vœu de Louis XIII* is seen on the wall of the Salon.

when he had a gallery entirely filled with his main production to that date.[1]

In his later years he painted a number of portraits of Second Empire ladies which continue the Daguerrotype manner of the *Mme de Senonnes* at Nantes. The London National Gallery has recently acquired his *Mme Moitessier* of this type.

Ingres made a great many preliminary studies for all his pictures, and some hundreds are preserved in the Musée Ingres at Montauban. There the visitor will also find the *Jesus among the Doctors* —a picture horrible in colour and Raphaelesque in design—which Ingres painted at the age of eighty-two. A day in this Musée Ingres at Montauban is a depressing experience. But the student will find a second day, when he has mastered the relation of the individual drawings to the artist's *œuvre* as a whole, exceedingly instructive. Ingres appears here as a man of extraordinary zeal and moral energy especially if we remember that he suffered all his life from rheumatism, asthma and *vertiges*.

Had Ingres died, as Raphael and Watteau died, at thirty-seven, the world would rank him very high indeed. Is it possible that Raphael and Watteau would also have degenerated had they also painted till the age of eighty-six ? One more judgment on Ingres must be recorded—that of Baudelaire, a critic who belongs more to our century than his own. To Baudelaire Ingres was " *ce pédant dont j'aime peu les facultés malingres.*" But we must remember that this was written of the later periods as Baudelaire only frequented the Salons from 1845 onwards. He may not have been acquainted with *Mme Rivière* and *Jupiter and Thetis*.

7 THE ROMANTIC MOVEMENT

In the later years of the reign of Louis XVIII, and all through the reigns of Charles X (1824-1830) and Louis-Philippe (1830-1848), liberal thought in France and especially in Paris was in a state of ferment. Charles X was a grotesque reactionary who believed that the misfortunes which had befallen Louis XVI were due to the concessions which he had made to liberal ideas ; he

[1] In this exhibition, where Delacroix also had a gallery of his own, Ingres to his intense annoyance only received the second medal ; the first was given to Horace Vernet (1789-1863), a painter of military pictures. Others who received medals were Delacroix, Meissonier and the English animal painter Landseer. The English Pre-Raphaelites were represented in this exhibition and their work was remarked by Delacroix.

had nothing but contempt for the English theory of a constitutional monarchy; he muzzled the Press and tried to put the clock back to the seventeenth century. The discontent aroused by this stupidity continued under the more prudent Louis-Philippe and culminated in the revolution of 1848 and the establishment of the Second Republic.

The celebrated Romantic movement in literature and art that arose and flourished between 1820 and 1850 was the artistic equivalent of the individualist liberal thought of the period.

The official doctrinaire and propaganda painting of the Revolution, and the official propaganda painting of the Empire, had been followed, as noted, by official " *troubadour* " painting under Louis XVIII. The Romantic movement developed this " *troubadour* " style, not as a renewal with the past but as an exaltation of Gothic freedom and individualism as opposed to classical order and control. As M. Hautecœur has put it : " *à la beauté il opposa le caractère, à la raison le sentiment, au dessin la couleur, à l'antiquité les temps modernes, à Raphael Michel-Ange, aux Carraches Rubens, au nu le vêtement, à la nature humanisée la nature sauvage.*"

I have discussed the relation of the Romantic movement to the Cubist-classical Renaissance of 1886-1914 in *The Modern Movement in Art*, where I wrote : " The idea of art served by the artists of the Romantic movement a hundred years ago was the idea that the artist's function was to discover and record unusually emotive fragments. For the creation of a formal harmony and unity symbolising the harmony and unity of the universe, which is and always has been the classical architectural idea of art, the Romantic artist substituted the search for some emotive fragment hitherto regarded as without emotive power. The fragments chosen by the Romantics were chosen not for their formal or generic but for their emotive significance ; they were the fragments which had affected the artist's emotions. Whether, judged by standards of Greek or Græco-Roman sculpture or Renaissance painting, the fragment was beautiful or ugly did not affect the issue ; if the fragment aroused emotion in the artist it was ' beautiful ' ; and its reproduction was worth while on that ground alone." In that book I have also pointed out that according to the Romantic creed the artist must be in a state of emotion at the time of working and that this emotion must be evident in the actual handling of the paint ; and I have discussed there the general character of the pictures painted as a result of this new creed, and the effects of that creed on pictorial technique.

From the social standpoint the Romantic movement was of great significance because the Romantic creed launched the concept of the artist as an individual charged with the duty of increasing his sensibility and his emotional receptivity to the utmost in order to react with the utmost emotional vitality to emotive fragments of life ; and by the same token it created the concept of the artist as an eccentric, an individual outside society, subject only to laws dictated by the needs of his peculiar vocation. The Bohemian artist was thus the creation of the Romantic movement, because original Romantic art could not be produced by a *bon bourgeois* who thought it important to wear the same clothes as his neighbours and to come home punctually for meals.

As the Romantic movement was part of the liberal individualism of the period, and as the Bohemian artist defied the laws and standards of bourgeois life, the period also saw the beginning of that hostility between the artist and the bourgeois which, together with the concept of the original artist as of necessity a Bohemian, persists to some extent to-day. The hostility has been fomented by the popular artists, who, jealous of original art, have endeavoured to discredit all the original artists of the last hundred years.

The Romantic movement at the outset was not understood by the public who looked at its first manifestations in amazement. But its individualist character was stigmatised by the artists who remained attached to the Davidian tradition and opposed their own confused concept of the classical principle to the new creed.

Both sides painted demonstration pictures, defending their principles, and sent these pictures to the Salons ; and thus began the production of pictures, often gigantic in size, which were painted to attract attention and defend a principle in public exhibitions, and had no further function when the exhibition closed.

These huge demonstration pictures were, of course, quite unsuited for a private house and unless they were purchased by the State they returned as " white elephants " to the artists' studios.

In the eighteenth century, as we have seen, all the large pictures painted were either commissioned as decorations for particular places or else commissions from the *Surintendant des Bâtiments* for tapestries to be made at the Gobelins and Beauvais factories for the Royal palaces or other luxurious interiors. When this demand began to disappear the production of large history-pictures was artificially continued by D'Angivilliers and Louis XVI for the sake of perpetuating the Grand Manner, and the pictures thus

commissioned, when ultimately purchased by the State, were sent to Versailles. The Revolutionary Government, as noted, had commissioned and given money prizes for patriotic history-pictures ; but they could not absorb all the production of such work, and David himself, who could not sell his *Sabines* and his *Léonidas*, reimbursed himself for the time and money expended on them by charging for admission to his studio to see them. During the First Empire, the Napoleonic propaganda pictures, officially commissioned or bought, were hung in the Tuileries and at Versailles. When, under Louis XVIII, the looted pictures in the Musée Napoleon were returned to their countries of origin, the empty spaces on the Louvre walls were partly covered by the removal of the Rubens Medici panels from the Luxembourg Palace to the Louvre ; and this was followed in 1818 by the arrangement of the Luxembourg as a gallery for contemporary pictures, and the official purchases of " *troubadour* " pictures in this and succeeding reigns were sent there. But the Luxembourg eventually became " full up " and then provincial galleries were instituted to take the overflow. Under the Third Republic the fund allotted by the Revolutionary Government for the purchase of contemporary pictures was developed to the *caisse des musées* and it became the custom for the State to buy and send to the Luxembourg or some provincial museum a certain number of pictures every year. As the choice has usually been for pictures that would otherwise be " white elephants " in the artists' studios, a visit to most of the French provincial museums entails a good deal of rapid walking until the works of a more significant character (which they generally possess as the result of gifts and bequests) are discovered.

I have already referred to the Classical demonstration Salon pictures produced by the pupils of David. The earliest Romantic demonstration pictures were produced by Théodore Géricault, painter of the famous *Radeau de la Méduse*, which was a Salon sensation in 1819.

Other early exponents of the new creed were E.-F.-M.-J. Devéria (1805-1865), painter of *La Naissance de Henri IV*, which attracted attention in the Salon of 1827 and is now in the Louvre ; and Richard Parkes Bonington (1801-1828), an English pupil of Gros, who scored successes in the Salons of 1822 and 1824, and was a friend of Delacroix, the one great artist of the movement.

8 THÉODORE GÉRICAULT (1791-1824)

Théodore Géricault was a rich amateur who scored a Salon

success at the age of twenty-one with his *Officier de chasseurs à cheval* (now in the Louvre) where we see an officer of the Imperial Guard mounted on a rearing horse (copied from an engraving after Raphael's *Battle of Constantine*). He tried to repeat the success in the Salon of 1814 with *Le Cuirassier blessé quittant le feu* (now also in the Louvre) which was painted in a fortnight; but this picture, where the horse was not copied from Raphael, failed to impress the public or the critics. In 1816 he went to Italy where he studied Michelangelo's frescoes in the Sistine Chapel and the drawings of horses by Leonardo da Vinci. On his return to Paris in 1818 he painted *Le Radeau de la Méduse.*

This picture, now in the Louvre, shows shipwrecked men on a raft. It made a sensation in the 1819 Salon because the wreck of the *Méduse* was then of topical interest, and the liberals who were accusing the captain of incompetency were making the disaster an excuse for attacks upon the Government. For the emaciated survivors on the raft Géricault made studies in hospitals and from corpses; for the central figure he made a study from a friend who was suffering from jaundice, and he borrowed the attitude of this figure from *Ugolino and his sons* (by Reynolds), engravings of which were known in the Parisian studios at the time.

In 1820 Géricault went with *Le Radeau de la Méduse* to England where the picture was exhibited and brought him considerable money—(the sum mentioned by his biographers varies from 17,000 to 20,000 francs. I cannot translate this into present values). Géricault must also have made money from engravings of this picture; but he never was able to sell it; the Louvre acquired it at the sale of his pictures after his death.

In England Géricault was influenced by the English genre school which he imitated in lithographs and paintings of urban and rustic subjects; he also looked at English sporting prints and produced *Le Derby d'Epsom*, now in the Louvre, in imitation; but above all he was impressed with the animal paintings by James Ward and Landseer. Géricault saw their pictures at the Academy and the British Institution, and wrote from London to a friend: " *Vous ne pouvez pas vous faire une idée des beaux portraits de cette année et d'un grand nombre de paysages et de tableaux de genre ; des animaux peints par Ward et par Landseer, agé de dix-huit ans ; les maîtres n'ont rien produit de mieux en ce genre . . .*" In London Géricault also saw and admired Wilkie's *Chelsea pensioners reading the Waterloo Gazette* (which Wilkie painted for the Duke of Wellington whose descendants still own it).

In England Géricault seems to have become (as Watteau became) avaricious. He now regarded his considerable private means as insufficient and returning to France in 1822 he engaged in business speculations in order to increase them. But the speculations were unsuccessful and before he died two years later he was almost ruined.

He died at the age of thirty-three as the result of a fall from his horse. There is a tendency at the moment in France to overrate his work which was coarse and derivative (and incidentally the source of the painting of Rosa Bonheur (1822-1899)).

Géricault had a most disagreeable streak in his psychological constitution. In Rome he enjoyed and made drawings inspired by the brutal sport known as the *Barberi* in which riderless horses with spurs attached to them were thrashed into racing in Carnival time on the *Piazza del popolo*. His drawings for compositions show men thrashing horses and pulling their tails, horses biting one another, men stunning oxen in the slaughter-house, and negroes being beaten by slave drivers. He made a terra cotta group (which has disappeared) called *Nègre qui brutalise une femme* ; he chose stallions for mounts and overrode them.

He did not marry ; as my knowledge goes, he introduced no female figures into his compositions and he painted no pictures of women except several studies of mad women, one of which can be seen in the Lyons Museum.

His *Carabinier* (in the Louvre), painted when he was twenty-three, is probably his best picture ; but it is no more than a good art-school study. The Wilstach Collection, Philadelphia, has the[N1] head and bust of a soldier with his head bandaged which is known as *The Wounded Soldier*.

9 EUGÈNE DELACROIX[1]

BORN CHARENTON-SAINT-MAURICE 1798 DIED PARIS 1863

Characteristic Pictures

London	National Gallery	The Baron Schwiter
London	National Gallery, Millbank	Attila driving Beauty, Art and Pleasure before him
London	National Gallery	Sketches for the Palais Bourbon decorations
London	Wallace Collection	The Execution of the Doge Marino Faliero

[1] The student should read Delacroix's own *Journal*, and Baudelaire's essay on him in *L'Art Romantique*. For catalogues of his works he should consult Robaut's book (1885), R. Escholier's (1926-9) and L. Hourticq's (1930).

London	Wallace Collection	Faust and Mephistopheles
London	Victoria and Albert Museum	The Good Samaritan
London	Victoria and Albert Museum	The Shipwreck of Don Juan
New York	Metropolitan Museum	The Abduction of Rebecca
New York	Metropolitan Museum	The Garden of Georges Sand at Nohant
New York	Metropolitan Museum	Jesus on Lake Gennesaret
New York	S. Lewisohn Collection	Decorative panels : [N1] Hesiod and the Muse The Captivity in Babylon The Death of St. John the Baptist The Drachma of the Tribute The Death of Seneca Aristotle describes the Animals
New York	S. Lewisohn Collection	Martyrdom of St. Sulpicius (sketch) [N1]
Boston	Museum of Fine Arts	Lion Hunt
Boston	Museum of Fine Arts	Pietà
Chicago	Art Institute	Dante's Barque
Chicago	Art Institute	Oriental Lion Hunt
Philadelphia	Fairmont Park	L'Amende honorable [N2]
Cleveland	Museum of Art	Arabs resting in a forest
Washington	National Gallery (Chester Dale)	Columbus and his son at La Rabida
Paris	Louvre	Dante et Virgile aux enfers
Paris	Louvre	Les Massacres de Scio : Familles grecques attendant la mort et l'esclavage
Paris	Louvre	La Mort de Sardanapale
Paris	Louvre	Le 28 juillet 1830. La Liberté guidant le peuple
Paris	Louvre	Jeune tigre jouant avec sa mère
Paris	Louvre	Femmes d'Alger dans leur appartement
Paris	Louvre	Le prisonnier de Chillon
Paris	Louvre	Noce juive dans le Maroc
Paris	Louvre	Hamlet et Horatio au cimetière
Paris	Louvre	Prise de Constantinople par les Croisés
Paris	Louvre	Le naufrage de Don Juan
Paris	Louvre	Le Christ en croix
Paris	Louvre	Lion et sanglier
Paris	Louvre	L'enlèvement de Rebecca par le templier de Bois Guilbert
Paris	Louvre	Chevaux arabes se battant dans une écurie
Paris	Louvre	Medea furieuse allant poignarder ses enfants
Paris	Louvre	Still life with landscape background

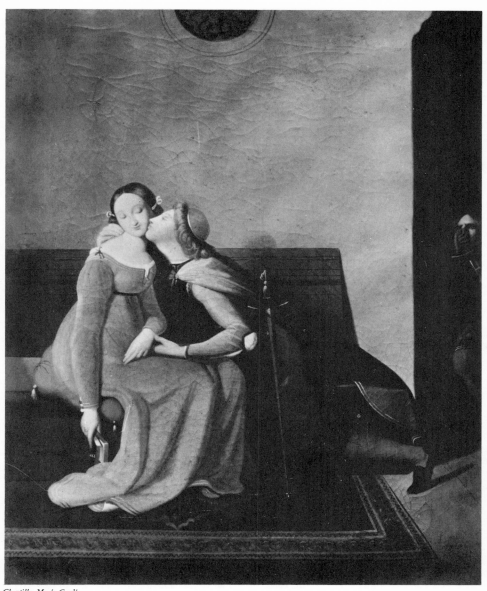

77. J. A. D. INGRES : Francesca da Rimini

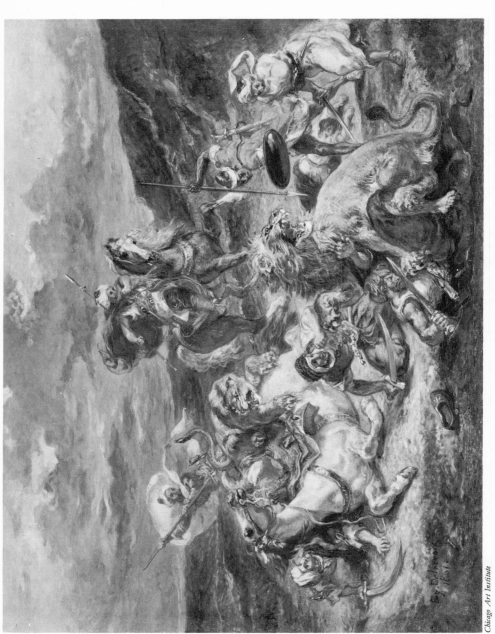

78. EUGÈNE DELACROIX : Oriental Lion Hunt

Paris	Louvre	Portrait of Chopin
Paris	Louvre	Portrait of Georges Sand
Paris	Louvre (Gallery of Apollo)	Apollon vainqueur du serpent Python
Chantilly	Musée Condé	Prise de Constantinople par les Croisés (sketch)
Chantilly	Musée Condé	Les deux Foscari
Chantilly	Musée Condé	Corps de garde marocain
Grenoble	Museum	Roger et Angélique
Lyons	Museum	Odalisque couchée
Lyons	Museum	Derniers moments de l'Empereur Marc Aurèle
Lyons	Museum	Assassinat de l'évêque de Liége
Montpellier	Musée Fabre	Aline la Mulatresse
Montpellier	Musée Fabre	Exercice militaire des Marocains
Montpellier	Musée Fabre	L'Education d'Achille
Montpellier	Musée Fabre	Femmes d'Alger dans leur intérieur
Montpellier	Musée Fabre	Daniel dans la fosse des lions
Montpellier	Musée Fabre	Michelangelo dans son atelier
Montpellier	Musée Fabre	Orphée secourt Eurydice mordue par un serpent
Rouen	Museum	La bataille de Taillebourg
Rouen	Museum	La Justice de Trajan
The Hague	Mesdag Museum	Descent from the Cross
The Hague	Mesdag Museum	The eve of Waterloo

(a) Delacroix's Life

Eugène Delacroix's father was a lawyer, who eventually became Republican ambassador to Holland and Préfet at Marseilles. His mother's family included several artists. His parents had means, and Delacroix himself did not at first contemplate painting as a profession. After completing the ordinary education of his class he entered Guerin's studio as an amateur. " *Je veux y passer quelque temps*," he wrote, " *pour avoir au moins un petit talent d'amateur.*"

In 1819 after the death of both his parents he found himself penniless as the result of an unsuccessful lawsuit about the family property ; and he was never completely without money difficulties for the rest of his life.

In 1820 he painted a picture for the convent of Les Dames du Sacré-Cœur at Nantes which can still be seen there. This commission had been passed on to him by Géricault when he heard of his financial difficulties. Delacroix's next picture was the *Dante et Virgile* which was a feature of the Salon of 1822 and was bought by the *Administration des Beaux Arts*. The famous *Massacres de Scio* was in the Salon of 1824.

In these years he had been sharing a studio, in conditions of

poverty, with an English artist named Fielding. In 1825 he went for a few months to England and stayed with Fielding ; and there he called on Wilkie, Lawrence and Etty. Delacroix admired all these English artists. He also admired Constable. He stated that he had altered his own method of painting after studying Constable's *Hay Wain* (now in the National Gallery) in the Salon of 1824.

On his return to Paris he painted *La Mort de Sardanapale* and in the next two years he had commissions from the Minister of the Interior and from Louis-Philippe. In 1830 Louis-Philippe bought his *Le 28 juillet* 1830 : *La liberté guidant le peuple* from the Salon, and awarded him the Legion of Honour in recognition of the picture's political significance. *L'Amende Honorable*, now in[N1] the Wilstach Collection in Philadelphia, was painted in 1831.

This ends the first period of Delacroix's activity. He was now thirty-three and his Romantic demonstration pictures *Les Massacres de Scio* and the *La Mort de Sardanapale* had brought him great celebrity and called forth virulent abuse from the partisans of the Institute. But there was no denying his amazing facility as a painter, or the richness of his pictorial conceptions ; there was no escape from the dramatic appeal of such a subject as *La Mort de Sardanapale* with its subtitle in the catalogue which read : " *Couché sur un lit superbe au sommet d'un immense bûcher, Sardanapale donne l'ordre à ses eunuques et aux officiers du palais d'égorger ses femmes, ses pages, jusqu'à ses chevaux et ses chiens favoris, aucun des objets qui avaient servi à ses plaisirs ne devaient lui survivre . . .*" especially as the excitement of the subject was carried into the tumultuous rhythms of the picture and the vigorous touches of a " *brosse ivre.*"

In 1832 he went to Morocco with the Comte de Mornay, French Ambassador to the Sultan ; in the following year he went to Spain ; on his return to Paris he exhibited paintings recording his experience on these journeys, and these pictures were the beginning of the wave of so-called " Orientalism " which I have discussed in *The Modern Movement in Art*, where I also refer to the work of Théodore Chassériau (1819-1856) who began as a follower of David and Ingres and ended as an imitator of Delacroix's " Orientalism."

The *Oriental Lion Hunt* (Pl. 78) in the Chicago Art Institute, the *Lion Hunt* in the Boston Museum of Fine Arts, and the *Exercises militaires des Marocains* in the Musée Fabre at Montpellier are typical of Delacroix's " Oriental " pictures which greatly increased his reputation in Paris. His *Femmes d'Alger dans leur appartement* (Pl. 80b) was an official purchase from the Salon of 1834 and he

was commissioned to paint *L'Entrée des Croisés à Constantinople* for Versailles, and decorations for the Salon du Roi in the Palais Bourbon.

It was in fact now realised that Delacroix had superb decorative talents and these commissions for decorations were followed by commissions in 1844 for decorations in the Library of the Palais Bourbon, in 1845 for the Library of the Luxembourg, and in 1849 for the Salon de la Paix in the Hôtel de Ville and for the ceiling of Le Brun's Gallery of Apollo in the Louvre. Delacroix was able to get these official commissions because owing to his social position he had many highly placed personal friends in political circles. He secured them in spite of the Institute's hostility.

Yet another aspect of his talent is seen in the splendid *Pietà* (Pl. 79) now in the Boston Museum of Fine Arts, which was painted in 1848 when the artist was fifty.

Delacroix's final triumph came in 1855 at the *Exposition Universelle* where he had a gallery of his own filled with thirty-five of his most important pictures. The Romantic movement by this time had won all its battles and Delacroix was recognised by all intelligent people as its central figure though the general public preferred the work of his less-vigorous imitators.

In that year also he received the commission for the decorations in the church of Saint-Sulpice.

In 1837 he had applied for a vacancy in the Institute and been refused. In 1838 he had applied again and been again refused. In 1849 he had applied a third time and been a third time refused. In 1853 he applied a fourth time and his application was not even considered. In 1857 when he was nearly sixty and had only six more years to live he applied a fifth time and was elected to a seat vacated by the death of one of his most ignoble (and most successful) imitators Paul Delaroche (1797-1856), painter of *The Princes in the Tower* and *The Death of Queen Elizabeth*.

(b) Delacroix's Art

Delacroix was the last of the Old Masters and the first great master of the modern school. He picked up the European tradition of decorative painting at the point where it had been left by the Venetians and Rubens. The art of Rubens had been the epic art of the Italian High Renaissance and early Baroque masters translated into Flemish. For the remainder of the century the followers of Rubens imitated the externals of his pictures. Then Watteau translated the Rubens epic into delicate French lyrics.

Delacroix went back behind Watteau to Rubens himself. The
Rubens series of Marie de Medicis panels was transferred, as noted,
to the Louvre in 1818 ; and in his youth Delacroix had doubtless
seen magnificent works by the Venetians in the Musée Napoleon ;
here were masters who worked on a scale and in a spirit that
aroused his ambition and when the time came to test his own
capacities he found that he could challenge even in this majestic
field.

To the modern student with his eye and mind attuned to the
Cubist-Classical Renaissance the whole Romantic creed as repre-
sented by the work of Delacroix seems a disconcerting heresy. Most
of the material that went to the making of Delacroix's demonstra-
tion pictures may seem to such students absurd and vulgar.
Trained by the classical calm and dignity of the pictures by Seurat,
Cézanne and the Cubists we find ourselves distracted by the
tumultuous rhythms, the drama, and the rhetoric in Delacroix's
pictures. From the modern standpoint which appreciates David's
dictum *pas d'emportement du pinceau* Delacroix's *brosse ivre* seems
braggadocio, a form of exhibitionism that leaves us unmoved ;
and compared with the architectural deliberation that pervades the
work of the new classical masters a painting by Delacroix seems
not so much a picture as a series of dramatic records of the artist's
sensuous reactions to emotive fragments collected in one frame.

But if we contemplate any individual passage in a picture by
Delacroix, or one of the still-life groups which he threw off now
and then as relaxation, we find the artist's verve and use of colour
an intoxicating vintage that it is hard if not impossible to resist ;
and thus it comes that Delacroix seems to us most essentially a
master in fragments ; and that he seems above all a master when
he abandons the *rubato* of his most characteristic pictures and gives
us a relatively tranquil picture like the *Pietà* (Pl. 79), which recalls
Tintoretto by whom it was obviously inspired.

In the later nineteenth century when great interest was taken
in *methods* of painting Delacroix's technique was much applauded.
His use of broken colour to increase the vitality of the picture's
surface—a device already used by Watteau on a miniature scale
—made a great appeal to the Impressionists. The modern student
is less concerned with methods of painting. The Romantics and
the Impressionists finally established for the artist a right to dispose
his paint upon the canvas in spots or dashes or in any other manner
that he might adopt or invent. When those movements degenerated
it was seen that this freedom was, in itself, no aid to the creation

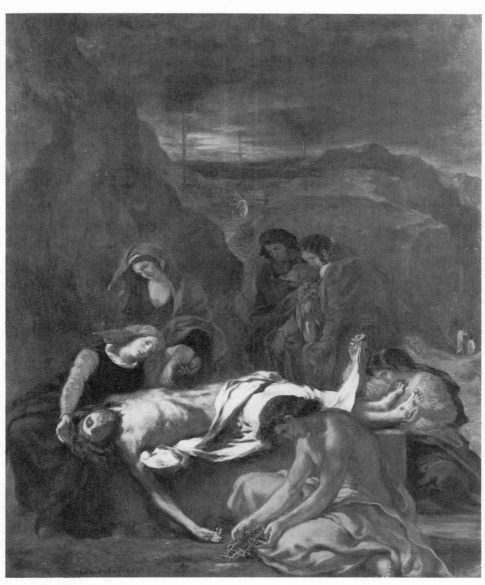

79. EUGÈNE DELACROIX: Pietà

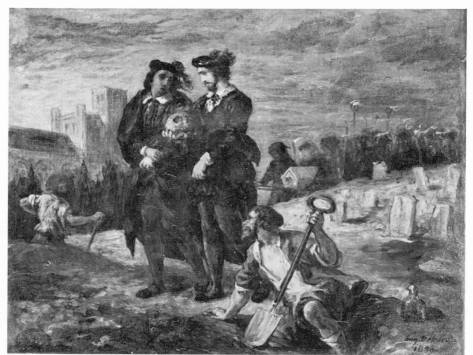

80a. EUGÈNE DELACROIX: Hamlet and Horatio

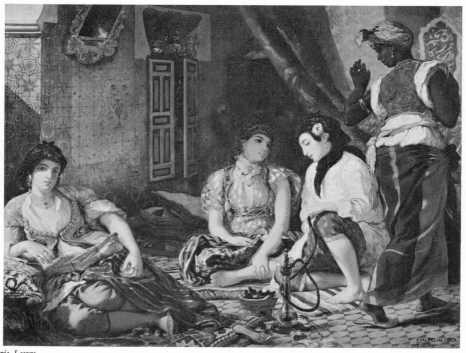

80b. EUGÈNE DELACROIX: Algerian Women in their Apartment

of a work of art. But when Delacroix first proclaimed this freedom he was proclaiming a paradox; and by so doing he made possible the achievements of Manet, Renoir and Cézanne.

10 FRANCO-DUTCH LANDSCAPE PAINTERS

While liberalism and individualism were being symbolised in Delacroix's pictures, another aspect of the period—the growth of the middle classes—was being symbolised in a group of French landscape painters who appeared at the same time.

After the arrogance of Charles X, Louis-Philippe made a show of democratic sentiment and posed deliberately as *le roi bourgeois*; he walked the streets of Paris, unattended, carrying an umbrella, and his Queen continued her needlework when she received the ladies of her Court. Modern bourgeois France as we know it began in fact about 1830; and these conditions created a new school of popular landscape painting of the kind which had appeared in similar conditions about 1630 in Holland.[1]

The leading names among these Franco-Dutch landscape painters, some of whom worked a good deal in the region of Fontainebleau forest, are Jules Dupré (1812-1889), Théodore Rousseau (1812-1867), Charles-François Daubigny (1817-1878), and Henri Harpignies (1819-1916); with them we must associate Charles Jacque (1813-1894), who specialised in landscapes with ducks and geese and chickens, and Constant Troyon (1810-1865), who painted landscapes with cows, sometimes of a considerable size.

Some of the landscapes produced by this school were less obviously categoric than the Dutch seventeenth-century pictures which they resemble and by which they were influenced; the artists were affected by the Romantic movement and they often made their landscapes dramatic and emotive by recording the effects of light in nature that seem to correspond to human moods. This was notably the case with Théodore Rousseau whose work, moreover, sometimes shows qualities derived from the picturesque-classical tradition of French landscape; and it was also the case with Diaz de la Pena (1808-1876), a French painter

[1] It is usual to ascribe the blame for these Franco-Dutch landscapes to the influence of Constable and the English painters of the Norwich School who had begun to imitate Hobbema and other Dutch eighteenth-century popular landscape painters a little earlier. But the growth of the French middle class at this period would in any event have caused a recrudescence of this and other forms of popular art. (Cf. my *Dutch Painting*, Faber.)

of Spanish parentage, who alternated landscape with little pictures of nude groups influenced by Delacroix himself.

The Institute adopted an attitude of violent hostility to this school of popular landscape ; it persecuted the artists with all the means at its command ; and it was scarcely less hostile to Camille Corot, the outstanding French landscape painter of the period.

11 CAMILLE COROT[1] (1796-1875)

(a) Corot's Life

Camille Corot was the son of a Parisian coiffeur who married a Swiss modiste and then opened a *magasin de modes* in the rue du Bac, where he became prosperous and a *fournisseur* of the Tuileries. When Camille was nineteen he was an assistant in a draper's shop in the rue Richelieu ; he already drew and painted in his spare time but his parents refused to finance him for the career of an artist. Five years later the situation was much the same ; but that year saw the death of a poor relation whom Corot's father had supported and Camille now received this allowance with parental permission to devote himself to art.

This occurred in 1822 when Corot was twenty-six. He lived on this small allowance and other funds provided by his father, without selling a single picture, for the next sixteen years, and he did not begin to make a regular income from his work till he was nearly sixty, when he had already inherited his father's property. " *Camille s'amuse* " his father used to remark to his friends, just as Chardin's contemporaries—astonished at his later concentration on still-life paintings and his neglect of his opportunities for making money—remarked that " *M. Chardin ne peint que pour son amusement.*"

From 1822 to 1825 Corot painted landscapes at Rouen, on the Normandy coast, and at his father's country house at Ville d'Avray ; in 1825 his father provided funds for a three years' stay in Italy and in 1834 he again provided money for a second visit with the proviso this time that the visit should not exceed six months. " *Nous ne sommes plus jeunes, ta mère et moi,*" his father said to him,

[1] For a catalogue of Corot's paintings and details of his life the student is referred to the works by Alfred Robaut and Etienne Moreau-Nelaton (1905), and a recent book by G. Bazin (1942). Most of the leading museums in Europe and America contain examples of Corot's work ; a characteristic series showing his work at all periods is dispersed in various galleries in the Louvre. After his death his pictures were so much sought after by collectors that they were forged in great numbers. But the number of his genuine works is large because he never did anything but paint pictures from the age of twenty-six.

"*ne nous abandonne pas trop longtemps.*" Corot inherited his parents' largeness of heart. When he was himself an old man and dealers flocked round him he used to send them pictures by poor artists, whose work he respected, together with his own.

Corot sent examples of his numerous paintings year after year to the Salons, but nobody bought them. Eventually the Duc d'Orléans bought two in 1838. The State bought one the year after and another in 1842. In 1843 the Salon rejected his picture and the same thing happened the next year. In 1846 when he was fifty he received his first commission—a *Baptism of Christ*, which was ordered for the Church of Saint Nicolas-du-Chardonnet. In the same year he received the Legion of Honour. "*Puisque l'on décore Camille, il faut qu'il ait du talent,*" said his father who thought at first that the decoration was intended for himself.

In 1849 a reconstitution of the Salon Jury had a considerable effect on Corot's situation. Under the Restoration Kings and Louis-Philippe the Jury was exclusively composed of the Institute caucus. When, after the Revolution of 1848, the Second Republic arrived, with Louis Bonaparte as President, the brilliant art historian Charles Blanc became a Director of the *Administration des Beaux Arts*, and the exhibition for that year was thrown open to everyone, without an intervening Jury, as it had been thrown open in the first Revolution in 1791. The flood of popular landscapes and other popular pictures was so enormous at the 1848 Salon that the Jury was re-established in the following year, but its members were elected not by the Institute but by the votes of the whole body of exhibitors. In these conditions Corot found himself elected to the Jury and the Hanging Committee by the votes of the Franco-Dutch landscape painters who admired his work.

About this time he adopted his fluffy grey treatment of trees and foliage which the public admired because it resembled trees and foliage as recorded in photographs ; and dealers began to think of securing his production.

Corot, personally, was a very agreeable companion. As he had never had to bother about selling his pictures, and as he had the sense to be content with his small independent means, he presented the engaging spectacle of a man with simple tastes who stood outside the struggle for existence and was always ready to be kind to other people. He spent a good deal of his time in visits to various friends and wherever he went he painted landscapes in the surrounding country.

When the Franco-Prussian war broke out he was seventy-four and by that time he had been making a large income from dealers for fifteen years. During the war he worked in his studio in Paris and he sent a sum of money to the mayor of his *arrondissement* for " *la confection des canons pour chasser les Prussiens des bois de Ville d'Avray.*" He died in Paris at the age of seventy-nine.

(b) Corot's Art

Corot was the first French artist of consequence to look at nature with a photographic eye. He worked in his early years with minor French landscape painters who still retained something of the picturesque-classical tradition of Vernet, Robert and Moreau ; he was all his life a student of the work of the Old Masters ; but, with a natural tendency to mechanical imitation, he had the misfortune to begin painting just before the arrival of the camera and to work in the years of his maturity in the first flush of the photographic period.

The photographic vision which pervades Corot's *œuvre* inevitably prejudices the modern student against it. We live in a photograph-sodden age. We have photographs thrust before us in the morning paper at breakfast and again in the afternoon ; and many people go of their own volition in the evenings to establishments that exhibit still more photographs—photographs that succeed one another with lightning rapidity (and are now accompanied, I am told, by noises that resemble human speech). The modern student, who has followed the magnificent efforts made by the artists of the Cubist-classical Renaissance to drag painting from the morass of this photographic vision, cannot fail to rank Corot as an artist who succumbed. But he will recognise that Corot could not fore-see the photographic tyranny of our own age ; and that, though he had a photographic vision and imitated photographs, he also had a genuine simplicity of outlook that enabled him to steer clear of the Romantic movement, and a lyric quality in his sensibility that lifts his work above that of other painters of the photographic school.

Corot's pictures fall into several types. We have (*a*) early landscapes including a number painted in Italy, (*b*) subject-pictures with figures inserted into landscapes in the manner of Claude, (*c*) fluffy grey landscapes painted after 1850, and (*d*) photographic studies of figures.

In all these periods we find Corot seeking, unconsciously, for a

compromise between the photographic vision and the achieve-
ments of the architectural artists of the past. The student will find
it instructive to compare on the one hand his *Venice* (Pl. 81a),
painted in 1834, with the views of Venice painted by Canaletto
(1697-1768) who used a *camera-oscura*; and to compare on the
other his sketch *Narni : Pont d'Auguste sur la Nera*, painted in
1826 and now in the Louvre, with Claude's drawing *The Tiber
above Rome* (Pl. 112b). *Narni : Pont d'Auguste sur la Nera* was a
sketch for a picture *Le Pont de Narni* which Corot exhibited at his
first appearance in the Salon of 1827. The Salon picture which
is worked up into a classical-picturesque composition with large
umbrella pines in the middle distance was hung in the Salon
between paintings by Constable and Bonington; and Corot at
his debut thus represented the picturesque-classical tradition hung
between the Dutch seventeenth-century popular landscape tradition
and the new Romantic movement.

Corot's continual contact with tradition will also be seen if his
Saint Jérôme, painted in 1837 and now in the church of Ville
d'Avray, be compared with *Saint Anthony and Saint Paul the Hermit*
by Velasquez in the Prado, if his *Diane au bain*, painted in 1855
and now in the Bordeaux Museum, be compared with landscapes
with figures by Claude, or if his *Homère et les Bergers*, shown in
the Salon of 1845 and now in the Saint Lô Museum, be compared
with *The Funeral of Phocion* (Pl. 32a) by Poussin.

There were moments in the period before 1850 when Corot
almost arrived at a conscious concept of architectural space
and the creation of a new type of architectural picture. In
Honfleur—maisons sur les quais (Pl. 81b), painted about 1830, he
was within an inch of such achievement but his photographic
vision was responsible for the rowing boat which has nothing to
do with the picture and was inserted because it happened to be
there at the moment when Corot was making his sketch.

Such incidental and accidental details together with incidental
and accidental effects of light occur in the work of all photographic
artists and the elimination of such elements was the first achieve-
ment of the Cubist-classical Renaissance.

After 1850 Corot made great efforts to recapture the secrets of
the art of Claude and of Poussin's last phase. But by this time
his eye was vitiated by photographs and he had acquired his
degenerate naturalistic formula for the light on foliage and trees.
There was thus a fatal disaccord between the type of picture at
which he was aiming and the means he employed to produce

it; and there was a further disaccord because Corot in these subject-pictures was generally more photographic in his landscape background than in his treatment of the figures.[1]

In the 'sixties Corot's fluffy photographic foliage, in the grey colour of photographs, degenerated into a mannerism; and in the pictures of this period, turned out for the dealers, he abandoned even the attempt to remain in the field of perceptive and creative art. In his last years he returned to the manner of *Honfleur—maisons sur les quais* and he then used compositional effects which he had observed in photographs.

Corot often painted photographic studies from models posed in the studio, and a series of such pictures dates from the period of the Franco-Prussian War when he worked exclusively in his studio in Paris. *La Femme à l'atelier* (Pl. 82b), painted in 1870 and now in the Museum at Lyons, is an example of these photographic studies. If we compare this picture with Prud'hon's *Mme Dufresne* (Pl. 82a), reproduced here on the same page, we can see the difference between light and shade used as architectural elements in a picture, and light and shade copied in a photographic way. Prud'hon perceived the model before him as a series of forms entirely independent of light and shade and he invented a picture of which an architectural disposition of light and shadow is an integral part. Corot with half-closed eyes recorded an accidental effect of light and shade before him and by so doing a semblance of forms has appeared upon his canvas; but the picture itself is as formless as a photograph because the artist has degraded his perception to the mechanical vision of the human eye—which is much the same as the vision of the camera's lens.

In the later nineteenth century when the photographic vision was officially regarded as the vision proper to an artist Corot's pictures were enormously admired, and his method of painting —known as painting " by the tone values "—was universally taught in schools. In the pictures painted " by the tone values " colour was reduced to a system of tinted greys; and many hundreds of thousands of grey pictures were produced in France. Of these the little marine paintings by Louis-Eugène Boudin (1824-1898) were among the most pleasant; and the method was seen forced to its extreme photographic limit in the portraits and figure studies by Eugène Carrière (1849-1906) and Fantin-Latour

[1] Cf. *The Modern Movement in Art* (Pls. 10a and 10b) where I reproduce trees and foliage from Corot's *Concert Champêtre*, painted in 1857 and now in the Louvre, and a photograph of similar trees and foliage on the same page.

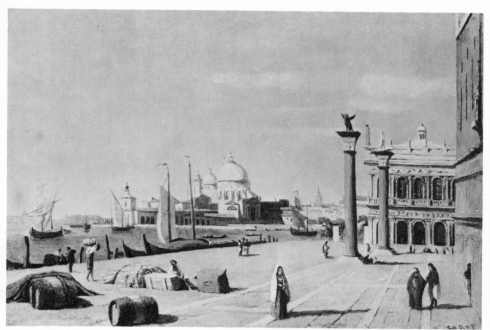

81a. CAMILLE COROT: Venice

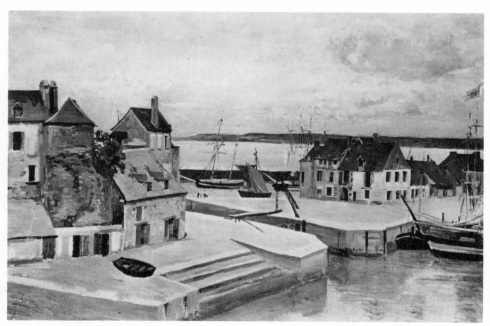

81b. CAMILLE COROT: Honfleur—Maison sur les Quais

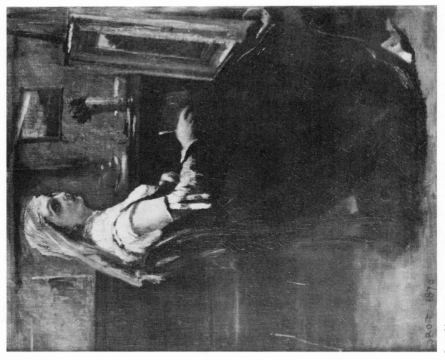

8²b. CAMILLE COROT: Dans l'atelier

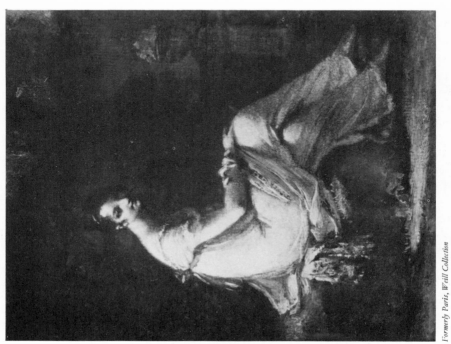

8²a. PIERRE PRUD'HON: Mme. Dufresne

(1836-1904). These artists were influenced by actual photographs. The Daguerreotype which influenced Ruskin and the English Pre-Raphaelites had little influence in France except, I fancy, on the work of Ingres and of Bastien-Lepage (1848-1884) an artist who substituted a Daguerreotype ideal for the Romantic elements in the art of Millet (who was himself a good deal influenced by photographs). Corot was not, I think, influenced by Daguerreotypes. But he was fascinated by photographs and frequently sat to photographers himself.

12 REALISM AND THE SALON PUBLIC

Corot was the father of the Impressionist movement in French painting. But between Corot and the Impressionists there was a movement known as Realism which was an application to figure subjects of the principles of the Franco-Dutch imitative landscape already chronicled.

The Realist doctrine excluded imagination, invention, architectural construction, and Romantic comment. Its slogan was *un peintre ne doit peindre que ce que ses yeux peuvent voir*. The painters who submitted to this doctrine were popular artists and their pictures appealed to the Salon public of the time.

This Realist doctrine was launched in the first place by a man who was not himself a Realist of this calibre but a Romantic Realist—Gustave Courbet (1819-1877) an artist whose work the Salon public particularly detested.

Courbet described the aims which he pursued as follows: " *Savoir pour pouvoir, telle fut ma pensée. Être à même de traduire les mœurs, les idées, l'aspect de mon époque, selon mon appréciation ; être non seulement un peintre, mais encore un homme ; en un mot faire de l'art vivant, tel est mon but.*" For Courbet the essential part of this pronouncement was the qualification *selon mon appréciation* ; and it was the evidence in his work of this qualification that rendered it odious to the Salon public.

It is impossible to understand the treatment to which Courbet and, later, the Impressionists were subjected by the Salon public unless we realise that a host of venal purveyors of popular art had now flattered that public into an attitude of extreme Philistinism.

In the eighteenth century the Salon public saw relatively few contemporary pictures ; they began to see more when the exhibits became more numerous, as noted, in the days of the Revolution ;

in the first quarter of the nineteenth century the interest excited by the works of the Italian Old Masters in the *Musée Napoléon* competed with the interest in contemporary art ; when the *Musée Napoléon* was dispersed at the Restoration, the biennial Salons, held in the Salon Carré of the Louvre, became the centre of focus, and under Louis-Philippe and the Second Republic the Salons became steadily larger. The public thus acquired a large experience of popular genre pictures and of popular demonstration pictures in the pseudo-classical and pseudo-romantic manners produced in order to attract attention and advertise the painters' names.

The painters of these demonstration pictures posed as the guardians of our old friend the Grand Manner ; and the uninstructed public adopted the products of this showmanship as their standard in judging works of art.

The venal popular and demonstration painters and the public thus revolved together in a vicious circle. The painters worked to achieve contact with the Salon public's average experience of phenomena and with that public's experience of their own pictures ; and the public, thus flattered into a Philistine attitude, were entirely convinced that this flattery was the proper function of fine art.

The vicious circle became still more water-tight after 1855 because in that year the Government constructed for the *Exposition Universelle* the vast *Palais de l'Industrie* in the Champs Elysées ; the Salons thereafter were held there and in order to fill the huge galleries of this new building the number of pictures shown was enormously increased and the public had correspondingly increased experience of mediocre and venal popular art produced to flatter them.[1]

In these conditions the Salon painters found it easy to lead the public to the active persecution of original artists ; and persecutions thus fomented have been an unedifying feature of art-politics in Paris from 1840 to the present day.

The first victim was Courbet whose work and curious career we must now consider.

[1] The Salons were held in the *Palais de l'Industrie* till 1899 ; it was then pulled down and the present *Grand Palais* and *Petit Palais* were built (with the Pont Alexandre) for the *Exposition Universelle* of 1900. Since then the Salons have been held in the *Grand Palais* where some eight thousand pictures and large quantities of sculpture are exhibited each spring.

13 GUSTAVE COURBET[1]

BORN ORNANS 1819 DIED LA TOUR DE PEILZ 1877

Characteristic Pictures

London	Tate Gallery	Deer in a Forest
London	Tate Gallery	The Pool
London	Tate Gallery	Seascape
London	Tate Gallery	Self Portrait
London	Tate Gallery	Snow Scene
London	Tate Gallery	The Storm
London	Victoria and Albert Museum	L'Immensité
London	Victoria and Albert Museum	Landscape
Scotland	Sir W. Burrell Collection	L'Aumône d'un mendiant à Ornans [N1]
Scotland	Sir W. Burrell Collection	Les Laveuses
New York	Metropolitan Museum	Nude Woman with a parrot, Salon
New York	Metropolitan Museum	Les Demoiselles de Village
New York	Metropolitan Museum	Brook of the Black Well
New York	Metropolitan Museum	Coast Scene
New York	Metropolitan Museum	Snow Scene
New York	Metropolitan Museum	The Amazon
New York	Metropolitan Museum	The Polish Exile
New York	Metropolitan Museum	The Source
New York	Metropolitan Museum	The Young Bather
New York	Metropolitan Museum	The Girl with the Mirror : Whistler's " Jo "
New York	Metropolitan Museum	Deer
New York	Metropolitan Museum	Marine—the Waterspout
Boston	Museum of Fine Arts	The Quarry (La Curée)
Chicago	Art Institute	La Mère Gregoire
Chicago	Art Institute	Alpine Scene
Philadelphia	Wilstach Collection	A view of Ornans [N2]

[1] The student will find useful books on Courbet by G. Riat (1906) and Léger (1929 and 1934).

Philadelphia	Wilstach Collection	A Mountain Stream [N1]
Philadelphia	Wilstach Collection	The Waves [N2]
Philadelphia	Academy of Fine Arts	Urbain Cuenot
Philadelphia	Academy of Fine Arts	Le grand chêne d'Ornans
Washington	National Gallery	Girl reading
Washington	National Gallery	Young girl in a hat
Worcester (Mass.)	Art Museum	Low Tide
Minneapolis	Institute of Arts	The Roe Covert
Northampton (Mass.)	Smith College	La Toilette de la Mariée
Paris	Louvre	Self Portrait. L'Homme Blessé
Paris	Louvre	Un enterrement à Ornans
Paris	Louvre	Berlioz
Paris	Louvre	L'homme à la ceinture de cuir (self portrait)
Paris	Louvre	L'Atelier du peintre : Allégorie réelle
Paris	Louvre	Combat de cerfs, Salon
Paris	Louvre	Remise des chevreuils, Salon
Paris	Louvre	Mer orageuse
Paris	Petit Palais	Self portrait with a black dog
Paris	Petit Palais	P.-J. Proudhon
Paris	Petit Palais	Les Demoiselles des bords de la Seine
Paris	Petit Palais	La Sieste
Paris	H. Matisse Collection	La blonde endormie
Montpellier	Musée Fabre	L'homme à la pipe (self portrait)
Montpellier	Musée Fabre	Baudelaire
Montpellier	Musée Fabre	Baigneuses
Montpellier	Musée Fabre	Le Rencontre : " Bonjour M. Courbet "
Montpellier	Musée Fabre	Bruyas
Ornans	Hôtel de Ville	Courbet in prison
Ornans	Hôtel de Ville	Le Château de Chillon
Ornans	Hôtel de Ville	Retour de Chasse
Lille	Museum	Une après-dinée à Ornans
Dresden	Museum	Les Casseurs de pierres
The Hague	Mesdag Museum	Mountain Landscape
The Hague	Mesdag Museum	Recumbent Nude
The Hague	Mesdag Museum	Chevreuil mort
The Hague	Mesdag Museum	Au bord du lac
The Hague	Mesdag Museum	Road in Sunlight

Jean-Désiré-Gustav Courbet was born in the village of Ornans
that lies in the harsh and gloomy country near the Jura mountains.
He was the son of a wealthy farmer and after refusing to study
law he worked in one or two art schools in Paris. His earliest
works, painted when he was about twenty-three, already reveal

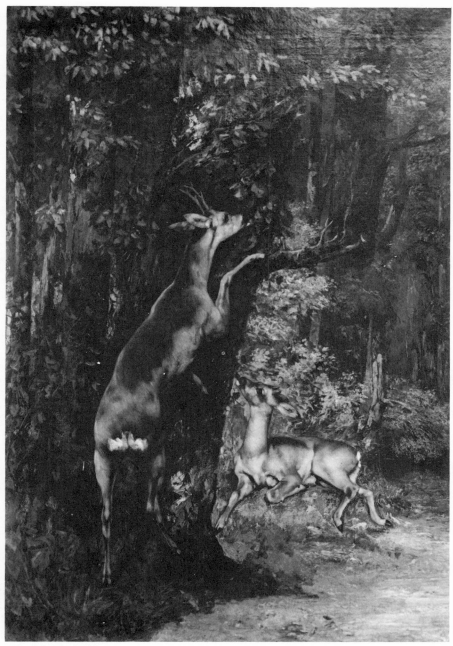

83. GUSTAVE COURBET: The Roe Covert

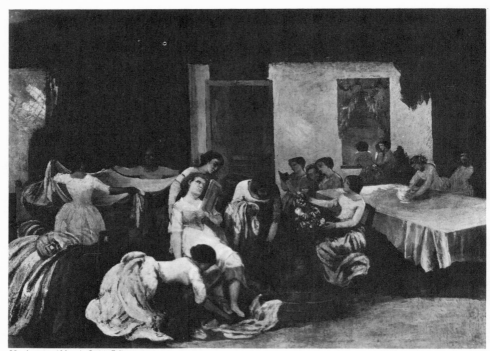

84a. GUSTAVE COURBET: La Toilette de la Mariée

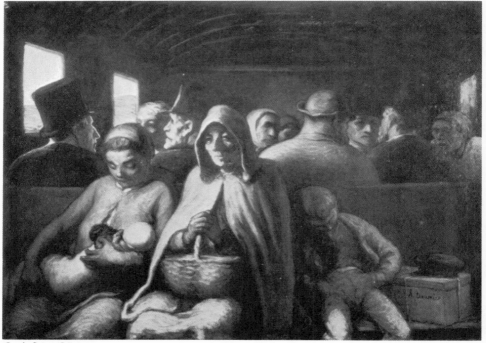

84b. HONORÉ DAUMIER: Le Wagon de troisième Classe

a choice of Rembrandt and the Spaniards as his favourite masters in the Louvre.

In the 1849 Salon, which included Corot, as noted, on an exceptionally liberal Jury, Courbet exhibited the self portrait known as *L'Homme à la ceinture de cuir* and also *Une après-dinée à Ornans* which was remarked by Charles Blanc, bought by him for the State, and awarded a medal. (The acquisition of a medal was very important for an artist at this time, because it placed him *hors concours* for future exhibitions to which he could contribute without submitting to the Jury. Courbet's later works would all have been rejected from the Salons if he had not thus acquired the right to exhibit at this early stage.) In 1850 Courbet took full advantage of his *hors concours* position. He sent nine pictures to the Salon including the celebrated *Un Enterrement à Ornans*, the *Casseurs de pierres* and the self portrait known as *L'Homme à la pipe*.

The originality of *Un Enterrement à Ornans*—a group of intensely romantically observed peasantry round a grave—horrified both the Salon painters and the public debauched by popular fare; and the Salon authorities led the opposition by suggesting that the subject of this picture and of the *Casseurs de pierres* (which depicts an old peasant and a boy breaking stones) were offensively Socialistic. Courbet who at this period had nothing but a normal sympathy with the peasants of the regions round his home thus found himself regarded as a dangerous Socialist in Paris.[1]

In the Salon of 1853 Courbet exhibited his *Baigneuses* now at Montpellier; the Salon painters pointed out that the massive figures of the women showed their plebeian origin and that this choice of plebeian models showed the painter's Socialist bent.

The *Baigneuses* was bought by Alfred Bruyas, a collector in Montpellier, who became Courbet's host and patron about this time and bought a number of his pictures including the *Portrait of Baudelaire* which was painted in 1853, and passed with the other Courbets in the Bruyas Collection to the Musée Fabre at Montpellier in 1868; it shows the poet seated at a table smoking a pipe and reading a book; it is at present in need of cleaning

[1] Stonebreakers entered English art in 1858 when there were two pictures of this subject in the Royal Academy both praised by Ruskin " because the humblest subjects are pathetic when Pre-Raphaelitically rendered." The pictures were *The Stonebreaker* (which depicted a boy breaking stones and is now in the Walker Art Gallery, Liverpool) by John Brett, and *Thou wert our Conscript* (which depicted an old man asleep over his heap) by A. Wallis.

and conditioning and it is hung at such a height that it cannot
be examined in detail ; it would seem, however, to be quite un-
interesting as a portrait and to suggest nothing of the sitter's
characteristics except the massive brow. Baudelaire himself
thought nothing of the picture. The portrait of Baudelaire in
L'Atelier du peintre was evidently painted from it.

In 1854 Courbet went to stay with Bruyas at Montpellier and
painted the celebrated *Le Rencontre : Bonjour M. Courbet*, which
shows a meeting between himself and Bruyas on a country walk.

In the following year, at the age of thirty-six, he painted the
remarkable picture which he called *L'Atelier du peintre : Allégorie
réelle*. This shows the artist seated at his easel with a nude woman
standing by his side ; one half of the studio is occupied by a
group of the artist's models who had figured in his realistic
pictures—labourers, peasants, the priest of the *Enterrement à
Ornans* and so forth ; the other half is occupied by a group of
his friends including Bruyas, Baudelaire, Champfleury, who was
one of the first to praise his pictures, and the Socialist writer
Proudhon whose portrait he had painted in 1853.

Courbet sent *L'Atelier*, together with *Un Enterrement à Ornans*,
which he wished to exhibit a second time, to the *Exposition
Universelle* of 1855, where his *hors concours* privilege did not apply,
because there was a special International Jury. Both pictures were
rejected. Courbet was indignant. He had plenty of money, as he
had an allowance from Ornans and he had already, as noted,
procured some patrons for his pictures, which he never sold except
for considerable sums, and he accordingly decided to put up a
shed and hold a one-man show of his own in the Exhibition. In
this one-man show he placed the two rejected pictures and forty
others. The show was a failure ; hardly anyone went in. But
Delacroix (who was then nearly sixty and had just been refused
membership of the Institute for the fourth time by the Salon
caucus) went, and noted in his Diary : "*Je vais voir l'exposition de
Courbet. J'y reste seul pendant près d'une heure. J'y découvre un chef
d'œuvre dans son tableau refusé (L'Atelier). Je ne pouvais m'arracher
de cette vue. . . . On a refusé là un des ouvrages les plus singuliers de ce
temps.*" Courbet arranged another independent one-man show of
a hundred of his pictures in the *Exposition Universelle* of 1867.
This also was a failure.

Courbet was very ambitious ; he was also vain and not at all
shrewd. He had collected round himself a number of young
painters who flattered him and called him *maître*, and he regarded

himself as an important *chef d'école*. At the same time he began
to live up to his new reputation as a Socialist in which he was
encouraged by Proudhon and a group of young Socialists; he
thus began to regard himself also as a *chef de partie* and painted
Le Retour de la Conférence which seems really to have been a Socialist
propaganda picture. It represented a procession of priests coming
from a Conference where it was obvious that many had had too
much to drink. The picture was huge in size. Courbet sent it to
the 1864 Salon where the Jury, who could not reject it owing to
his *hors concours* position, procured a special decree of the Govern-
ment in order to reject it on political grounds. The picture was
subsequently bought by a religious gentleman and destroyed.

Courbet's Socialism had very little effect on his work. He only
painted two Socialistic pictures—*Le Retour de la Conférence* and
L'Aumône d'un mendiant (1868) now in the Burrell Collection in N1
Scotland; but it brought him disaster later in his life.

At the beginning of 1870 he was offered the Legion of Honour,
and he refused it in offensive terms. When the Second Empire
came to an end in September he was thus in the public eye as a
militant Socialist and he was called on by the new régime to act
as President of a *Commission des Beaux Arts* in charge of the
nation's art treasures. In this position he doubtless indulged in
memories of Louis David and dreams of an art-dictatorship; and
when the Commune arrived in 1871 he became a Deputy in the
Assemblée Nationale. In the civil war that raged in Paris from
March to May of that year the *Colonne Vendôme* was overthrown.
This was a tragic misfortune for Courbet because as President
of the *Commission des Beaux Arts* he had written a memorandum
suggesting that this emblem of the Empire should be taken down.
After the Commune when the Thiers Government was taking
drastic vengeance on the *Communards* Courbet was arrested and
held responsible for the destruction of the monument; and he
was condemned to six months' imprisonment and ordered to
reconstruct the column at his own expense.[1]

[1] The Place Vendôme, as noted, was originally Place des Conquêtes when
it was laid out under Louis XIV. It then contained an equestrian statue of
Louis XIV by Girardon, which is now in the Louvre. The *Colonne Vendôme*
was erected in 1805 to celebrate Napoleon's victories and it was then sur-
mounted by a bronze statue of Napoleon as a Roman Emperor. In 1814
the Royalists under Louis XVIII took down the statue, melted down the metal
and remade it as the statue of Henri IV on the Pont Neuf, on the principle
of renewal with the past already noted in the official Restoration commissions

Courbet was a man of means but he was quite unable to produce the 400,000 francs required by this condemnation. He was also morally shattered by the failure of his dreams of a Davidian career. He escaped accordingly, when an opportunity occurred, to Switzerland, and there a few years later he died at the age of fifty-eight.

Courbet's main activity as an artist was distinct from his position as *chef d'école* and also from his position as *chef de partie*. He was a truly original artist who painted numerous figure subjects, landscapes with animals, and seascapes. He was not content with the photographic vision but always reinforced it to perception; and that perception, though harsh, was extremely personal. He demonstrated that the Romantic stress of emotive fragments could be accomplished without any of the accessories—the Arab steeds and waving banners—that we find in works by Delacroix; he made it clear that the most familiar fragments can be made emotive when recorded by an original mind.

Technically he was also a very individual painter. He often applied his colours with a palette knife instead of a brush—a procedure which he initiated (and which was imitated, in his early days, by Cézanne).

As a result of this procedure, and of his intense perception, Courbet's paintings are often rich in quality and this applies especially to his pictures of deer in forests such as *The Roe Covert* (Pl. 83) now in the Minneapolis Institute, and some of his seascapes which are very dramatic. His colour varies a good deal as he sometimes used a light scale and sometimes a darker one. It is usually harsh and unsubtle; occasionally—especially in the seascapes—he achieved a vitreous green that had not appeared in painting since Rubens.

As Courbet did not succumb to the photographic vision his work appeals to students of the later efforts to escape from that vision.

I reproduce as an extra plate in this edition his *Toilette de la Mariée* (Pl. 84a).

for pictures. In place of the statue a fleur-de-lys was placed on the column. In 1833 Louis-Philippe replaced the fleur-de-lys by a statue of Napoleon in uniform and a cocked hat; in 1863 Napoleon III removed this to the Invalides and put back a copy of the original statue. When the column was re-erected after the *Communards* had overthrown it the present statue was made; this repeats the original type. The column itself, of course, is an imitation of Trajan's column in Rome.

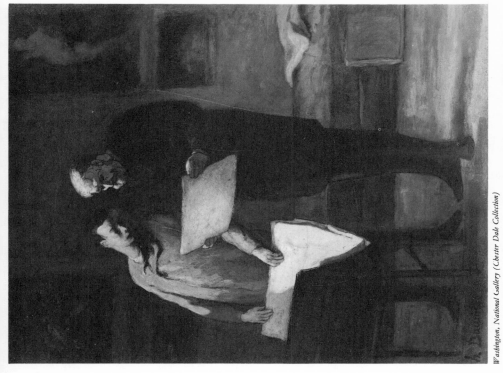
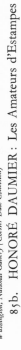

85b. HONORÉ DAUMIER: Les Amateurs d'Estampes

85a. LOUIS-LÉOPOLD BOILLY: Les Amateurs d'Estampes

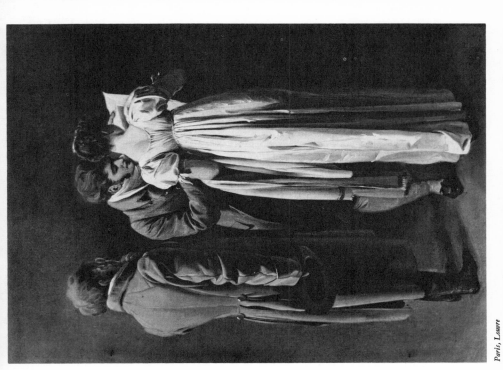

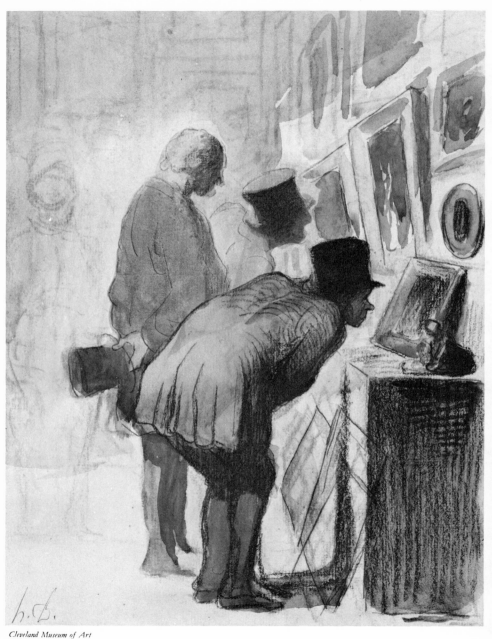

86. HONORÉ DAUMIER : Les Amateurs de Peinture

14 OTHER ROMANTIC REALISTS (MILLET, LEGROS, DAUMIER)

Another Romantic Realist, whose vision was, however, on the photographic side, was Jean-François Millet (1814-1874), painter of the well-known *L'Angélus* in the Louvre.

Millet translated the old Dutch tradition of the peasant genre picture into the new Romantic language of his day. At moments he achieved the profoundly intimate contact with his subject that we have noted in the work of Louis Le Nain and Chardin ; *La Soupe* (Pl. 88), in the Marseilles Museum, is a picture of this kind.

Millet was himself a peasant and he painted sign-boards and other hack works for a living for many years. He was nearly sixty before a dealer assured him a regular income.

He is well represented in the Louvre, in the Boston Museum of Fine Arts, in the Chicago Art Institute, and in the Victoria and Albert Museum in London.

Alphonse Legros (1837-1899) was also a Romantic Realist. He imitated both Courbet and Millet. He came to England at Whistler's suggestion in 1875 and was made Professor at the Slade School.

Under the Restoration Kings and Louis-Philippe there were fierce battles about the freedom of the Press, and the political cartoons of the period were extremely virulent. The history of these cartoons is outside my subject but I must refer to one cartoonist, Honoré Daumier (1808-1879), whose paintings and drawings are highly ranked to-day.

Daumier was the son of a glass painter and his talents were discovered by Lenoir, the creator of the first museum in Paris. He learned to lithograph in his youth and made a meagre living as a lithographic illustrator all his life.

He began as a political cartoonist on a paper called *Caricature*, in 1830, and in 1832 he was imprisoned for six months for a caricature of Louis-Philippe called *Gargantua swallowing bags of gold extracted from the people*. *Caricature* was replaced by *Charivari* in 1835 and Daumier worked on this paper for forty years, producing four thousand lithographs—an average of nine a month.

In these lithographs Daumier appeared not only a political cartoonist but also a satirist of social life. He picked up the tradition of the *gravures de modes* and transformed it to a tradition of *gravures de mœurs* which had already appeared in England in the work of Hogarth and Rowlandson, and was to be continued in France by J. L. Forain (1852-1931).

While Daumier earned his living in this way he also made drawings of contemporary life, modelled little caricature heads of personalities observed in public places, and painted pictures ; but only his lithographs were known in his lifetime and he was never able to sell any of his paintings and drawings (most of which were acquired from his widow by a syndicate of dealers).

At the age of sixty-nine his eyesight failed and he retired in poverty to a country cottage given him some years before by Corot. The Government of the Third Republic allotted him a small pension as a reward for a lifetime devoted to Republican propaganda. He died two years later.

On the staff of *Charivari* Daumier had Balzac as a collaborator, and Balzac said of him : " *Ce garçon a du Michel-Ange sous la peau.*" This to some extent was true ; but it was less the spirit of Michelangelo, the first Romantic, than that of Rembrandt, the second, that resided in Daumier, and the spirit found expression in a language largely borrowed from Delacroix and Jean-François Millet—as we see in the celebrated *Wagon de troisième classe* (Pl. 84b), formerly in Sir James Murray's collection in London and now in a private collection in Canada.

At the same time we find in Daumier's paintings the preoccupation with formal relations already encountered in *La Récureuse* (Pl. 57) by Chardin ; and this quality gives architectural significance to pictures like *Les Amateurs d'Estampes* (Pl. 85b), reproduced here on the same page as *Les Amateurs d'Estampes* (Pl. 85a) by Boilly who concentrated on surface polish and the imitation of folds and textures in the tradition of the *tableau de modes*.

In his drawings Daumier used Rembrandt's technique and he worked to some extent in Rembrandt's spirit. But he found it hard, with a mind blunted by long drudgery at journalistic lithographs, to escape from caricature. The difference between the Romantic artist's distortions designed to stress the emotivity of characteristic features, and the caricaturist's distortions designed to render those characteristics funny, is a very fine one. Daumier in his most impressive drawings remained on the Romantic side, but sometimes he was on the caricaturist's side, as in his lithographs. I reproduce a typical drawing, *Les Amateurs de peinture* (Pl. 86), now in the Cleveland Museum of Art.

We see Daumier at his highest level in the *Don Quixote* painting (Pl. 87). This picture, almost a monochrome, achieves an astonishing result with great economy of means ; it combines

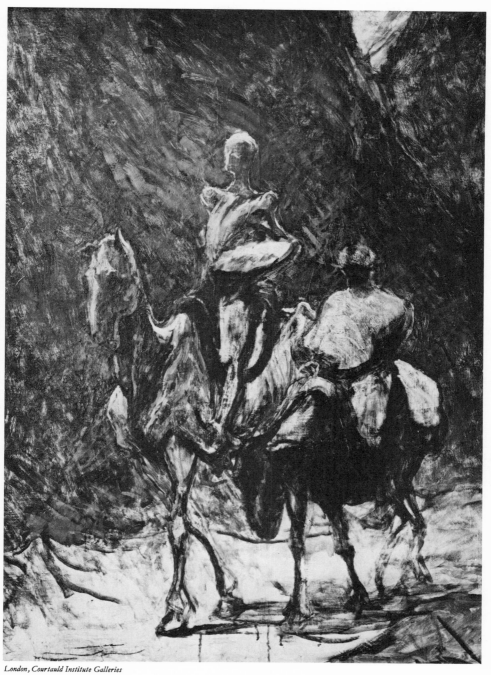

87.　HONORÉ DAUMIER: Don Quixote

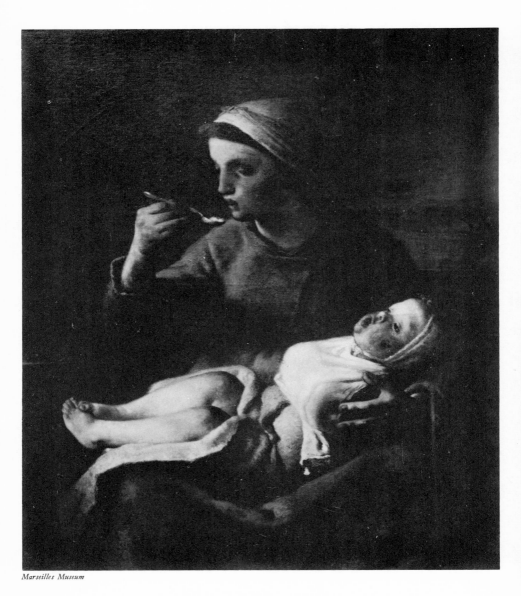

88. JEAN-FRANÇOIS MILLET: La Soupe

the emotivity of Romantic painting with a large degree of the architectural stability of classical art; and Daumier here demonstrates that an equestrian group can live and move before us though the artist has not delineated lapels or harness, buttons or bits, eyes or noses, fingers or toes.

Other examples of Daumier's drawings and paintings can now be seen in the London Tate Gallery, and Victoria and Albert Museum; in the Louvre; in the Metropolitan Museum of New York, the Chicago Art Institute and other museums. Mrs. Charles Payson, New York, has his *Audience at the Théâtre Français*.

15 CONSTANTIN GUYS

Constantin Guys (1805-1892) also drew for the illustrated papers and produced other work highly valued to-day.

He was the son of upper middle-class French parents. At eighteen he fought with Byron in the Greek War. Four years later he became a *dragon* in the French Army. About 1830 he left the Army and travelled for some years in Spain, Italy, Bulgaria, Egypt and Algeria where he made a number of sketches. Returning to Paris he started to sell these drawings and to make others of operas, ballets and so forth which he sold to the *Illustrated London News*. For that paper he then went as war correspondent to the Crimea and he was present at Inkermann and Balaclava.

At this stage he seems to have quarrelled with his aged father, who had married a girl of sixteen, and to have gone in the 'forties to London where he gave lessons in French and drawing. In the 'fifties he returned to Paris and became an eccentric recluse; the numerous *dessins de mœurs*, on which his reputation rests, date from the 'fifties, 'sixties and 'seventies.

Baudelaire made his acquaintance in 1859 and published in 1863 in the *Figaro* the celebrated articles on his work called *Le peintre de la Vie Moderne*, in which at the artist's request he referred to him simply as " M. G." These were written in 1859; but Baudelaire, who after the *Fleurs du Mal* prosecution had great difficulty in getting his work published, was not able to sell them till 1863.

In 1885 when he was eighty, Guys took several portfolios of his drawings to the Musée Carnavalet and handed them to the porter. The drawings were unsigned and the parcel contained no name or address. The Curator, however, realised that they must be the work of Baudelaire's *Peintre de la Vie Moderne* and he carefully preserved them and eventually bought them at two francs apiece. These drawings include many of the finest surviving

examples of Guys' work ; they are still in the Musée Carnavalet.

Later in the same year Guys was run over by a carriage in the street and he was bedridden for the remaining seven years of his life. He died at the age of eighty-seven.

Guys was a most engaging artist and his drawings and water-colours constitute a fascinating chronicle of Parisian *mœurs* under the Second Empire. He drew entirely from memory, and his mind registered both psychological and architectural impressions. In practice he began by recording his architectural impressions ; the subject first appeared on the paper as an architectural arrangement of light and shade ; then he went over this adding specific form and psychological stresses ; finally, sometimes but not always, he added lines with a pen.

His work had an influence on Manet who was doubtless introduced to it by Baudelaire. Both Manet and Baudelaire owned examples.

Guys, in fact, gave Baudelaire a number of his drawings ; and Baudelaire, in 1859, sent a drawing of a Turkish woman by Guys as a Christmas present to his mother, Mme Aupick, who had lived in Constantinople ; she did not acknowledge the present and he wrote her three days later : " Do not scruple to tell me (if it is your opinion) that you think the Turkish lady is very ugly. I am afraid you are not very strong on the arts but that does not reduce my affectionate feelings and my respect for you." Mme Aupick preferred two heads by Greuze which her husband had acquired.

A drawing by Guys (now in Baron Gourgaud's collection in Paris) called *La Promenade au bois* must have been seen by Manet before he painted his *Concert aux Tuileries* now in the London National Gallery, Millbank ; in Baron Gourgaud's collection there is also a full-length wash drawing called *Une Dame*, which is known[N1] to have belonged to Manet and certainly influenced his painting.

The student is referred (*a*) to the hundred and seventy excellent reproductions that accompany P. G. Konody's translation of Baudelaire's articles, published by " The Studio " as *The Painter of Victorian Life*, and (*b*) to Gustave Geffroy's book on Guys where some of the finest drawings in the Musée Carnavalet are reproduced.

PART SIX

THE IMPRESSIONISTS

THE IMPRESSIONISTS

I THE IMPRESSIONIST MOVEMENT

The Impressionists adopted Courbet's theory of Realism in respect of their choice of subjects, and in their technique they followed Corot's photographic procedures which they developed to suit their several needs. Manet was the pioneer of the movement; Renoir proved himself, in the end, the great master; Monet, whose use of colour was architectural, anticipated the Cubists in this way; Degas was a Romantic journalist whose work was pushed to its logical conclusion by Toulouse-Lautrec.

Other artists connected with the movement were Camille Pissarro (1830-1903), Alfred Sisley (1840-1899), Frédéric Bazille (1841–1870), Berthe Morisot (1840–1895), Eva Gonzalès (1850–1883) and Mary Cassatt (1845-1926).

Pissarro, son of a French Jewish father and a Creole mother, was an honest intelligent man who had intellectual contact with all the Impressionist masters and also with Gauguin, Cézanne and Seurat, a contact that was always mutually beneficial. He was influenced successively by Corot, Millet and the artists of the later movements; his painting was prudent and conscientious. He followed Monet in experimenting with the bird's-eye view familiar in Japanese prints; and he applied this with success to street scenes in his later years. In *Mi-carême sur les Boulevards* (Pl. X), painted in 1897, we see him at his best.

Sisley was born in Paris of English parents. He began as an amateur with an allowance from his father. In 1870 his father was ruined and thereafter he lived in poverty for the rest of his life. In his art he enlivened Corot's photographic vision with Monet's colour and in this formula he produced many charming little landscapes.

Bazille, who was associated with the Impressionist artists in the early days, was killed in the Franco-Prussian War. He might have developed into an artist of consequence. The Louvre (Jeu de Paume) has his *Réunion de famille* (1869), *La Robe rose*, *Atelier de l'artiste* and a landscape, and the Musée Fabre, at Montpellier, his *Vue de Village* (1868) showing a young peasant girl against a landscape with a view of Castelnau in the distance.

Berthe Morisot was a granddaughter of Fragonard and at first an informal pupil of Corot and afterwards a regular pupil of

Manet whose brother she married. She imitated Manet's technique in his Impressionist pictures and achieved at times very pleasant effects of spontaneity and colour. *La Toilette* (Pl. 108a), now in the Chicago Art Institute, shows the light touch characteristic of her work. She is represented in the Jeu de Paume by *La Chasse aux papillons* (with portraits of her sister and her children), *Femme se poudrant, Le berceau* (also a portrait of her sister), *Le champs de blé* and other works ; the London Tate Gallery has a charming example, *Jour d'été* (two young women in a punt on a river).

Eva Gonzalès was a pupil of Manet who imitated the manner which he employed in painting her portrait. Her picture *La Loge*, quite a good imitation, is in the Louvre ; her *Matinée rose* (young woman in a pink négligé at her dressing table) is in the Jeu de Paume.

Mary Cassatt was born in Pittsburgh and worked under Renoir and Degas. She is well represented in the New York Metropolitan, the Washington National Gallery and the Jeu de Paume.

The Impressionist movement was a studio experiment. The artists all adopted the position of the research scientist working in his laboratory to solve a problem of his own selection considered as an end in itself. They did not regard themselves as tradesmen, like the artists of the old *Maîtrise*, or as members of a liberal profession like Claude and Poussin, or as professional craftsmen like Le Brun or Boucher, or as propagandists in a battle of contemporary ideas like Delacroix and Courbet. They regarded themselves, as Corot, and possibly Chardin and Watteau had regarded themselves, as servants of a vocation ; and, therefore, from the standpoint of bourgeois society, they painted, like Chardin and Corot, for their own " amusement."

The persecution to which the Impressionist painters were subjected had its source, as noted, in the camp of the popular and demonstration artists of the Salon ; and conditions, when Manet was ridiculed in 1865, and the other Impressionists were ridiculed in the 'seventies, were much the same as they had been when Courbet appeared, except (*a*) that in 1863 the Salon had become an annual, instead of a biennial function, and the public experience of popular Salon painting was, therefore, increased, and (*b*) that the Salon Jury had again developed to a bigoted caucus.

The ridicule and really scandalous abuse showered on the original French artists of this period were directed partly against

the supposed socialistic and immoral tendencies of their pro-
ductions. When Cézanne first appeared the Salon artists and their
supporting critics tried to discredit him by describing his pictures
as obviously the work of a *Communard*. Manet's *Déjeuner sur l'herbe*
and *Olympia* were attacked as indecent and there can be no doubt
that the public which had then very little experience of Romantic-
Realistic nude painting were genuinely shocked by both pictures.
It was, of course, the duty of the Salon painters to explain to the
public the real relation between Manet's *Olympia* and Giorgione's
Venus in Dresden, Titian's *Venus* in Florence, and Titian's *Venus
and the man playing the Organ* in Madrid ; and also the relation of
Manet's *Déjeuner sur l'herbe* (Pl. 90b) to Giorgione's *Concert
Champêtre* and an engraving after Raphael (Pl. 90a). They did not
do so because (*a*) it did not suit their purpose, and (*b*) they were
probably unacquainted with the Italian works in question—the
bigotry and ill-nature of such artists being frequently accompanied
by a remarkable ignorance of the history of art.

But the main attacks were directed against the technical pro-
cedures of the artists. Manet painted his shadows into his lights
instead of the prevailing practice of painting his lights into his
shadows ; and after 1870 all the Impressionists painted in bright
tints and with little touches of divided or broken colour. Left to
themselves the public would probably have ignored these original
artists as they ignored Corot for forty years, and they would have
been mildly puzzled by these innovations when they chanced to
come their way. There is nothing in the use of bright tints and
spots and dashes which naturally arouses indignation in an average
common-sensed decent-minded middle-class man. But the popular
Salon artists stigmatised these technical devices as heinous, indeed
as almost bestial, crimes, and encouraged the general public to
persecute the criminals and wallow in the pleasure of ridiculing
technical procedures which happened to be new.

The history of the Impressionists' struggles is well known and
can now be briefly told.

From 1859 to 1874 Manet fought the Salon painters and the
Salon public almost single-handed.

In 1863 the Salon Jury's persecution of their rivals reached a
point when protest became inevitable and the rejected artists,
including Manet, Pissarro and Whistler, appealed directly to the
Emperor who ordered a gallery in the *Palais de l'Industrie,* where
the Salon itself was held, to be allocated to the rejected pictures ;

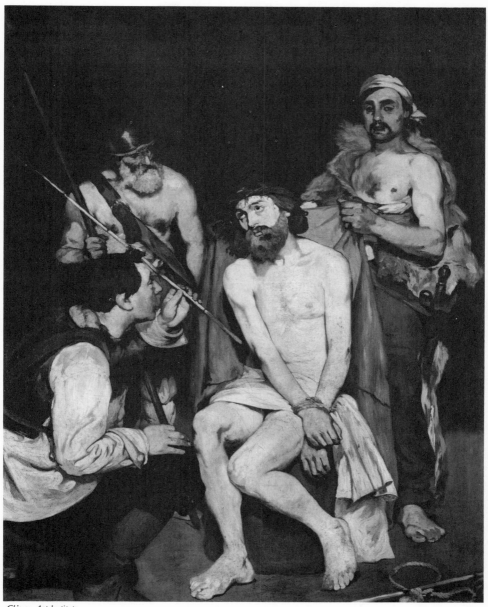

89. EDOUARD MANET: Jesus insulted by the Soldiers

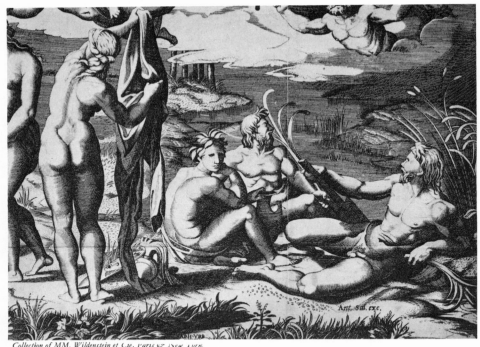

90a. MARC ANTONIO: Engraving after Raphael: The Judgement of Paris (detail)

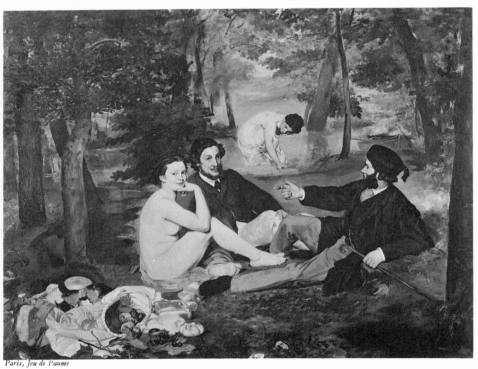

90b. EDOUARD MANET: Le Déjeuner sur l'herbe

and the Emperor himself accompanied by the Empress officially visited this *Salon des Refusés*.

In 1874 a group of thirty artists including Boudin, Pissarro, Monet, Sisley, Berthe Morisot, Renoir, Degas and Cézanne, formed themselves into an exhibiting society (with the title *Société anonyme des artistes, peintres, sculpteurs et graveurs*), as a protest against their treatment by the Salon Jury—(and in so doing they had the precedent of the *Société des Amis des Arts*, founded as a protest against the Academy's tyranny just before the Revolution).

Boudin was then fifty, Monet was thirty-four, Renoir was thirty-three, Degas forty, Pissarro forty-four, and Cézanne thirty-five. Manet, then forty-two, did not join and he never exhibited with this group though he helped the members in many ways.

The Société's first exhibition was held in the same year on the Boulevard des Capucines in the studio of the photographer Nadar, an extraordinary man who contrived to be an aeronaut, a caricaturist and an intimate friend of Baudelaire as well as a photographer. In 1863 when Nadar intended to go to London, Baudelaire gave him a letter of introduction to Whistler in which he said : " *Un de mes meilleurs et de mes plus vieux amis, M. Félix Nadar, va à Londres, dans le but, je crois, de raconter au public les aventures qu'il a courues avec son grand ballon, et aussi, je présume, pour faire partager au public anglais ses convictions relativement à un nouveau mécanisme qui doit être substitué au ballon.*" He also gave him a letter to Swinburne in which he took the opportunity to thank Swinburne for his " *merveilleux article* " on the *Fleurs du Mal* in the *Spectator* a few months earlier. In this letter Baudelaire stated his art-creed : " *Tout objet d'art bien fait suggère naturellement et forcément une morale.*" Nadar's book on Baudelaire throws valuable side-lights on his character. Baudelaireans will remember the revealing story of the child and the cake.

The Salon painters and their supporters in the Press encouraged the public to ridicule this First Impressionist Exhibition, which contained Monet's *Impression : Soleil levant* that gave the group its name.

To this exhibition Renoir sent *La Petite Danseuse*, now in the Washington National Gallery, Widener Collection, and *La loge*, now in the London National Gallery, Courtauld Collection ; Degas *Voitures aux courses* now in the Boston Museum, *Répétition d'un Ballet sur la Scène*, *Le Foyer de la danse* and *Le pédicure*, all now in the Louvre ; and Cézanne *La Maison du Pendu*, now in the Jeu de Paume.

In 1876 the Second Impressionist Exhibition was held in the galleries of the dealer Durand-Ruel, who had decided to support the rebels by 1872 when he bought twenty-two pictures by Manet in one day. At this exhibition the number of the exhibitors was reduced to sixteen, as the less adventurous members had fallen away. Gustave Caillebotté (1848-1894) appeared as a new member. Renoir sent eighteen pictures, and Monet and Berthe Morisot contributed.

This exhibition was even more virulently attacked than the first. Albert Wolff, art critic of the *Figaro*, wrote: " *On vient d'ouvrir chez Durand-Ruel une exposition qu'on dit être de peinture. Le passant inoffensif entre et à ses yeux épouvantés s'offre un spectacle cruel. Cinq ou six aliénés, dont une femme, s'y sont donné rendez-vous pour exposer leurs œuvres. Il y a des gens qui pouffent de rire devant ces choses-là, moi j'en le cœur serré. Ces soi-disant artistes s'intitulent les Intransigeants, les Impressionnistes. Ils prennent des toiles, de la couleur et des brosses, jettent au hasard quelques tons et signent le tout. C'est ainsi qu'à la Ville-Evrard des esprits égarés ramassent les cailloux sur leur chemin et croient avoir trouvé des diamants.*"

In 1877 the Société numbered eighteen members, who now called themselves officially *Peintres Impressionistes*, and the Third Impressionist Exhibition was held in an empty house in the rue le Peletier. Pissarro sent pictures of kitchen gardens, and Renoir *Le Moulin de la Galette* (Pl. 94); Cézanne sent sixteen works, landscapes, compositions of bathers, still-life studies and the *Portrait of Chocquet* now in Lord Rothschild's Collection; Degas sent twenty-five works including *Un Café*, *Boulevard Montmartre* (Pl. 101b) and *La danseuse au bouquet* (Pl. 100b), both now in the Jeu de Paume; and Monet sent *Les Dindons blancs* (painted in 1873) also now in the Jeu de Paume.

At this exhibition Cézanne's pictures excited the chief odium; the Salon painters and their associates spoke of him as a Socialist and a species of monster, though he never at any time in his life took an interest in politics. Discouraged by this stupidity and malice, he retired to the country, as he had independent means, and his work was not seen again in Paris for twenty years. Renoir and Monet shared the abuse that was poured upon him. *La Chronique des Arts et des Curiosités* wrote: " *MM. Claude Monet et Cézanne, heureux de se produire, ont exposé le premier 30 toiles, le second 14. Il faut les avoir vues pour s'imaginer ce qu'elles sont. Elles provoquent le rire et sont cependant lamentables. Elles dénotent la plus*

profonde ignorance du dessin, de la composition, du coloris. Quand les enfants s'amusent avec du papier et des couleurs, ils font mieux."

But the artists were now supported by a small number of patrons and admirers. In the first category there was Chocquet, a civil servant who overspent his income to secure pictures by Renoir, in which he delighted, and who was one of the first people to understand Cézanne ; Georges Charpentier the publisher ; Caillebotte, a rich naval architect, owner of a fine house on the river and numerous sailing boats, who bought pictures by all the Impressionists and Cézanne and was himself a gentleman-artist and member of the group ; and the Count Camondo, who also began to collect about this time.

The artists were also supported by the critic-collector Théodore Duret, and Emile Zola, who had both already defended Manet, and by the critics Duranty and Henri Rivière, who published, during the third exhibition, an illustrated weekly paper called *L'Impressioniste*, which lauded and explained the pictures. The main support came, however, as noted, from Durand-Ruel, an art dealer who really knew his business. Two other names must be mentioned—Muret, a restaurant keeper, who gave meals to the poor members of the group, including Monet and Renoir, in return for pictures ; and Tanguy, an artist colourman who supplied them with colours on the same terms.

The Impressionists in the years of adversity held two or three auction sales of their pictures at the Hôtel Drouot. The pictures were knocked down for very small sums amid the jeers of the spectators ; the popular painters' supporters in the Press added derisive comments.

The fourth, fifth, sixth and seventh Impressionist Exhibitions were held in 1879, 1880, 1881 and 1882. In 1883 there was no group exhibition, but Durand-Ruel arranged a series of one-man shows by Monet, Renoir, Pissarro and Sisley in an empty house on the Boulevard de la Madeleine. The eighth and last Impressionist Exhibition was held in 1886.

By this time the Impressionist battle was really won. An exhibition of pictures by Monet, organised in New York by Durand-Ruel in 1886, was a considerable success, and all the leading artists of the group were now recognised—except Cézanne, who was working out in his retirement a new orientation for modern art.

But the Salon painters still encouraged the general public in hostility to these artists ; they used all their influence to prevent

any expenditure from *la caisse des musées* on their work. No Impressionist pictures were ever *acquis par l'État*, and when they were bequeathed or presented, they were not accepted without protest, and some were actually refused.

None of the pictures by the Impressionists, Post-Impressionists, and by Cézanne and Seurat now in the Jeu de Paume have been purchases. Manet's *Olympia*, offered by subscription in 1890, was at first refused and only accepted after protracted negotiations. When the whole of the Caillebotte Collection came to the nation by bequest, in 1895, the Administration des Beaux Arts refused two pictures by Cézanne, one by Manet, three by Sisley, eight by Monet and eleven by Pissarro and accepted the remainder under protest.

The Impressionists' pictures, painted seventy and eighty years ago, have been imitated by derivative popular painters all over the world ; these imitations abound in all official exhibitions to this day. At the present moment Impressionism has taken the place of History-painting in the Grand Manner as the popular painters' creed ; and for the last thirty years it has been used by them as a weapon with which to attack the various forms of original painting that have since appeared.

2 EDOUARD MANET

BORN PARIS 1832 DIED PARIS 1883

Characteristic Pictures[1]

London	National Gallery	The Execution of the Emperor Maximilian. (Two fragments)
London	Tate Gallery	Concert aux Tuileries
London	Tate Gallery	Mlle Eva Gonzales
London	Tate Gallery	La Servante de Bocks
London	Tate Gallery	Mme Manet with a cat
London	Formerly S. Courtauld Collection	Le Déjeuner sur l'herbe (first version) [N1]
London	Formerly S. Courtauld Collection	Argenteuil [N2]
London	Formerly S. Courtauld Collection	Les Paveurs de la rue de Berne [N3]

[1] A complete catalogue of Manet's work is contained in Paul Jamot and Georges Wildenstein's *Manet* (2 vols., Paris, 1932).

London	Formerly S. Courtauld Collection	Le Bar des Folies Bergères [N1]
New York	Metropolitan Museum	Boy with a sword
New York	Metropolitan Museum	The Woman with a parrot
New York	Metropolitan Museum	The Funeral
New York	Metropolitan Museum	Jeanne—le Printemps [N2]
New York	Metropolitan Museum, Havemeyer Collection	Victorine en costume d'Espada
New York	Metropolitan Museum, Havemeyer Collection	Dead Christ with Angels
New York	Metropolitan Museum, Havemeyer Collection	Young Man as a Majo
New York	Metropolitan Museum, Havemeyer Collection	Matador Saluting
New York	Metropolitan Museum, Havemeyer Collection	En bateau
New York	Metropolitan Museum, Havemeyer Collection	Le Chemin de Fer [N3]
New York	S. Lewisohn Collection	Boy blowing Soap Bubbles [N4]
New York	S. Lewisohn Collection	The Beggar [N5]
New York	Osborn Collection	Le Guitarrero [N6]
Washington	National Gallery (Chester Dale)	Le Vieux Musicien
Chicago	Art Institute	Jesus Insulted by the Soldiers
Chicago	Art Institute	A Philosopher
Chicago	Art Institute, Mrs. Potter Palmer Collection	Les Courses à Longchamp
Boston	Wittemore Collection	Racing in the Bois : (Les Courses au bois de Boulogne)
Boston	Wittemore Collection	The Port of Calais
Philadelphia	Wilstach Collection	Marine View in Holland [N7]
Philadelphia	J. G. Johnson Collection	The fight between the *Alabama* and the *Kearsage*

Washington	Phillips Memorial Gallery	Ballet Espagnol
Paris	Jeu de Paume	Lola de Valence
Paris	Jeu de Paume	Le Déjeuner sur l'herbe
Paris	Jeu de Paume	Still life. Peonies
Paris	Jeu de Paume	Still life. Fruit
Paris	Jeu de Paume	Le Fifre
Paris	Jeu de Paume	Le Port de Boulogne
Paris	Jeu de Paume	Mme Manet lying on a sofa
Paris	Jeu de Paume	Mme Manet sitting on a sofa (La lecture)
Paris	Jeu de Paume	Mme Manet at the piano
Paris	Jeu de Paume	Olympia
Paris	Jeu de Paume	Le Balcon
Paris	Jeu de Paume	Emile Zola
Paris	Jeu de Paume	La dame aux eventails
Paris	Jeu de Paume	Mme Emile Zola (pastel)
Paris	Jeu de Paume	Berthe Morisot with a fan
Paris	Jeu de Paume	La Parisienne (Nina de Callias)
Paris	Jeu de Paume	La Viennoise (Irma Brunner) (pastel)
Paris	Jeu de Paume	Jean de Cabanes (pastel)
Paris	Jeu de Paume	La blonde aux seins nu
Paris	Jeu de Paume	Stephan Mallariné
Paris	Jeu de Paume	Clémenceau
Paris	M. Gallimard Collection	Le Linge
Tournai	Museum	En Bateau : Argenteuil
Tournai	Museum	Chez le Père Lathuille
Berlin	Museum	Dans la Serre
Frankfort	Staedelsches Institut	The Croquet Party
Copenhagen	Carlsberg Museum	Le Buveur d'Absinthe

(a) Manet's Life

Edouard Manet, the real originator of the Impressionist movement, belonged to an older generation—the generation of his friend and champion, Baudelaire—(whose *Fleurs du Mal* appeared in 1857 and who retired to Brussels in 1864 and died there in 1867).

Manet, like Baudelaire, came from the upper middle-class. His father, himself the son of a well-to-do bourgeois, was a magistrate ; his mother also came of a moneyed bourgeois family. His parents objected to his desire to be an artist ; and this was comprehensible seeing that the gentleman-artist was still a relatively rare phenomenon in French social life—though Delacroix provided a distinguished precedent.

In 1850, at the age of eighteen, Manet declared that he would rather go to sea than study law as his parents wished ; and to

sea he went, with funds supplied by his father, on a merchant vessel bound for Rio de Janeiro, where he probably acquired the germs of the paralysis from which he died.

On his return he again insisted on his vocation, and joined the art school of Thomas Couture, a Salon demonstration painter, whose *Romains de la Décadence*, now in the Louvre, was a Salon success in 1849. Manet worked there intermittently for five years, and in this period he spent much time in the Louvre, and copied, among other things, the *Cavaliers* then ascribed to Velasquez— (in 1850-1856 the only real Velasquez in the Louvre was the half-length of *L'Infante Marie Marguerite*). Between 1851 and 1858 Manet also copied in the Louvre Tintoretto's *Self Portrait*, Titian's *Vierge au lapin*, and, in the Luxembourg, *La Barque du Dante*, by Delacroix, whose studio he had visited. Ribera's *Le Pied bot*, which we might assume to have been a source of inspiration for his early work, was a La Caze gift in 1869.

In the evenings he took pianoforte lessons from a Mlle Suzanne Leenhoff, who became his mistress, the mother of his son, and eventually his wife.[1]

This liaison was kept secret from his father, who now provided funds for travel in Italy, Germany and Holland. About 1857 he shared a studio with another gentleman-artist, the Comte de Balleroy, and at the beginning of 1859, when he was twenty-seven, he painted *Le Buveur d'Absinthe* (Pl. 103b), now in Copenhagen.

Manet invited his master, Couture, to inspect this picture in his studio. " *Mon ami*," said Couture, " *il n'y a qu'un buveur d'absinthe ici—c'est celui qui a produit cette insanité*." The picture was sent to the Salon and rejected.

In 1860 he took a studio of his own and painted *La Musique aux Tuileries*, now in the Tate Gallery, a series of figures from a model called Victorine, and another series of figures in Spanish costumes, some painted from members of a troupe of Spanish dancers then in Paris, and others from Victorine and members of his family dressed up. For Manet, like Watteau, had a number of costumes—especially Spanish costumes—as studio properties and nearly all his Spanish pictures were painted before he went

[1] Manet's picture, *Mme Manet au piano*, now in the Jeu de Paume, was painted about 1867. Whistler's *Piano Picture*, once in the collection of Sir Edmund Davis, London, was painted in 1859. Fantin Latour's *Autour du piano*, now in the Luxembourg, was painted in 1857; Renoir's *Jeunes filles au piano* (of which several versions exist) dates from 1891 ; his *Enfants de Catulle Mendès*, where three children are grouped round a piano, dates from 1888.

to Spain. In the same way the sitter for *Le Buveur d'Absinthe* was
not really an absinthe-drunkard but an out-of-work rag-and-bone
merchant whom Manet had picked up in the Louvre where the
poor wretch had gone for shelter on a cold day.

The outstanding pictures of this double series are *Lola de Valence*,
Victorine en costume d'Espada (Pl. 91b), *The Woman with a parrot*,
the *Young Man as a Majo*, the *Ballet Espagnol*, and *Le Vieux
Musicien*. At this period he also painted the octoroon, *Jeanne
Duval*, who played so strange a part in the life of Baudelaire. This
picture, which was never finished, is now, I believe, in Germany;
it represents the sitter in a white crinoline muslin dress lying on
a sofa with a white lace curtain as a background; it was pre-
sumably the source of Whistler's *Symphonies in White*, the first of
which was rejected by the Salon in 1863.

After his father's death in 1862 Manet became a man of com-
fortable though not large independent means. He married the
next year.

At the beginning of 1863 he held a one-man show of his pictures
in the gallery of a dealer named Martinet. The pictures were
violently abused by the critics ; *La Musique aux Tuileries* and *Lola
de Valence*, which both seem to us restrained and almost sombre
in colour, were described as offending by *un bariolage rouge, bleu,
jaune et noir*, though the *Lola de Valence* was then even less aggressive
in colour than it is to-day, because it had a plain grey background
which was afterwards changed to the *coulisse de théâtre* background
that now appears in it. Of this picture and *La Musique aux
Tuileries*, Paul de Saint-Victor wrote in *La Presse*: " *Imaginez
Goya passé au Mexique, devenu sauvage au milieu des pampas, et bar-
bouillant des toiles avec de la cochenille ecrasée, vous aurez M. Manet,
le réaliste de la dernière heure. Ses tableaux . . . sont des charivaris de
palette. Jamais on n'a fait plus effroyablement grimacer les lignes et
hurler les tons. . . . Son ' Concert aux Tuileries ' écorche les yeux,
comme la musique des foires fait saigner l'oreille.*"

The *Déjeuner sur l'herbe* (Pl. 90b) was painted in 1862-3, rejected
by the Salon in 1863, and shown in the *Salon des Refusés* of that
year. The Emperor and Empress led the way in the general con-
demnation of the picture which was described as an offence against
decency ; no one, it would seem, perceived that it was painted in
emulation of Giorgione's *Concert Champêtre* in the Louvre, or
noticed that Manet had taken the composition of the central part
of this picture from Marc Antonio's engraving, *The Judgement of
Paris*, after a drawing by Raphael, *The Judgement of Paris* (Pl. 90a).

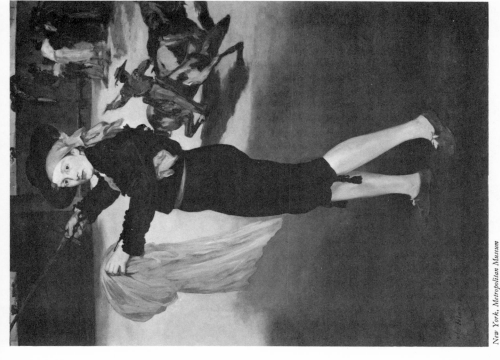

Paris, Jeu de Paume 91a. EDOUARD MANET: Le Balcon

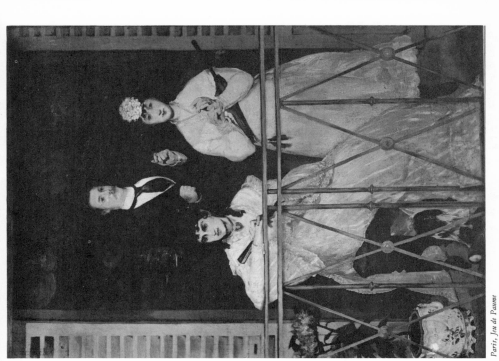

New York, Metropolitan Museum

91b. EDOUARD MANET: Victorine en costume d'Espada

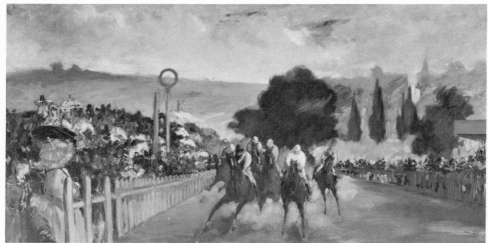

92a. EDOUARD MANET: Les Courses à Longchamp

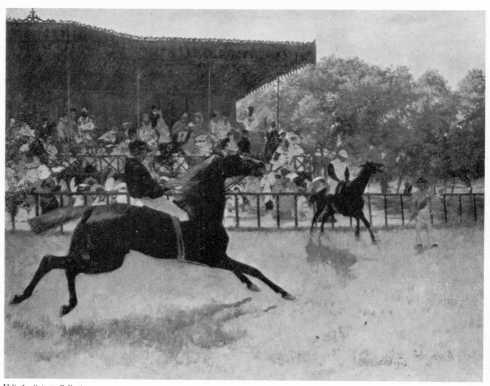

92b. EDGAR DEGAS: Le Départ

The *Dead Christ with Angels* was shown in the Salon of 1864; the *Jesus insulted by the soldiers* (Pl. 89) was in the Salon of 1865 together with the celebrated *Olympia*. The scandal of the *Déjeuner sur l'herbe* was repeated by the exhibition of these pictures, and the critics who supported the popular painters were violently hostile. Thus Saint-Victor wrote: "*La foule se presse, comme à la Morgue, devant 'l'Olympia' faisandée* (i.e. high, as of game) *et l'horrible 'Ecce homo' de M. Manet. L'art descendu si bas ne mérite même pas qu'on le blâme.*" . . . "*Ne parlons pas d'eux; regarde et passe.*"

Manet was much distressed by this hostile reception of his work; he particularly resented the suggestion disseminated by the popular painters that he was merely a vulgar self-advertiser seeking notoriety by the exhibition of an offensive nude. To escape from this persecution he went to Madrid, where he met Théodore Duret, who became one of his most faithful champions and friends.

In 1866, after his return from Spain, the Salon rejected *Le Fifre* and *L'Acteur tragique*, and about this time Manet sent two pictures —probably these two—to the Royal Academy in London which rejected them.

In 1867 he was not invited to exhibit at the *Exposition Universelle* and, like Courbet, he put up a shed and arranged fifty of his works as a private exhibition; hardly anyone went in, and none of the pictures were sold.

On the other hand, he had now won for himself a number of admirers, the critics Théodore Duret, Duranty and Théophile Thoré, and Emile Zola, who had written an enthusiastic article about his work, and lost his post as art critic to *L'Evènement* as a result. Zola's article contained the sentence: "*La place de M. Manet est marquée au Louvre. . . . Il est impossible—impossible, entendez-vous—que M. Manet n'ait pas un jour de triomphe et qu'il n'écrase pas les médiocrités timides qui l'entourent.*" This was considered so fantastic in 1866 that the editor thought his contributor was insulting his readers by "pulling their legs." Duret, who arranged to write articles without payment on the 1870 Salon in *L'Electeur Libre*, had to give an undertaking that if he praised Manet the praise must be *atténué et enveloppé de circonlocutions*.

These men and the artists who were about to form the Impressionist group used to frequent the Café Guerbois to meet one another, and especially to meet Manet, whom they all regarded as their leader.

Le Balcon (Pl. 91a) was in the Salon of 1869, and was greeted

literally with roars of laughter ; *Eva Gonzales*, a portrait for which Manet had forty sittings, had the same fate in the Salon of 1870.

This continued laughter at his pictures had a bad effect on Manet's nerves. As after the *Olympia* scandal, he was for the moment a little paranoiac, and in 1866 he quarrelled with Duranty, with whom he fought a duel.

There was no Salon in 1871, and during the war Manet served in the *garde nationale*, where his colonel was the Salon painter, Meissonier, who took no steps to make his acquaintance.[1]

He resumed work in 1872, and sent to the Salon *Le Repos* (a portrait of Berthe Morisot) which had the usual bad reception. But this picture was accompanied by *Le Bon Bock* representing a fat man, smoking a pipe, with a glass of beer in his hand. Pictures of fat men, especially of fat men eating or drinking, always appeal to Salon publics. This one was no exception to the rule, and Manet for the first time heard the Salon visitors make enthusiastic comments on his work.

Manet now found himself short of money ; in the thirteen years in which he had been practising as an artist he had only sold two or three pictures; he had overspent his income, especially at the time of his one-man show in the *Exposition Universelle*, when he had gambled on the hope of selling some works ; and his actual capital was now considerably reduced. This position was relieved when the dealer Durand-Ruel came to his studio and bought twenty-two pictures for thirty-five thousand francs. The pictures bought included four port scenes and *Victorine as an Espada* (Pl. 91b), *Le Fifre*, *L'Acteur tragique*, *The Woman with a parrot*, *La Chanteuse*

[1] Jean-Louis Ernest Meissonier (1815-1891), a genre painter, chiefly of *cortegaardjes* in the Dutch tradition, was a pillar of the Salons and the first French artist to receive the Grand Cross of the Legion of Honour. His work was much admired by Madame Sabatier to whom Baudelaire wrote the poem beginning :

> *Ange plein de gaîté, connaissez-vous l'angoisse,*
> *La honte, les remords, les sanglots, les ennuis*
> *Et les vagues terreurs de ces affreuses nuits*
> *Qui compriment le cœur comme un papier qu'on froisse ?*
> *Ange plein de gaîté, connaissez-vous l'angoisse ?*

Meissonier was a very short man who wore a very long beard. Mr. Walter Pach, the distinguished American art-critic, has described him as " a rancorous dwarf." In 1872 when Courbet was victimised on political grounds by the Thiers Government, Meissonier helped to make it impossible for him to pay the indemnity by urging the Salon Jury to exclude his work from all exhibitions. " He must be considered by us," said Meissonier, " as one dead."

des rues, Young Man as a Majo, Dead Christ with Angels, Le Ballet espagnol, and *Le Repos.* Durand-Ruel did not buy *Olympia, Le Déjeuner sur l'herbe* (Pl. 90b), *Le Balcon* (Pl. 91a), *Lola de Valence,* or *Jesus Insulted by Soldiers* (Pl. 89), which remained with at least a hundred other pictures in the studio.

This was Manet's position at the time of the First Impressionist Exhibition. He had only ten more years to live, and he was to hear again the Salon public's derisive laughter and to have his pictures again refused.

In addition to his figure subjects he had been painting, from the middle of the 'sixties, Impressionist seascapes, port scenes, scenes on the beach, at the races and so forth ; and he now began to use this Impressionist technique also for Salon pictures of outdoor scenes.

It must be clearly realised that Manet was the first to paint Impressionist scenes of daily life and that he was imitated by Monet and Degas in their early works. Manet painted his first racecourse pictures about 1864. In 1867 he painted a *Vue de l'exposition universelle* where we see people on horseback, a man watering a lawn, a boy with a dog, soldiers and so forth and a balloon in the air—a typical Impressionist sketch of the kind still considered dashing by Academy and Salon painters three-quarters of a century later ; he painted *La Plage de Boulogne* in 1869, *Le Port de Bordeaux* in 1871—a picture itself anticipated by Whistler's *Thames in Ice* which dates from 1862 ; *Les Courses à Longchamp* (Pl. 92a), now in the Chicago Art Institute, was painted in 1872, and in that year he painted the *Young Man on a Bicycle.* His *Croquet Party,* now in the Staedelsches Institut at Frankfort, dates from 1874. The first imitations of these pictures by foreign artists date from the 'eighties. Sir John Lavery's *Tennis Party,* formerly in the Munich Neue Pinakotek, was painted in 1885, two years after Manet's death.

Le Chemin de fer (New York, Metropolitan), shown in the Salon[N1] of 1874, and *Argenteuil* (now at Tournai), shown in 1875, were both outdoor (*plein air*) effects painted in the light colours favoured by the Impressionist group. The Salon painters and the Salon public were even more infuriated by these pictures than they had been by his earlier style. *Le Linge,* with its lovely light blues, so enraged the Jury of 1876 that they refused it ; and Manet had other pictures refused in 1877 and 1878, years in which he painted the charming *Paveurs de la rue de Berne* and *La Serveuse de Bocks ; Chez le père Lathuille* was derided in 1880.

But in 1881 the Salon Jury was once more reconstituted on the old plan of election by the votes of all the exhibitors of the past year, and the Jury thus elected gave Manet a medal for the strange picture, *Le Chasseur de lions*, exhibited in 1881. *Le Chasseur de lions* shows a huntsman kneeling with a dead lion behind him ; the model was posed, not in a forest, but among the trees in the Champs Elysées.

Thus Manet had to wait till two years before his death to secure the *hors concours* position which gave him the right to exhibit his pictures without interference from the Jury.

But by this time he was attacked by the paralysis to which he succumbed in 1883. He painted, nevertheless, before his death, some Impressionist landscapes (that were imitated by Sargent), *Jeanne—le Printemps*, a success in the Salon of 1882, and the celebrated *Bar aux Folies Bergères* (Pl. VIII). He painted his later pictures seated in a wheeled chair.

(b) Manet's Art

Manet was essentially a painter's painter. Like Chardin and Corot, he " amused himself " by painting. But whereas Chardin had " amused himself " with architectural exploration and Corot with an attempt to express a lyrical concept of landscape in photographic technique, Manet " amused himself " by concentrating on the actual handling of oil paint. He was the first artist to regard the practice of a particular *method* of oil painting as a vocation in itself. He was the inventor of the notion of " painting for painting's sake "—a notion elaborated by Walter Pater into the " æsthetic " doctrine which is still upheld in our own day by art critics of one school.

Manet's early pictures were all exercises in his chosen method of " direct " oil painting. He was attracted by effects noted in over-exposed photographs and tried to capture them in his personal method of oil painting. He mixed up on his palette a large lump of the general tone which he desired to be the final tone for each passage ; into this on his canvas he worked the minimum of shadows. He found dexterity in this procedure an enthralling " amusement."

In the subject-content of his pictures Manet took relatively little interest. He accepted the general doctrine of Realism, of which he heard a good deal from his friend Zola, and he painted subjects of everyday life. But he was not an original Romantic recorder of everyday life like Courbet or Daumier, Degas or Lautrec.

Nor was he an original descriptive recorder. He was purely a painter who happened to select this material to paint.

Le Déjeuner sur l'herbe (Pl. 90b) is in character simply an attempt to paint Giorgione's *Concert Champêtre* in his own technique, and it was for this reason that he was content to take the composition from the Marc Antonio engraving. For the *Concert aux Tuileries* he borrowed, as noted, a composition by Guys ; *The Execution of Maximilian, Victorine as an Espada* (Pl. 91b), *Le Balcon* (Pl. 91a), *Olympia*, and his pictures of Spanish bull-fighting, were all probably based on Goya's aquatints and on photographs of his pictures. I have not been able to discover what experience of Goya's work Manet actually had. There were no paintings by Goya in the Louvre in 1864 and the two portraits bequeathed by Guillemardet in 1865 were probably not exhibited there till 1866. Goya's *La Femme à l'éventail*, now in the Louvre, which would seem to have influenced the *Eve Gonzales*, was not acquired by the Louvre till 1898. The critic Thoré described Manet's early paintings as influenced by Goya ; but Baudelaire in the famous letter of 1864, in which he said that he himself had written phrases that occurred in Poe's works before reading Poe, stated categorically : " *M. Manet n'a jamais vu de Goya. . . . M. Manet n'a jamais vu la galerie Pourtalès. Cela vous paraît incroyable mais cela est vrai. . . . M. Manet, à l'époque où nous jouissions de ce merveilleux Musée Espagnol que la stupide République française, dans sa respect abusif de la propriété, a rendu aux princes d'Orléans, M. Manet était un enfant et servait à bord d'un navire. On lui a tant parlé de ses pastiches de Goya que, maintenant, il cherche à voir des Goya.*" Manet did not go to Spain, as noted, till the autumn of 1865 after the exhibition of his *Olympia*. It is, however, probable that he was acquainted either with Goya's *Maja vestida* and *Maja desnuda* (now in the Prado, Madrid) or with photographs of these pictures. Baudelaire makes obscure references to the pictures and to photographs of them in two letters dated May 14th and 16th, 1859, to the photographer Nadar, whom he urges to obtain or make photographs of the pictures (or copies of them) which it would seem were then in Paris and for sale for 2,400 francs. My own view is that Nadar did obtain photographs of these pictures and gave them to his friend Manet. About 1864 Manet painted a sketch, *Jeune femme couchée en costume espagnole* (Arnhold Collection, Berlin), which is based on the *Maja vestida* ; he gave this sketch to Nadar, possibly in exchange for the photographs. It was presumably Nadar who made the photograph of the *Olympia* which is pinned up on the wall in Manet's *Portrait of*

Zola now in the Louvre. The composition of Manet's *Le Balcon* is certainly based on Goya's *Majas of the Balcony*. Three versions of it now exist in private collections in Spain. There is no version in the Prado.

In his Impressionist sketches of outdoor scenes, such as *Les Courses à Longchamp* (Pl. 92a), where, as noted, he was the pioneer, Manet set the fashion for pictures that rival the effects of instantaneous photographs ; and when he painted such scenes in light colours he was influenced by the general Impressionist interest in the spectrum palette, itself an attempt to reduce perception to the vision which the camera would achieve if it could chronicle colour.

His pictures of the late 'seventies such as *Argenteuil* and *La Serveuse de Bocks* are photographic both in vision and composition. A good deal of the *Bar aux Folies Bergères* was possibly painted from photographs—(as was some of Degas' work).[1]

No one who has handled oil paints can fail to react to Manet's masterly technique in this medium ; and it is impossible to believe that the Salon painters did not deliberately shut their eyes to it from base motives when they encouraged ridicule of his *Eve Gonzales* in 1870, and rejected *Le Linge* in 1876.

Every painting by Manet has now been imitated ten thousand times. In *Le Buveur d'Absinthe* (Pl. 103b), his first picture painted just after he had copied the Velasquez *Cavaliers*, he used thin flowing colour in a technique which he never repeated. But this technique was imitated in all his full-length portraits by Whistler who was in Paris on and off from 1856 to 1863, and frequenting the Manet-Baudelaire circle. Whistler's various *Symphonies in White*, as noted, were all, I believe, the result of Manet's portrait of *Jeanne Duval*. The pseudo-Impressionist photographic pictures, now an Academic convention in all official exhibitions in Europe and America, are all debased imitations of Manet's original Impressionist explorations.

3 CLAUDE MONET

BORN PARIS 1840 DIED GIVENCHY 1926

Characteristic Pictures

| London | Tate Gallery | Plage de Trouville |
| London | Tate Gallery | Vétheuil—Sunshine and Snow |

[1] The relation of the camera's records to human perception and modern art is discussed in my book, *The Modern Movement in Art*.

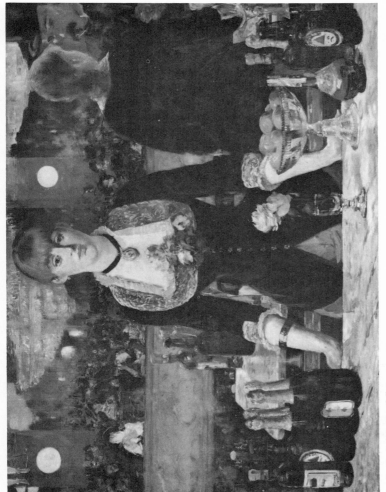

PLATE VIII

London, Courtauld Institute Galleries

EDOUARD MANET (1832-1883)
Le Bar des Folies Bergère

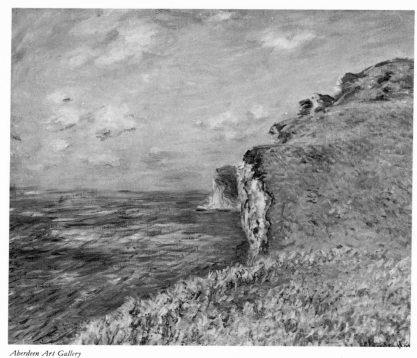

93a. CLAUDE MONET: La Falaise de Fécamp

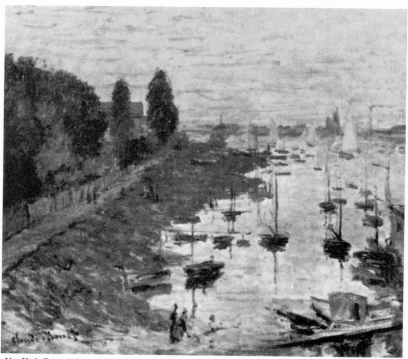

93b. CLAUDE MONET: The Seine

London	Tate Gallery	The Poplars
London	Tate Gallery	Water Lily Pond (Le bassin aux nymphéas)
London	Tate Gallery	Rouen Cathedral
London	Tate Gallery	Mme Monet in a park
London	Formerly Courtauld Collection	Juan-les-Pins
London	Formerly Courtauld Collection	The Seine at Vétheuil
London	Formerly Courtauld Collection	St. Lazare Station [N1]
London	Formerly Courtauld Collection	Vase of Flowers [N2]
Aberdeen	Art Gallery	La falaise de Fécamp
New York	Metropolitan Museum	The Green Wave
New York	Metropolitan Museum	La Grenouillère
New York	Metropolitan Museum	Sunflowers
New York	Metropolitan Museum	Poplars
New York	Metropolitan Museum	Haystacks in Snow
New York	Metropolitan Museum	The Ice Floe
New York	Metropolitan Museum	Water Lilies : (Nymphéas)
New York	S. Lewisohn Collection	The Seine [N3]
New York	S. Lewisohn Collection	Valley, Giverny [N3]
New York	S. Lewisohn Collection	Venice : (The Contarini Palace) [N4]
New York	S. Lewisohn Collection	Waterloo Bridge [N3]
Chicago	Ryerson Collection	Westminster [N5]
Chicago	Ryerson Collection	La Gare St. Lazare [N5]
Chicago	Art Institute	Argenteuil
Chicago	Art Institute	Boats in Winter Quarters, Etretat
Pittsburg	Carnegie Institute	The Seine at Lavacourt
Pittsburg	Carnegie Institute	Water Lilies : (Nymphéas)
Philadelphia	Fairmount Park	Amsterdam, Westchurch Tower
Philadelphia	J. G. Johnson Collection	Railroad Bridge
Merion	Barnes Foundation	Madame Manet Embroidering

Worcester (Mass.)	Art Museum	Waterloo Bridge
Worcester (Mass.)	Art Museum	Water Lilies (Nymphéas)
Detroit	Institute of Arts	Garden Scene
Minneapolis	Art Institute	Morning on the Seine
Paris	Jeu de Paume	Les Dindons
Paris	Jeu de Paume	Mme Monet
Paris	Jeu de Paume	La Charrette. Effet de neige
Paris	Jeu de Paume	L' Été : Femmes dans un jardin
Paris	Jeu de Paume	Zaandam
Paris	Jeu de Paume	Carrières-Saint-Denis
Paris	Jeu de Paume	Grosse mer à Etretat
Paris	Jeu de Paume	Le Pont du chemin de fer à Argenteuil
Paris	Jeu de Paume	Les Barques à l'ancre (Argenteuil)
Paris	Jeu de Paume	Les Tuileries
Paris	Jeu de Paume	Les Barques Régates à Argenteuil
Paris	Jeu de Paume	Le Bassin d'Argenteuil
Paris	Jeu de Paume	Les Voiles à Argenteuil
Paris	Jeu de Paume	Le Déjeuner
Paris	Jeu de Paume	Un Coin d'appartement
Paris	Jeu de Paume	La Gare St. Lazare
Paris	Jeu de Paume	La Seine à Vétheuil
Paris	Jeu de Paume	Le Givre
Paris	Jeu de Paume	Les Coquelicots
Paris	Jeu de Paume	Les Rochers de Belle-Isle
Paris	Jeu de Paume	Femme à l'Ombrelle
Paris	Jeu de Paume	La Cathédrale de Rouen : Temps gris
Paris	Jeu de Paume	La Cathédrale de Rouen : Soleil matinal
Paris	Jeu de Paume	La Cathédrale de Rouen : Plein soleil
Paris	Jeu de Paume	Nymphéas : harmonie verte
Paris	Jeu de Paume	Nymphéas : harmonie rose
Paris	Jeu de Paume	Vétheuil. Soleil couchant
Paris	Jeu de Paume	Londres, le Parlement
Paris	Jeu de Paume	L'Eglise de Vétheuil
Paris	Jeu de Paume	Champs de tulipes (Hollande)
Paris	Jeu de Paume	Self Portrait
Bremen	Museum	Camille, La Dame à la robe verte
Frankfort	Staedelsches Institut	Le Déjeuner sur l'herbe

(a) Monet's Life

Claude Monet was the son of a grocer of Le Havre. At the age of fifteen he started to draw caricatures and earn money by selling them from a shop window. Shortly afterwards he met Boudin who taught him to handle palette and brushes. At sixteen he competed for a Municipal Art Scholarship to take him to Paris ; he failed to get the scholarship, and in the following year he went to Paris on money saved from the sale of his caricatures. In Paris he worked in the studio of Troyon.

The next year he was due for military service. His parents offered to buy him out if he would give up painting. He refused, and served two years in Algeria.

In 1862 he was back at Le Havre painting on the coast with Boudin and Jongkind, a Dutch landscape and marine painter of the school of Corot and Boudin. At the end of the year his parents yielded to his determination to become a painter and provided funds for a course of instruction in Paris under Marc-Gabriel-Charles Gleyre, a Swiss painter who had had some Salon successes and was then directing an art school.

In Gleyre's studio Monet found Renoir, Sisley and Bazille; at the end of 1863 they left together—Sisley (whose father was then providing him with money), in a spirit of *camaraderie*, Renoir and Monet to try to earn their living.

Monet's enthusiasms at this time were for Boudin, Jongkind and Courbet. But in 1863 he saw Manet's one-man show at Martinet's and *Le Déjeuner sur l'herbe* in the *Salon des Refusés*; and a new enthusiasm for Manet began to drive out the others.

In 1865, when he was twenty-five, he had two marines accepted by the Salon; and he then painted his own *Déjeuner sur l'herbe*, a replica of which is now in the Staedelsches Institut in Frankfort. In 1866 he was taken to Manet's studio and saw the imposing array of unsold pictures which it then contained. He rushed back home and painted—it is said in four days—*Camille, La Dame à la robe verte*, now in the Bremen Museum. *Camille* was accepted by the 1866 Salon. In 1867 he painted *L'Été : Femmes dans un jardin* (now in the Jeu de Paume), which was rejected by the Salon; his pictures were again rejected in 1869 and 1870.

Shortly before the war he married and established himself at Argenteuil on the Seine. He was driven out by the German occupation in 1870 and travelled to Holland, where he accidentally discovered Japanese prints, and to London, where he painted the river and discovered Turner. On his London journey he was accompanied by Pissarro. After the war he returned to Argenteuil, and worked there and in Paris, with occasional visits to the coast, for the next few years.

From 1874 to 1886 he was associated, as noted, with the Impressionist exhibitions, and failed with the others to sell more than an occasional picture. In 1880 he had a completely unsuccessful one-man exhibition in a gallery on the Boulevard des Italiens belonging to Georges Charpentier the publisher, who has already

been mentioned as one of the few people who bought the Impressionists' work in the early days.

In 1883 Durand-Ruel arranged a one-man show of fifty-six of his pictures in an empty house on the Boulevard de la Madeleine. This exhibition was almost a success, and Monet, who had lived hitherto in real poverty, was able to acquire a country house at Giverny, where he lived for the remainder of his life.

The relative success of the 1883 exhibition was continued in shows organised by Durand-Ruel in 1886 in New York, and in 1887 in Boston, and in an exhibition which Monet held with the sculptor Rodin in the Galerie Georges Petit in 1889.

After 1891 Monet was a prosperous artist; and his pictures shown in one-man exhibitions in the 'nineties and the beginning of the present century were all applauded and bought by dealers and collectors.

In these later shows he exhibited paintings of *Haystacks* in sunlight at different hours of the day (1891), of *Rouen Cathedral* in different effects of light (1893), of *Poplars* on the Epte (1898), of *Vétheuil* seen across the river (1902), of the *Thames* near Westminster (1904), of *Venice* (1912) and of the water-lilies (*Nymphéas*) in his garden (1891 and 1909). From 1914 to 1918 he worked on a series of large decorative panels based on his *Nymphéas*.

In 1918, when he was seventy-eight, his eyesight failed. He died at eighty-six.

(b) Monet's Art

Before his marriage Monet painted mainly on the Normandy coast and occasionally in Paris. From 1874 to 1880 he painted mainly on the Seine, in Paris and on the coast. In 1880 he worked at Etretat, in 1882 on various parts of the Normandy coast. From 1883 onwards he worked at Giverny and also in 1884 at Bordighera, in 1885 and 1886 at Etretat, in 1886 at Belle Isle, in 1888 at Antibes, in 1889 at La Creuse, in 1892 at Rouen, in 1895 in Norway. He worked in Holland in 1870 and 1879, and in London in 1871 and between 1900 and 1908.

He did not develop his personal style till the beginning of the 'eighties when he was over forty. Till then his pictures were influenced by Boudin, Jongkind, Manet, Pissarro, Turner, Japanese prints, photographs and Renoir. His *Déjeuner sur l'herbe*, painted in 1866, was influenced by Manet's *Déjeuner sur l'herbe*, and by the forest landscapes of Courbet. Monet, who doubtless knew that Manet was emulating Giorgione's *Concert Champêtre*, tried

himself to emulate Van Loo's *Déjeuner de Chasse* (Pl. 49b). Monet's *Déjeuner sur l'herbe* was painted in the forest of Fontainebleau ; Van Loo's picture had been painted for Fontainebleau ; it was not nationalised or sold by Louis David's assessors, as they considered it worthless ; it remained rolled up in an attic till 1846, when it was taken to the Tuileries ; it was restored and transferred to the Louvre some years later. Monet's picture, which would seem to have been sequestered by his landlord for rent, was also rolled up and neglected for some time ; in 1868 Monet made the replica which is now in Frankfort ; the recumbent figure, based on the figure in the same attitude in Manet's picture, was painted from Bazille.

In his personal manner he concentrated on the problem of symbolising the perpetual movement of light. In so doing he eventually reduced the representation of specific forms to a minimum, and the formal content of his pictures to an architectural content of colour.

The colour itself was mainly restricted to the colours of the spectrum, as he was influenced by the scientific doctrine that we only perceive colour in terms of light, as it is seen by the camera. In practice this meant the dismissal of blacks and browns from the palette ; and much of the gaiety and charm of the colour in his pictures, and in those of Renoir and Sisley who adopted the same procedure, is due to the exclusion of those colours.

He painted many of his early pictures and the *Haystack* series entirely in the open air ; but about 1892 he realised—as all artists before him had realised—that it is not advisable to do more than sketch in the open air, because the violence of the light soon affects the eye, and it becomes impossible to know what the picture will look like when brought indoors. His *Rouen Cathedral* pictures and the *Thames* series were painted from windows ; after 1892 he worked over all his pictures in the studio.

I reproduce a fine example of his early work, *The Seine* (Pl. 93b), now in the Lewisohn Collection, New York ; and, as an[N1] example of his more personal work, *La Falaise de Fécamp* (Pl. 93a), now in the Aberdeen Art Gallery.

4 AUGUSTE RENOIR

BORN LIMOGES 1841 DIED CAGNES 1919

Characteristic Pictures

London	National Gallery	The Umbrellas (Les Parapluies)
London	Tate Gallery	At the Theatre (La Première Sortie)

London	Tate Gallery	Nu dans l'eau
London	National Gallery (Courtauld Collection)	In the Box (La Loge) [N1]
London	Formerly Courtauld Collection	La Place Pigalle
London	Formerly Courtauld Collection	Portrait of Vollard [N2]
London	Formerly Courtauld Collection	The Shoelace [N3]
London	Formerly Courtauld Collection	The Skiff (La Yole) [N4]
London	Formerly Courtauld Collection	Spring (landscape) [N5]
London	Sir Kenneth Clark Collection	La baigneuse blonde [N6]
London	Mrs. Chester Beatty Collection	Mother and Child (Femme allaitant son enfant)
New York	Metropolitan Museum	Mme Charpentier and her Children
New York	Metropolitan Museum, Havemeyer Collection	By the Seashore
New York	S. Lewisohn Collection	Mme Darras, 1871 [N7]
New York	S. Lewisohn Collection	Les canotiers à Chatou [N8]
New York	S. Lewisohn Collection	Les Vendangeurs [N8]
New York	S. Lewisohn Collection	In the Meadow [N9]
Washington	National Gallery	Odalisque
Washington	National Gallery (Chester Dale)	Little girl with watering can
Washington	Phillips Memorial Gallery	Le Déjeuner des Canotiers
Boston	Museum Fine Arts	Le Bal à Bougival
Cambridge, U.S.A.	Fogg Museum	Chez la modiste
Chicago	Art Institute	Circus Children
Chicago	Art Institute	Mme Clapisson
Chicago	Art Institute (Ryerson Collection)	Les Chapeaux d'été

Chicago	Mrs. L. Coburn Collection	Sur la Terrasse [N1]
Cleveland	Coe Collection	Le Pont Neuf
Minneapolis	Institute of Arts	Battledore and shuttlecock
Northampton (Mass.)	Smith College	Mme Maître
Merion	Barnes Foundation	Le Déjeuner
Merion	Barnes Foundation	Half-nude girl doing her hair
Merion	Barnes Foundation	Mother and Child
Merion	Barnes Foundation	Washerwoman and Child
Merion	Barnes Foundation	La Famille Renoir
Merion	Barnes Foundation	Three Girls at an embroidery frame, c. 1897
Merion	Barnes Foundation	La Promenade 1898
Merion	Barnes Foundation	Déjeuner sur l'herbe, c. 1909
Merion	Barnes Foundation	Le petit déjeuner, c. 1910
Merion	Barnes Foundation	Bathing Girls at play, c 1915
Philadelphia	Tyson Collection	Les grandes Baigneuses [N2]
Paris	Jeu de Paume	Bazille
Paris	Jeu de Paume	Mme Th. Charpentier
Paris	Jeu de Paume	Mme Georges Charpentier
Paris	Jeu de Paume	La Rose
Paris	Jeu de Paume	Paysage aux environs de Paris
Paris	Jeu de Paume	Mme Hartmann
Paris	Jeu de Paume	La Liseuse
Paris	Jeu de Paume	Le Moulin de la Galette
Paris	Jeu de Paume	La Balançoire
Paris	Jeu de Paume	Chemin montant dans les hautes herbes
Paris	Jeu de Paume	Les Bords de la Seine à Champrosay
Paris	Jeu de Paume	Jeunes filles au piano
Paris	Jeu de Paume	Portrait of Monet
Paris	Jeu de Paume	Boats on the Seine
Paris	Jeu de Paume	Jeune femme à la voilette
Paris	Jeu de Paume	At La Grenouillère
Paris	Jeu de Paume	Railway bridge at Chatou
Paris	Jeu de Paume	Algerian landscape
Paris	Jeu de Paume	Moss roses
Paris	Jeu de Paume	Jeune femme nue en buste
Paris	Jeu de Paume	Girl in green, reading
Paris	Jeu de Paume	Mme Stephen Pichon
Paris	Jeu de Paume	Girl in white, reading
Paris	Jeu de Paume	La fillette au chapeau de paille
Paris	Jeu de Paume	Jeune fille assise
Paris	Jeu de Paume	Gabrielle à la rose
Paris	Jeu de Paume	La Toilette : femme se peignant
Paris	Jeu de Paume	Mlle Colonna Romano
Paris	Jeu de Paume	Les Nymphs (two recumbent nudes and three bathing girls)
Paris	Jeu de Paume	Theodore de Banville (pastel)
Paris	Jeu de Paume	Torse de jeune fille au soleil

Paris	Paul Guillaume Collection	Gabrielle with the jewels
Paris	Paul Guillaume Collection	Au piano [N1]
Paris	A. Cortot Collection	Richard Wagner
Paris	Bader Collection	Ode aux Fleurs
Berlin	National Gallery	Les demoiselles Bérard
Cologne	Wallruf-Richartz Museum	Sisley and his Wife
Essen	Folkwang Museum	Lise
Frankfort	Staedel Museum	Le Déjeuner
Winterthur	O. Reinhardt Collection	Portrait of Chocquet
Moscow	Museum of Modern Western Art	Nude : (Anna)
Moscow	Museum of Modern Western Art	Mlle Samary (full length)
Moscow	Museum of Modern Western Art	La Tonnelle
Stockholm	National Museum	Chez la mère Antoine
Stockholm	National Museum	La Grenouillère
Stockholm	National Museum	Conversation
Tokio	Matsugata Collection	Parisiennes habillées en Algériennes

(a) Renoir's Life

Auguste Renoir was the central artist of the Impressionist group, and one of the greatest masters of the whole French school, if not, indeed, of European painting. His work was unequal because, as an essentially original artist, he was always in process of development. But he painted fine pictures at all periods and the works of his extreme old age, when his brush was strapped to his hand, are among the finest of all his productions.

Renoir was the son of a tailor of Limoges, who came to Paris and arranged for him to work as a painter in a porcelain factory. Later he managed to save enough money to enter Gleyre's art school in 1862. He left this atelier, as noted, with Monet and Sisley in the following year, at the age of twenty-one.

Between 1863 and the end of the Franco-Prussian war he shared the poverty of Monet, with whom he was all the time on terms of intimate friendship. In this period he made ends meet with occasional porcelain painting and other commercial work, and with a little assistance from his mother.

Between 1870 and 1878 his pictures were regularly rejected from the Salons and shown at the Impressionist exhibitions as

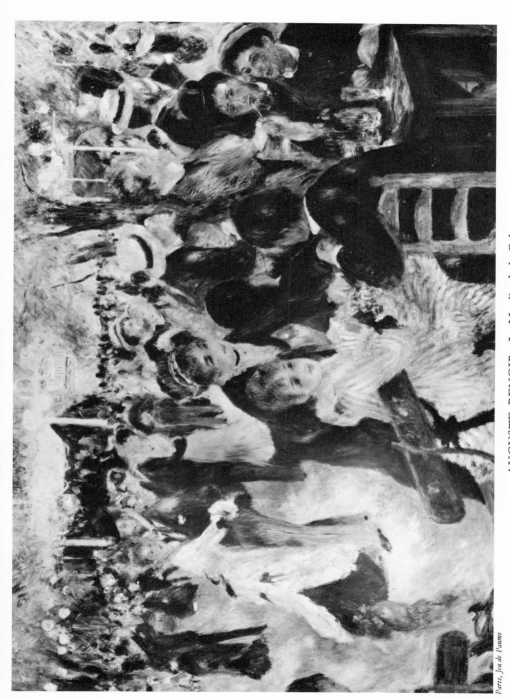

94. AUGUSTE RENOIR: Le Moulin de la Galette

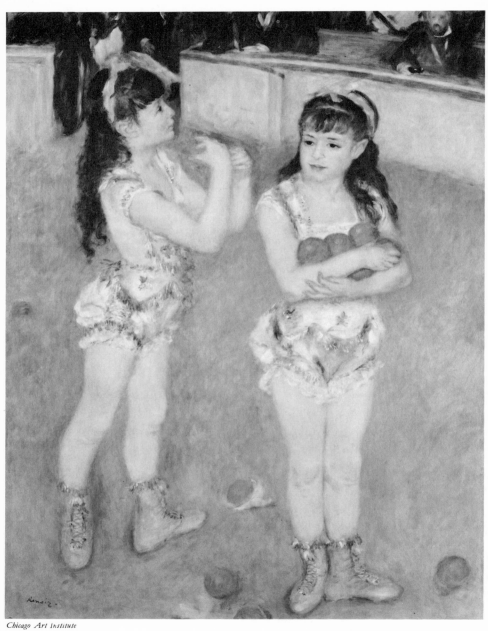

95. AUGUSTE RENOIR: Circus Children

noted ; in these years he sold pictures to Caillebotte and Chocquet and received support from Durand-Ruel.

In the 'seventies, also, he began to paint portraits, and this was his main source of income till the middle of the 'eighties. His chief patrons for portraits were the publisher, Charpentier, and Mme Charpentier, who procured him a number of commissions and insured by influence the exhibition in the 1879 Salon of his portrait of the actress, *Jeanne Samary* (Moscow Museum of Modern Western Art). The large group, *Mme Charpentier and her children*, painted in 1878, is now in the Metropolitan Museum, New York.

In 1880-1881 he went to Italy, visiting Rome, Venice, Naples and Palermo, where he painted a portrait of Wagner, for which Wagner sat only for half an hour.

On his way back to France he was attacked by the rheumatic gout, which was eventually to paralyse him, and he spent the early months of 1882 in Algeria in the hope of curing it.

When he returned to Paris he received commissions for ten portraits from a wealthy family named Bérard, which put him in funds. His group, *Les Demoiselles Bérard*, belongs to the National Gallery, Berlin.

In 1883 Durand-Ruel arranged a one-man show of seventy of his pictures in the empty house in the Boulevard de la Madeleine, to which I have already referred. From this time onwards he benefited by the growing appreciation of Impressionist pictures, and he made business arrangements with Durand-Ruel which enabled him to support himself and a wife and family without difficulty.

Soon after 1890 the rheumatic gout began to cripple him, and he established himself at Cagnes, in the Midi, where he remained for the rest of his life. In his last years he painted seated in a wheeled chair with his brush strapped to his hand which was contracted by arthritic gout.

(b) Renoir's Art

Renoir's earliest pictures, which he subsequently destroyed, were Romantic illustrations in the manner of the followers of Delacroix. He then worked through a moment when he was influenced by photographs ; of this *Lise*, which was in the Salon of 1868, and belongs to the Folkwang Museum at Essen, and *La Grenouillère* in Stockholm, are examples.

In the 'seventies he became a mature and personal artist, especially intrigued with the play of light. To symbolise this play of

light he banished black and brown from his palette and applied the colours of the spectrum to his canvas in small touches.

La petite fille à l'arrosoir, *La Place Pigalle*, *Circus Children* (Pl. 95), and *Le Moulin de la Galette* (Pl. 94), of which there are versions in the Louvre and in a private collection in America, are typical of his delightful painting at this period.

In the choice of subject at this period he was influenced by the Realism of Courbet, Manet and Zola, and he sought material in places where people foregathered for amusement. At the same time he painted some landscapes and began those studies of women and children and nudes that he was to continue all his life. He regarded portraiture at this period as a form of potboiling, and when painting portraits he concentrated on representation and likeness. But even so, he was able to impart considerable charm to most of his productions.

On his Italian journey he was impressed by Raphael and by Pompeian paintings, and he became dissatisfied with his own light touch. He decided to abandon painting out of doors and to seek linear rhythms and more architectural stability in his compositions. In order to master line, he worked on his return to Paris in an art school, and eventually he removed, for a time, the charming madder reds and spectrum colours from his palette and made efforts to paint severe pictures, with insistence upon drawing, in a range of colours restricted to red and yellow ochre, terre verte and black.

The *Femme allaitant son enfant* (Pl. 97a), in Mrs. Chester Beatty's collection, and *Les grandes Baigneuses* (Pl. 96), now in the Tyson[N1] Collection, Philadelphia, are two masterpieces produced as a result of the new orientation; both would hold their own in any collection of great pictures in the world. But the " tight," rather dry, manner which Renoir employed in these pictures was a great disappointment to amateurs who had just begun to appreciate the loose handling of the Impressionists and the photographic snapshot *tranche de vie* pictures which had been produced by Manet, who was now just dead, and by the artists who had followed him in this manner. George Moore wrote, about 1886 : " Some seven or eight years ago Renoir succeeded in attaining a very distinct and personal expression of his individuality. Out of a hundred influences he had succeeded in extracting an art as beautiful as it was new. . . . Then he went to Venice. . . . When he returned to Paris he resolved to subject himself to two years of hard study in an art school. For two years he laboured in a life class

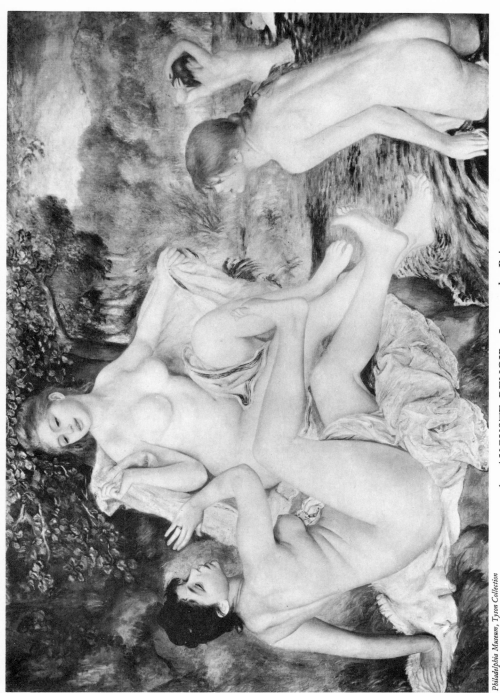

96. AUGUSTE RENOIR: Les grandes Baigneuses

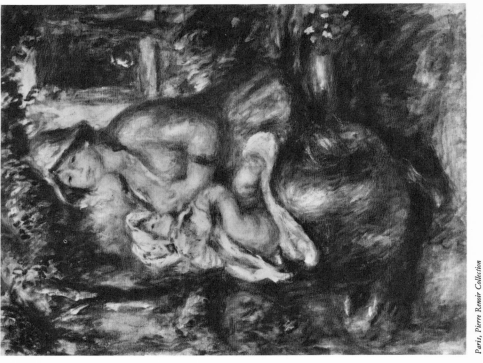

97a. AUGUSTE RENOIR: Femme allaitant son enfant

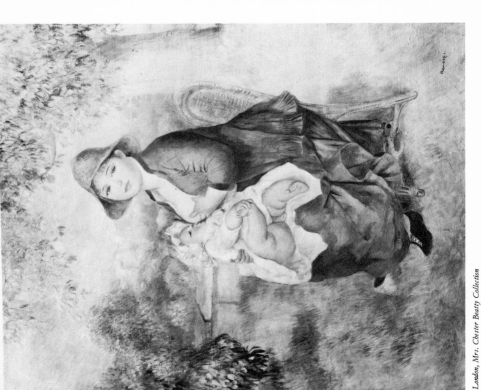

97b. AUGUSTE RENOIR: Femme allaitant son enfant

working on an average from seven to ten hours a day, and in two years he had utterly destroyed every trace of the charming and delightful art which had taken him twenty years to build up."

In point of fact the discipline to which Renoir subjected himself for the purpose of these pictures was of enormous service to his development. *La petite fille à l'arrosoir*, a thing of exquisite colour gradated to pale blues and pinks from the strong Prussian blue of the child's dress and the strong red of the poppies in the grass, is an enchanting picture; but if Renoir had merely repeated this for ever his work in the end would inevitably have become flimsy. After the Italian journey all his pictures show architectural qualities that gradually increase as the years go on.

When the " tight " manner had served its purpose Renoir abandoned it, and in the last years of the 'eighties and in the early 'nineties he sought and found a compromise between his early manner and the severe linear and architectural rhythms, of which he was now a master. *Les Chapeaux d'été*, now in the Ryerson Collection, Chicago, is an example of the works in which this compromise was achieved.

At the end of the 'nineties he painted versions of most of the " tight " pictures in the new manner of *Les Chapeaux d'été*. There is, for example, a version of *Femme allaitant son enfant* (Pl. 97b) which it is instructive to compare with the 1886 picture (Pl. 97a).

After his retirement to Cagnes he painted few " subject " or exhibition pictures, and very few portraits. All financial problems having been solved by his arrangements for selling his work, he was now free to paint " for his amusement." This he continued to do every day for the remaining twenty-five years of his life, and he concentrated ever more and more on the perception of monumental grandeur in simple material and on the animation of the picture surface into architectural colour. *Gabrielle with the jewels* (Pl. 98) is an example of his majestic painting about the age of seventy.

In the last period of all he reduced his palette to a few colours in which reds predominated; with his brush strapped to his hand he replaced manual agility by knowledge derived from sixty years' incessant study, and produced a large number of pictures in which abstract rhythms and architectural relations are the main preoccupation.

Renoir was thus one of the rare artists who continuously developed their conception of picture-making all through their

lives ; and this development corresponded to the general develop-
ment of the art of painting at the time. From 1868 to 1883 he
was a notable figure in the Impressionist-Realist movement. In
1885 and 1886, with *Les grandes Baigneuses* and *Femme allaitant son
enfant*, he arrived by his own efforts at the starting point of the
Cubist-Classical Renaissance as it was appearing, at that very
moment, in Seurat's *Baignade* and *Un Dimanche d'Eté à la Grande
Jatte* (Pl. 115), which were then being shown in the *Salon des
Indépendants*, where the new movement was launched. After 1900
he arrived again by his own efforts at solutions of the same problems
which preoccupied Cézanne.

But this development—though intensely interesting to students
of art history—is not sufficient in itself to rank Renoir among the
great masters. He enters that company (*a*) because this develop-
ment was accompanied by the power to make his work a microcosm
of which the great artists alone hold the secret, and (*b*) because he
achieved intuitively in a superlative degree that intimate contact
with root simplicities which, as already noted, is one of the
characteristics of the French genius.

For the last thirty years of his life he painted only women,
children and flowers ; but he was not a painter of particular
women, particular children, or particular flowers. He was a painter
—almost perhaps *the* painter—of *la femme, l'enfant* and *fleurs*. To
Renoir all women, all children and all flowers looked alike because
he perceived them generically. A nude figure by Renoir after 1884
is not a painting of a naked girl called Jeanne This or Henriette
That, but a pictorial symbol of the first woman and the last. A
flower piece by Renoir is not a painted imitation of a bunch of
blossoms, just picked by his servant in the garden, but a painted
symbol of the life that flowers convey.

There was a moment when the portrait painting by which, for
a time, Renoir had to earn his living almost decoyed him to a
habit of individual characterisation. We see this, for example, in
Le Déjeuner des Canotiers (Phillips Memorial Gallery in Wash-
ington), painted when he was much engaged with portraits. But
after 1884 he became a classical artist, and remained one to the end.

At the same time he was an artist who retained his contact with
sensual life. He was scarcely conscious of the classical nature of
his preoccupation. Immensely learned in the science of picture-
making, he remained to the last as simple as a child.

Renoir said, " *Chacun chante sa chanson s'il a de la voix.*" The
world has been deliciously enriched by the song that Renoir sang.

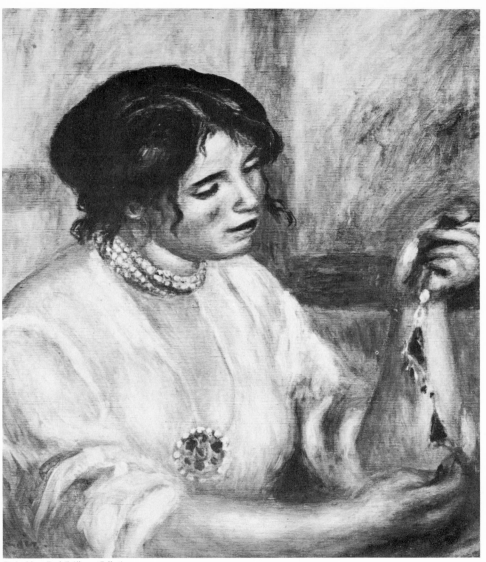

98. AUGUSTE RENOIR: Gabrielle aux bijoux

PLATE IX

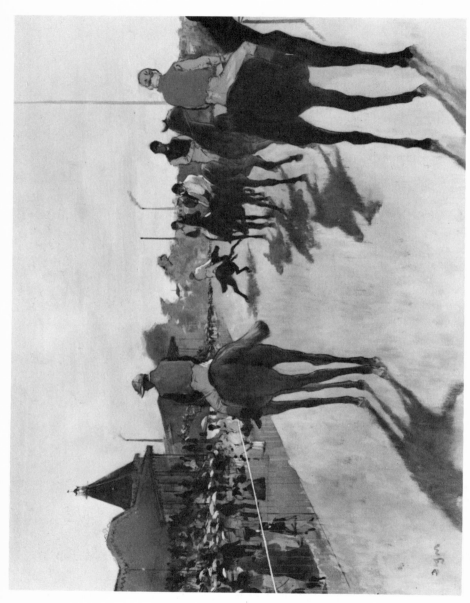

Paris, Jeu de Paum

EDGAR DEGAS (1834-1917) : Aux Courses

5 EDGAR DEGAS

BORN PARIS 1834 DIED PARIS 1917

Characteristic Pictures

London	Tate Gallery	Jeune Spartiates s'exerçant à la lutte
London	Tate Gallery	La Plage
London	Tate Gallery	Miss Lola at the Cirque Fernando
London	Tate Gallery	Danseuses
London	Tate Gallery	Carlo Pellegrini
London	Tate Gallery	Portrait of a woman
London	Tate Gallery	Head of a woman
London	Tate Gallery	Woman seated
London	Tate Gallery	La Toilette (pastel)
London	Tate Gallery	Nude figure in bed (pastel)
London	Victoria and Albert Museum	The Ballet in Roberto il Diavolo, 1872
London	Formerly Courtauld Collection	Deux danseuses sur la scène : La pointe [N1]
London	Formerly Courtauld Collection	Danseuses : Corsages jaunes (pastel)
London	Lord Ivor Spencer Churchill Collection	Femme s'essuyant (pastel) [N2]
Oxford	Ashmolean Museum	Two Women in a Café, *c.* 1879
Edinburgh	National Gallery of Scotland	Diego Martelli
Scotland	Sir William Burrell Collection	La Repetition
Scotland	Sir William Burrell Collection	Duranty (pastel)
Scotland	Cargill Collection	Le foyer de la danse à l'Opéra
New York	Metropolitan Museum	Woman with chrysanthemums
New York	Metropolitan Museum	L'Amateur d'estampes
New York	Metropolitan Museum	La Bouderie
New York	Metropolitan Museum	Danseuses à la barre
New York	Metropolitan Museum	Interieur
New York	Metropolitan Museum	La Modiste (pastel)
New York	S. Lewisohn Collection	Jules Finot [N3]
New York	S. Lewisohn Collection	Ballet Scene [N4]
New York	S. Lewisohn Collection	Etude pour Danseuse sur la scène [N5]

New York	S. Lewisohn Collection	Duranty (pastel) [N1]
New York	S. Lewisohn Collection	Danseuse dans sa loge (pastel) [N1]
New York	S. Lewisohn Collection	Femme Couchée (pastel) [N1]
Boston	Museum of Fine Arts	Chevaux de courses
Boston	Museum of Fine Arts	Voitures aux courses
Chicago	Mrs. L. L. Coburn Collection	Uncle and Niece [N2]
Washington	National Gallery (Chester Dale)	Achille de Gas
Washington	National Gallery (Chester Dale)	Mme Camus
Washington	Corcoran Gallery	École de danse (pastel)
Washington	Corcoran Gallery	Café chantant (pastel)
Washington	Corcoran Gallery	Les diseuses (pastel)
Washington	Corcoran Gallery	La loge (pastel)
Washington	Corcoran Gallery	Le Ballet (pastel)
Paris	Jeu de Paume	Le violoncelliste Pillet
Paris	Jeu de Paume	Self portrait
Paris	Jeu de Paume	La duchesse de Morbilli
Paris	Jeu de Paume	Giovanni Belelli
Paris	Jeu de Paume	La famille Belelli
Paris	Jeu de Paume	Sémiramis construisant Babylone
Paris	Jeu de Paume	Les Malheurs de la Ville d'Orléans
Paris	Jeu de Paume	Mlle Dihau au piano
Paris	Jeu de Paume	Avant le départ
Paris	Jeu de Paume	Portrait de famille
Paris	Jeu de Paume	L'Orchestre
Paris	Jeu de Paume	Le Foyer de la danse
Paris	Jeu de Paume	La femme à la potiche
Paris	Jeu de Paume	Le Pédicure
Paris	Jeu de Paume	A la Bourse
Paris	Jeu de Paume	Répétition d'un Ballet sur la scène
Paris	Jeu de Paume	Classe de Danse
Paris	Jeu de Paume	L'Absinthe
Paris	Jeu de Paume	La Danseuse au bouquet saluant sur la scène (pastel)
Paris	Jeu de Paume	Devant les Tribunes
Paris	Jeu de Paume	Aux Courses
Paris	Jeu de Paume	Les Repasseuses
Paris	Jeu de Paume	Après le bain (pastel)
Paris	Jeu de Paume	Le tub (pastel)
Paris	Jeu de Paume	Un Café, Boulevard Montmartre (pastel)
Paris	Jeu de Paume	Les Figurants (pastel)
Paris	Jeu de Paume	Danseuses montant un escalier

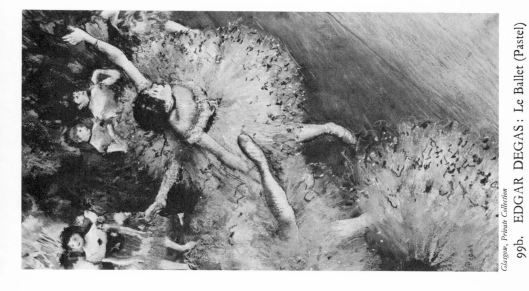

Glasgow, Private Collection
99b. EDGAR DEGAS: Le Ballet (Pastel)

London, Wallace Collection
99a. FRANÇOIS BOUCHER: Cupid a Captive

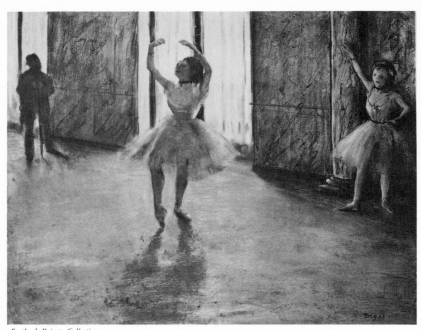

100a. EDGAR DEGAS : Le Foyer de la danse (Pastel)

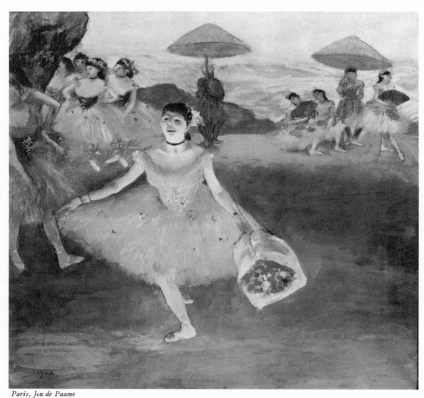

100b. EDGAR DEGAS : La Danseuse au bouquet saluant sur la scène (Pastel)

Paris	Jeu de Paume	Danseuse se massant la cheville gauche (pastel)
Paris	Jeu de Paume	Danseuse sur la scène (pastel)
Lyons	Museum	Aux Ambassadeurs (pastel)
Pau	Museum	Le Comptoir de Coton
Frankfort	Staedelsches Institut	Musiciens à l'orchestre
Stockholm	National Museum	Danseuses

(a) Degas' Life

Edgar Degas was the son of a French banker and a Creole mother from New Orleans. His father was a man of means, and Degas himself was always provided with money.

Degas was first educated for the Law, but found his vocation in 1855, at the age of twenty-one, when he entered the École des Beaux Arts. In 1856 he went to Italy, where he seems to have remained for two years. He visited, among other places, Rome and Naples.

On his return to Paris he painted history-pictures in the pseudo-classical Beaux-Arts tradition and exhibited them in the Salons; he also painted portrait groups and interiors influenced by Courbet and Fantin-Latour.

A few years before the war he began to frequent the Café Guerbois, where he met Manet and the other Impressionists and also the critic Duranty who eventually persuaded him to turn his back on the Beaux Arts and to join in the Impressionist movement of his own day.

In 1870 he served in the National Guard and in 1871 left Paris before the street fighting of the Commune. In 1873 he went to New Orleans where the family business had a branch in which he himself had an interest. He painted there *Le Comptoir du Coton* now in the Museum at Pau.

On his return he ceased to exhibit at the Salons, and contributed up to 1886 to most of the Impressionist exhibitions as already noted.

After 1886, at the age of fifty-two, he became a recluse and ceased to exhibit. He had a contract with Durand-Ruel to whom he delivered all his pictures. He never married. He worked incessantly in his studio in Paris till he died, in 1917, at the age of eighty-three. He was rather ill-natured, and he had a caustic wit.

(b) Degas' Art

When Degas was persuaded by Duranty to join the Impres-

sionist-Realist movement, he began by painting descriptive pictures of racecourses of which I reproduce *Aux Courses* (Pl. IX).

After the war he continued to record life in places where people foregathered for amusement. He sometimes worked in oil and sometimes in pastel. The brilliant pastel, *Aux Ambassadeurs* (Pl. 102) is typical of his finest achievements in this field.

But Degas was fundamentally a Romantic; he was intrigued by the unusually emotive fragment; he was less interested in generic than in individual and characteristic form; and he was fascinated by occupational gestures. In the second half of the 'seventies he concentrated on those studies of ballet dancers practising such as *Le Foyer de la danse* (Pl. 100a) and actually dancing on the stage, as in *La Danseuse au bouquet saluant sur la scène* (Pl. 100b) by which he is most widely known.

From 1875 to 1885 most of his work was concerned with the study of occupational gestures. In 1879 he painted *Miss Lola at the Cirque Fernando*, which shows a girl-acrobat hanging by her teeth above the heads of the spectators at the circus. *Les Repasseuses*, depicting women ironing shirts in a laundry, and *La Modiste*, are other examples. At this period he was also an observer of prostitutes; his pastel *Un Café, Boulevard Montmartre* (Pl. 101b) dates from 1877; he made studies in *maisons closes* in 1879.

At this time he also began a series of pastels of nude women at their toilet; and here he concentrated on the individual characteristic attitudes of his models.

We find a similar approach in the case of his portraits. Like the pastellist La Tour, he delighted in the marks which occupation and environment imprint on the physique, and in his portraits he always sought to present his sitters in their environment. *Diego Martelli* and *L'Absinthe* (Pl. 103a), which contains a portrait of the engraver Desboutins, are typical examples of his portraiture.

In his later years he continued the series of pastels of ballet dancers and the series of intimate female nudes.

Degas must be ranked as a Romantic-Realist; and he thus stands nearer to Courbet than to Manet and the Impressionists. But he also had a keen decorative sense and a delight in pictorial colour. He looked upon the life in the places where people foregathered for amusement as a new kind of social pageantry, which had replaced the pageantry of the old régime. Like the French painters of the eighteenth century, like Watteau and Boucher, he found in the performances at the theatre material for

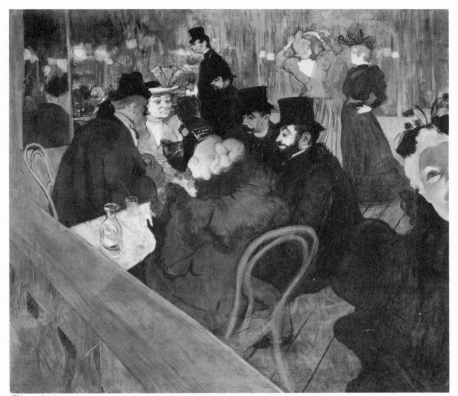

101a. H. DE TOULOUSE-LAUTREC: Au Moulin Rouge

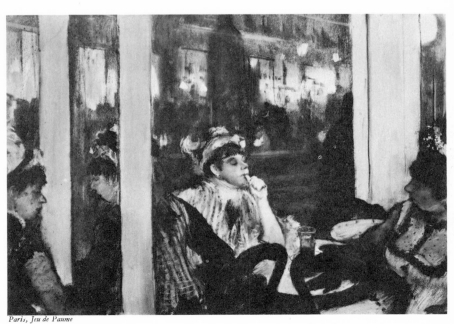

101b. EDGAR DEGAS: Un café, Boulevard Montmartre (Pastel)

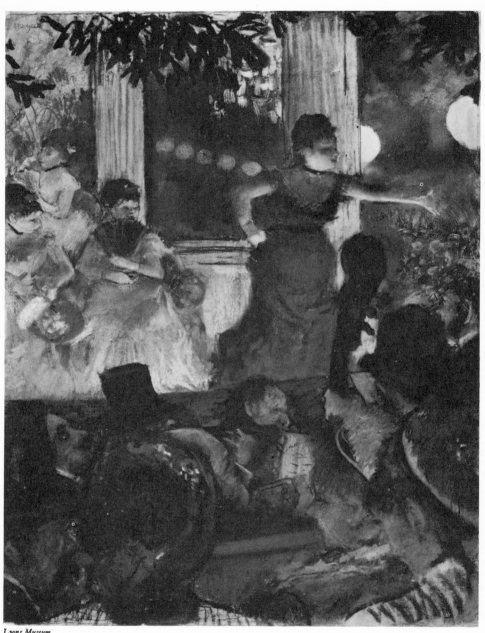

102. EDGAR DEGAS: Aux Ambassadeurs

decorative pageant painting, and in the eighteenth century he would have been continuously employed on decorations.

Degas was both a superb and a subtle colourist. *La Répétition*, in Sir William Burrell's collection, which is fundamentally an occupational record, is rendered decorative by exquisite disposal of the coloured sashes worn by the dancers ; *La danseuse au bouquet saluant sur la scène* is a sonorous harmony of earth-reds, greys and greens ; and in the later pictures the colour glows and burns with ever more glorious intensity. In a pastel like *Le Ballet* (Pl. 99b), drawn in 1890, Degas, in fact, arrived at a new type of picture as decorative, in its way, as Boucher's *Cupid a Captive* (Pl. 99a), which I reproduce on the same page.

In evolving this new type of decorative picture Degas used Japanese prints and photographs ; and all through his career he produced compositions in which the accidental effects of photographs were deliberately and most ingeniously exploited. He was fond, for example, of putting a large head or object in the foreground or cutting off half a figure by the frame.

At the same time we must realise that as a Romantic Realist he preferred an ugly characteristic face to a smooth pretty one, and limbs distorted by occupational abuse to the smoothly rounded limbs of the nymphs portrayed by Boucher. No French artist before the Romantic movement would have made the plebeian face of the dancer in *Le Ballet* the point of focus in a decorative scheme.

6 HENRI DE TOULOUSE-LAUTREC

BORN ALBI 1864 DIED MALRAMÉ 1901

Characteristic Pictures

London	National Gallery, Millbank	Femme assise
London	Courtauld Institute	Jane Avril leaving the Moulin Rouge
Oxford	Ashmolean Museum	La Toilette
Scotland	D. W. T. Cargill Collection	À la mie [N1]
New York	Mr. and Mrs. C. S. Sullivan Collection	La Rousse au jardin
New York	S. Lewisohn Collection	The Opera " Messalina " at Bordeaux [N2]
New York	S. Lewisohn Collection	Riding to the Bois [N3]

New York	S. Lewisohn Collection	La Liseuse [N1]
New York	Museum of Modern Art (Bliss Collection)	May Belfort singing
Brooklyn	Museum	La femme à la cigarette
Chicago	Art Institute (Birch Bartlett Memorial)	Au Moulin Rouge
Chicago	Art Institute (Birch Bartlett Memorial)	Danseuses sur la scène
Chicago	Art Institute	Au Cirque Fernando
Chicago	W. S. Brewster Collection	May Milton
Cleveland	Museum of Art	M. Boileau au café, 1893
Buffalo	Albright Art Gallery	La Rousse
Washington	National Gallery (Chester Dale)	Au bar. Alfred la Guigne
Washington	National Gallery (Chester Dale)	The Quadrille at the Moulin Rouge
Washington	National Gallery (Chester Dale)	Maxime de Thomas at the Opera Ball
Paris	Jeu de Paume	La Clownesse
Paris	Jeu de Paume	Paul Leclerq
Paris	Jeu de Paume	Baraque de la Goulue à la Foire du Trône (1) La Danse mauresque (2) La Danse au Moulin Rouge
Paris	Jeu de Paume	Alphonse de Toulouse-Lautrec conduisant son mail-coach à Nice
Paris	Jeu de Paume	La Femme au boa noir
Paris	Jeu de Paume	Le lit
Paris	Jeu de Paume	Jane Avril dansant
Paris	Jeu de Paume	Profil de Mme Lucy
Paris	Jeu de Paume	Louis Bouglé
Paris	Jeu de Paume	La Toilette
Paris	Mme Dortu Collection	Chilpéric
Paris	Mme Dortu Collection	May Belfort singing " Daddy wouldn't buy me a bow-wow "
Paris	Mme Dortu Collection	Au lit : Le Baiser
Paris	Mme Dortu Collection	La Goulue
Albi	Museum	Gueule de bois
Albi	Museum	Tenanciers de maison close
Albi	Museum	Le Blanchisseur de la Maison
Albi	Museum	Au Salon : rue des Moulins
Albi	Museum	L'Anglaise du Star au Havre

Albi	Museum	Deux femmes : Maison de la rue des Moulins
Albi	Museum	Yvette Guilbert : Les gants noirs (Project for a poster)
Albi	Museum	Un examen à la Faculté de Médecine
Albi	Museum	Soldat anglais fumant sa pipe
Prague	Gallery of Modern Art	Au Moulin Rouge : Les Deux Valseuses
Stockholm	Museum	La grosse Marie
Copenhagen	Carlsberg Museum	Suzanne Valadon
Copenhagen	Carlsberg Museum	M. Delaporte au Jardin de Paris

(a) Lautrec's Life and Work

Henri de Toulouse-Lautrec, who brought the Romantic-Realism of Degas to a climax, was a direct descendant of the Counts of Toulouse, and he could trace his family history from the thirteenth century. His father was an eccentric sportsman and amateur sculptor who modelled animals in clay ; his uncle was an amateur painter. He was born on the family estate at Albi ; and suffered from infancy with weakness of the bones. In childhood he met with accidents and broke both thighs ; he thus became a cripple with abnormally short legs.

As a young man he inherited his father's love of open-air sports and the traditional occupations of country gentlemen, and he began to paint pictures of horses, grooms and so forth before he was twenty. His *Alphonse de Toulouse-Lautrec conduisant son mail-coach à Nice* was painted when he was seventeen.

In 1882, when he was eighteen, he went to Paris and worked in the studio of Léon Bonnat for five years ; he then worked for a few months in the studio of Cormon.[1]

During these years he painted academic studies (the Stockholm Museum has *La grosse Marie* of 1884) and began to show his individuality in the portrait drawings of *Suzanne Valadon* and of Van Gogh, whom he met in 1886.

When he abandoned the art schools he shared with a friend a studio in Montmartre ; this was in a courtyard where Degas

[1] Léon Bonnat (1833-1922) was born at Bayonne, and spent his early years with his family in Madrid, where his father had a bookshop. In 1853 his father died and he returned to Paris, where he worked at the Beaux Arts and won a Prix de Rome. In his early work he was influenced by Fantin-Latour. Later he painted compositions of religious subjects and photographic portraits. His collection of pictures and many admirable drawings by the Old Masters and Ingres can be seen in the Musée Bonnat at Bayonne. Fernand Cormon (1845-1924) was a Salon painter of military and other " subject " pictures.

also had his studio; and he seems at this time to have made Degas' acquaintance. About 1887, when he was twenty-three, he made an arrangement with his family which secured him an independent income, and he took a studio of his own in the same region. In 1888 and 1889 he painted pictures of the *Cirque Fernando* and *plein air* and atelier studies of young women.

At this time he became a regular frequenter of the music halls, bars and dancing establishments of Montmartre and began his chronicles of the life he observed there.

In 1891 his cousin, Dr. Tapié de Celeyran, came to Paris to work in the Hospital International, founded by the surgeon Péan. Lautrec witnessed several operations and recorded them afterwards in pictures.

Between 1891 and 1896 he was at the height of his powers. His most brilliant studies of Montmartre habitués and music-hall singers date from these years. His output was prodigious. The grim café scene, *À la mie* (Pl. 103c) dates from 1891. *Au Moulin Rouge* (Pl. 101a) was painted in 1892. A series of studies of the Moulin-Rouge floor-dancers, La Goulue and Jane Avril, dates from 1892 and 1893. *Au bar : Alfred la Guigne* (Pl. 104), and the celebrated series of lithographs of Yvette Guilbert date from 1894. The May Belfort paintings, drawings and lithographs were produced in 1895. Yvette Guilbert herself appeared in 1890; Lautrec had been a delighted follower of her work, and made many sketches of her from the stalls; in 1894 he approached her with a proposal to design a poster; she was at first horrified by his productions and wrote him : " *Pour l'amour du ciel ne me faites pas si atrocement laide,*" but her intelligence and wit soon led her to recognise the merit of the dozens of drawings and lithographs which he devoted to recording her expressive gestures and grimaces, and the two artists eventually became friends. The most famous of the May Belfort studies depicts her singing, " Daddy wouldn't buy me a bow-wow."

At this period also he made drawings and paintings of the inhabitants of *maisons closes* (as Degas had done in 1879, and as Guys had done some twenty years before), and he decorated the interior of one of these establishments. He never publicly exhibited the *maison close* series, though they are technically among his finest paintings; they now can be seen in the Lautrec Museum at Albi.

In 1893 he exhibited thirty of his pictures in a gallery on the Boulevard Montmartre; none were sold; and, indeed, he was never able to sell his pictures at any period of his life. But he

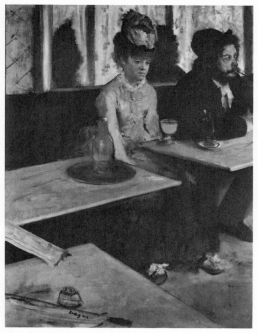

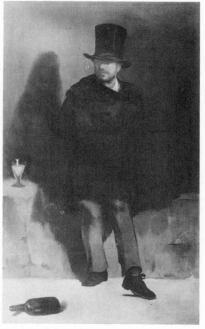

103a. EDGAR DEGAS: L'Absinthe

103b. EDOUARD MANET:
Le Buveur d'Absinthe

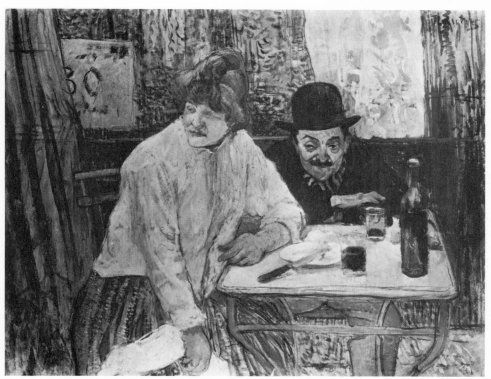

103c. H. DE TOULOUSE-LAUTREC: À la Mie

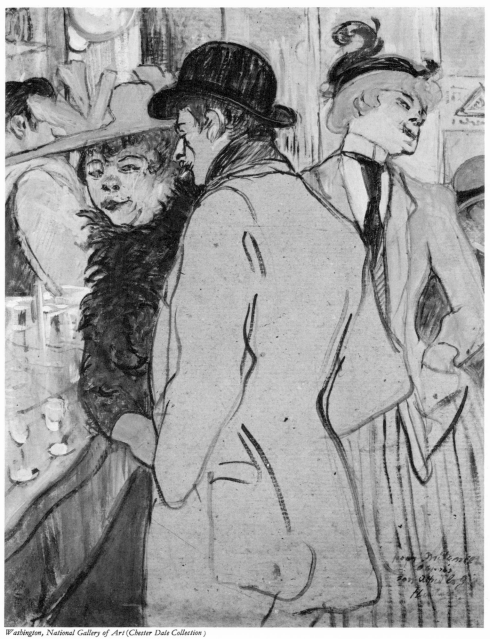

104.　H. DE TOULOUSE-LAUTREC: Au bar: Alfred la Guigne

made some money by his numerous lithographs, posters and illustrations.

Degas visited the exhibition on the Boulevard Montmartre. "*Ça, Lautrec, on voit que vous êtes du bâtiment,*" was his comment.

By 1895 Lautrec had begun to take too much alcohol, and some friend suggested to his father that he ought to go into a home. "Nonsense," replied the eccentric sportsman, "let him go to England where *tous les nobles s'alcoolisent.*" And to England he went several times between 1895 and 1898 ; there he associated mainly with Whistler and Conder and drank less, in fact, than he had been drinking in France. He was in London during the Wilde trial, and made a coloured drawing of Wilde after meeting him for a few minutes.[1]

In 1898 he had an exhibition in London at the Goupil Gallery, which created a *succès de scandale*, but was otherwise a failure. It had a bad Press ; the critic of the *Daily Chronicle* wrote : "M. de Toulouse-Lautrec has only one idea in his head—vulgarity."

At the end of 1898 he began to be affected by his alcoholic habits ; and in February, 1899, he had a serious nervous breakdown and was removed to a mental home. He recovered after a few days' abstinence from alcohol, and ten weeks later he was discharged by his doctors. In the home he produced fifty drawings and lithographs, including a series of circus subjects, and the oil pictures, *The Keeper* and *Inmates of the Home*, which can be seen at Albi.

In July, 1899, he went to Le Havre intending to sail to Arcachon. There he was attracted by an English barmaid at the "Star"— a low bar frequented by English sailors. From this girl he painted *L'Anglaise au "Star" du Havre* (now at Albi), a work comparable only with Hogarth's *Shrimp Girl* in the National Gallery in London. He returned to Le Havre in June, 1900, to recapture the barmaid, but without success, as we know from a letter which reads : "*Old chump. Les Stars et autres bars sont très surveillés par la police, rien à faire ; il n'y a plus de barmaids. . . . A toi, H. L. and Co. (tout ce qu'il y a de plus limited).*"

In April, 1901, he was back in Paris painting racecourse pictures, scenes at Armenonville, nudes, and *Un examen à la Faculté de Médecine* which is now at Albi.

In August, 1901, he felt his end approaching and joined his mother at the Château de Malramé in the Gironde. In September he died there at the age of thirty-six.

[1] This portrait is reproduced in my *Modern French Painters* (Faber).

(b) Lautrec's Art

Debarred by his infirmity from the open-air life and the pleasures of the world in which he was born, Lautrec sought the world of society's outcasts among whom, as an aristocrat, he could feel himself a king. By this world he soon became intensely fascinated. As a Romantic-Realistic artist he sought for ever closer contact with its realities. He cared little for the pageantry of lights and colours that had inspired Renoir to paint *Le Moulin de la Galette* (Pl. 94) and Degas to create his colourful decorations ; the vulgar little face in Degas' *Le Ballet* (Pl. 99b) was his *point de départ*, and he peered ever closer into the sordid drama that lay behind the glamour of the footlights and of the night haunts of Paris.

Guys in the 'seventies had already drawn the women of the dance halls performing the Can-Can. He had drawn them as generic figures moving forward with uplifted skirts like lovely vessels in full sail ; he had extracted architectural light and shade from the contrast of the white linen and the dark surrounding clothes. Lautrec drew these women as individuals ; they were so much individuals to him that he imbued them with the life, if not of historical personalities, with, at any rate, the life of the most vivid characters in fiction. No novelist has created a personality whom we see more vividly than Jane Avril. Lautrec has shown us her lean legs dancing, her scarlet lips parted in the dancer's smile, and the green shadows under the livid cheek-bones as she passed the gas lamp outside the dance hall when her work was done. In the same way he has shown us La Goulue, a woman of coarser mould who throned it in the Moulin Rouge for a brief moment, and then went steadily downhill.

Degas was a social recorder who made comments on occupational gesture as he drew. But his comments are mild and obvious compared with Lautrec's. Degas drew features and muscles distorted by occupation. Lautrec drew occupationally distorted souls.

I reproduce together Manet's *Le Buveur d'Absinthe* (Pl. 103b), Degas' *L'Absinthe* (Pl. 103a) and Lautrec's *A la mie* (Pl. 103c). Manet's picture of a dressed-up studio model is purely painting ; Degas has given us an environmental portrait ; Lautrec has portrayed a drama of the underworld that is hideous and true.

Lautrec was a very interesting colourist. He experimented with green shadows and achieved intriguing and sinister effects. He studied Japanese prints for his compositions, and from the Japanese he acquired a calligraphic line that he used ingeniously in his

attractive posters. As a poster designer he still stands, in fact, supreme. He is the father of the art as it is practised in Paris to this day.

After Lautrec's death, his mother presented numerous works remaining in his studio, together with some early works, to his native town ; they are now exhibited in the Palais Archiépiscopal. A visit to this museum is essential for the student of his work. *Au Salon : rue des Moulins,* a *maison close* picture, and the most important in the museum is, I think, his finest work.

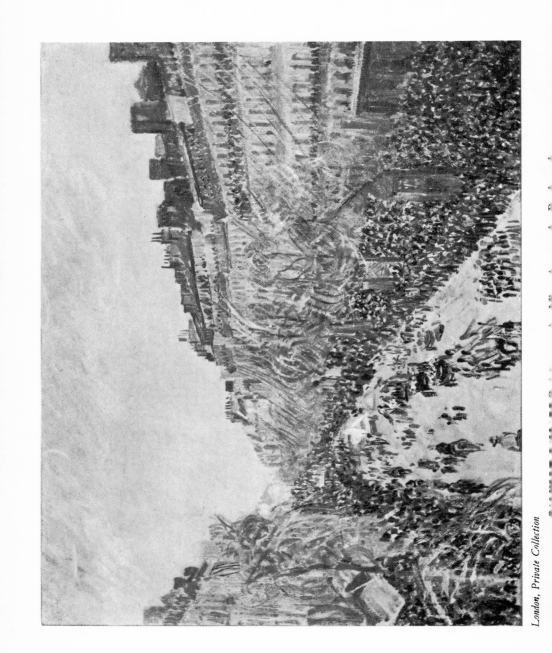

PART SEVEN

THE POST-IMPRESSIONISTS

THE POST-IMPRESSIONISTS

Post-Impressionism is a term of convenience used to describe the paintings by Gauguin and Van Gogh and by their followers and imitators. The works by the German imitators of these artists are described by German critics as "*Expressionismus*."

I have traced the growth of the vocational concept of the artist from Chardin, who gave up his lucrative figure painting to devote himself to still-life, and Corot, who was content to earn nothing and to be supported by his parents for sixteen years, to the Impressionists who braved hostile criticism and stuck to their experimental art. With Gauguin and Van Gogh the story takes on a new and more sinister aspect.

Gauguin abandoned a lucrative position in a bank, his wife and family, the society of artists and literary men, and the amenities of Parisian civilisation in a fanatical belief that popular painting could be regenerated and the photographic vision conquered by contact with primitive life in the South Sea Islands.

Van Gogh, who was always an *exalté*, poured his vitality, debilitated by years of hardship, with fanatical prodigality into his pictures. On the material side both asked of life nothing but the most meagre necessities ; and even these they were unable to earn regularly by their work.

Monet and Renoir had worked for twenty years in poverty before fortune began to favour them ; in those years they adjusted themselves to conditions, derived what they could from available amenities, and added nothing of their own volition to their hard fate ; after the tide turned they both painted in comfort for another forty years. Gauguin painted in all for only twenty years and Van Gogh for only eight ; both suffered, at certain moments, extremities of hardship unimagined by Monet and Renoir, who were merely poor, both tormented themselves also at the same time, and both eventually succumbed.

It is important to recognise that Gauguin and Van Gogh converted the vocational concept of the artist to a standard of fanaticism that society has no right to demand or even, perhaps, tolerate ; because the activity called art as pursued by these men was not only a vocation but also a prolonged and spectacular form of suicide.

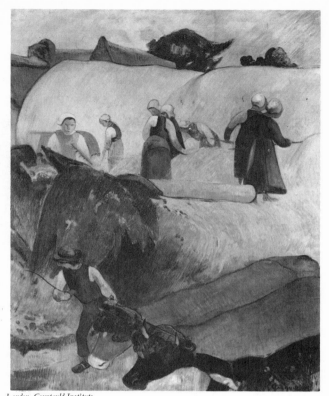

105a. PAUL GAUGUIN: Stacking Hay

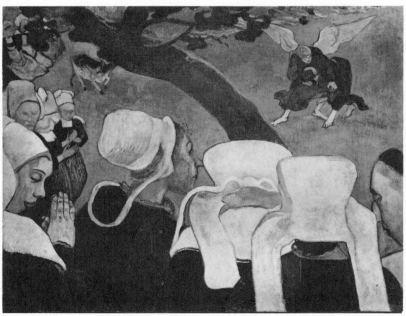

105b. PAUL GAUGUIN: Jacob wrestling with the Angel

PLATE XI

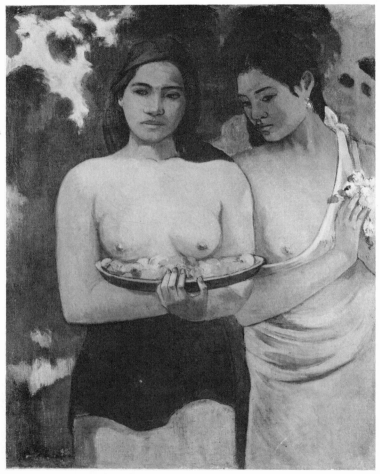

New York, Metropolitan Museum of Art

PAUL GAUGUIN (1851-1903)
Les Tahitiennes

Gauguin himself discovered this too late. *" La souffrance vous aiguise le génie,"* he wrote, *" il n'en faut pas trop cependant sinon elle vous tue."*

From the æsthetic standpoint the contributions of Gauguin and Van Gogh, which were made nearly sixty years ago, constituted at once the finale of the Romantic movement and the overture of the Cubist-Classical Renaissance. In Gauguin's colour we encounter the drums and trumpets of Delacroix, which have now taken on the timbre of the tom-tom and the reed pipe, and with the new timbre we get a less impetuous though not less compelling rhythm. In Van Gogh's passionate records of emotive fragments we get the spirit of Delacroix's *Death of Sardanapalus* keyed up to what is often an intolerable pitch. But both Gauguin and Van Gogh had contact with the pictorial concepts that created the Cubist-Classical Renaissance which was the real artistic movement of their day. They studied Japanese prints, and they were acquainted with Seurat and Cézanne. They were both conscious of the attempts that were being made around them to explore the emotivity of architectural relations of lines and colours, spaces and planes; they themselves made explorations in this field. But they were not temperamentally or intellectually equipped to regenerate European painting. They were both psychologically abnormal personalities who painted great autobiographical pictures at the price of their own lives.

2 PAUL GAUGUIN

BORN PARIS 1848 DIED MARQUESAS ISLES 1903

Characteristic Pictures

London	Tate Gallery	Tahitian group
London	Tate Gallery	Flower piece
London	Tate Gallery	Faa Iheihe (Tahitian group)
London	Courtauld Institute	Stacking Hay
London	Tate Gallery (Courtauld Collection)	Te Rerioa (Le rêve) [N1]
London	Tate Gallery (Courtauld Collection)	Nevermore [N1]
Edinburgh	National Gallery of Scotland	Jacob wrestling with the Angel
New York	Metropolitan Museum	Tahitian landscape

New York	Museum of Modern Art	Hina Tefatou (The Moon and the Earth)
New York	S. Lewisohn Collection	Ia Orana Maria (Ave Maria) [N1]
New York	S. Lewisohn Collection	Maternité [N2]
New York	S. Lewisohn Collection	The Bathers [N2]
New York	H. C. Goodyear Collection	L'esprit veille [N3]
Boston	Museum Fine Arts	D'où venons nous . . .
Chicago	Art Institute	Te Burao (Tahitian landscape)
Chicago	Art Institute (Birch Bartlett)	Mahana no Atua (The Day of the God)
Chicago	Art Institute (Birch Bartlett)	Tahitian portrait group
Chicago	Art Institute	Marie Henry
Worcester (Mass.)	Art Museum	Te Faaturuma : La Femme accroupie
Paris	Jeu de Paume	The Pont d'Iéna in Paris
Paris	Jeu de Paume	La Belle Angèle (Pont-Aven)
Paris	Jeu de Paume	Le Cheval blanc
Paris	Jeu de Paume	Femmes de Tahiti
Paris	Jeu de Paume	Still life
Paris	Jeu de Paume	Hay stacking in Brittany
Paris	Jeu de Paume	Arles Landscape (Les Alyscamps)
Paris	Jeu de Paume	" And the gold of their bodies "
Lyons	Museum	Nave nave Mahana (Jours delicieux)
Cologne	Wallraf-Richartz Museum	Riders by the Sea
Essen	Folkwang Museum	Contes barbares
Essen	Folkwang Museum	Le Christ Jaune
Copenhagen	Museum	Nude Woman Sewing
Copenhagen	Museum	Gauguin's family with a baby-carriage in a garden
Copenhagen	Museum	Garden in Snow
Copenhagen	Museum	Pont Aven in Spring
Stockholm	National Museum	Le Poldu
Oslo	National Gallery	Interior : Gauguin's home in Paris
Oslo	National Gallery	Exotic still life
Moscow	Museum of Modern Western Art	Tahitian pastoral with dog in foreground
Moscow	Museum of Modern Western Art	Nave Nave Moe. Tahitian pastoral
Moscow	Museum of Modern Western Art	Still life. Oiseaux des Isles

(a) Gauguin's Life

The story of Gauguin's life has been repeatedly told.
He was the son of a Parisian journalist and a mother of Creole

origin. In 1851 his father set off with his family to Peru and died on the journey. Paul lived at Lima with his mother for five years in a house where there were negro and Chinese servants and a lunatic chained up on the roof—a lunatic who once escaped and got into the child's bedroom. When he was eight he was brought back to Paris and educated in a Jesuit seminary at Orleans, where his father's brother lived. At seventeen he went to sea, and remained at sea till he was twenty-one. He then entered a financial house in Paris, where he succeeded and made money. In his spare time at this period he dabbled in painting and sculpture. He married a Danish girl in 1873.

A year or two later he met Pissarro and on his advice he began to collect pictures by the Impressionist group and bought two pictures by Cézanne. In 1880, 1881 and 1882 he was himself represented in the Impressionist exhibitions.

In 1883 he gave up his employment and his income and decided to find some post that would enable him to give more time to painting pictures. He looked for such posts in Rouen and in Denmark and found nothing. His wife then quarrelled with him; encouraged by her Danish relations she reproached him for throwing away his income for the senseless mania of painting pictures and the pleasure of posing as a Bohemian artist; in 1885 he left her in Denmark with four of their five children and took one boy with him to Paris.

There he was soon entirely without money and he got employment as a bill-sticker; then he was promoted to the office of the bill-sticking company and was able to paint in some spare time. In 1886 he contributed nineteen pictures to the last Impressionist exhibition.

Later in that year he went to Pont Aven in Brittany, where living was cheap. In 1887 he sold everything he possessed and sailed with an artist friend for Martinique, where he had heard that living was still cheaper; to earn money on the way he took on navvy's work at Panama. After a few months in Martinique his companion contracted fever and attempted suicide; and Gauguin brought him back to Paris.

In the early part of 1888 he was financed for a while by a friend of his old stockbroking days; and he began to take an interest in ceramics and mediæval stained glass. He also had a one-man show in a gallery, of which Van Gogh's brother Theo was manager, and sold a few pictures for small sums. In the summer he was in Brittany; from October to December at Arles with Van Gogh.

In 1889 he was again in Brittany, where he had financial assistance from the eccentric Dutch *littérateur*, Meyer de Haan ; in 1890 he began to share a studio with Daniel de Monfried, who remained his friend and confidant and helped him with money to the end.

At the beginning of 1891 he sold thirty of his pictures by auction, and made just under 10,000 francs. With this money and funds raised by a benefit performance and exhibition at the Théâtre des Arts, he went to Tahiti.

He remained in Tahiti on this first visit for two years.

In August, 1893, he returned to France to take up a legacy of 13,000 francs from his uncle at Orleans. He installed himself in a studio in Paris, where he dressed and entertained in a fantastic manner with a Javanese woman as his companion and attendant. Later in the year he exhibited forty-six Tahitian pictures and some carvings at the Durand-Ruel Gallery ; they caused a sensation, but very few works were sold.

In 1894 he went to Brittany with the Javanese woman and had his ankle broken in a brawl with some sailors. In that year also he contracted syphilis in Paris.

In February, 1895, he tried to sell the pictures from the Durand-Ruel exhibition by auction ; but few reached the nominal reserves ; later in the year with such money as he had made from this sale and what remained of the 13,000 francs he returned to Tahiti.

During this second period in Tahiti his disease grew upon him, and he lived in conditions of misery, continually quarrelling with the French officials, whom he accused of ill-treating the natives. In 1898 he tried to commit suicide.

In 1901 he left Tahiti and moved to the Marquesas Isles. There he began fresh quarrels of the same kind, and there he died two years later, at the age of fifty-five.

(b) Gauguin's Art

Gauguin did not become a really personal artist till he had been painting continuously for five or six years and on and off for ten. His early pictures were influenced by Pissarro and the Impressionists. The decisive year was 1888—the year when he studied mediæval glass.

The personal style appears in the pictures painted in Brittany in 1888, 1889 and 1890, such as *Jacob wrestling with the Angel* (Pl. 105b), *Le Christ Jaune*, *Stacking Hay* (Pl. 105a), the *Landscape with a red dog* in Mr. Maresco Pearce's collection in London, and *The*

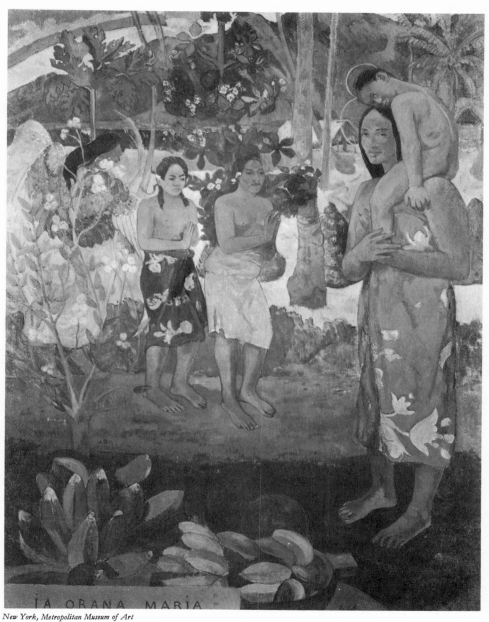

IA ORANA MARIA

106. PAUL GAUGUIN: Ia Orana Maria (Ave Maria)

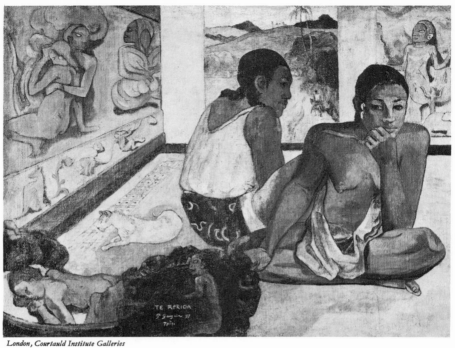

107a. PAUL GAUGUIN: Te Rerioa (Le Rêve)

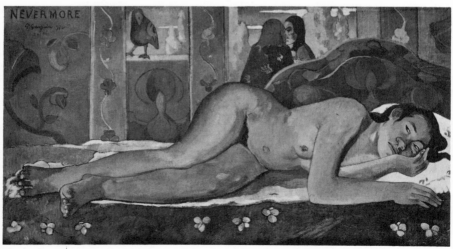

107b. PAUL GAUGUIN: Nevermore

Agony in the Garden formerly in the late Sir Michael Sadler's collection at Headington, near Oxford. It is fundamentally a decorative style appealing by rhythmic line and arbitrary colour; but in the religious pictures Gauguin has also tried to recapture the naïf directness of observation and imagination which he had observed in the stained-glass windows. In *Jacob wrestling with the Angel* we see the episode as it appeared to the Breton peasant women after a sermon in the village church; and Gauguin, partly to express this idea, has used the colours and, to some extent, the technique of the early glass designers.

In the first period at Tahiti Gauguin's sensibility was enriched by the experience of his new surroundings; he developed his style to symbolise tropical sunlight and shade and also what he conceived to be the primitive spirit of the natives; and the pictures which he painted on this first Tahitian visit are his finest productions. They include *Ia Orana Maria* (*Ave Maria*) (Pl. 106), and the great picture *L'esprit veille*. In the final period in the Marquesas the excitement of the contact with this non-European world had a little evaporated; and though the later pictures are often noble in design and superbly sonorous in colour, they are sometimes, in my judgement, less admirable, because less intense, than the earlier productions.

Gauguin, as I have said, made genuine and abnormal sacrifices for his painting. But there was also an element of the *poseur* in his constitution. Tall and handsome in a rather barbaric way he had a very conspicuous personality; he was vain and liked making an impression and creating a scandal. There was an element of mumbo-jumbo in all his Tahitian pictures, which was reinforced by the Tahitian titles which he frequently inscribed upon them. In the early works this element is incidental to the decorative splendour of the ensemble; in the later works it is a conspicuous constituent of the picture's content.

Gauguin's talent was essentially decorative. He was a magnificent colourist, an admirable designer and a master of flowing line. Like Degas, he would have found regular employment as a decorator in the seventeenth or eighteenth century in France. At the end of the nineteenth century he could not find employment; and the task of regenerating European painting, which he set himself, was accomplished by two men with more brains, more patience and more humility—Georges Seurat and Paul Cézanne.

3 VINCENT VAN GOGH

BORN GROOT-ZUNDERT 1853 DIED AUVERS 1890

Characteristic Pictures[1]

London	Tate Gallery	Sunflowers
London	Tate Gallery	The Chair with the pipe
London	Tate Gallery	Landscape with corn and cypress trees
London	Tate Gallery	View at Auvers
London	Tate Gallery	Grass with butterflies
London	Formerly Courtauld Collection	Landscape at Arles [N1]
London	Courtauld Institute	Self-portrait with the bandaged head
Edinburgh	National Gallery of Scotland	Olive Trees
New York	Museum of Modern Art	The Starry Night
New York	Chester Dale Collection	Marcel Roulin [N2]
New York	Chester Dale Collection	Girl in a striped dress (La Mousmé) [N2]
New York	S. Lewisohn Collection	L'Arlésienne (Mme Ginoux) [N3]
Buffalo	Albright Art Gallery	La Maison de la Crau [N4]
Buffalo	Albright Art Gallery	Landscape near Saint-Rémy [N4]
Chicago	Art Institute (Birch Bartlett)	Montmartre
Chicago	Art Institute (Birch Bartlett)	Van Gogh's Bedroom at Arles
Chicago	Art Institute (Birch Bartlett)	La Berceuse (Mme Roulin)
Chicago	Art Institute (Birch Bartlett)	Still life. Melon, Fish, and Jar
Detroit	Institute of Arts	J. McNeill Reid in a straw hat
Philadelphia	Barnes Foundation	The Factory
Philadelphia	Barnes Foundation	The Postman Roulin
Philadelphia	Barnes Foundation	Le Lupanar (La salle de café)
Buffalo	Albright Gallery	Landscape near Saint Rémy
Paris	Jeu de Paume	La Guingette
Paris	Jeu de Paume	Restaurant de la Sirène à Joinville
Paris	Jeu de Paume	Still life
Paris	Jeu de Paume	Gipsy caravans
Paris	Jeu de Paume	The Painter Boch
Paris	Musée Rodin	Le Père Tanguy
Amsterdam	Municipal Museum	Carnations
Amsterdam	Municipal Museum	Montmartre

[1] Van Gogh painted several versions of some of his important pictures. The student should consult J. B. De La Faille *Vincent Van Gogh*, London and Toronto (1939) which has a complete catalogue.

Holland	V. W. Van Gogh Collection[1]	The Potato Eaters
Holland	V. W. Van Gogh Collection	Still life with Bible
Holland	V. W. Van Gogh Collection	View of Montmartre
Holland	V. W. Van Gogh Collection	Self portrait at his easel
Holland	V. W. Van Gogh Collection	Orchard in Blossom (triptych)
Holland	V. W. Van Gogh Collection	Van Gogh's house at Arles
Holland	V. W. Van Gogh Collection	Gauguin's chair
Holland	V. W. Van Gogh Collection	Pietà (after Delacroix)
Holland	V. W. Van Gogh Collection	Crows flying over a cornfield
Holland	V. W. Van Gogh Collection	Stormy Landscape, Auvers
Otterlo	Kröller-Müller Museum[2]	Night café at Arles
Otterlo	Kröller-Müller Museum	Drawbridge with washerwomen
Otterlo	Kröller-Müller Museum	The Postman Roulin
Otterlo	Kröller-Müller Museum	La Berceuse (Madame Roulin)
Otterlo	Kröller-Müller Museum	Les Alyscamps, Arles
Otterlo	Kröller-Müller Museum	The Ravine
Otterlo	Kröller-Müller Museum	The Good Samaritan (after Delacroix)
Essen	Folkwang Museum	Armand Roulin
Essen	Folkwang Museum	Harvest, Saint-Rémy, 1889
Essen	Folkwang Museum	Hospital garden at Saint-Rémy
Frankfort	Staedelsches Institut	Doctor Gachet, 1890
Copenhagen	Museum	Mountain landscape at Saint-Rémy
Stockholm	Museum	The Haystacks

(a) Van Gogh's Life

The story of Van Gogh's life has been told and re-told. Stripped of the dramatisation the following would seem to have been the facts.

[1] Mr. V. W. Van Gogh, Theo Van Gogh's son, has a large collection of his uncle's works. [2] The Kröller-Müller Museum, formed as a private collection, also has a large collection of Van Gogh's paintings.

He was the son of a Protestant pastor of Groot-Zundert in Holland. In 1869, at the age of sixteen, he was put to work in the picture-dealing firm of Goupil at The Hague, with which his uncle was connected. Four years later he went to the firm's branch in London where he fell in love with a girl who was engaged to someone else. In 1875 and the early part of 1876 he worked in the firm's branch in Paris. Then he left or was dismissed.

In the summer of 1876 he went again to England and worked as a schoolmaster at Ramsgate and at Isleworth near London. He was now a religious zealot and did some lay preaching among the poor.

In 1877 he returned to Holland to train as a minister of the Gospel. He was impatient to begin service and did not complete his training.

In 1878 he procured some work as a lay preacher among the miners of the Borinage in Belgium. The missionary society which employed him disapproved of his fanatical asceticism and at the end of 1879 they dispensed with his services.

After some months of misery and frustration during which he tried to orient himself by reading Shakespeare, Dickens, Victor Hugo, Michelet and *Uncle Tom's Cabin*, he decided to become an artist. His brother Theo, who was in the Goupil firm in Paris, encouraged and financed him; and thereafter he was financed by Theo all his life.

Van Gogh began to draw continuously in 1880 at the age of twenty-seven. In 1881 he fell in love with a cousin, a widow; she refused to have anything to do with him. In 1882 he worked for a time under Anton Mauve (1838-1888), a Dutch follower of Corot.

In 1882 also he established a simple household with a street-woman whom he hoped to regenerate. He left her the next year and went to Nuenen, a village in Brabant, to which his parents had moved. He remained at Nuenen till 1885, when he went to Antwerp.

In this period he paid visits to the Rijks Museum in Amsterdam and to the gallery in Antwerp.

In 1886, when he was thirty-three, he went to Paris and established himself with Theo. There he met Gauguin, Lautrec, Pissarro and Seurat, and as a result of these contacts he became the artist that we know.

In February, 1888, he went down to Arles in Provence. He was joined there in October by Gauguin.

In December he had an attack of madness and cut off his ear. After this he went into the local hospital. Gauguin, when Theo arrived to make arrangements, went back to Paris.

Van Gogh recovered from this fit almost immediately. (He never became chronically insane.) After a few days he was discharged from the hospital.

In February, 1889, he resumed work in the little yellow house where he had lived for the past year. The older Arlesians made light of his attack; but the idlers and the school children began to treat him as the village idiot; they collected outside his windows and teased him into violent rages. Finally, the Mayor was petitioned, and in March Van Gogh was taken to the local lunatic asylum where he continued to paint his pictures.

In May he went to an asylum at Saint-Rémy. He was allowed to paint in his room and in the garden; he was allowed also to go out and he painted in the neighbouring country, between brief fits of madness that descended upon him periodically. Theo sent him prints after Delacroix, Rembrandt, Millet, Doré, all sorts of artists, and when he was not allowed out Van Gogh painted pictures from these prints—(not copies but improvisations in colour on the basis of the prints' designs).

In May, 1890, he left Saint-Rémy, visited Theo in Paris, and then placed himself under the care of Dr. Gachet at Auvers. Dr. Gachet collected pictures by the Impressionists and also by Gauguin and Cézanne with whom he was acquainted. He was a man who believed he understood artists. At Auvers, Van Gogh had complete liberty, and in Dr. Gachet he found a genuine admirer of his pictures. There he painted landscapes and Dr. Gachet's portrait; and there, in July, he shot himself.

(b) Van Gogh's Art

Van Gogh was a man who had little education and scarcely any culture. He was always addle-pated; and the amorous and other frustrations of his early manhood contributed to the confusion of his brain. Moreover, he was always excessive in his enthusiasms and his sacrifices. He entirely lacked the sense of what the French call *la mesure*—the quality that creates the even *tempo* in the work of Poussin and Chardin, Renoir, Seurat and Cézanne.

He did not become an artist of consequence till he had contact with Gauguin, Lautrec and Seurat in Paris. Till then he had made genre drawings and painted gloomy pictures influenced by Millet and the Dutch popular nineteenth-century artists. His early work

has intensity because in this period of frustration it represented a channel of release for his inhibitions. If Van Gogh had died in 1885 we should rank him as a minor Romantic-Realist—if we chanced to be acquainted with his name.

In his early work he asked art to help him towards that contact with humble life which he had sought in his missionary activities. At Nuenen he was a kind of hysterical Louis Le Nain.

When he met Seurat he was persuaded that man's architectural conscience was as real as any other aspect of his spirit, and that the painter's business was to acquire a language that would achieve contact with that aspect of man's spirit. Van Gogh accepted this new concept of the painter's function, though he was temperamentally incapable of architectural creation as it was understood by Seurat. In Paris he cleared the browns and greys from his palette and painted *La Guingette* and *Le Restaurant de la Sirène*, where we see the Impressionism of Pissarro and Monet stiffened on the one hand by Seurat's doctrines, and rendered on the other more intense by Van Gogh's temperament and vision. At this time also he painted *Le Père Tanguy*, the artist colourman who was then storing most of Cézanne's pictures. In Van Gogh's picture Tanguy is seen in a short jacket and peasant's hat against a background of Japanese prints. The background is significant because Japanese prints contributed a great deal to the development of Van Gogh's art.

When Van Gogh went to Arles, he suddenly had direct contact with forms of simple happiness which, he recognised, were as fundamental as the misery of the Borinage and the gloom of his early years. Here men were not all frustrated. They lived simply, drank wine, made love without tears, and were burned brown by the sun. To this harassed Northerner the sun of the Midi was a continual intoxication ; in Arles the pores of Van Gogh's skin opened, the sweat poured out, and he felt for the first time in his life a peaceful and a happy man. He worked with the energy that can only come in such conditions. He painted all day, every day. He worked in shadeless places, in the hottest hours, and he frequently went out without a hat. When he had his first attack and cut off his ear, his Arlesian friends, Roulin, the postman, and his wife (*La Berceuse*) and Mme Ginoux, the café keeper (*L'Arlésienne*), ascribed his illness to sunstroke.

Nearly all Van Gogh's enormous *œuvre* was painted between March and December, 1888. In the excitement of his new experience he forgot all about Seurat and invented his own method to

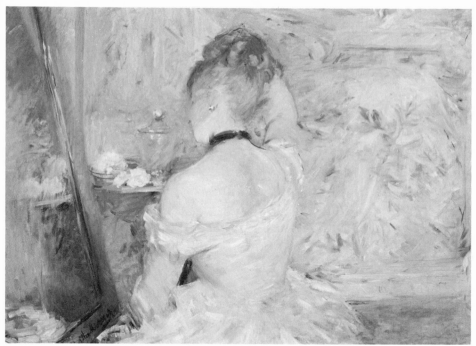

108a. BERTHE MORISOT: La Toilette

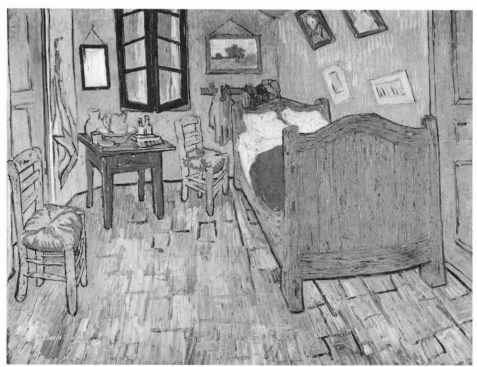

108b. VINCENT VAN GOGH: Van Gogh's Bedroom at Arles

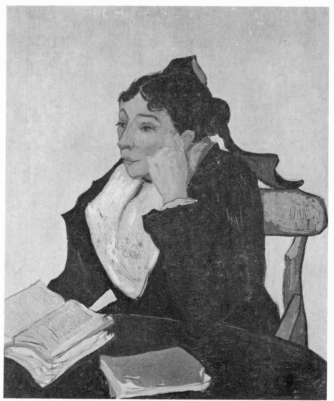

109a.　VINCENT VAN GOGH: L'Arlésienne

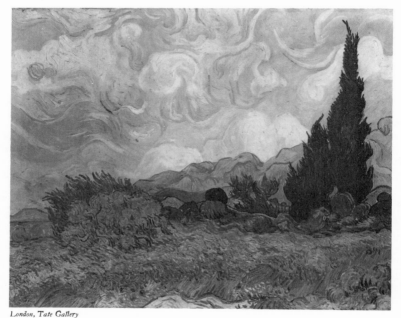

109b.　VINCENT VAN GOGH: Landscape with Cypress Trees

symbolise the vitality that poured into him from the glorious south. He broke right away from the Impressionists, and completely abandoned the photographic vision. He used colours as agents producing emotive associations, and used them for this reason in their fullest intensity. The blue of the sky in *Van Gogh's House at Arles* is deliberately forced to extreme emotive pitch; the yellows in the *Sunflowers* are pitched up for the same reason and in the same way. Blue for Van Gogh was not a colour—it was the sky. Yellow was not a colour—it was sun itself.

At the same time he retained the emotive handling of his Paris period and increased it—not in the Romantic way to stress his own emotional condition at the moment of painting, but in order to symbolise the throb and pulse of life.

In this spirit and in this technique he painted the picture known as *Van Gogh's Bedroom at Arles* (Pl. 108b), which has the qualities of the celebrated *Chaise à la pipe*. I reproduce *Van Gogh's Bedroom at Arles* on the same page as Berthe Morisot's *La Toilette* (Pl. 108a) to point the distance which Van Gogh travelled from Impressionism when he surrendered his frustrated being to the south.

When Gauguin arrived, Van Gogh was reminded not of Seurat, of whom Gauguin thought nothing, but of the claims of decoration and of Japanese prints. The figure in *L'Arlésienne* (Pl. 109a) is silhouetted against the background like the figures in the prints behind *Père Tanguy's* head. The background is a brilliant lemon yellow; the chair is scarlet; the table-cloth is green; the front book is scarlet; the open book has a scarlet edge; the white of the pages and of the woman's scarf is a pale bluish green; the woman's hair and dress are deep Prussian blue. There is the whole atmosphere of Arles in this amazing picture—all its curious stillness, its vitality that seems to have roots in the Forum, and its searching light. Van Gogh's terrific desire to achieve contact with his subject also comes out in the portrait characterisation of this picture.

Van Gogh's debt to Gauguin appears also in *La Berceuse* and the picture titled *Gauguin's Chair*. But it is seen most clearly in the last pictures which he painted at Auvers. In Arles he was so profoundly stirred, so furiously eager to penetrate his surroundings, that he rarely paused to co-ordinate his pictures into linear rhythms. At Auvers, where the sun was milder and the atmosphere more calm, his art became more rational. The lines swirl and dance, it is true, in a kind of ecstasy, and the colour is more than ever arbitrary and symbolic; but the dance obeys a rhythm,

and the lines are lines of growth. His last pictures are among the best organised and the most controlled.

It is, however, essential to recognise that Van Gogh's best pictures are what they are because he destroyed himself to paint them. They set a standard of intensity which no artist who respects his sanity can dare to rival or repeat.

PART EIGHT

THE CUBIST-CLASSICAL RENAISSANCE

THE CUBIST-CLASSICAL RENAISSANCE

I CHARACTER OF THE MOVEMENT

I have discussed the Cubist-Classical Renaissance in my books *The Modern Movement in Art* and *Modern French Painters*. Here I need only indicate its salient features and some outstanding dates.

Speaking generally the movement in its first phase was a revolt against the Romantic-Realist attitudes of the nineteenth century; and in its technical aspects it was a revolt against photographic and Impressionist procedures in painting. At the same time it was an effort—and a most amazingly successful effort—to create classical pictures based on the concept that Architecture is the Mother of the Arts.

This Renaissance took form between 1884 and 1900. The pioneers were Renoir, whose *Grandes Baigneuses* (Pl. 96) was painted in 1885, and Seurat, whose *Un Dimanche d'été à la Grande Jatte* (Pl. 115) dates from the same year. Seurat continued with a series of pictures exhibited between 1884 and 1890 at the Salon des Indépendants, of which he was one of the founders in 1884. Cézanne had begun to work on the classical basis about 1877, and he arrived at the climax of his classical manner about 1895 when he was approaching sixty.

The movement has brought about a regeneration of the art of painting. In 1880 it looked as though the camera had destroyed the faculties of perception and imagination in European painters. France seemed to have nothing to look forward to but an endless succession of Fantin-Latours and Bonnats producing black-and-white photographs in oil colours, and of Manets painting Kodak snapshots in a formula of pinkish-yellows for the lights and blues for the shadows. Since 1900 except in circles devoted to official academic painting (which is now mainly pseudo-Impressionist painting) we have about us an art that has abandoned competition with the camera and is concerned instead with problems of design in structural or organic form.

2 PAUL CÉZANNE

BORN AIX-EN-PROVENCE 1839 DIED AIX-EN-PROVENCE 1906

Characteristic Pictures[1]

London	Tate Gallery	Rocky Landscape, Aix
London	Tate Gallery	Self portrait
London	Tate Gallery	Bathers (four male figures)
London	Tate Gallery	The Gardener
London	Lord Ivor Spencer Churchill Collection	Self portrait with felt hat
London	Lord Ivor Spencer Churchill Collection	Bathers (six male figures)
London	Formerly Courtauld Collection	L'Amour en plâtre [N1]
London	Formerly Courtauld Collection	L'homme à la pipe [N1]
London	Formerly Courtauld Collection	Les Grands Arbres [N1]
London	Courtauld Institute	Le lac d'Annecy [N1]
London	National Gallery (Courtauld Collection)	La Montagne Sainte-Victoire [N1]
London	Formerly Courtauld Collection	Still life. Le Pot de Fleurs [N1]
London	Courtauld Institute	Les Joueurs de Cartes (two figures) [N1]
New York	Metropolitan Museum	La Colline des Pauvres
New York	Metropolitan Museum (Havemeyer)	Man with a straw hat
New York	Metropolitan Museum (Havemeyer)	L'Estaque
New York	Metropolitan Museum	Landscape with Mont Sainte-Victoire
New York	Metropolitan Museum (Havemeyer)	Still life

[1] Since the first edition of this book L. Venturi has published his *Cézanne* (two vols. Paris 1936), where the student will find a complete catalogue of the paintings. My list above names only some of the works which have special relation to my text. For books on Cézanne's life and personality the student is referred to the Bibliographic Note in my *Modern French Painters*.

New York	Metropolitan Museum (Havemeyer)	Rocks—Forest of Fontainebleau
New York	Chester Dale Collection	Louis Guillaume [N1]
New York	S. Lewisohn Collection	Still life (Primula, apples and drapery) [N2]
New York	S. Lewisohn Collection	L'Estaque [N3]
New York	S. Lewisohn Collection	Mme Cézanne [N4]
New York	S. Lewisohn Collection	Head of L'oncle Dominique [N5]
New York	Museum Modern Art	L'homme au bonnet de coton [N6]
Philadelphia	Museum	Sainte-Victoire from the Louves
Washington	National Gallery (Chester Dale)	Still life with liqueur and water bottles
Washington	Phillips Memorial Gallery	La Montagne Sainte-Victoire
Washington	Phillips Memorial Gallery	Self portrait
Merion	Barnes Foundation	More than forty examples
Chicago	Art Institute	The Bay from L'Estaque
Cleveland	Museum	The Pigeon Tower
Paris	Jeu de Paume	La Maison du Pendu
Paris	Jeu de Paume	Les Joueurs de Cartes (two figures)
Paris	Jeu de Paume	Seven still-life pictures
Paris	Jeu de Paume	L'Estaque
Paris	Jeu de Paume	Self portrait
Paris	Jeu de Paume	The poplars
Paris	Pellerin Collection	Portrait of Gustave Geffroy [N7]
Paris	Pellerin Collection	Les Grandes Baigneuses [N8]
Paris	Formerly Vollard Collection	Portrait of Zola
Paris	Formerly Vollard Collection	Portrait of Vollard
Paris	Formerly Vollard Collection	Les Joueurs de Cartes (five figures)
Hollywood	E. G. Robinson Collection	Still life with black clock : (La pendule noir) [N9]
London	Lord Rothschild Collection	Harlequin
Paris	Doucet Collection	La Femme au chapelet
Paris	Doucet Collection	Paysage avec rochers
Lausanne	C. F. Reber Collection	Le Garçon au gilet rouge
Lausanne	C. F. Reber Collection	Mme Cézanne in a striped blouse

| Lausanne | C. F. Reber Collection | Jeune homme à la tête de mort (Le Philosophe) |
| Moscow | Museum of Modern Western Art | La Montagne Sainte-Victoire and nineteen others |

(a) Cézanne's Life

Paul Cézanne was the son of a hat manufacturer of Aix-en-Provence, who later became a banker and a man of means. He was trained for the law but soon discovered his artistic bent. In 1863, when he was twenty-two, it was decided that he would adopt painting as his profession and that his father would make him an annual allowance of 3,600 francs. He received this allowance (equivalent to rather more than £300 a year in English money of to-day) for twenty-three years. At the end of that time when he was forty-six he was still unable to support himself by his pictures ; he had hardly, in fact, sold anything at all.

At an art school in Paris Cézanne met Pissarro ; he saw Manet's *Déjeuner sur l'herbe* at the *Salon des Refusés*, and later met Manet himself, Renoir, Monet, Sisley and Bazille. Zola, who was also an Aixois, was already his friend.

In 1866 he submitted pictures (which have now disappeared) to the Salon ; the pictures were rejected, and he wrote to the Surintendant des Beaux Arts demanding a new *Salon des Refusés*, but without result.

In 1867 he saw the one-man shows of Courbet and Manet in the *Exposition Universelle*.

He spent some time every year with his family at Aix and in 1870 when war broke out he was staying at his father's country farm house, *Le Jas de Bouffan*, and painting landscapes. He remained in the south throughout the war, painting at, among other places, L'Estaque on the bay opposite Marseilles.

In 1872 he returned to Paris. In the summer of that year and of succeeding years till 1877 he painted landscapes near Paris—at Auvers, Pontoise and Saint-Ouen-l'Aumone.

At Auvers he worked a good deal in the company of Pissarro and there too he met Dr. Gachet already mentioned in connection with Van Gogh. *La Maison du pendu*, now in the Jeu de Paume Museum, was painted at Auvers in 1872.

In 1873, as already noted, he sent *La Maison du pendu* to the first Impressionist exhibition, and in connection with that exhibition he met Chocquet whose portrait he painted in the following year. Chocquet was the first collector to appreciate his work (and

by 1899 he owned thirty-three of his paintings including the *Mardi Gras* and *La Maison du Pendu*).

Cézanne did not contribute to the second Impressionist exhibition of 1876, but in 1877 he sent his portrait of Chocquet to the third, and painted several portraits of his mistress who frequently sat to him and was later his wife.

After 1877 he no longer exhibited with the Impressionists; from 1878 to 1889 he worked almost exclusively in the Midi, and only one of his pictures was publicly shown in Paris—a portrait which he sent to the Salon in 1882.

In 1886 his father died leaving him a third of 1,200,000 francs and various property. Between 1877 and 1889 he stored his pictures in Paris with the artist-colourman Tanguy (Van Gogh's *Père Tanguy*), who showed them to artists and amateurs. Tanguy apparently had permission to sell the pictures on a fixed scale, 40 francs for the small sizes and 100 francs for the large ones. Very few were sold; but Duret bought some about 1879 at these prices. In 1889 one of Cézanne's pictures was shown at the *Exposition Universelle*. It was lent by Chocquet, who refused to lend other things which the Committee wanted unless it was accepted. In the exhibition the picture was " skied."

By 1889 his name had quite dropped out of artistic life in Paris; his work was under-rated by the Impressionist leaders and it had not yet been discovered by the new generation of the Salon des Indépendants. In that year he returned to Paris and between 1890 and 1894 he worked there, at Fontainebleau, and at Aix; he also made a journey to Switzerland where he was not moved to paint. The well-known pictures (one with seven figures in the Barnes Foundation at Merion, one with five and several with two) called *Les Joueurs de Cartes* date from this period. *L'homme à la pipe* was painted from one of the peasants who sat for these pictures.

In 1892, when Cézanne was fifty-three, the dealer, Ambroise Vollard, began to take an interest in his pictures; appreciative articles by the critic Gustave Geffroy began to appear in the papers; and Cézanne's work began to be discussed in Parisian art circles. In 1895 he painted the *Portrait of Gustave Geffroy* (Pl. 111) and began *Les grandes Baigneuses* (Pl. 113b). Vollard opened a shop in the rue Laffitte to exhibit and sell his pictures; and the Luxembourg Museum refused three bequeathed by Caillebotte.

The superb picture *Le Lac d'Annecy* (Pl. 112a) was painted in 1897. In 1899 he finally retired to Aix, where he remained (with a short visit to Paris in 1904) till his death in 1906.

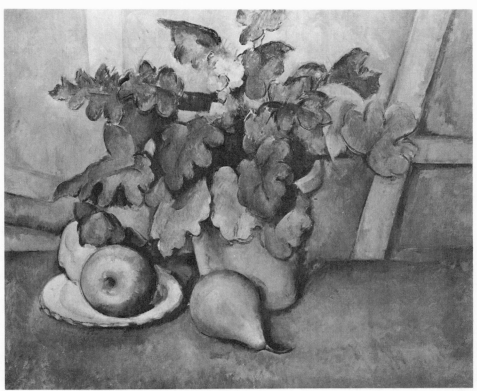

110a. PAUL CÉZANNE: Le Pot de Fleurs

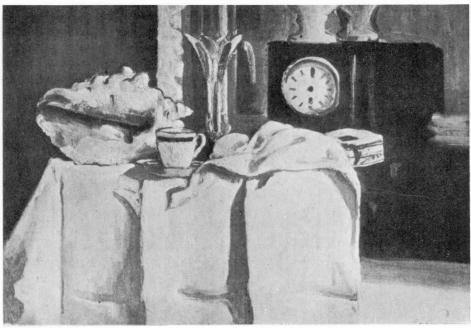

110b. PAUL CÉZANNE: Still life with a black Clock

111. PAUL CÉZANNE: Gustave Geffroy

In 1899, when he was sixty, he was persuaded by the artists of the Salon des Indépendants to exhibit two still-life pictures and a landscape ; he exhibited in that Salon also in 1901 and 1902. In 1904 the Salon d'Automne allotted a room to his pictures ; his portrait of the critic *Gustave Geffroy* was in the Salon d'Automne in 1905. A retrospective exhibition was held in the Salon d'Automne in 1906. Since then his fame has steadily increased especially in the United States where the museums and private collections have many of his finest works.

(b) Cézanne's Art

Cézanne n'était qu'un lamentable raté.
(A. M., *La Lanterne*, 1904.)

Cézanne n'a fait ni un tableau ni une œuvre.
(E. Schuffenecker, *Mercure de France*, 1905.)

Rien à dire des tableaux de Cézanne. C'est de la peinture de vidangeur saoul.
(Victore Binet, *Mercure de France*, 1905.)

Cet honnête vieillard qui peint en province pour son plaisir . . . et produit des œuvres lourdes, mal bâties . . . n'a jamais pu produire ce qu'on appelle une œuvre.
(Camille Mauclair, *La Revue*, 1905.)

If the greatest name in European painting is not Cézanne it is Giotto.
(Mr. Clive Bell, 1920.)

Cézanne's organisation of the lines and planes of his pictures will stand as an even greater achievement than his work with colour.
(Walter Pach, 1925.)

With Cézanne a mere crumpled tablecloth may take on the majesty of a mountain.
(Sir Charles Holmes, 1927.)

We can write critically of Cézanne now ; we can treat him with as little respect as we treat Rembrandt, Rubens or Titian.
(Anthony Bertram, 1929.)

The fumbling Cézanne.
(James Greig, London *Morning Post*, 1931.)

There is really no mystery about these pictures which we thus see described on the one hand as " drunken scavenger's painting " and on the other as the greatest productions of European painting.

Cézanne began as a follower of Courbet. In the 'sixties he painted with heavy colours and often applied them with a palette knife, as in *L'Oncle Dominique*, now in Mr. Lewisohn's collection in New York. His touch and colour were still heavy in 1870, when he painted *Still life with a black clock* (Pl. 110b).

In these years he was an earnest student in the Louvre. He admired the Venetians, the Baroque masters, Poussin and Delacroix.

In the early 'seventies when he painted *La Maison du pendu*, he

was influenced by Pissarro; but he never saw eye to eye with the other Impressionists and Manet's Kodak-snapshot manner did not interest him at all. At the end of the 'seventies he adopted, nevertheless, the Impressionists' light palette, and the task which he set himself was the grafting of Impressionism on to the main tree of classical art—as we know from his own definitions of his aims: " *faire du Poussin sur nature* " and " *faire de l'Impressionisme l'art des musées.*"

From the outset he had been at heart an architectural artist. If we compare his *Still life with a black clock* (Pl. 110b) with Chardin's *Still life* (Pl. 59a) in Boston, we see the formal character of Cézanne's preoccupation even in this early work. He is already less concerned with the objects before him as objects and more with their formal relations than was the case with Chardin; and later, when he had schooled his perception and mastered his language of expression, he painted still-life groups where the formal relations, which include relations of colour, constitute the central content of the picture as a whole. *Le Pot de fleurs* (Pl. 110a) is a splendid example of this later style.

Like Chardin, he never wearied of painting still life; but he also attacked the same problems in compositions—usually of bathers—in figure-studies and portraits, and in landscapes, painted mainly in the south.

The figure-studies culminate in *Le Garçon au gilet rouge*, painted about 1888, *Les Joueurs de Cartes*, *Le jeune homme à la tête de mort*, painted about 1895, and the great portrait *Gustave Geffroy* (Pl. 111).

These pictures appeal not only by their majestic architecture, but also by that intimate contact with life which we have already observed as a characteristic of one aspect of French art. This quality in Cézanne's figure-studies and portraits, has not, I think, been adequately stressed by commentators. Everyone now recognises that Cézanne was a superb architect and a consummate technician. But architectural power and craftsmanship are not in themselves sufficient to place a painter with the small group to whom the civilised world pays homage as masters of the very highest rank. Cézanne enters this company, as Renoir enters it, partly because, at moments, he could use his architectural science to capture contact with root simplicities and the very springs of life itself. He enters this company partly because he was not only the painter of *Les grandes Baigneuses*, but also the painter of *Gustave Geffroy*.

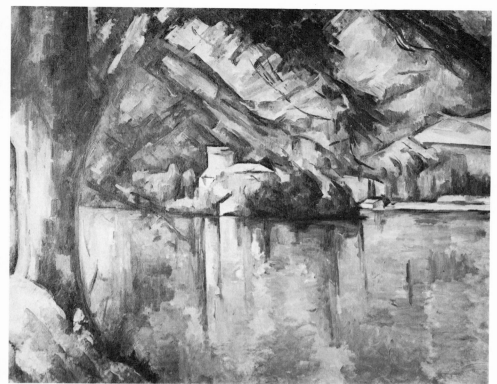

112a.　PAUL CÉZANNE: Le lac d'Annecy

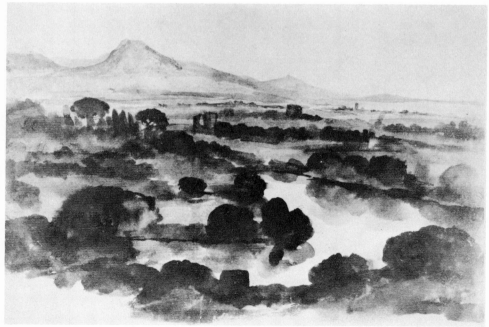

112b.　CLAUDE LE LORRAIN: The Tiber above Rome (Drawing)

PLATE XII

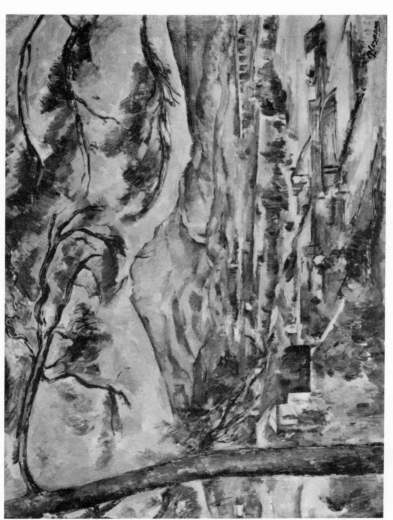

PAUL CÉZANNE (1839-1906)
La Montagne Sainte-Victoire

In Cézanne's landscapes we find the same intimate contact with the spirit of his subject that we find in the figure-subjects and the portraits. Cézanne was born in the Midi ; he was not a sun-starved Northerner like Van Gogh ; he could work in the sun 'without losing his head ; he knew and loved every foot of the country which he has immortalised, and his pictures symbolise that knowledge and that love. But he never copied what he chanced to see before him. His landscapes are among the most architectural of his works ; and at his highest level, as in *Le lac d'Annecy* (Pl. 112a) and *La Montagne Sainte-Victoire* (Pl. XII), and in the *Rocky Landscape*, in the London Tate Gallery, the planes are dovetailed with skill and ingenuity only comparable with Poussin's skill and ingenuity in the landscape of the *Funeral of Phocion* (Pl. 32a).

Cézanne is even more incontrovertibly a master in his land-scapes than in his figure-studies and his portraits. Like Poussin, he could make his picture a microcosm by a space concept of which every imagined particle was realised ; and he was a greater land-scape painter than Poussin because he achieved the realisation not only in the formal field but also—if the word can be used of a landscape—in the psychological field as well.

Cézanne's supreme skill of hand in his later years is not apparent to the uninstructed because he refused to permit himself the slightest bravura or the slightest fake. *Pas d'emportement du pinceau* was his motto as it had been the motto of Louis David. He meditated every touch. For the *Portrait of Gustave Geffroy* he had eighty sittings ; for a portrait of Vollard, which he eventually abandoned, he had a hundred and fifteen, and at the end he pro-nounced himself " *pas mécontent du devant de la chemise.*"[1]

In his later pictures he began with the architectural structure. In *Le lac d'Annecy*, for example, he would have begun with the arch formed by the boughs of the tree which join with the sky and mountains at the back of the picture. If he was not satisfied at any stage that the architecture was holding together in every direction he abandoned the canvas and began again.

Of this architecture, colour was an integral and central con-stituent. In his later manner he used thin transparent colour and every touch contributed to the final result. This method precluded the drastic alterations which are possible with opaque colour. And Cézanne was indeed one of the world's great colourists. I know

[1] The sittings for this picture have been amusingly described by Vollard in his *Paul Cézanne.*

no landscape finer in colour than *Le lac d'Annecy* (Pl. 112a). He had made an intensive study of the Old Masters in the Louvre, and he knew that the great colourists never copied the colours that they saw before them; he knew that the colour of Titian, Rubens and Watteau was " artificial "; he also knew that Renoir's colour was the same. In his compositions of bathers the exquisite mother-of-pearl flesh tints are in this great tradition; and in land-scape he founded a new tradition of " artificial " colour of his own.

Corot and the photographic painters of the nineteenth century had achieved imitations of effects of light and shade by destroying local colour and painting " by the tone values." The Impres-sionists had ignored local colour and substituted arbitrary colours symbolising light. Cézanne knew that the Old Masters had re-joiced in local colour and exploited it in glorious ways; he, too, rejoiced in and exploited local colour, and he succeeded in painting sunlight at the same time. It was thus that he converted Impres-sionism into the *art des musées*. In the same way he refused to follow the Romantics, the photographic painters, and the Impres-sionists, in their sacrifice of architecture to the imitation of effects of atmospheric perspective. He contrived to render that perspective without sacrificing his architectural concept of defined and dove-tailed space.

In his pictures every form and every touch of colour has formal relation with its neighbours, and those relations are the real subject from the first six touches on the bare canvas, or paper, to the end.

3 GEORGES SEURAT

BORN PARIS 1859 DIED PARIS 1891
Characteristic Pictures

London	Tate Gallery	The Bathing Place (La Baignade)
London	Courtauld Institute	Woman at her Dressing Table (La Pou-dreuse) [N1]
London	Formerly Courtauld Collection	The Bridge at Courbevoie [N1]
London	Mrs. Chester Beatty Collection	Landscape Study for La Grande Jatte [N1]
London	Formerly Courtauld Collection	The Port at Gravelines [N1]
London	Formerly Courtauld Collection	Sketch for Chahut [N1]
London	Sir K. Clark Collection	The Rock

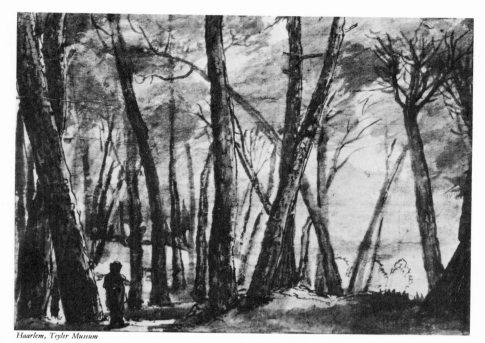

113a. CLAUDE LE LORRAIN: The wood (Drawing)

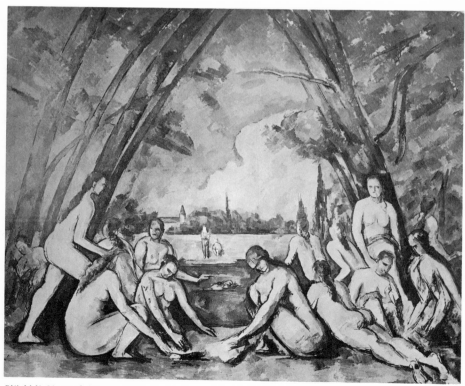

113b. PAUL CÉZANNE: Les grandes Baigneuses

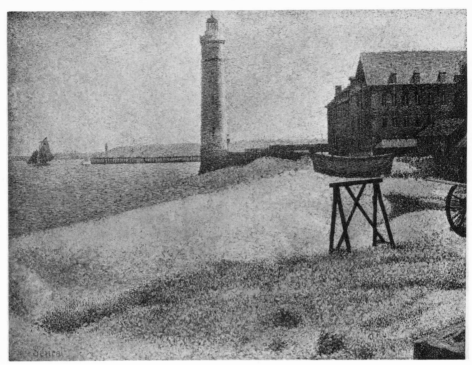

114a. GEORGES SEURAT: Honfleur: L'Hospice et le Phare

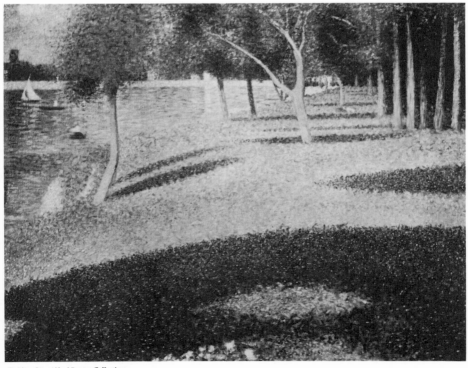

114b. GEORGES SEURAT: Study for La Grande Jatte

London	Sir K. Clark Collection	The Wood
New York	Museum of Modern Art	Fishing Fleet at Port-en-Bessin
New York	S. Clark Collection	The Fair (La parade) [N1]
London	Mrs. Chester Beatty Collection	Honfleur : L'Hospice et le Phare [N2]
London	Mrs. Chester Beatty Collection	Landscape Study for La Grande Jatte [N2]
New York	S. Lewisohn Collection	Study for La Grande Jatte [N3]
Buffalo	Albright Art Gallery	Study for Chahut [N4]
Chicago	Art Institute (Birch Bartlett)	Un Dimanche d'Eté à la Grande Jatte
Harvard	University	Head of a Girl (Profile perdu)
Indianapolis	Herron Institute	The Chenal de Gravelines
Merion	Barnes Foundation	Models Posing (Les Poseuses)
Paris	Jeu de Paume	The Circus
Paris	Jeu de Paume	Three studies for Poseuses
Paris	Jeu de Paume	Sketch for Grande Jatte
Otterlo	Kröller-Müller Museum	The High Kickers (Le Chahut)

(a) Seurat's Life

Georges Seurat was the son of a bailiff of La Villette, Paris, from whom he seems to have received an allowance all his life sufficient for his requirements. I can find no record that he was ever in financial distress or that he made any money by his work (he in fact only sold four or five pictures in all).

After an ordinary education he worked for four years at the École des Beaux Arts ; then he shared a studio with the painter Aman-Jean and worked in the Louvre and the Library of the École des Beaux Arts studying the Old Masters. Of the nineteenth-century painters he admired Ingres and Delacroix—especially Delacroix's decorations in Saint Sulpice. He also studied Charles Blanc's *La grammaire des arts du dessin* and Chevreul's *De la loi du contraste simultané des couleurs et de l'assortiment des objets coloriés* either at this period or on his return from a year's military service where he acquired his first experience of harbours and ports.

In 1881, at the age of twenty-one, he took a studio and began an intensive concentration on pictorial problems ; he continued for ten years, working by day and by night in his Paris studio and out of doors at various places.

In 1881 and 1882 he worked occasionally in the country round Paris. In 1883 he made studies of boating and bathing at Asnières which culminated in *La Baignade*. In 1884 he began to make

studies on the Island of La Grande Jatte and at Courbevoie on the same stretch of the Seine ; these studies culminated in *Un Dimanche d'Eté à la Grande Jatte* (Pl. 115). In 1884 he took part in the foundation of the Salon des Indépendants at which he was a regular and leading exhibitor for the rest of his life.

In 1885 he worked at Grandcamp and on the Grande Jatte ; in 1886 and 1887 at Honfleur and at Courbevoie ; in 1888 at Port-en-Bessin and in Parisian music halls ; in 1889 at Le Crotoy, in 1890 at Port-en-Bessin, and in 1891 at Gravelines.

When in Paris he lived in his studio and took most of his meals at his mother's house. The sitter for *La Poudreuse* was his mistress and the mother of his son. In 1891, at the age of thirty-one, he was attacked by some infectious form of pneumonia of which he died. His little son was infected and died too.

Seurat was very reserved about his private affairs. His most intimate friends were unaware of the existence of his mistress. As he painted on a scientific system he could paint by artificial light and his working day was regularly prolonged into the night. It is assumed that the pneumonia to which he succumbed might not have proved fatal had his constitution not been debilitated by this habitual overwork.

At Seurat's death his paintings and drawings were divided between his mother, his mistress, and a few friends who included the painter Paul Signat, first owner of *Le Cirque*, Emile Verhaeren, first owner of *Honfleur : L'Hospice et le Phare* (Pl. 114a), Felix Fénéon, first owner of *La Baignade*, and Edmond Cousturier, first owner of *Un Dimanche d'Eté à la Grande Jatte* (Pl. 115).

In 1900, nine years after his death, one of his pictures was sold at auction in Paris for twenty-seven francs. In 1901 fifty-three of his works (paintings and drawings) were collected into an exhibition on the Boulevard des Italiens and not one was sold.

(b) Seurat's Art

Seurat was a scientific artist of great intellectual powers and incredible industry and patience. With Cézanne he set the standard of conscientious workmanship that has been an outstanding feature of the Cubist-Classical Renaissance as a whole.

In his ten working years he produced seven important figure compositions and twenty or thirty pictures of harbours and ports. The compositions are *La Baignade*, *Un Dimanche d'Eté à la Grande Jatte* (Pl. 115), *Les Poseuses*, *La Parade*, *Le Chahut* (Pl. 116), *Le Cirque*, and *La Poudreuse*.

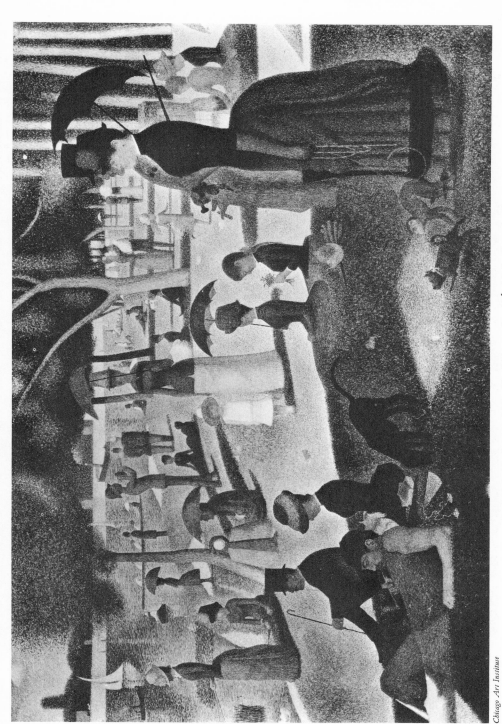

115. GEORGES SEURAT: Un Dimanche d'Été à la Grande Jatte

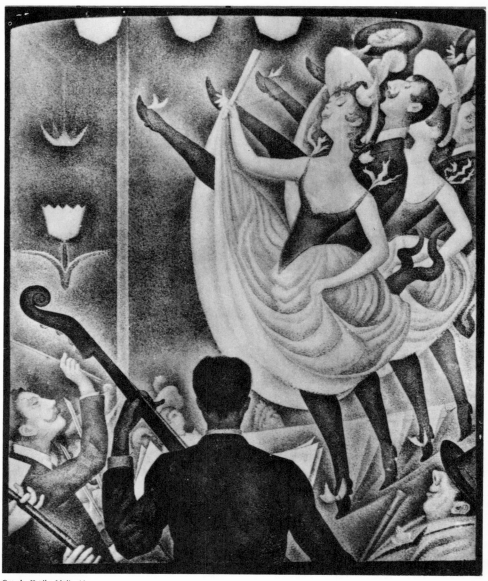

116. GEORGES SEURAT: The High Kickers (Le Chahut)

The character of Seurat's art is immediately apparent if we compare his *Honfleur : L'Hospice et le Phare* (Pl. 114a) with Manet's *Les Courses à Longchamp* (Pl. 92a). Seurat at the very beginning of the 'eighties had the intelligence to realise that Kodak-snapshot Impressionism had already run its course, and that, unless the painter was prepared to acknowledge defeat by the camera, painting must be brought back to the classical basis. Like David and Cézanne, he wrote *pas d'emportement du pinceau* and *faire du Poussin sur nature* on his doorpost.

To do this he began by the theoretical study of the laws of pictorial harmony and contrast ; he made hundreds of drawings of experimental combinations of lines, and numerous charcoal drawings from nature in which he sought to recapture the art of chiaroscuro as it was understood by artists before the camera arrived.

From this he proceeded to a theoretic grasp of the action of colour, and he made scores of colour experiments in which, with the aid of Chevreul's book already mentioned, he elaborated the Impressionists' empirical use of the spectrum palette to a complete system with separated spots of colour which took on the required relations to their neighbours when the picture was seen from a distance as a whole. His later pictures were painted spot by spot in accordance with this system, which is known as Pointillisme.

Seurat eliminated all spontaneity and all records of his mechanical vision from his pictures. He used the Impressionist technique for sketches ; he then analysed this material ; and he then made a synthesis for the final work. For *Un Dimanche d'Eté à la Grande Jatte*, he painted scores of Impressionist oil sketches as a beginning ; he then worked out in his studio every aspect of the picture separately considered. Mrs. Chester Beatty in London has his preliminary worked-out study for the landscape (Pl. 114b) ; Mr.[N1] Lewisohn in New York has a version of the whole picture which[N2] stands half-way between the first Impressionist sketches and the final work ; and there are many charcoal drawings in which the exact tonal relations of each figure to the surrounding passages are meticulously set down.

It should be observed that, like Cézanne, Seurat did not find it necessary to paint Venus and Adonis, or Paris and Helen, to indicate his return to the most austere conceptions of classical art. He accepted the subjects of the Impressionists. He painted holiday-makers by the riverside, dancers in music halls and performers in a circus. He took the same material as Renoir and Degas, and in

frequenting the circus he was following the example of his friend Toulouse-Lautrec. But from Seurat's standpoint the records by Renoir, Degas and Lautrec were journalism. He foresaw the day when descriptive photographic records would appear every morning in the illustrated newspapers and every evening in the cinemas. The task he set himself was the use of this material not for descriptive or Romantic but for architectural ends.

In *La Baignade*, *Les Poseuses* and *La Grande Jatte* he was concerned with the creation of static compositions, with recapturing, for example, the stability and serenity of Le Sueur's *Mass of St. Martin of Tours* (Pl. 21a). In *Le Chahut* and *Le Cirque* he attacked the problem of retaining this serenity and at the same time symbolising gaiety and movement by linear rhythms. He was still working on this problem when he died.

Seurat's death robbed the twentieth century of a superlatively original artist. Cézanne, of course, was the greater master ; his nature was richer and his mind was less dogmatic. But we must not forget that Cézanne studied for fifty years, and Seurat worked for only ten. We can set no limit to the possible achievements of a man who was able to see a path that modern art was about to follow and to advance himself, in a brief period, so far along the way.

4 THE DOUANIER ROUSSEAU

By a strange irony of fate Seurat's intellectual achievements could be compared in successive Salons des Indépendants with the pictures by Le Douanier Rousseau (1844-1910). This extraordinary artist, the son of an ironmonger, was at one time, as his *sobriquet* denotes, an excise official. In his spare time he played the fiddle and painted pictures. About 1886, when he was just over forty, he sent his first pictures to the Indépendants, and some years later he retired from his employment and devoted all his time to painting.

For the remainder of his life he worked in poverty ; he kept the wolf from the door by giving violin and painting lessons in the suburb where he lived ; he hardly ever sold his pictures, and when he did so he received the smallest sums. Like Chardin, Corot and Cézanne, *il peignait pour son amusement*. His pictures in the Salons des Indépendants eventually attracted the attention of the poet Guillaume Apollinaire and the painters Picasso and Braque who made his acquaintance and helped him in the last ten years.

This uncultured son of the people, who knew nothing of

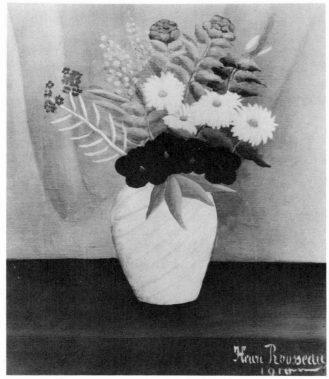

117a. LE DOUANIER ROUSSEAU: Flowerpiece

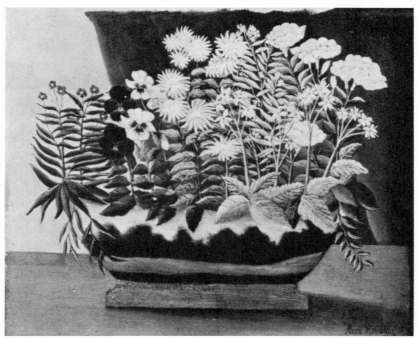

117b. LE DOUANIER ROUSSEAU: Fleurs de Poète

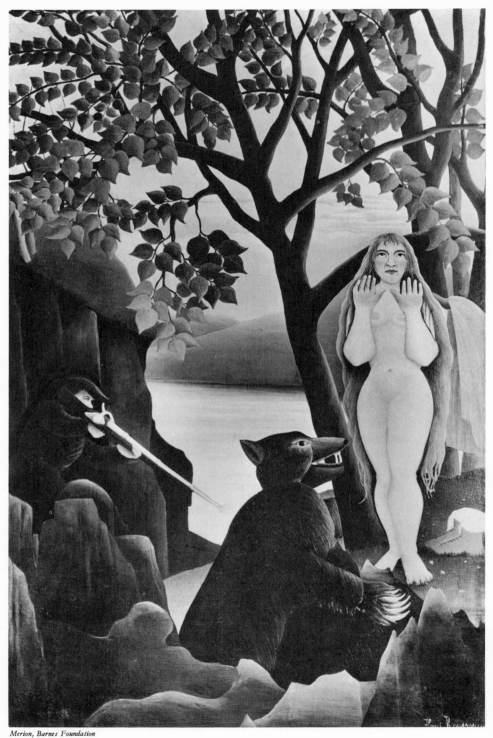

118. LE DOUANIER ROUSSEAU: The Surprise

drawing as it was taught in the art schools, and nothing of Impressionism, and who never thought about the struggle of art against the camera, arrived by instinct at a point reached by Seurat by intellectual effort and endless experiments with compasses and rules.

I am not suggesting, of course, that the organisation of Rousseau's pictures has the complex architectural qualities of Seurat's masterpieces ; but Rousseau did arrive intuitively at astonishing solutions of architectural problems ; he had an instinct for scale and proportion and a compelling decorative sense, as can be seen in the superbly decorative composition *The Surprise* (Pl. 118).

Rousseau, as Charles Marriott put it, " refused to be taught to see." For the public that roared with laughter at his pictures he had nothing but contempt. To an art critic who had referred to his work as " *naïf* " he wrote : " *je ne pourrai maintenant changer ma manière que j'ai acquise par un travail opiniâtre, vous devez le penser.*" In a biographic note which he compiled himself for a publication in 1895 he wrote : " *C'est après de bien dures épreuves que M. Rousseau arriva à se faire connaître du nombre d'artistes qui l'environnent. Il s'est perfectionné de plus en plus dans le genre original qu'il a adopté et est en passe de devenir l'un de nos meilleurs peintres réalistes.*" He was certain that he was really an artist ; and he was right.

Rousseau, like the great artists, created a microcosm in his pictures. As a boy he went to Mexico in a military band, and years later he painted a series of jungle pictures that are microcosms of a tropical world. I reproduce his *Jungle with wild beasts* (Pl. 119a), and his *Jungle with monkeys* (Pl. 119b). Another magnificent jungle picture is *Le Repas du Lion*, where a lion devours his prey in a landscape of huge tropical flowers. Yet another, *The Snake Charmer*, now belongs to the Louvre, and hangs in the Jeu de Paume with the works by Seurat and Cézanne.

Seurat—in spite of his immensely elaborate method—preserved an astonishing freshness in his observation, as we see in *La Grande Jatte* (Pl. 115) and *Le Chahut* (Pl. 116). But no man can *consciously* achieve the freshness and simplicity that we encounter in Rousseau's *The Surprise* (Pl. 118).

Rousseau, moreover, was a poet. His flower pieces (Pls. 117a, 117b) are delicious in colour. And he had real imagination. Marriott rightly compared him to Blake. His jungle pictures are pictorial equivalents of Blake's " Tiger."

Rousseau's biographers tell us that he believed he saw the spirit

of his first wife returned to inspire him when he was painting his most ambitious pictures. They also tell us that he painted nothing from nature except the faces in his portraits and some of his flower pieces.

As a technician, at his best, Rousseau was faultless ; his hand did exactly what his mind, his spirit and his imagination willed. But his work was unequal—inevitably, since only conscious and cultivated artists can maintain a consistent technical level. Also it must be noted, some forgeries of his work have already appeared here and there.[1]

[1] The student will find a basic catalogue of Rousseau's work and all that is known of his life in my *Modern French Painters*.

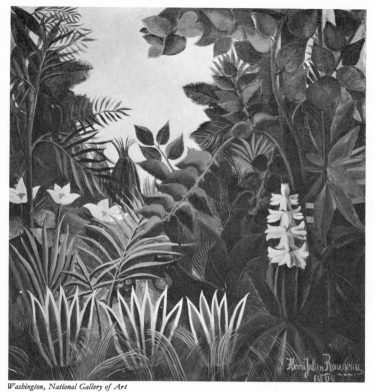

119a. LE DOUANIER ROUSSEAU: Jungle with Wild Beasts

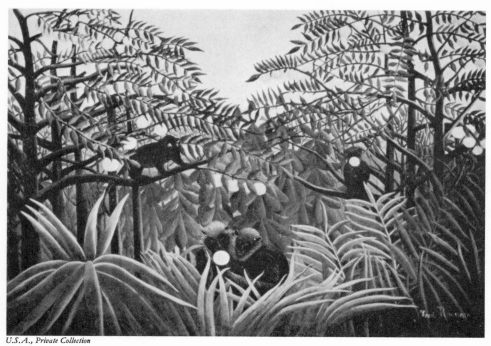

119b. LE DOUANIER ROUSSEAU: Jungle with Monkeys

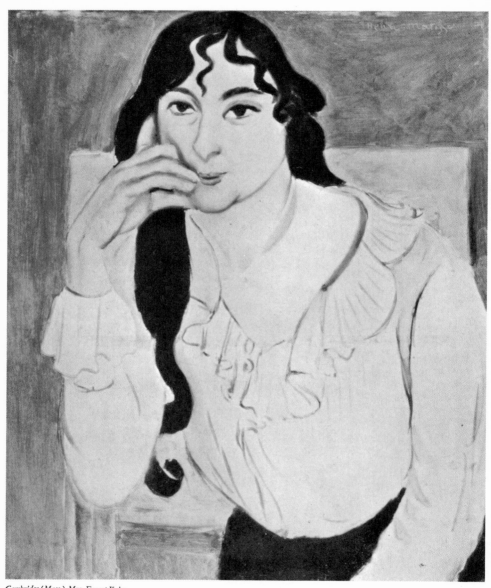

Cambridge (Mass.) Mrs. Ernest Kahn

120. HENRI MATISSE: Jeune Femme accoudée

EPILOGUE

EPILOGUE

Some leading figures in the Impressionist and Post-Impressionist movements lived into the twentieth century. Degas, as recorded, died in 1917, Renoir in 1919, Monet in 1926, Cézanne in 1906, Gauguin in 1903, Lautrec in 1901 and the Douanier Rousseau in 1910. Of the second generation of Post-Impressionists the ablest artists Pierre Bonnard (1867-1947), Edouard Vuillard (1868-1940) and Maurice Denis (1870-1943) led a group called the " Nabis " which was formed in 1892. Bonnard and Vuillard used the pretty Impressionist colouring and painted the same subjects as the Impressionists, but they concentrated more on colour-patterning and their sensitively controlled pictures are thus less descriptive and more abstract in aim than those of their masters. Maurice Denis, who was at first much influenced by Gauguin, painted many murals for churches in his later years. Van Gogh's influence, on the other hand, was the basis of the famous Fauve movement which began about 1903 ; and Cézanne's influence was the basis of the Cubist movement which began about 1907.

The Fauve movement gained its name from a critic who described a room full of pictures in the third Salon d'Automne of 1905 as " The Wild Beasts' Cage " (Cage aux Fauves). The artists thus labelled were Henri Matisse (born 1869), Georges Rouault (born 1871), André Derain (born 1880), Maurice de Vlaminck (born 1876), Othon Friesz (born 1879), Raoul Dufy (born 1879) and a Dutchman Kees Van Dongen (born 1877) ; at this stage they were all enthusiastic imitators of Van Gogh's use of the most brilliant colours as symbols of vitality and excitement ; they all painted landscapes and figures, street and port scenes, and floral still life in vivid mosaics of vermilion, emerald green, cadmium and cobalt ; and all at this time used a heavy and vigorous touch. The Fauve movement, being mainly concerned with emotive colouring and handling, was basically a Romantic movement. But it also marked a stage in the Cubist-Classical Renaissance in the sense that it contributed to the recognition of colour as a factor in itself apart from representational or descriptive service. As the century advanced each of these artists developed in a personal direction. Matisse, the leader of the movement,

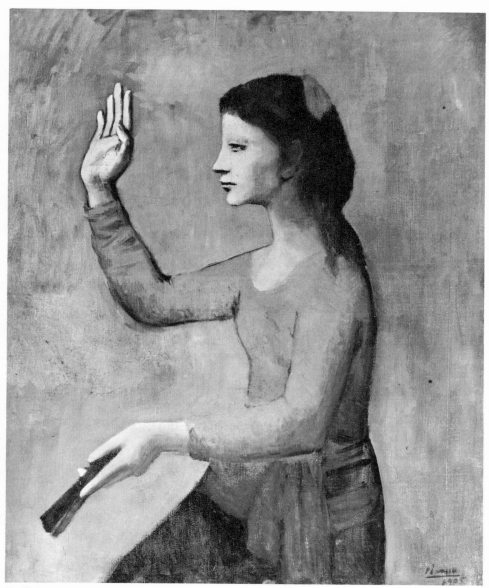

121. PABLO PICASSO: Petite Fille à L'Éventail (1905)

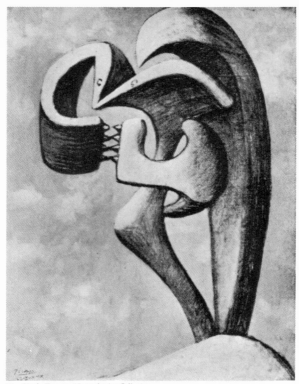

122a. PABLO PICASSO: Abstract Composition (1930)

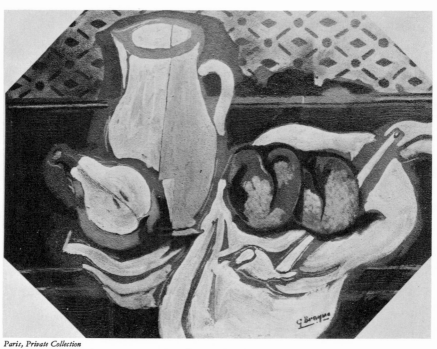

122b. GEORGES BRAQUE: Still Life Abstraction

passed on to other phases that will be separately discussed. Rouault, who had begun life as a glass painter, eventually subjected his Romantic Fauvism to a discipline inspired by the geometric elements in early stained-glass windows; he bounded spaces of deeply resonant reds, blues, greens and orange yellows with a heavy black line which performs the function of the leading in the windows; he applied this to religious and lay subjects (circus figures); and he produced for the dealer Ambroise Vollard two superb books with coloured wood engravings that will surely be greatly prized by our descendants. Vlaminck also soon introduced black as a major element in his colour schemes; but he has used it to give dramatic character to Romantic representation and in moving away from Fauvism he moved not forward into architectural Cubism but backward to the drama of the baroque. Dufy, æsthetically a descendant of Fragonard, soon developed a deliciously light touch and a gay calligraphy applied with equal success in charmingly coloured paintings of contemporary life (racecourse and other " mondain " scenes) and in designs for textiles and so forth; and Van Dongen, who gave parties attended by " tout Paris " in the hectic days immediately after the first German war, used Fauve procedures to record with mock ferocity the special glamours of the fashionable beauties of that day.

The Cubist movement was the logical conclusion of the Cubist-Classical Renaissance begun by Seurat and Cézanne. Its creators and leading exponents were the Spaniard Pablo Picasso (born 1881), Georges Braque (born 1881), Juan Gris another Spaniard (1887-1922) and Amedée Ozenfant (born 1886). Andrée Derain moved from Fauvism to Cubism for a year or two (1908-1914) and painted some admirable pictures in this style. The Cubists concentrated on the creation of a pictorial architecture, in which representational and descriptive elements were deemed unnecessary or at best incidental. The Cubist æsthetic, essentially Western, preferred straight lines, circles and geometric forms to the free-flowing organic lines and rhythms of Far Eastern art; and Cubist art was fundamentally classical, reasonable and austere. The spade work, which called down much derision on the artists, was done by Picasso, Braque and Gris before the 1914 German war. Perfection was achieved in a few pictures painted just after that war by Ozenfant who avoided empirical procedures, excluded incidental or accidental variations, and sought for constant and in that sense " normal " or type forms. Ozenfant invented the term " Purist " to describe his essentially classic Cubist pictures; and

this Purism, translated into actual architecture and the applied arts, became the modern style of glass and steel and concrete which we see around us, still in process of development, at this day. I reproduce two of his pictures (Pls. 125a and 125b).

The third famous artistic movement of the twentieth century, the Surrealist movement, is really two movements which must be carefully distinguished and given two separate names. The first, properly called the Surrealist movement, was created in Paris in 1911-1914 by the Italian Giorgio de Chirico (born 1888) and the Russian Marc Chagall (born 1887). These artists explored the possibilities of certain dream-images (including incongruous juxtapositions) and dream-sensations (including claustraphobia and agoraphobia) as material for a new Romantic-lyrical imaginative art within the framework of the Cubist formal Renaissance. For dream-pictures they had as precedent in French art some etchings and pastels by Odilon Redon (1842-1916); but Redon as we see in his *Orpheus* (Pl. 124) had the nineteenth-century concept of the dream-world as a vague formlessness where all the images had blurred edges; Chirico and Chagall reminded us that clarity is the true essence of the dream-image, and that in dreams we believe the most incredible disproportions and incongruities just because they are precise and clear. Chagall has continued in this path and produced within it many beautifully coloured and sensitively imaginative pictures. Chirico continued there through the nineteen twenties but has since retired to less adventurous fields. No French artists have contributed to Surrealism.

The second phase of Surrealism, which I christened Neo-Surrealism (in my *Modern French Painters*), is outside the field of the Cubist-Classical Renaissance because it is not concerned with painting as an aspect of formal art. Many of the Neo-Surrealists use a photographic representational technique, and descriptive colour; and they all set out to arouse the maximum of disquiet in the spectator by exploiting the subconscious as revealed in Freudian clinics. This movement was launched in 1924 by a group of writers and painters. The leading writer André Breton (trained as a psychiatrist) is French. But the first leader among the painters Max Ernst (born 1891) was German and of the most conspicuous later adherents Salvador Dali (born 1904) is Spanish and R. Magritte (born 1898) is Belgian. No French painters have contributed to this movement (which is to me most antipathetic).

In the whole period since 1900 two major artists, Matisse and

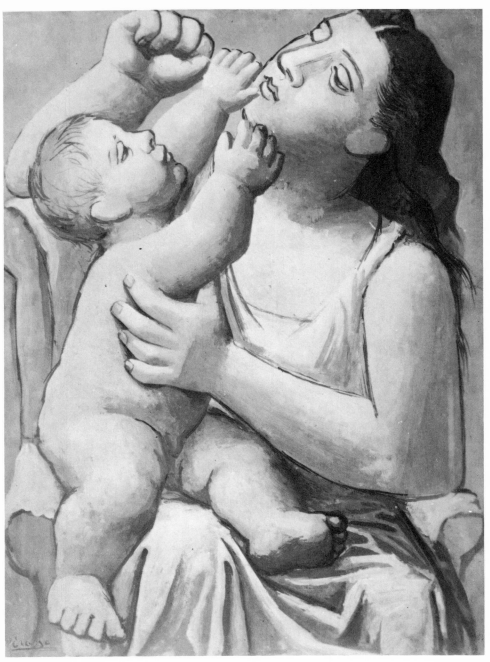

123. PABLO PICASSO: Mother and Child (c.1923)

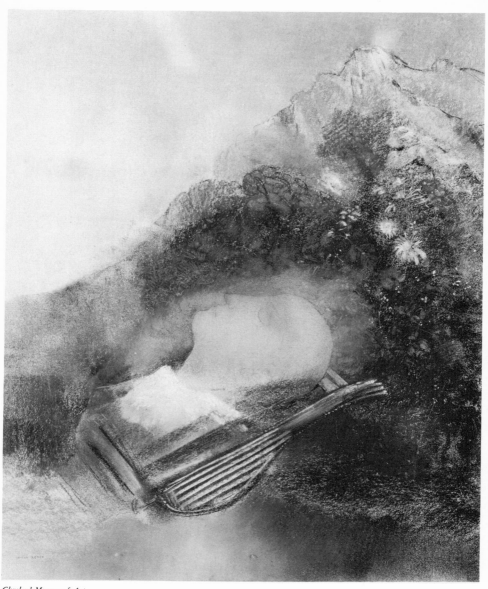

124. ODILON REDON: Orpheus

Picasso, indubitably stand out. And I must end this survey with brief considerations of their work.

2 HENRI MATISSE

Henri Matisse was born at Le Cateau (Northern France) in 1869. On leaving school he worked for some years in the École de Droit with the intention of becoming a lawyer; but he had found his right path by 1890 when he was twenty-one and three years later he became a pupil of Gustave Moreau (1826-1897) in the École des Beaux Arts. Moreau, a painter of dramatic and illustrative imaginative compositions, had scored many Salon successes in the 'seventies; though essentially a painter of ideas, he was alive to the purely visual and formal talents of Matisse, and he never pressed him to give his pictures illustrative content. By 1896 Matisse was exhibiting low-toned landscapes and still-life studies in the Salon de la Nationale, and *La Desserte* shown in 1897 proved that he could make a career in the Impressionist tradition if he wished to do so. But he chose instead to join the young men who were out to create a new phase in the history of painting, and early in our century he was a conspicuous figure in the Salon des Indépendants and the Salon d'Automne and the recognised leader of the Fauve Group as already related. In 1906 he was invited by a number of his admirers—French, English, American and Scandinavian—to act as their professor in an art school, and he taught in this way, informally, taking no fees, for two or three years, a gesture which caused the radiation of his personal artistic creed and greatly influenced the course of modern painting. In 1911-1912 he worked in Morocco; during the first German war he worked partly in the north, and, in the winter, at Nice; and since then he has lived and worked almost continuously near Nice.

As an artist Matisse passed from his Fauve adventure to the creation of a rhythmic calligraphic decorative art more organic and less geometrical than Cubism, an art in which the forms seem to have grown together as plants grow or as rivers flow. The creation of this art has been his central purpose since he painted the decorative panel *Bonheur de vivre* (now Merion, Barnes Foundation) in 1907. He has departed from this central line occasionally; his art was more static when he painted a number of flat-pattern brightly coloured pictures on his first visit to Morocco; and genre elements played more part in it for a number of years in the

nineteen twenties. But the paintings of his later years are the logical outcome of the formative period before 1918.

As subject-matter he has been content for the most part with the material of the genre painters—figures, interiors, flowers, still life and occasionally landscape ; there is a whole series of pictures where figures in an every day Nice room suffice as instruments for his calligraphic compositions ; and there is another series where " Odalisques," nude or in Turkish trousers, are shown with Oriental and Near Eastern decorative surroundings imported to his studio for the purpose. But the material used in Matisse's pictures is never more than incidental ; it is always a jumping-off point for the creation of a picture based upon it but governed after the first touch on the canvas by nothing but its own organic structure and deployment.

Matisse holds the rank of a great artist because in addition to his pictorial talents—an infallible instinctive sense of scale and decoration, a personal and most delightful sense of colour, and an observation as direct and fresh as that of the Douanier Rousseau, as we see for example in *Jeune Femme accoudée* (Pl. 120)—he has both the intellectual power to analyse his visual perception and to assemble the elements in deliberate design, and the technical skill to express both the talents and the science in a gay calligraphy. And thus, as M. Jean Cassou, Director of the Musée National d'Art Moderne has put it in a brilliant essay : " The works of Matisse are subtle operations of the mind and also images of joy."[1]

Characteristic pictures by Matisse are in the Musée National d'Art Moderne in Paris, in the London Tate Gallery and in the New York Museum of Modern Art. The Moscow Museum of Modern Western Art has about forty paintings, many of the period before the first German war (including works painted in Morocco). The Barnes Foundation in Merion (Philadelphia) has a large representative collection. I reproduce a late example *The Scarlet Coat* (Pl. 128).

3 PABLO PICASSO

Pablo Picasso was born in Málaga in 1881 ; both his parents were Spanish ; and as a Spaniard he has strictly speaking no place in a book devoted to the French School. But as he has worked in France for nearly fifty years and has been for more than forty a central figure in the Parisian art world, it is fitting to salute him as the latest figure in the history I have outlined.

[1] In Faber Gallery *Matisse*, 1948.

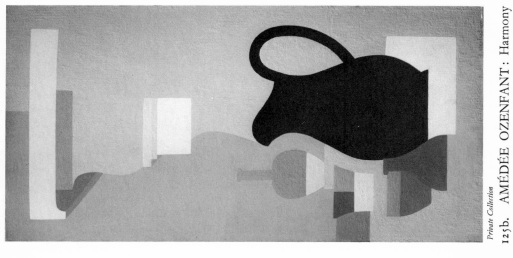

125b. AMÉDÉE OZENFANT: Harmony

125a. AMÉDÉE OZENFANT: Objects forming Fugue

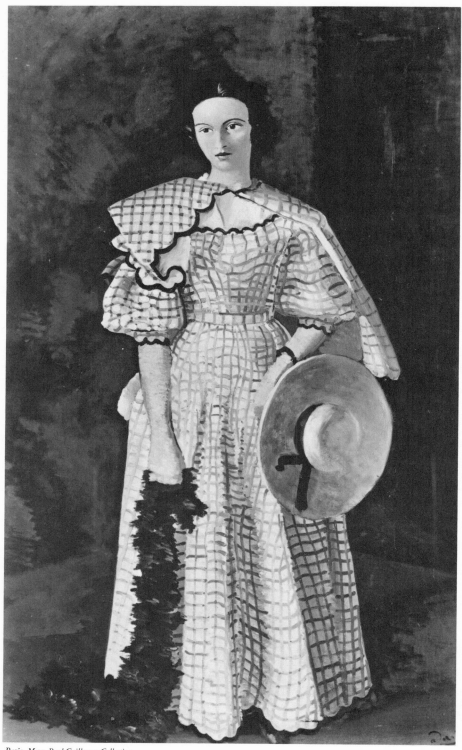

126. ANDRÉ DERAIN: Le Boa

He began as a Romantic-Realist impressed by the achievements of Toulouse-Lautrec. He developed this Romantic-Realism in the so-called " Blue period " and " Pink period," 1901-1906, with a series of paintings known as *Les Saltimbanques* showing figures connected with life behind the scenes in a travelling circus, treated in a purely personal way. The pictures of this type, produced when he was in the early twenties, are very moving and poetical and definitely on the sentimental side. I reproduce as an example *La petite fille à l'eventail* (Pl. 121) painted in 1905.

In 1907 he abandoned this Romantic production ; he excluded everything charming from his work and sought to imbue it with the fierce vitality of negro sculpture. *Le Corsage Jaune*, which has all the magnetic power of an African idol, expressed paradoxically in very *raffiné* colour, is the most imposing production of this phase.

Soon after this he invented Cubism which, as a movement and a system of æsthetic, I have referred to above. The outstanding Cubist picture was *Les Trois Masques*.

About 1919 he left for a time the geometric basis of his Cubist period and set out to create a new form of monumental painting and outline drawing, turning for inspiration to the antique as Poussin and David had done before him. This phase is known as his " Classical " period. I reproduce as an example the *Mother and Child* (Pl. 123), surely a masterpiece, majestic in structure and most tender in feeling—in Picasso's case a characteristic combination of opposites because even in his monumental manner his Romantic temperament usually worked through.

Till about 1923 he made no contribution to the Surrealist movement. But in that year he painted *Femmes effrayées au bord de la Mer* which must be ranked as a Surrealist picture ; since then he has painted many pictures in which both Surrealist and Neo-Surrealist characters appear ; and in some (symbols of the sadisms which right and left extremists practise in our brave new world) he has given us monstrous images that scarify the mind and revolt the soul. Of these later works the outstanding examples are *Guernica* (occasioned by the Spanish Civil War) and a series of terrifying pictures painted during the second German invasion of France.

I have discussed in detail many aspects of Picasso's art in my *Modern French Painters*. Here I need only draw attention to his staggering gifts, his endless powers of invention, his versatility and his energy (he has painted over a thousand pictures, he has

made thousands of drawings and many lithographs, he has carved and modelled and recently he has painted and fired some hundreds of ceramics).

He is without question the most interesting artist now alive. He has never painted a dull picture or made a dull drawing ; he has never ceased to enlarge his experience ; he has attacked incessantly problem after problem ; he has never repeated a success. His influence can be seen in paintings all over the civilised world. His followers can be counted by hundreds. As I write (in 1949) he is sixty-seven and men in many countries, who look on creative art as significant and important action, still say to one another, " I wonder what kind of pictures Picasso will paint next ? "

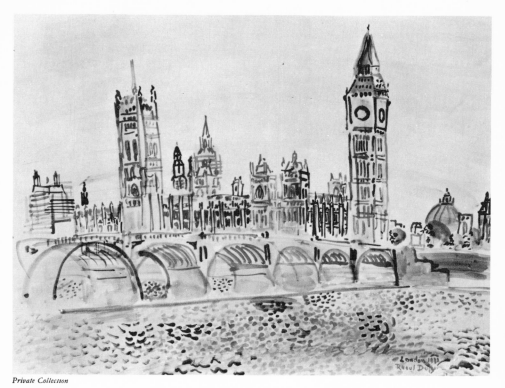

Private Collection

127a. RAOUL DUFY: The Houses of Parliament

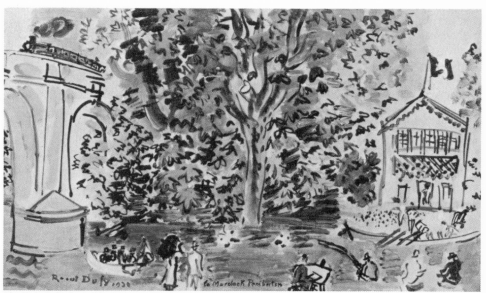

New York, M. Pemberton Collection

127b. RAOUL DUFY: River Scene

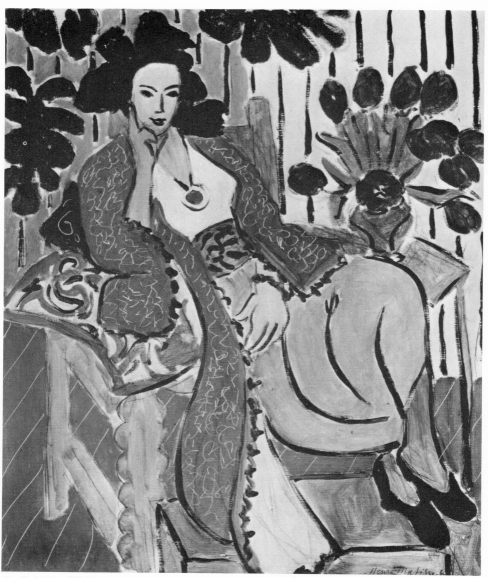

128. HENRI MATISSE: The Scarlet Coat

NOTES TO THE 1973 EDITION

PAGE 5

1. *Virgin and Child with Saint and Donor* is now identified by the Worcester Art Museum as *The Blessed Pierre du Luxembourg Presenting a Donor to the Virgin and child.*

PAGE 10

1. The portion of the *Annunciation Altarpiece* formerly in the Cook Collection is now in the Museum Boymans-van Beuningen, Rotterdam.

PAGE 15

1. The Louvre now catalogues *The Finding of the True Cross* as Flemish School. G. Ring (no. 175) attributes it to Simon Marmion.

PAGE 29

1. The Clouet formerly in the Cook Collection is now in the National Gallery of Art, Washington, D.C.

2. *Gabrielle d'Estrées and her Sister the Duchesse de Villars* is now in the Louvre, Paris.

PAGE 31

1. *Diana de Poitiers in her Bath* is now in the National Gallery of Art, Washington, D.C. (Kress Collection).

PAGE 32

1. The catalogue of the Walker Art Gallery (1963) pp. 71f., attributes this to the French School, c. 1520–30, (an artist working in the circle of Clouet) and calls it *Portrait of a Lady with a Parakeet*, noting that the identification with Marguerite of Valois is probable but not certain.

PAGE 39

1. Both the *Cabinet d'Amour* and the *Chambre des Muses* are now in the Louvre, Paris.

PAGE 46

1. *The Mendicants* is by a follower of Louis Le Nain.

PAGE 47

1. *Old Woman Frying Eggs* by Velasquez is now in the National Gallery of Scotland, Edinburgh.

PAGE 50

1. *St. Sebastian Mourned by Women* is now in the Staatliche Museen, Berlin-Dahlem.

PAGE 54

1. The *Farnese Hercules* is now in the National Museum, Naples.

PAGE 60

1. *The Shepherds in Arcady* is now in the Chatsworth Settlement, Chatsworth.

2. *The Seven Sacraments* (seven pictures) are now in the National Gallery of Scotland, Edinburgh.

3. *Rape of the Sabines* is now in the Metropolitan Museum of Art, New York.

4. Of the seven pictures in *The Seven Sacraments*, one has been destroyed by fire and one was sold to the National Gallery of Art, Washington, D.C. (Kress Collection).

5. The 1963 catalogue says that *Arcadian Landscape* is only "attributed to Poussin," and many scholars believe it to be by a follower.

6. *Orpheus and Eurydice* is by an imitator of Poussin and is no longer part of the Havemeyer Collection.

PAGE 61

1. *Landscape with Hercules and Cacus* is in the Pushkin Museum, Moscow.

PAGE 66

1. Of the seven pictures in this series of *The Seven Sacraments*, formerly in the Duke of Rutland Collection, one has been destroyed by fire and one was sold to the National Gallery of Art, Washington, D.C. (Kress Collection).

2. This series of *The Seven Sacraments*, formerly in the Lord Ellesmere Collection, is now in the National Gallery of Scotland, Edinburgh.

3. This version of the *Rape of the Sabines*, formerly in the Cook Collection, is now in the Metropolitan Museum of Art, New York.

PAGE 99

1. Adhémar (1950) attributes *La Rêve de l'Artiste* to Schall, not Watteau.

PAGE 100

1. *La Danse (Iris C'est de Bonheur)* is now in New York, formerly part of the H. Moser Collection. This picture was ceded to the former reigning Prussian house, but sold from the royal collection, c. 1928.

2. *Les Bergers* is now in Neues Schloss, Potsdam.

PAGE 119

1. Antoine Pesne's portrait of Frederick the Great is now in the Staatliche Museen, Berlin-Dahlem.

PAGE 124

1. *Still Life: Preparations for a Breakfast* is now considered to be from the workshop of Jean-Baptiste-Siméon Chardin.

2. *Still Life: Jug and Peaches* is now in the National Gallery of Art, Washington, D.C.

3. *The Admonition (La Gouvernante)* is now in the National Gallery of Canada, Ottawa.

PAGE 125

1. *La Garde Attentive* is now in the National Gallery of Art, Washington, D.C. (Kress Collection).

PAGE 135

1. *Mme de Pompadour* was a larger version dated 1757 in the Rothschild Collection, Vienna of the painting dated 1758 in the collection of Baron Maurice de Rothschild, Paris. (Pl. 62).

PAGE 143
 1. *L'Île d'Amour* is in the Gulbenkian Collection, Lisbon.

PAGE 144
 1. *Le Serment d'Amour* is now in the McVeigh Collection, New York.
 2. *La Lettre* is in a private collection in Far Hills, New Jersey.
 3. *Taureau Blanc à l'Étable* is now in the Wildenstein Gallery, New York.
 4. *Les Pins à la Villa Pamphili* (drawing) is now in the Rijksmuseum, Amsterdam.
 5. *Les Pétards* (drawing) is now in the Museum of Fine Arts, Boston.

PAGE 150
 1. *Le Serment d'Amour* is now in the McVeigh Collection, New York.

PAGE 152
 1. The Gulbenkian Collection is now in Lisbon.

PAGE 160
 1. Duplessis' original portrait of Benjamin Franklin, signed and dated 1778, exhibited at the Salon in Paris in 1779, is in the Metropolitan Museum of Art, New York. More than ten replicas and copies are known.

PAGE 168
 1. *Mlle Charlotte du Val d'Ognes* is no longer attributed to David.
 2. The portrait of the chemist Lavoisier is now in the Rockefeller Institute for Medical Research, New York.

PAGE 178
 1. *Assumption of the Virgin* is now in the Louvre, Paris. A small copy of this painting was in the Metropolitan Museum of Art until it was sold in 1956.

PAGE 181
 1. *Portrait of a Man* is now correctly identified as *Portrait of Joseph Antoine Moltedo*.
 2. *Portrait of Cherubini* is now in the Cincinnati Art Museum.
 3. *La Princesse de Broglie* is now in the Lehman Collection, New York.

PAGE 191
 1. The Wilstach Collection is now in the Philadelphia Museum of Art.

PAGE 192
 1. The S. Lewisohn Collection has been dispersed. The decorative panels and *Martyrdom of St. Sulpicius* (sketch) are owned by various private collectors.
 2. *L'Amende Honorable* is now in the Philadelphia Museum of Art.

PAGE 194
 1. *L'Amende Honorable* is now in the Philadelphia Museum of Art.

PAGE 205
 1. *L'Aumône d'un Mendiant à Ornans* is now in the Glasgow Art Gallery (Sir W. Burrell Collection).
 2. *A View of Ornans* is now in the Philadelphia Museum of Art (Wilstach Collection).

PAGE 206

1. *A Mountain Stream* is now in the Philadelphia Museum of Art (Wilstach Collection).

2. *The Waves* is now in the Philadelphia Museum of Art (Wilstach Collection).

PAGE 209

1. *L'Aumône d'un Mendiant* is now in the Glasgow Art Gallery (Sir W. Burrell Collection).

PAGE 214

1. Guys' *Une Dame* is no longer in the Baron Gourgaud Collection.

PAGE 222

1. *Le Déjeuner sur l'Herbe* (first version) is now in the Courtauld Institute Galleries, London.

2. *Argenteuil* is now in the private collection of Lady Aberconway, London.

3. *Les Paveurs de la Rue de Berne* is now in the private collection of Mrs. R. A. Butler, London.

PAGE 223

1. *Le Bar des Folies Bergères* is now in the Courtauld Institute Galleries, London.

2. *Jeanne-le Printemps* is now in the private collection of Mrs. H. P. Bingham, New York.

3. *Le Chemin de Fer* is now in the National Gallery of Art, Washington, D.C.

4. *Boy Blowing Soap Bubbles* is now in the Gulbenkian Collection, Lisbon.

5. *The Beggar* is owned by the Norton Simon Foundation, Los Angeles.

6. *Le Guitarrero* is in the Metropolitan Museum of Art, New York.

7. *Marine View in Holland* is now in the Philadelphia Museum of Art (Wilstach Collection).

PAGE 229

1. *Le Chemin de Fer* is now in the National Gallery of Art, Washington, D.C.

PAGE 233

1. *St. Lazare Station* is now in the private collection of the Honorable Christopher McLaren, London.

2. *Vase of Flowers* is now in the Courtauld Institute Galleries, London.

3. The Lewisohn Collection has been dispersed. The locations of these paintings are not known.

4. *Venice: (The Contarini Palace)* is now in the private collection of Mrs. Kahn, Cambridge, Mass.

5. *Westminster* and *La Gare St. Lazare* are in the Chicago Art Institute (Ryerson Collection).

PAGE 237

1. The Lewisohn Collection has been dispersed. The present location of *The Seine* is unknown.

PAGE 238

1. *In the Box* (*La Loge*) is now in the Courtauld Institute Galleries, London.

2. *Portrait of Vollard* is now in the Courtauld Institute Galleries, London.

3. *The Shoelace* (*Woman at Her Toilet*) is now in the Courtauld Institute Galleries, London.

4. *The Skiff (La Yole)* is now in the private collection of Lady Aberconway, London.

5. *Spring (Landscape)* is now in the private collection of Lady Aberconway, London.

6. *La Baigneuse Blonde* is in the Agnelli Collection, Turin.

7. *Mme Darras, 1871* is in the Metropolitan Museum of Art, New York.

8. *Les Canotiers à Chatou* and *Les Vendangeurs* are in the National Gallery of Art, Washington, D.C.

9. *In the Meadow* is in the Metropolitan Museum of Art, New York.

PAGE 239

1. *Sur La Terrasse* is in the Chicago Art Institute (Mr. and Mrs. L. Coburn Collection).

2. *Les Grandes Baigneuses* is in the Philadelphia Museum of Art (Tyson Collection).

PAGE 240

1. *Au Piano* is now in the Louvre, Paris (Paul Guillaume Collection).

PAGE 242

1. *Les Grandes Baigneuses* is now in the Philadelphia Museum of Art (Tyson Collection).

PAGE 245

1. *Deux Danseuses sur la Scène: La Pointe* is in the Courtauld Institute Galleries, London.

2. *Femme S'Essuyant* (pastel) is no longer in the Lord Ivor Spencer Churchill Collection. The present location is unknown.

3. *Jules Finot* is in the Metropolitan Museum of Art, New York.

4. *Ballet Scene* is in the private collection of Mrs. Kahn, Cambridge, Mass.

5. The S. Lewisohn Collection has been dispersed. The location of this painting is unknown.

PAGE 246

1. The S. Lewisohn Collection has been dispersed. The three pastels are owned by various private collectors.

2. *Uncle and Niece* is in the Chicago Art Institute (Mr. and Mrs. L. Coburn Collection).

PAGE 249

1. *À la Mie* is now in the Museum of Fine Arts, Boston.

2. *The Opera "Messalina" at Bordeaux* is in the County Museum, Los Angeles.

3. The S. Lewisohn Collection has been dispersed. The location of this painting is unknown.

PAGE 250

1. The S. Lewisohn Collection has been dispersed. The location of this painting is unknown.

PAGE 259

1. *Te Rerioa (Le Rêve)* and *Nevermore* are now in the Courtauld Institute Galleries, London.

PAGE 260

1. *Ia Orana Maria* (*Ave Maria*) is now in the Metropolitan Museum of Art, New York.

2. The S. Lewisohn Collection has been dispersed. The locations of these paintings are not known.

3. *L'Esprit Veille* is now in the Albright-Knox Art Gallery, Buffalo, New York (A. C. Goodyear Collection).

PAGE 264

1. *Landscape at Arles* is now in the Courtauld Institute Galleries, London.

2. *Marcel Roulin* and *Girl in a Striped Dress* (*La Mousmé*) are in the National Gallery of Art, Washington, D.C. (Chester Dale Collection).

3. *L'Arlésienne* (*Mme Ginoux*) is in the Metropolitan Museum of Art, New York.

4. *La Maison de la Crau* and *Landscape Near Saint-Rémy* are in the Albright-Knox Art Gallery, Buffalo, New York.

PAGE 273

1. The seven paintings are in the Courtauld Institute Galleries, London.

PAGE 274

1. *Louis Guillaume* is now in the National Gallery of Art, Washington, D.C. (Chester Dale Collection).

2. *Still Life* (*Primula, Apples and Drapery*) is now in the Metropolitan Museum of Art, New York.

3. *L'Estaque* is now in the Museum of Modern Art, New York.

4. *Mme Cézanne* is now in the collection of Mr. and Mrs. John L. Loeb, New York.

5. The S. Lewisohn Collection has been dispersed. The location of *Head of L'Oncle Dominique* is not known.

6. *L'Homme au Bonnet de Coton* is now in the Metropolitan Museum of Art, New York.

7. *Portrait of Gustave Geffroy* is now in the M. Lecomte Collection, Paris.

8. *Les Grandes Baigneuses* is now in the Philadelphia Museum of Art.

9. *Still Life with Black Clock:* (*La Pendule Noir*) is owned by Stavros Niarchos, London.

PAGE 280

1. These five paintings are now in the Courtauld Institute Galleries, London.

PAGE 281

1. *The Fair* (*La Parade*) is now in the Metropolitan Museum of Art, New York.

2. *Honfleur: L'Hospice et le Phare* and *Landscape Study for La Grande Jatte* are now in the Sir Alfred Chester Beatty Collection, Dublin.

3. *Study for La Grande Jatte* is now in the Metropolitan Museum of Art, New York.

4. *Study for Chahut* is in the Albright-Knox Art Gallery, Buffalo.

PAGE 283

1. *Landscape Study for La Grande Jatte* is now in the Sir Alfred Chester Beatty Collection, Dublin.

2. *Study for La Grande Jatte* is in the Metropolitan Museum of Art, New York.

INDEX

Dover Books on Art

Dover Books on Art

STYLES IN PAINTING, Paul Zucker. By comparing paintings of similar subject matter, the author shows the characteristics of various painting styles. You are shown at a glance the differences between reclining nudes by Giorgione, Velasquez, Goya, Modigliani; how a Byzantine portrait is unlike a portrait by Van Eyck, da Vinci, Dürer, or Marc Chagall; how the painting of landscapes has changed gradually from ancient Pompeii to Lyonel Feininger in our own century. 241 beautiful, sharp photographs illustrate the text. xiv + 338 pp. 5⅝ x 8¼.

20760-9 Paperbound $2.25

THE PRACTICE OF TEMPERA PAINTING, D. V. Thompson, Jr. Used in Egyptian and Minoan wall paintings and in much of the fine work of Giotto, Botticelli, Titian, and many others, tempera has long been regarded as one of the finest painting methods known. This is the definitive work on the subject by the world's outstanding authority. He covers the uses and limitations of tempera, designing, drawing with the brush, incising outlines, applying to metal, mixing and preserving tempera, varnishing and guilding, etc. Appendix, "Tempera Practice in Yale Art School" by Prof. L. E. York. 4 full page plates. 85 illustrations. x + 141pp. 5⅜ x 8½.

20343-3 Paperbound $2.00

GRAPHIC WORLDS OF PETER BRUEGEL THE ELDER, H. A. Klein. 64 of the finest etchings and engravings made from the drawings of the Flemish master Peter Bruegel. Every aspect of the artist's diversified style and subject matter is represented, with notes providing biographical and other background information. Excellent reproductions on opaque stock with nothing on reverse side. 63 engravings, 1 woodcut. Bibliography. xviii + 289pp. 11⅜ x 8¼.

21132-0 Paperbound $4.00

A HISTORY OF ENGRAVING AND ETCHING, A. M. Hind. Beginning with the anonymous masters of 15th century engraving, this highly regarded and thorough survey carries you through Italy, Holland, and Germany to the great engravers and beginnings of etching in the 16th century, through the portrait engravers, master etchers, practicioners of mezzotint, crayon manner and stipple, aquatint, color prints, to modern etching in the period just prior to World War I. Beautifully illustrated —sharp clear prints on heavy opaque paper. Author's preface. 3 appendixes. 111 illustrations. xviii + 487 pp. 5⅜ x 8½.

20954-7 Paperbound $3.50

Dover Books on Art

200 DECORATIVE TITLE-PAGES, edited by A. Nesbitt. Fascinating and informative from a historical point of view, this beautiful collection of decorated titles will be a great inspiration to students of design, commercial artists, advertising designers, etc. A complete survey of the genre from the first known decorated title to work in the first decades of this century. Bibliography and sources of the plates. 222pp. 8⅜ x 11¼.

21264-5 Paperbound $3.50

ON THE LAWS OF JAPANESE PAINTING, H. P. Bowie. This classic work on the philosophy and technique of Japanese art is based on the author's first-hand experiences studying art in Japan. Every aspect of Japanese painting is described: the use of the brush and other materials; laws governing conception and execution; subjects for Japanese paintings, etc. The best possible substitute for a series of lessons from a great Oriental master. Index. xv + 117pp. + 66 plates. 6⅛ x 9¼.

20030-2 Paperbound $2.50

PAINTING IN THE FAR EAST, L. Binyon. A study of over 1500 years of Oriental art by one of the world's outstanding authorities. The author chooses the most important masters in each period—Wu Tao-tzu, Toba Sojo, Kanaoka, Li Lung-mien, Masanobu, Okio, etc.—and examines the works, schools, and influence of each within their cultural context. 42 photographs. Sources of original works and selected bibliography. Notes including list of principal painters by periods. xx + 297pp. 6⅛ x 9¼.

20520-7 Paperbound $3.00

THE ALPHABET AND ELEMENTS OF LETTERING, F. W. Goudy. A beautifully illustrated volume on the aesthetics of letters and type faces and their history and development. Each plate consists of 15 forms of a single letter with the last plate devoted to the ampersand and the numerals. "A sound guide for all persons engaged in printing or drawing," Saturday Review. 27 full-page plates. 48 additional figures. xii + 131pp. 7⅞ x 10¾.

20792-7 Paperbound $2.25

PAINTING IN ISLAM, Sir Thomas W. Arnold. This scholarly study puts Islamic painting in its social and religious context and examines its relation to Islamic civilization in general. 65 full-page plates illustrate the text and give outstanding examples of Islamic art. 4 appendices. Index of mss. referred to. General Index. xxiv + 159pp. 6⅝ x 9¼. 21310-2 Paperbound $2.75

HANDBOOK OF DESIGNS AND DEVICES, C. P. Hornung. A remarkable working collection of 1836 basic designs and variations, all copyright-free. Variations of circle, line, cross, diamond, swastika, star, scroll, shield, many more. Notes on symbolism. "A necessity to every designer who would be original without having to labor heavily," ARTIST AND ADVERTISER. 204 plates. 240pp. 5⅜ x 8. 20125-2 Paperbound $2.00

THE UNIVERSAL PENMAN, George Bickham. Exact reproduction of beautiful 18th-century book of handwriting. 22 complete alphabets in finest English roundhand, other scripts, over 2000 elaborate flourishes, 122 calligraphic illustrations, etc. Material is copyright-free. "An essential part of any art library, and a book of permanent value," AMERICAN ARTIST. 212 plates. 224pp. 9 x 13¾. 20020-5 Clothbound $12.50

AN ATLAS OF ANATOMY FOR ARTISTS, F. Schider. This standard work contains 189 full-page plates, more than 647 illustrations of all aspects of the human skeleton, musculature, cutaway portions of the body, each part of the anatomy, hand forms, eyelids, breasts, location of muscles under the flesh, etc. 59 plates illustrate how Michelangelo, da Vinci, Goya, 15 others, drew human anatomy. New 3rd edition enlarged by 52 new illustrations by Cloquet, Barcsay. "The standard reference tool," AMERICAN LIBRARY ASSOCIATION. "Excellent," AMERICAN ARTIST. 189 plates, 647 illustrations. xxvi + 192pp. 7⅞ x 10⅝. 20241-0 Clothbound $6.50

AN ATLAS OF ANIMAL ANATOMY FOR ARTISTS, W. Ellenberger, H. Baum, H. Dittrich. The largest, richest animal anatomy for artists in English. Form, musculature, tendons, bone structure, expression, detailed cross sections of head, other features, of the horse, lion, dog, cat, deer, seal, kangaroo, cow, bull, goat, monkey, hare, many other animals. "Highly recommended," DESIGN. Second, revised, enlarged edition with new plates from Cuvier, Stubbs, etc. 288 illustrations. 153pp. 11⅜ x 9.

20082-5 Paperbound $3.00

VASARI ON TECHNIQUE, G. Vasari. Pupil of Michelangelo, outstanding biographer of Renaissance artists reveals technical methods of his day. Marble, bronze, fresco painting, mosaics, engraving, stained glass, rustic ware, etc. Only English translation, extensively annotated by G. Baldwin Brown. 18 plates. 342pp. 5⅜ x 8. 20717-X Paperbound $3.50

Dover Books on Art

A HANDBOOK OF ANATOMY FOR ART STUDENTS, Arthur Thomson. This long-popular text teaches any student, regardless of level of technical competence, all the subtleties of human anatomy. Clear photographs, numerous line sketches and diagrams of bones, joints, etc. Use it as a text for home study, as a supplement to life class work, or as a lifelong sourcebook and reference volume. Author's prefaces. 67 plates, containing 40 line drawings, 86 photographs—mostly full page. 211 figures. Appendix. Index. xx + 459pp. 5⅜ x 8⅜. 21163-0 Paperbound $3.50

WHITTLING AND WOODCARVING, E. J. Tangerman. With this book, a beginner who is moderately handy can whittle or carve scores of useful objects, toys for children, gifts, or simply pass hours creatively and enjoyably. "Easy as well as instructive reading," N. Y. Herald Tribune Books. 464 illustrations, with appendix and index. x + 293pp. 5½ x 8⅛.
20965-2 Paperbound $2.00

ONE HUNDRED AND ONE PATCHWORK PATTERNS, Ruby Short McKim. Whether you have made a hundred quilts or none at all, you will find this the single most useful book on quilt-making. There are 101 full patterns (all exact size) with full instructions for cutting and sewing. In addition there is some really choice folklore about the origin of the ingenious pattern names: "Monkey Wrench," "Road to California," "Drunkard's Path," "Crossed Canoes," to name a few. Over 500 illustrations. 124 pp. 7⅞ x 10¾. 20773-0 Paperbound $2.00

ART AND GEOMETRY, W. M. Ivins, Jr. Challenges the idea that the foundations of modern thought were laid in ancient Greece. Pitting Greek tactile-muscular intuitions of space against modern visual intuitions, the author, for 30 years curator of prints, Metropolitan Museum of Art, analyzes the differences between ancient and Renaissance painting and sculpture and tells of the first fruitful investigations of perspective. x + 113pp. 5⅜ x 8⅜. 20941-5 Paperbound $1.50

TEACH YOURSELF TO STUDY SCULPTURE, Wm. Gaunt. Useful details on the sculptor's art and craft, tools, carving and modeling; its relation to other arts; ways to look at sculpture; sculpture of the East and West; etc. "Useful both to the student and layman and a good refresher for the professional sculptor," Prof. J. Skeaping, Royal College of Art. 32 plates, 24 figures. Index. xii + 155pp. 7 x 4¼. 20976-8 Clothbound $2.50

Dover Books on Art

ARCHITECTURAL AND PERSPECTIVE DESIGNS, Giuseppe Galli Bibiena. 50 imaginative scenic drawings of Giuseppe Galli Bibiena, principal theatrical engineer and architect to the Viennese court of Charles VI. Aside from its interest to art historians, students, and art lovers, there is a whole Baroque world of material in this book for the commercial artist. Portrait of Charles VI by Martin de Meytens. 1 allegorical plate. 50 additional plates. New introduction. vi + 103pp. 10⅛ x 13¼.

21263-7 Paperbound $2.50

PRINTED EPHEMERA, edited and collected by John Lewis. This book contains centuries of design, typographical and pictorial motives in proven, effective commercial layouts. Hundreds of the most striking examples of labels, tickets, posters, wrappers, programs, menus, and other items have been collected in this handsome and useful volume, along with information on the dimensions and colors of the original, printing processes used, stylistic notes on typography and design, etc. Study this book and see how the best commercial artists of the past and present have solved their particular problems. Most of the material is copyright free 713 illustrations, many in color. Illustrated index of type faces included. Glossary of technical terms. Indexes. 288pp. 9¼ x 12. 21037-5 Clothbound $15.00

DESIGN FOR ARTISTS AND CRAFTSMEN, Louis Wolchonok. Recommended for either individual or classroom use, this book helps you to create original designs from things about you, from geometric patterns, from plants, animals, birds, humans, landscapes, manmade objects. "A great contribution," N. Y. Society of Craftsmen. 113 exercises with hints and diagrams. More than 1280 illustrations. xv + 207pp. 7⅞ x 10¾.

20274-7 Paperbound $2.75

ART AND THE SOCIAL ORDER, D. W. Gotshalk. Is art only an extension of society? Is it completely isolated? In this delightfully written book, Professor Gotshalk supplies some workable answers. He discusses various theories of art from Plato to Marx and Freud and uses all areas of visual arts, music and literature to elaborate his views. "Seems to me the soundest and most penetrating work on the philosophy of art to appear in recent years," C. J. Ducasse, Brown Univ. Addenda: "Postscript to Chapter X: 1962." Bibliography in notes. Index. xviii + 255pp. 5⅜ x 8½. 20294-1 Paperbound $1.75

Dover Books on Art

THE COMPLETE BOOK OF SILK SCREEN PRINTING PRODUCTION, J. I. Biegeleisen. Here is a clear and complete picture of every aspect of silk screen technique and press operation— from individually operated manual presses to modern automatic ones. Unsurpassed as a guidebook for setting up shop, making shop operation more efficient, finding out about latest methods and equipment; or as a textbook for use in teaching, studying, or learning all aspects of the profession. 124 figures. Index. Bibliography. List of Supply Sources. xi + 253pp. 5⅜ x 8½.

21100-2 Paperbound $2.75

A HISTORY OF COSTUME, Carl Köhler. The most reliable and authentic account of the development of dress from ancient times through the 19th century. Based on actual pieces of clothing that have survived, using paintings, statues and other reproductions only where originals no longer exist. Hundreds of illustrations, including detailed patterns for many articles. Highly useful for theatre and movie directors, fashion designers, illustrators, teachers. Edited and augmented by Emma von Sichart. Translated by Alexander K. Dallas. 594 illustrations. 464pp. 5⅛ x 7⅛.

21030-8 Paperbound $3.50

CHINESE HOUSEHOLD FURNITURE, G. N. Kates. A summary of virtually everything that is known about authentic Chinese furniture before it was contaminated by the influence of the West. The text covers history of styles, materials used, principles of design and craftsmanship, and furniture arrangement—all fully illustrated. xiii + 190pp. 5⅝ x 8½.

20958-X Paperbound $2.00

THE COMPLETE WOODCUTS OF ALBRECHT DURER, edited by Dr. Willi Kurth. Albrecht Dürer was a master in various media, but it was in woodcut design that his creative genius reached its highest expression. Here are all of his extant woodcuts, a collection of over 300 great works, many of which are not available elsewhere. An indispensable work for the art historian and critic and all art lovers. 346 plates. Index. 285pp. 8½ x 12¼.

21097-9 Paperbound $4.00

Dover publishes books on commercial art, art history, crafts, design, art classics; also books on music, literature, science, mathematics, puzzles and entertainments, chess, engineering, biology, philosophy, psychology, languages, history, and other fields. For free circulars write to Dept. DA, Dover Publications, Inc., 180 Varick St., New York, N.Y. 10014.